T0331024

SONIC PASTS

Sonic Pasts explores the fields of acoustical heritage and historical soundscapes through an interdisciplinary perspective. Reflecting on different methods of research and dissemination, it critiques biases related to race, ethnicity, gender, socioeconomics, and disability that are intrinsic to these fields.

Academically rigorous while also deeply personal, *Sonic Pasts* introduces readers to how various disciplines have studied the sounds of the past, the connection those studies have to heritage more widely, including the concept of Intangible Cultural Heritage (ICH), and how sound is represented within UNESCO heritage listings. It offers a novel theoretical and practical framework on different approaches to the design of sound installations and online experiences on the topic, including the ethical challenges presented by different techniques.

This book is essential reading for students and researchers considering sounds of the past, as well as sound and heritage practitioners seeking to reflect on their current or future practices.

Mariana J López is a Professor at the University of York. Her research focuses on two fields: the interdisciplinary study of acoustical heritage and historical soundscapes and the use of sound design to create accessible experiences for visually impaired film and television audiences.

SONIC PASTS

Acoustical Heritage and Historical Soundscapes

Mariana J López

Routledge
Taylor & Francis Group

LONDON AND NEW YORK

Designed cover image: Wenqi Wan

First published 2025
by Routledge
4 Park Square, Milton Park, Abingdon, Oxon OX14 4RN

and by Routledge
605 Third Avenue, New York, NY 10158

Routledge is an imprint of the Taylor & Francis Group, an informa business

British Library Cataloguing-in-Publication Data
A catalogue record for this book is available from the British Library

ISBN: 978-1-032-30009-2 (hbk)
ISBN: 978-1-032-30005-4 (pbk)
ISBN: 978-1-003-30301-5 (ebk)

DOI: 10.4324/b22976

Typeset in Sabon LT Pro
by codeMantra

To my parents, for opening up worlds of possibilities.

CONTENTS

ACKNOWLEDGEMENTS

It took me about two years to write this book, but it took me much longer than that to crystallise in my mind what this book should be about and why it mattered. It took even longer for me to learn about this field enough to feel like I had something interesting to say (and I do hope that you find this book interesting or that at least some parts of it catch your attention). All those processes were possible thanks to counting with support from several different people throughout the years.

First, I'd like to thank Emily Tagg and Hannah Rowe for their editorial support, from proposal submission to print. Thanks for guiding me through the process with professionalism and understanding. Thanks to Karen Cook for the excellent work done on indexing. Thanks to Catherine A.M. Clarke, Robert Houghton, Simon C. Thomson, and the respective publishers Arc Humanities Press, De Gruyter and Brepols, for helping secure permissions to reuse sections of previous work for this volume. Thanks to the School of Arts and Creative Technologies at the University of York for supporting the research leave during which a lot of this book's work was carried out. Time is such a precious currency in academia and elsewhere, and I'm grateful to have been given the time I needed to write this piece and allow it to mature. Special thanks are due to Catherine A.M. Clarke, Gavin Kearney, Damian Murphy, and Rachel Willie for agreeing to read and comment on the manuscript. Thanks for taking the time to do this, your support is greatly appreciated. To my longtime collaborator, the wonderful Oswin Wan (Wenqi Wan), huge thanks for designing this beautiful book cover. Os sat through what probably felt like a never-ending excruciatingly detailed explanation of what this book was about and was able to take that and turn it into a visually appealing rendition of the ethos of this book.

Special thanks to Damian Murphy who back in 2008 got me interested in the fascinating world of acoustical heritage and inspired a whole career in the field. Thanks for your mentorship, support, and understanding throughout the years. I would also like to thank my friends and dear colleagues Lidia Álvarez Morales and Cobi van Tonder. It is a huge honour to me that both Lidia and Cobi trusted me enough to work with them on their acoustical heritage projects, and by doing so taught me new technical and creative ways of embracing the field. It was during Lidia's work on *Cathedral Acoustics* that I had the immense pleasure of meeting Ángel Álvarez Corbacho, as he joined us on acoustic measurement trips and never failed to bring with him all his architectural expertise as well as his huge smile, goodwill, and support. In addition to this, when starting the process of writing the historical summary of acoustic measurements, Ángel, together with Lidia and Damian, provided me with insights that had a huge impact on the shaping of that section. We miss you Ángel.

To Richard A. Carter for the very many car journeys in which we discussed this book, the proofreading of the manuscript that helped me polish the work, and for designing the figures in the volume – I'm thrilled that carpinchos/capybaras made it into this book; most of all for his endless support and encouragement. You made the process of writing a book much less lonely.

But most of all I'd like to thank my parents who, since I was very little, showed me the very many wonders the world holds and inspired an appreciation of cultural and natural sites that has always been precious to me. I've been very lucky to have been able to travel around the world from a very young age, a process that has nurtured my appreciation for the diversity of our world. Thank you very much!

Chapter Acknowledgements

Sections of this book have appeared in previous publications and are used here with permission from editors and publishers.

Lopez, Mariana (2016) "The York Mystery Plays: Exploring Sound and Hearing in Medieval Vernacular Drama," in Simon Thomson and Michael Bintley (eds) *Sensory Perception in the Medieval West*. Turnhout: Brepols.

Lopez, Mariana (2020) "Heritage Soundscapes: Contexts and Ethics of Curatorial Expression," in Catherine A. M. Clarke (ed) *The St. Thomas Way and the Medieval March of Wales: Exploring Place, Heritage, Pilgrimage*. Leeds: Arc Humanities Press.

López, Mariana, Hardin, Marques and Wan, Wenqi (2022) "The Soundscapes of the York Mystery Plays: Playing with Medieval Sonic Histories" in Robert Houghton (ed) *Teaching the Middle Ages through Modern*

Games: Using, Modding and Creating Games for Education and Impact. Berlin/Boston: De Gruyter.

Design Acknowledgements

The book cover design is by Wenqi Wan. The figures included within this book are by Richard A. Carter.

1
ON DEFINITIONS AND WHO WE ARE

It is a Saturday night, sometime in the 1990s, and I'm in Boulogne Sur Mer. No, not the French city, but a town in the Province of Buenos Aires (Argentina), and no, not near the obelisk, nowhere near it. I am sitting at a dining table in my paternal grandparents' house. I'm pretty sure we are having dinner – my grandmother was a truly exceptional cook – when the conversation turns to heritage, specifically the chopping up (literally) of a national Argentinian monument, *El Cabildo de Buenos Aires*. This was the site of the formation of the first national government in 1810, prior to independence in 1816. There has been a building on this site since the sixteenth century, but its shape as it is known now, with its arches and bell tower, dates from the eighteenth century (Schávelzon 2002). In 1889 and in 1931 some of its iconic arches (six in total) were cut down, initially to make way for the Avenida de Mayo and then, subsequently, the Avenida Julio A. Roca (Ruiz Díaz, n.d.; Schávelzon 2002). Only five arches remain of the iconic building. During dinner my dad expresses how appalling this demolition was, a true destruction of heritage. My grandfather disagrees, stating that progress requires letting go of the past to make way for the new, apparently expressed through avenues. My dad corrects him, saying that progress is the protection and valuing of the past, and our heritage. My dad and my grandad were far from the only ones to engage in a discussion of this sort. In 1931 the demolition of three of the arches of *El Cabildo* brought with it conversations about potentially dismantling the whole building. These were met with public resistance and led to the site being declared a historical monument in 1933 (Wolman 2010). Apparently, you cannot demolish one of those (Ballent 2016).

This book is about heritage, more specifically its sonic aspects, as framed by the concepts of *acoustical heritage* and *historical soundscapes*. It is a book

DOI: 10.4324/b22976-1

about what is chosen for preservation and what is not, who makes these decisions and why, how that preservation takes place, and who the guardians of this heritage are and who they should be, as well as how findings in the field are shared to non-specialist audiences. It is a book meant to be provocative in its questioning of the field, and in its denunciation of its manifold biases. These biases stem from inequalities across gendered, racial, ethnic, and social divisions, as well as a lack of consideration around issues of disability, and the fact that the field's ultimate origins and evolution cannot be disentangled from colonial histories. This book argues that incorporating much greater interdisciplinarity and intersectionality in the field can help revisit acoustical heritage studies, demonstrating that arguments of objectivity, derived from the sciences, have produced the exact opposite of the very objectivity sought after, leading to biased interpretations of sonic heritage findings, as well as biased selections in the primary sites of interest. Whereas history, archaeology, and other heritage fields have looked into revisiting their methods and findings through intersectional approaches, acoustical heritage studies have invariably lagged behind, often disappointing those in search of more progressive outlooks. Therefore, this book is also a reflection on what this field could do – and should do – to become not only more self-reflexive, but maybe, one would hope, become a vehicle for explorations of diversity, equality, and social justice.

I use the term *acoustical heritage* to refer to the acoustics of heritage sites that are representative of different past periods, all the way from prehistoric sites to those of very recent history. In so doing, I consider the acoustics of the sites themselves to be a representation of a culture's heritage, more specifically its intangible heritage. Within acoustical heritage studies we investigate how sound is affected by the characteristics of a site, which can either be a built or a natural environment, as well as a closed or open space. Acoustical heritage research is also sometimes referred to as *heritage acoustics, acoustic heritage*, and *archaeoacoustics* – the implications of this last term, together with the assumptions associated with it, are explored in a more in-depth manner in Chapter 2. Varying terminology aside, acoustical heritage explores how an environment modifies sounds, and how the relationship between sound and space can affect the perception of those sounds. Therefore, when studying acoustical heritage, this book considers together both the spaces themselves and the sounds that interact with them, and what they can tell us subsequently about the experiences of past cultures – acknowledging, all the while, the difficulty of fully understanding past sensorial experiences across different cultures, a topic that will be discussed in Chapter 2.

This book is also about what is sometimes referred to as *historical* or *historic soundscapes*,[1] which can be defined as soundscapes of the past, with the definition of soundscape being central to its understanding. As a term, soundscape is associated with Schafer, who defined it as a "sonic

environment" (1994) and suggested that this includes three main types of sounds: keynote sounds, signals, and soundmarks. "Keynote" sounds are sounds that are not consciously perceived, being continuous or frequent enough in an environment for its immediate community, and so act as a background for the perception of other sounds. These sounds are chiefly a result of a place's geography and climate. In a coastal community, for instance, this could be the sound of the sea, while in an urban space this could be a constant traffic hum. By contrast, "signals" are consciously listened to and are associated with announcement and warning sounds. This is the case of bells, whistles, horns, and sirens; they communicate meaning. Finally, "soundmarks" are equivalent to landmarks, being sounds that have features that make them noticed and particularly well-regarded by members of a particular community. They are likely to be identified as needing protection, precisely because they are deemed unique and valuable. An example given by Schafer (1994: 239) is that of the Big Ben, a sound to which we will return in Chapter 4.

The term "soundscape" is certainly useful in encouraging the awareness of the sounds around us and thinking about environments beyond the visual domain. However, the term as it pertains to Schafer's framework has received a number of criticisms and calls for reflection on its use. Arkette (2004) points out distinct biases embedded in Schafer's conceptions of the sonic environment and the sounds he privileges. Specifically, Schafer privileges natural sounds over urban sounds and proposes the preservation of those sounds that are key to a community and have a historical dimension, relegating urban sounds to the category of "sonic pollutants" (Arkette 2004: 161). Urban spaces, Arkette (2004) argues, have constantly changing sounds associated with its various communities, and those sounds change throughout the week and even within the same day (Arkette 2004: 162). It is this "urban prejudice" (Arkette 2004: 161) that constitutes Arkette's main critique of the term soundscape as defined by Schafer.

Ingold (2007) goes as far as suggesting that the term "soundscape" should be dispensed with, although for different reasons to those exposed by Arkette (2004). Ingold's (2007) main preoccupation is that the term compartmentalises the senses, undermining the fact that perception engages the senses simultaneously. The term landscape, he explains (Ingold 2007), is itself all encompassing, without any association with one sense or the other, and it can therefore be used in sound studies without the need to refer to soundscapes specifically.

Helmreich (2010: 10) has also presented apprehensive opinions on the concept of soundscape, due to its conception of a space that is there to be perceived as well as a listener that is both separate from that space while also being immersed in it. It is this contradictory construction of the relationship between object and subject that he finds most questionable (2010: 10).

Kelman (2010) presents a thorough reflection on the opportunities and tensions involved in the use of the term "soundscapes", exploring how the term has been often redefined to suit different researchers' needs, and how it is commonly either separated from its original meaning, or that this original meaning goes unexplored or unacknowledged. Kelman (2015) does not necessarily suggest that scholars abandon their use of the term, but that they should reflect on its definition as per Schafer and on their own particular deployments of it. Kelman argues that although the term is now being used very generically, that is far from Schafer's specific conception (2015: 214). Similar to Arkette (2004), Kelman defines Schafer's observations as largely ideological, heavily influenced by Schafer's personal preferences, and highly prescriptive on how one should listen – celebrating sounds of past times while lamenting those of modernity (Kelman 2015: 214). This idiosyncratic conception of a soundscape is, Kelman (2015: 216) suggests, presented clearly in Schafer's distinction between hi- and lo-fi soundscapes, which are defined by their signal-to-noise ratio (SNR), and which leaves those who populate lo-fi environments with little agency, unless they follow his specific suggestions on how to listen (Kelman 2015: 217). Schafer (1994: 43–44) defines hi-fi soundscapes as those with a high SNR, where individual sounds are more clearly audible because of low background noise, enabling foreground and background sounds to be distinguished clearly. By contrast, lo-fi soundscapes are those in which the SNR is low, meaning sounds cannot be differentiated clearly from one another, leaving us hearing less distinctly and with reduced auditory perception. According to Schafer, rural environments are prime examples of hi-fi soundscapes, whereas urban ones are distinctly lo-fi. Moreover, Schafer believed that the soundscapes of the past were distinctly more hi-fi than those of the present.

Schafer's idealisation of "natural" sounds has in itself a long history, dating back to the late Renaissance and early modern periods in Europe, in which the pastoral was idolised, with quiet environments emerging as coveted sanctuaries in opposition to the grating noise of urban ones, and which is itself linked to the emergence of the *pastorale* music genre (Biddle and Gibson 2019: 5–6).

Annie Goh (2017) takes a different approach to the critique of Schafer's work on soundscapes, by arguing that his work, rooted in sonic naturalism – with its nostalgia for quieter times and its traditional object-subject division – needs to be revised through feminist epistemologies (2017: 285). Goh (2017) argues that Schafer's division of subject (listener) and object (soundscape) is rooted in Western epistemology, and that it presents a gendered relationship, with the listener in Schafer's work being ahistorical and male, whereas the soundscape is a feminised object of study (2017: 285). Goh suggests that by questioning the subject-object relationship, through "embodiedness and situatedness" (Goh 2017: 293), we can break away

from "the tendencies towards universalizing, ahistorical, neutral subjects in sound studies" (2017: 293). This will be an important line of critique running throughout my exploration of sound heritage in this volume, emphasising contextual approaches that are intrinsic to work in the fields of Sensory History, Sensory Archaeology, and Sensory Anthropology, and this will be discussed in Chapter 2.

A question perhaps inevitably arises as to why I am still choosing to use "soundscapes" as a term in the face of such criticism. My use is motivated partly because I believe it *can* be disentangled from its original framework by critically repositioning and redefining it, all while acknowledging the shortcomings and biases present in its original conception – biases to which I will be returning continually throughout this book. Nonetheless, I think it is important to emphasise that this book is also about engaging non-specialists with sound and acoustics as a critical part of history and heritage, and I believe that doing so successfully requires employing terminology that is graspable and attractive, operating as a gateway towards more meaningful explorations. Stated pragmatically, sounding overly academic risks distancing non-specialists who might feel that the acoustics of the past are just not for them, and so creating further barriers to access. Moreover, I doubt that audiences encountering historical soundscape installations at museums perceive them as an opportunity to problematise Schafer's original concept of soundscape while doing so.

In this book, I am defining "historical soundscapes" as a combination of sounds that we believe, based on research, to have been experienced by individuals in a certain cultural context in a particular region and moment in time. Soundscapes are fluid, both now and then, and what is included in a soundscape can change from moment to moment and is highly dependent on the individual and their role at a specific moment in time and space. For example, as I walk towards the centre of the UK city of York on a Saturday, I hear all sorts of simultaneous sounds: the bells of the York Minster, the collective voice of the shopping crowds, the busker singing musicals in one street juxtaposed against the pan-pipe player in another. I might hear the sounds of rain and wind, depending on the weather. I might not be focusing on any of these sound elements at all, but they are still there, forming part of my experience as I walk along the streets. Indeed, there are other sounds happening at the same time that are not part of my immediate soundscape but form part of those belonging to others. For example, I might be talking to a friend, and those words contribute to the crowd sounds picked up by others, forming part of their soundscapes. And, of course, the acoustics of the environment are key to those soundscape experiences.

Soundscapes not only shift from moment to moment, from listener to listener, but also across shorter and longer periods in time. As a child I remember walking to school with my mum and hearing a whistle playing in the

street. I was curious and asked my mum what it was. She explained that it was a knife sharpener, and indeed, sometimes the sound of the whistle was accompanied by the shout of "afiladoooor". Interestingly enough, I do not remember actually seeing the knife sharpeners. Maybe I never did. I only remember hearing them, they were part of my soundscape. When asking my mum during the writing of this book, she confirmed she had not heard them herself for a long time and did not think that *afiladores* existed anymore. The soundscape has changed. It is the fluidity of soundscapes, as well as their cultural specificity, that makes it a challenge to study them.

Before proceeding further concerning what this book is about, it is worth noting, briefly, on what it is not aiming to cover. This book is not an exploration of historical musicology, and its focus is not music. However, it will consider music in its interaction with environments and its inclusion as part of wider soundscapes. For example, music performed in an eighteenth-century opera house might be considered in relation to how it is impacted by the acoustics of the space, but this volume does not engage in conversations around the modern performance of the repertoire and techniques for the recreation of historical musical instruments. Nevertheless, this book does bear in mind Biddle and Gibson's (2019: 6–7) warning on the intertwining of the cultural history of music with historical sound studies, which can make their separation unadvisable, because of how they influence each other. We can recall here our earlier discussion around the emergence of the pastorale as a musical genre, which is connected to notions of quiet and noise in the late Renaissance and early modern Europe (Biddle and Gibson 2019: 6–7).

It is finally worth emphasising that this is not a book on acoustical theory, or a book on audio engineering, and I will not be providing an in-depth explanation of acoustical theory or audio engineering principles – though I will briefly explore some basic acoustic principles in Chapter 2 as a necessary step to explain methods used in acoustical heritage studies. Whenever doing so, I have attempted to explain terminology and concepts in ways that I hope are useful for readers from different disciplinary backgrounds.

Challenges of and Challenging the Field

Research on acoustical heritage and historical soundscapes has its own unique challenges due to its focus on intangible heritage (see Chapter 3); challenges become even more pronounced when dealing with periods prior to the advent of recording technology, for which we have to rely on textual and physical remains to determine what sounds might have been present. Furthermore, when focusing on acoustics, the buildings and spaces being studied might no longer actually exist or do so in a very different state from that in which they were first used, posing critical obstacles to the recreation of their acoustic characteristics (see Chapter 2).

Interest in acoustical heritage and historical soundscapes has developed across several disciplines, including acoustic engineering, archaeology, anthropology, and history, among others. However, *multi*-disciplinarity has not always resulted in truly *inter*disciplinary work. Research is approached from very many different angles by researchers from different disciplinary backgrounds, with different knowledge and strengths. This has resulted often in a sense of a disjointed field, in which it is not always clear what is "next", and "progress" is measured differently depending on the disciplinary framing being invoked. Such disarticulation of the field sometimes results in the same questions being asked repeatedly, rather than the use of studies to complement each other and advance our collective understanding of different periods. Furthermore, juxtapositions between different disciplinary cultures have sometimes resulted in a distrust of methods and findings. For instance, researchers in the humanities can sometimes be sceptical about recreations of historical soundscapes and acoustics, questioning their value (Atkinson 2016: 2; Smith 2007). Conversely, acoustic engineers researching heritage sites do not always acknowledge the limitations of recreations in terms of cultural specificity, and often focus on technological aspects.

This gulf between approaches has often resulted, on the one hand, in studies that refer to sound mostly through the analysis of textual references, while on the other are those that involve complex numerical data. There are also numerous studies that have explored the sonic representation of findings through practical recreations of the sounds of the past, as undertaken within museums and heritage sites, as well as online. Chapter 2 will explore the implications of these different disciplinary investigations, whereas Chapter 5 will reflect on the variety of approaches taken by designers who are recreating the sonic pasts, as well as considering the limitations around the types of sonic pasts explored.

The field, particularly in relation to acoustical heritage, has ultimately shown an approach that is analogous to a cabinet of curiosities, with researchers *collecting* spaces to be measured, analysed, and auralised in their individuality and treasured in the shape of impulse responses (see Chapter 2), often leaving aside the potential for working on greater interrogations on how those buildings and spaces are connected to each other, and what they might then tell us about the sounds of a period in a particular region. Even more importantly, there is often little reflection, critical or ethical, on *why* particular spaces were chosen and *whose* spaces they are. More often than not, the spaces studied have tended to centre on European heritage, with only a minority of studies focusing on other regions – a tendency that mirrors UNESCO World Heritage Lists more broadly, as will be seen in Chapters 3 and 4. Such a limited geographical approach sends the message that the acoustical heritage of value lies in certain regions and not in others, and this imbalance can often be interrogated usefully through concepts of orientalism, as will be seen

in Chapter 3. Following on from this, we can observe that acoustical heritage studies have often focused on buildings and spaces of certain social, cultural, or political status, centring experiences linked to aristocratic and religious groups. This invites enquiry concerning whose sonic heritage we are attempting to study and recreate, and whose sonic histories matter versus those that do not. On this point, experiences in relation to gender are also key to sound considerations, but are often wholly missing from studies, or, alternatively, drive preconceptions that affect the interpretation of the final results, as will be reflected on in Chapter 3.

In summary, a core premise of this book is that all disciplines have something to contribute to the study of historical soundscapes and acoustical heritage, and that they should not be cast in opposition. A truly interdisciplinary approach is where the future strength and growth of the field lies, and I hope I can offer readers not only a window into what has been studied so far, but also suggestions on progressive ways forward, particularly regarding its diversification.

Who We Are

This introduction requires something else that is crucial before moving forward: a reflection on *who* is writing this text and how this affects its content. Years ago, and very naively, I believed that it was best to hide the author as much as possible in academic writing. My thinking was based on a pragmatic belief that people approach academic texts for their content, not the person, and this in itself was due to having been taught that only critical objectivity was what mattered – indeed, that it was possible at all, and something to aim for above all else. I have now changed my mind. It is impossible for this volume not to be affected by who I am and what I believe to be true.

I am writing this book as a Latina, a Latin American woman from Argentina who has been living in the UK for over a decade. This matters, my experiences as a woman and as a Latin American, and as one living in a foreign country, have all affected how I see my field of study, how I see myself as an academic and, invariably, how others see me. How I speak affects what people think about me, and expect from me, and even before I literally open my mouth to present my work, people will make assumptions based on my name – which they often misspell because they are Europeanising it, I suspect, or, at the very least, are not paying that much attention. Moreover, it is quite common for people to be mystified by my accent and, in academic settings, I have often been in situations in which my accent rather than my work becomes central. Accents and their consideration in sound recreations will be explored in Chapter 5.

I am also writing, in many ways, from a very privileged position. I am a Professor at a prestigious UK university, and I have had the chance of

travelling around the world since I was very young, thanks to my parents' keenness on myself and my siblings learning as much as we could about different countries and cultures. We all sit within spheres of inclusion and exclusion that invariably determine how we see the world.

In a recent visit to Buenos Aires I was confronted with an excellent example of these varying perspectives. My dad very kindly offered to drive me and my partner around the neighbourhoods in which I grew up, past my previous houses and school, as well as my late paternal grandparents' house, which was key to my experiences growing up. As we drove around my dad contextualised the experience for my British partner, explaining that those were middle-class neighbourhoods. I sat there, wondering. My dad was right; those were Argentinian middle-class neighbourhoods, but I also knew that my partner was probably thinking that they did not look like middle-class neighbourhoods. Class distinctions are not universal: the middle class of Argentina, in terms of their material accommodation, is equivalent to the working class of the UK. The working class in Argentina has a very different living experience indeed. This may strike as a simple and obvious reflection, but it is one that I have kept in mind while considering how we research the sounds of the past and characterise the experiences of its different social members. We should, in short, remain cautious about applying modern, universalising labels to past cultures.

My educational background also has an impact on how I present the research in this book and what I chose to investigate. My own mixed background in terms of disciplinary training has led me to be interested in creating an interdisciplinary approach to the study of historical soundscapes and acoustical heritage, as well as their presentation to non-specialist audiences. My undergraduate degree at the Universidad de Buenos Aires was in Arts with specialisation in Music, which is close to what many would associate with a degree in Musicology. The study of Music was grounded in different disciplines and in connection to its history. I studied music through the lenses of Anthropology, Psychology, Sociology, and Philosophy, as well as by considering its changes throughout history – although that history was, ironically, very much centred on Europe and North America, with far less content dedicated to other contexts. My undergraduate degree equipped me with a strong Arts and Humanities background, which has resulted in my desire to engage with the sounds of the past through approaches that carefully consider people, societies, diversity, and equality.

My postgraduate studies in sound design also equipped me with the skills to record, edit, and mix soundtracks, which are central to my interest in how creativity can be key to presenting results to non-specialists. In turn, my doctoral studies on the medieval drama cycle of the *York Mystery Plays*, and the acoustics of its performance spaces in the sixteenth century, equipped me with extensive technical knowledge of acoustic measurements, computer

modelling, and complex analyses, as well as focusing my critical attention on questions concerning the medieval period. The latter is the reason why, although this book does not focus on any one historical period, there might be instances in which there is a greater number of examples that are medieval in origin. Furthermore, throughout the pages ahead I have engaged critically with my own work in the field as well as that carried out in collaboration with others, utilising it to exemplify different processes of study.

My interest in the field of acoustical heritage and historical soundscapes started back in March 2008. As a Masters student at the University of York, working on postproduction sound for film and television, and very importantly as an international student, I was very keen to learn as much as possible outside of what was covered in the degree. I came across this one-day workshop organised by Damian Murphy and Jude Brereton titled "Virtual Audio and Past Environments: Audio and Acoustics in Heritage Applications" at the National Centre for Early Music.[2] It was a truly transformative experience. I had come across Murphy's work on the use of acoustic measurements and computer modelling only immediately prior to that workshop – mostly by reading his work on Coventry Cathedral with Mark Beeson, which then led me to explore things further (Murphy and Beeson 2007). Hearing about several different approaches to the study of the sonic pasts was fascinating. Until then, I had not even known that acoustical recreations existed and much less that they could be used to critically reflect on the past, and rethink our conceptions concerning it. This now strikes me as odd, as I had been involved in medieval music ensemble playing, and had maintained a keen interest in the philosophical and aesthetic considerations that entail the performance of early music through authors such as Taruskin (1995) and Leech-Wilkinson (2002). However, despite this, it had not crossed my mind to think about the spaces in which that music would have been performed, or how the presence of other sounds would have affected the performance overall. I certainly had yet to think about other sonic experiences that were not musical, such as theatre or even everyday experiences. It is therefore fair to say that this workshop back in 2008 started me on the path to exploring the field and eventually writing this book.

What's Next

The chapters ahead will examine different areas linked to the study of acoustical heritage and historical soundscapes, as understood from various research perspectives, before moving on to consider the role of heritage organisations, and then finally onto questions around research dissemination.

Chapter 2 will initially outline the many disciplines through which acoustical heritage and historical soundscapes have been explored, while reflecting on their connection to sensory studies more generally. It will then provide an

explanation as to how acoustical heritage is studied from the standpoint of acoustic engineering, as well as key terminology that is utilised.

Chapter 3 opens by examining the classification of acoustical heritage and soundscapes as a form of intangible heritage by different researchers – a perspective that started me on the path of exploring the UNESCO Intangible Cultural Heritage (ICH) lists in search of more such sonic examples. This chapter presents a thorough analysis of relevant entries, as well as a reflection of possible reasons behind certain omissions. Moreover, this chapter will explore the origins of the ICH Convention and its links to wishes by various groups to diversify heritage entries. This will be used as a vehicle to explore the field of acoustical heritage and historical soundscapes in relation to critical biases that have compromised these attempts towards diversification.

Despite the ready association we might make with intangibility, acoustics and soundscapes can also be linked to *tangible* heritage, which is why Chapter 4 focuses on the UNESCO World Heritage Convention and its associated lists, thereby reflecting on those entries that mention sonic elements and considering how those elements are included or excluded. This chapter will explore this topic through a variety of themes, including the sounds of nature, conceptions of quiet and tranquillity, politics of noise, and building acoustics, among others. The findings here will be intertwined with a reflection on the biases present in how sound heritage has been used and understood in different contexts.

Chapter 5 will shift the focus on questions of dissemination, particularly to non-specialist audiences and through sound creations. The chapter will explore a framework I have created through which we can consider these different methods of dissemination, while also exploring their opportunities, limitations, and ethical challenges. As part of this chapter, I will also discuss the use of sound recreations for sensitive topics linked to what I have called *soundscapes of trauma* and *acoustics of torture*.[3] It should be stated clearly that this section deals with content related to sound and acoustics that some readers might find upsetting.

Chapter 6 offers some concluding thoughts.

I hope this book is useful for those just starting out in the field, or with a budding curiosity in the topic, as well as seasoned researchers and heritage practitioners out there who are looking for a slightly different perspective on the topic.

Notes

1 The term is not my own and has already been used elsewhere, for example, the website *Paisajes Sonoros Históricos* (historicalsoundscapes.com) by Ruiz Jiménez y Lizarán Rus (2015) and in the project *Experiencing Historical Soundscapes: the Royal Entries of Emperor Charles V in Iberian Cities* by Rodríguez-García (2020–2022) (https://cordis.europa.eu/project/id/892680).

2 Murphy, Damian (2008), *Virtual Audio and Past Environments: Audio and Acoustics in Heritage Applications*, https://www-users.york.ac.uk/~dtm3/acoustics_heritage.html [last accessed 28th February 2024].
3 Although the terminology *soundscapes of trauma* and *acoustics of torture* was coined for this volume as a way of reflecting on soundscapes and acoustics in an inseparable way which allows us to study how those experiences could be conveyed through sound installations and online experiences, I would like to highlight that the term 'soundscapes of trauma' has been used as part of the ERC-funded project 'Soundscapes of Trauma: Music, Sound and the Ethics of Witnessing' led by Papaeti (https://cordis.europa.eu/project/id/101002720).

References

Arkette, Sophie (2004) "Sounds Like City," *Theory, Culture & Society*, 21:1, 159–168, DOI: 10.1177/0263276404040486.
Atkinson, Niall (2016) *The Noisy Renaissance: Sound, Architecture, and Florentine urban life*. Pennsylvania: The Pennsylvania State University Press.
Ballent, Anahi (2016) "El Estado como problema: el Ministerio de Obra Públicas y el centro de Buenos Aires durante la presidencia de Agustín P. Justo, 1932–1938," *Estudios de Hábitat*, 14:2, https://tinyurl.com/nhjs45ju.
Biddle, Ian and Gibson, Kirsten (2019) "Introduction" in Ian Biddle and Kirsten Gibson (eds) *Cultural Histories of Noise, Sound and Listening in Europe, 1300–1918*. Oxon: Routledge. pp. 1–14.
Goh, Annie (2017) "Sounding Situated Knowledges: Echo in Archaeoacoustics," *Parallax*, 23:3, 283–304, DOI: 10.1080/13534645.2017.1339968.
Helmreich, Stefan (2010) "Listening Against Soundscapes," in *Anthropology News*, December 2010.
Ingold, Timothy (2007) "Against Soundscape," in A. Carlyle (ed) *Autumn Leaves: Sound and the Environment in Artistic Practice*, Paris: Double Entendre, pp. 10–13.
Kelman, Ari Y. (2010) "Rethinking the Soundscape," *The Senses and Society*, 5:2, 212–234, DOI: 10.2752/174589210X12668381452845.
Leech-Wilkinson, Daniel (2002) *The Modern Invention of Medieval Music: Scholarship, Ideology, Performance*. Cambridge: Cambridge University Press.
Murphy, Damian, (2008) *Virtual Audio and Past Environments: Audio and Acoustics in Heritage Applications*, https://www-users.york.ac.uk/~dtm3/acoustics_heritage.html [Last accessed 28th February 2024].
Murphy, Damian and Beeson, Mark (2007) *Virtual Acoustics*, https://www-users.york.ac.uk/~dtm3/virtualacoustics.html [Last accessed 28th February 2024].
Papaeti, Anna (2021-2026) *Soundscapes of Trauma: Music, Sound and the Ethics of Witnessing*, DOI: 10.3030/101002720.
Rodríguez-García, Esperanza (2020–2022) *Experiencing Historical Soundscapes: The Royal Entries of Emperor Charles V in Iberian Cities*, DOI: 10.3030/892680.
Ruiz Díaz, Matías (n.d.) *El Cabildo de Buenos Aires*. Instituto de Arte Americano e Investigaciones Estéticas "Mario J. Buschiazzo," Facultad de Arquitectura, Diseño y Urbanismo, Universidad de Buenos Ares, https://www.iaa.fadu.uba.ar/?page_id=13180 [Last accessed 28th February 2024].
Ruiz Jiménez, Juan and Lizarán Rus, Ignacio José (2015) *Paisajes sonoros históricos* (c.1200–c.1800), https://www.historicalsoundscapes.com/ [Last accessed 28th February 2024].

Schafer, R. Murray (1994) *The Soundscape: Our Sonic Environment and the Tuning of the World*. Rochester: Destiny.

Schávelzon, Daniel (2002) *The Historical Archaeology of Buenos Aires: A City at the End of the World*. Kluwer Academic Publishers: New York.

Smith, Mark (2007) *Sensory History*. Oxford: Bloomsbury.

Taruskin, Richard (1995) *Text and Act: Essays on Music and Performance*. New York: Oxford University Press.

Wolman, Susana (2010) *Bicentenario. Pasado y presente de Buenos Aires, en clave de Mayo. Aportes para la enseñanza*. Escuela Primaria. Primer Ciclo. Ministerio de Educación, Buenos Aires, Gobierno de la Ciudad, https://www.bnm.me.gov.ar/giga1/documentos/EL002061.pdf [Last accessed 28th February 2024].

2

FROM VITRUVIUS TO ARCHAEOACOUSTICS

Studying Sonic Pasts

Introduction

The study of acoustical heritage and historical soundscapes has been approached from a variety of perspectives corresponding to different disciplines, which has turned the field into a multi-disciplinary arena, rather than an interdisciplinary one. This chapter explores some of the different approaches and considerations linked to the study of the sounds of the past by examining humanities and social sciences perspectives, as well as engineering ones, introducing different methodologies and considerations along the way.

On Sensorial Studies: History, Archaeology, and Anthropology

Douglas Kahn (2002) whimsically explains that from the mid-1990s historians seem to have "started growing ears" (2002: 5), characterising the growing number of texts on sound and listening as an "auditory turn" (2002: 6). Such texts included Felicia Miller Frank's *The Mechanical Song: Women, Voice and the Artificial in Nineteenth-Century French Narrative* (1995); Alain Corbin's *Village Bells: Sound and Meaning in the Nineteenth Century French Countryside* (1998); Bruce R. Smith's *The Acoustic World of Early Modern England: Attending to the O-Factor* (1999); and Emily Thompsons's *The Soundscape of Modernity: Architectural Acoustics and the Culture of Listening in America, 1900–1933* (2004), among others. This marked shift is connected to what has been referred to more widely as a sensory turn in the humanities and social sciences, which is also referred to as a sensory or sensual revolution (Howes 2005a, 2021). This sensual revolution has

DOI: 10.4324/b22976-2

its inception in the anthropology of the senses and its challenging of the traditional dominance of psychology over sensory studies (Howes 2021: 132). It also has roots in the "linguistic turn" of the 1960s, which approached the study of culture as a text (Howes 2005a: 1). Howes considers this embrace of the senses as nothing less than a paradigm shift (2021: 129), whereas Skeates and Day (2020: 4), in the context of archaeology, instead consider this growth of sensory studies as facilitating discussions on the topic that go on to impact other fields, but altogether not amounting to a profound intellectual change (2020: 4). In both cases, however, there is no doubt concerning the impact of the study of sensorial experiences on different fields, such as the ones explored below.

Sensory History is a field that considers the varied roles of the senses in past cultures and societies, and how they have shaped people's experiences and their understanding of the world (Smith 2007). Sensory History, together with Sensory Archaeology and Sensory Anthropology, operates on the key premise that the senses are not only physiological but are culturally constructed, and, from this, that they are not universal but are historically grounded, being linked to a particular time and place (see e.g. Bull et al. 2006). The act of hearing, for instance, is not just physiological but also cultural, such as when certain sounds become linked to cultural values within a particular society (Classen 1997). In short, while sensory experiences might, at first glance, appear universal, the way we assign meaning to them is not, for these experiences are influenced by factors such as class, gender, and age (Hamilakis 2015), and, in turn, play a crucial role in how we engage with those different characteristics (Howes 2005a: 4). A good example of this can be found in how "a pleasant sound" is not the same across all cultures across the centuries, and this can vary greatly even within the context of a specific culture, for there will be different sensorial regimes operating concurrently (Hamilakis 2015; Howes 2005a: 11), with different sensations deemed pleasant/unpleasant or safe/dangerous, and becoming connected to different groups of people associated with those characteristics at different times and places (Howes 2005a: 10). Given that sensorial experiences are central to all social and cultural practices (Bull et al. 2006), how the senses are considered, and what practices surround them become representative of the varying ideologies held by a particular society at a particular moment in time (Howes 2005a: 4). Societies and cultures will have different sets of sensorial norms that are followed and enhance identification with the group, whereas breaking them can result in the labelling of that person as an outsider or a rebel (Salter 2019: 775). Even the same sound may be considered appropriate or inappropriate depending on the context. Salter (2019: 775) illustrates this by indicating how the sound of "booing" by audiences might be found acceptable when directed at a football referee when audiences question their performance, but the same "booing" would surprise us if directed at an orchestra

conductor whose directing style we do not approve of. Different contexts and spaces are linked to different sounds, and in the context of verbal communication Truax (2017: 254) warns us about assigning universal meaning to paralinguistic aspects of speech (e.g. pitch, inflections, timbre) as they are also culturally specific. Interpreting such paralanguage in terms of mood, intent, sincerity, and the relationship between interlocutors by taking a sonic framework from one culture to the other is likely to lead to misinterpretations (Truax 2017: 254).

Howes (2005a) uses the term *sensescape* to describe the experience of the environment and those within it within a specific cultural context, as influenced by the division of senses, the values associated with them, and how they are combined (2005b: 143). The main differences in studies conducted in the fields of Sensory History, Sensory Archaeology, and Sensory Anthropology are rooted in their respective disciplinary outlooks, prioritising different methods of study and data gathering, although they still share an attitude that studying the senses is of particular value to their disciplines. Overall, the combination of various humanities and social sciences disciplines which share a common interest in studying the senses from a cultural perspective, as well as bringing a sensorial angle to cultural studies, can also be referred more generally as sensory studies (Bull et al. 2006; Howes 2020: 21)

In the field of Archaeology, Yannis Hamilakis' book *Archaeology and the Senses: Human Experience, Memory, and Affect* (2015) sets out a framework for an Archaeology of the Senses (also referred to as Sensory or Sensorial Archaeology). Hamilakis refutes any claim that Sensory Archaeology is not possible due to the focus of the discipline on materiality and argues that it is archaeology's work with materiality that makes it an ideal field for sensorial exploration. He gives examples, such as the exploration of "the smoothness or the roughness of surfaces, the sound-amplifying qualities of houses and other spaces, the odorous effects of plants and other substances" (2015: 4). To Hamilakis, there is no opposition between the study of "material" evidence in archaeology and the senses as intangible and ephemeral. Moreover, Hamilakis does not believe that an Archaeology of the Senses should be a subfield of archaeology, but instead he suggests that it is integrated to all archaeological work.

Hamilakis refers to a "sensorial field" (2015: 12) which is formed of "sensory perception and experience, materials, humans and other non-human sentient beings, the environment more broadly defined, time, and social memory…" (2015: 12). Studies on the senses are, therefore, not about the individual but about relations. Taking this as a starting point, Hamilakis proposes a methodology for Sensorial Archaeology based on a number of key considerations.

First, Hamilakis contends that *the senses are political*. That is, the hierarchy of the senses and how sensorial experiences are considered are always

politically motivated. Hamilakis illustrates this by referring to colonial practices, which impose the sensorial hierarchies of empires over the colonised, with the latter having to assimilate the sensorial regimes of their colonisers in order to bring them closer to being "civilised". This process Hamilakis defines as "sensorial racism" (2015: 56), with the five discrete senses being a Western construction imposed on others for colonial gain. By contrast, Hamilakis contends that if objects are considered to be extensions of the human body and there are an infinite number of objects as well as infinite number of contexts in which sensorial experiences can occur, then the senses themselves should also be understood as infinite (2015: 113–114). Similarly, from the field of Anthropology, Classen (1997: 401) argues that given the senses are cultural formations, the number of senses varies from culture to culture, with the Western five-sense framework being far from the only such model.

Having warned about the problems associated with a five-sense model, Hamilakis goes on to observe that even within modern Western sensorial regimes, which may accommodate wider sensory definitions, it is the experiences of the middle and upper social classes that remain foregrounded, marginalising numerous concurrent, alternative sensorial regimes – precisely of the sort which Sensory Archaeology can help bring to the forefront. Classen similarly refers to "sensory models" (1997: 402) which are culturally specific, being a combination of the meanings and values mapped onto various sensorial experiences and used by members of a society to interpret the world. Societies will have a dominant "sensory model" that can be subsequently challenged (1997: 402). Classen goes on to observe that "the sensory model supported by a society reveals that society's aspirations and preoccupations, its divisions, hierarchies, and inter-relationships" (1997: 402). The value assigned to senses in a society will thus be representative of the social hierarchies of that society (Howes 2005a: 10). Western societies' dominant groups are associated with sight and hearing, whereas subordinate groups (women, non-Western people, and working classes) are associated more closely with smell, taste, and touch, which are themselves considered to be the "lower" senses (Howes 2005a: 10)

A second key consideration that Hamilakis develops for his methodology for Sensorial Archaeology, following in the same vein as that of Sensory History, is that the *senses are historical*. That is, they are time- and context-specific, and some ideas we take for granted might not have been common in previous periods. For example, the notion of continued sleep throughout the night is a modern Western concept and, hence, the image of nighttime as a quiet period in which people would lay in the dark is not necessarily applicable to previous cultures, potentially affecting our sensorial analysis (Platts 2021: 134). Hamilakis also adds that sensorial experiences are shaped by memories (2015: 118), with every sensorial encounter tapping into memories of previous ones, as well as generating new ones going forward (2015: 118).

A third key component of Hamilakis' proposed methodology, and shared by other authors, is *sensorial reflexivity* (2015: 119). This means acknowledging the particular sensorial regimes we are operating under, both as individuals and within particular social contexts, evaluating what this means for our own approaches to the study of the past. Are we, for instance, unquestioningly assigning our own sensorial values to the interpretation of the past? If the understanding of the senses is defined by a specific historical period and a specific culture, then researchers themselves will bring with them an array of associations and contemporary attitudes related to the senses that they need to be aware of when conducting sensorial studies of past cultures (Mills 2014). Such thinking is in line with arguments by Stoller (1989), who forwards that anthropologists should "open their senses" (1989: 7) in order to engage with the cultures they study, and to think critically about their own preconceptions which can lead to the misrepresentation of other cultures (1989: 9). Classen (1997: 403) contends similarly that the anthropologist should be careful not to impose their own sensory models on the culture they are studying, but explore instead sensorial experiences within the context of the sensory model of that specific culture at that specific time. It is here especially that Classen (1997: 403) warns that the imposition of sensory models onto other cultures often results in multisensory experiences being transformed into sight-centred experiences, turned into artefacts of consumption within glass cases at museums – examples of this being the transformation of Navajo sand paintings and medieval religious relics into visual experiences (Classen 2017: 128). This particular line of argument resonates with that of Ramirez (2022: 141–142), who reminds us that medieval art needs to be considered within its context, such as in a house or church, and as part of a larger sensorial experience. Going further, Classen (1997) states that it is vital to acknowledge those sensory experiences that Western frameworks have outrightly discarded due to racism, with an unsavoury history of associating "the 'lower' senses [smell, touch, taste] with the 'lower' races" (1997: 405), all while privileging sight (and in second place, hearing) as the sign of civilisation (1997: 405).

It is worth noting that the implications of sensory reflexivity go beyond scholarly studies of the past, and encompass also the "recreation" of past experiences. As Bennett (1995) reminds us, we are always creating a facsimile. Even if we could, for example, recreate an exacting physical copy of a medieval town, it would still be different from the "original", because each of those towns was organised by societies operating under different sets of circumstances and under different cultural contexts. Therefore, even the act of making a recreation will leave it embedded within a particular cultural framework (Bennett 1995).

Ultimately, for Hamilakis, *the senses are multi-temporal* (2015: 122) and in sensorial studies it is necessary to move away from chronological time

and embrace multi-temporality. Multi-temporality, for Hamilakis, allows us to consider the different sensorial experiences associated with an object or a space, for example, including when it was first produced or built and in the different uses and engagements throughout history.

Finally, Hamilakis considers Sensorial Archaeologies as being, chiefly, *archaeologies of affect* (2015: 124). Hamilakis argues that the senses evoke affectivity, they allow us to be affected, "moved" (2015: 124). He separates emotion from affect, indicating that while the former is focused on the individual, the latter entails connectivity, removing the subject-object separation (2015: 125). For Hamilakis, affect "connects with the sensorial field as a space of flows and encounters, as a sensorial contact zone" (2015: 125).

It is in this context that Hamilakis (2015) also puts forward the notion of *sensorial assemblages* (2015: 126) as a strategy to move away from studying archaeological findings as grouped by assemblages, such as "pottery" on the one side, "animal bones" on the other (2015: 127), and instead looking at materiality in terms of the ability to engage in sensorial interactions (2015: 127–128). Assembling different types of materiality and considering them in relation to the sensorial experience, rather than compartmentalising them according to types of material, while advocating for archaeology's potential to "unearth the lost and forgotten sensorial modalities of humans" (Hamilakis 2015: 199–200).

It is useful at this point to consider again the work of Constance Classen, (1997) who proposes an Anthropology of the Senses (also known as Sensory Anthropology) as a way of studying culture (1997: 402) and whose critical genealogy can be traced back to the late 1980s (1997: 406). Classen reminds us that the senses are "avenues for the transmission of cultural values" (1997: 401), are "regulated by society" (1997: 402), and those sense/s which are considered most important will vary depending on the cultural context involved and how they are utilised within it (1997: 401).

Classen (1997: 402) highlights that one of the major obstacles to the growth of Sensory Anthropology is the importance ascribed to sight – often considered as the most important sense, and the one associated with reason, due to the connection created between sight and the sciences in the eighteenth and nineteenth centuries (1997: 402). In relation to this, Classen (2005a) heavily critiques McLuhan's (1962) categorical division between literate societies as being predominantly visual, versus the supposedly aural emphasis of oral societies, arguing instead that the primacy of senses in oral societies varies across cultures, making it impossible to generalise. Classen (2005a) exemplifies this with research conducted on three oral societies, with each of them having a different way of making sense of the world: the Tzotzil of Mexico, having heat as central to their cosmology; the Ongee of Little Andaman Island, odour; and the Desana in Colombia, colour. McLuhan, Classen argues (2005a), deploys an external Western sensorial scheme to discuss

other cultures, rather than reflecting on the cultural specificity of ways of sensing. Moreover, even within visual and aural terms, there are distinctions among societies, so when referring to visuality McLuhan is referring only to Western visuality and the same goes for aurality (Classen 2005a). Similarly, Howes (2017: 163) discusses the lack of division of senses that characterises some cultures, such as the Desana of the Colombian Amazon. For example, when crafting baskets the Desana might choose fibres by considering their colour, their texture, and their smell, and it is that cross-sensoriality that is appreciated (Howes 2017: 163).

As with Hamilakis (2015), Classen (1997) considers the senses to be historical – sensory models change over time – and political, "the study of sensory symbolism forcefully reveals the hierarchies and stereotypes through which certain social groups are invested with moral and political authority and other groups disempowered and condemned" (Classen 1997: 409). Crucially, sensorial codes are also key to generating and maintaining gender divisions (Classen 1997: 409). Classen traces the gendered nature of the senses by studying the period from Renaissance to Modernity in Europe, during which sight, and hearing (although the latter, less so), were considered to be quintessentially "masculine: dominating, rational, orderly in its discrete categorization of the world" (Classen 2005b:70), whereas touch, taste, and smell were invariably feminine, "nurturing, seductive, dissolute in its merging of self and other" (Classen 2005b: 70). On this basis, women were seen as needing to be guarded from hearing, which could lead them down the "wrong" path, and, from this, were considered as needing to be silent (Classen 2005b :75) in opposition to the vocal domain of men. Such gendered sensory divisions have continued to impact everything from the social roles that each gender is expected to fulfil (Classen 2005b: 70), down to those artforms associated with being women-made, predominantly tactile, and, thus, of inferior status and cultural interest, being set aside in museum exhibitions (Classen 2017). As a striking aside, Classen notes that even accusations of witchcraft have been linked to the senses, as witches were seen as women that were using their senses for nefarious intentions that took them away from the field of domesticity, seeking control by allying themselves with evil (2005b: 71).

Referring to nineteenth-century French narrative, Miller Frank (1995) analyses the representation of women's voices and argues that they are a reflection of male desire and considered as inhuman, either by equating them to angels and, as a result, a vehicle towards an experience of the sublime, or by linking them to mechanical artificiality.

Going further back in time, Bude (2022) also provides an analysis of sound and silence in relation to women, in this case European medieval women, and argues that it was on occasions in which they chose to remain silent, rather than forced to do so, that they were in most control. Bude (2022) explores silences in the work of the English mystic Margery Kempe and argues that

Margery's power did not rest in sound-making, which she could not control, but in her tactical silences (López 2022). To Bude it was through her silence that Margery forced those in power towards attentive listening, using for her own benefit the association between silence and authority (López 2022). Bude reflects on how in present times making one's voice heard is equated with fighting for one's rights, but she explores how this was a more complex situation for medieval women. Referring to the stories of female martyrs, she explains that there is a strong association with them speaking out to defend themselves and then just being killed, with those two events being closely connected (Bude 2022: 78). In a scenario in which that was likely to be the result for speaking out, Bude argues, is there not power in keeping silent and capitalising on the connection between silence and the powerful? Silence can then turn into a form of resistance. Bude traces examples of such tactical use of silence to figures such as Marguerite Porete, a French mystic, and Joan of Arc, who during their respective heresy trials, the former's in 1310 and the latter's in 1431, refused to answer questions as a way of avoiding falling into the unavoidable trap of incriminating themselves (2022: 79).

These historical hierarchies of the senses have also had a significant impact on notions of disability. Vierestraete and Söderfeldt (2018) argue that the generally higher standing of sight and hearing (over touch, smell, and taste) has led to a greater awareness of visual impairment and deafness, over the impairment of other senses. In nineteenth-century Europe, the association of sight and hearing with human nature, knowledge, and civilisation, as opposed to animal nature, led to the questioning of the intellectual capacities of visually impaired and deaf people, and in particular deaf-blind people. Therefore, the proof of success in educating deaf-blind children in the booming European institutions of the nineteenth and early twentieth centuries was considered remarkable in itself.

The use of sound and listening for racialisation purposes can also be traced throughout history, with Ochoa Gautier (2014) and Stoever (2016) providing examples from different contexts, the former researching nineteenth-century Colombia, and the latter tracing the history of "othering" black people in the USA back to the nineteenth century. Stoever (2016) focuses on tracing the development of what she refers to as "the sonic color line" which she defines as the process through which some people are associated with certain sounds which become normative and start signifying "whiteness", whereas other sounds are used to signal black people as "others" and signify "blackness" (Stoever 2016: 7–8). The racialisation of sound, Stoever argues, is possible through "the listening ear", that is the dominant listening practices which make said associations between sounds and race seem like "natural" (Stoever 2016: 7–8). "Whiteness" constructs itself as inaudible, because it is seen as the norm, and through that position binaries of sound/noise, quiet/loud, proper/improper, are constructed (Stoever 2016: 12). For example, dialects,

accents, and slang are classified as improper and associated with immigrants and people of colour (Stoever 2016: 12).

"Improper" sounds and perceptions of voices are also featured in Ochoa Gautier's study of nineteenth-century colonial Colombia, in which she argues that different acoustic practices (with a power imbalance) came together, those of the colonisers and the colonised. In this case, a key aspect of the use of sound for racialisation is centred around notions of the human and the non-human. Ochoa Gautier specifically refers to the vocalisations of the *bogas*. The bogas were boat rowers of the Magdalena River, and by the eighteenth century they were mostly men of mixed indigenous and African descent (Ochoa Gautier 2014: 52). Written documents indicate that European travellers often compared their vocalisations to animal "howling" (2014: 11) and considered them to be a sign of their (less than human) animal nature. Their vocalisations were constructed as noise and deemed to ruin the silent soundscape (2014: 42). However, those vocalisations meant something very different to the bogas, with Ochoa Gautier explaining that they were a sign of their shifting states between unity and multiplicity (2014: 12) and that their practices purposefully included "sounding like animals, learning sounds from animals, or incorporating nonhuman entities in sound" (2014: 61). Normative listening practices are applied to judge sounds and justify racism. We will return to reflections on constructions of "noise" in Chapter 4.

Before moving forward in this discussion, it is worth making a final observation concerning how, in the field of Anthropology, a frequently encountered concept is that of "acoustemology" (Feld 2005), which was coined by Feld in 1992 as a result of work in Bosavi, Papua New Guinea (Feld 2015). It is a combination of "acoustics" and "epistemology" and refers to "acoustic knowing" (2005: 185), to sound and sound awareness as central to making sense of the world, with experiences and memories being influenced by sound, and sonic dimensions (as well as the interplay of various senses) being key to the experience of place. The term is a result of Feld's earlier work, which he referred to as "anthropology of sound" (2015: 14) and which he wished to refine and to make less centred on the human experience by removing the word "anthropology" (2015: 14) and taking away a potential association of the word "sound" with propagation, rather than his intended focus on perception (2015: 14). Acoustemology is knowing through sound and listening and seeks to evade any associations with sonorous equivalents of landscape (i.e. Schafer's concept of soundscape) and instead highlight agency and perception (2015: 15).

On Multisensoriality

Some authors engaging with the senses have identified the need for multisensorial studies, that is, studies that do not necessarily focus on one sense,

such as hearing, but reflect on how people's experiences are a combination of different senses (Hamilakis 2015; Tilley 2020).

An interesting recent example is the appropriately titled book *Multisensory Living in Ancient Rome: Power and Space in Roman Houses* by Hannah Platts (2021). Platts provides an exploration of sensorial experiences linked to Roman household life through ancient literary accounts and material remains. Concerning the latter, Platts focuses on Pompeii, and in particular on the houses of the Roman elite between second century BC and second century AD, using these to argue that the traditional scholarly emphasis on visual experiences has limited our understanding of Roman domestic spaces. Platts thus explores how homeowners sought to control their sensorial experiences, and that of others, in order to showcase power and status, as well as reflecting on how sensory studies can help further our understanding of the public and private realms, which Platts considers to be contextually grounded, with the overall meanings of private and public being fluid.

Platts offers an excellent example of how sensory studies can go beyond a focus on a particular sense and achieve a smooth interweaving of different sensorial analysis. The research is not divided into discrete senses, and instead Platts starts the journey into the Roman house and its sensorial world by exploring the connection between the house and its environment, before gradually, chapter by chapter, receding into the house's interior – exploring initially the entrance and *atrium-tablinum*, then moving to the bedroom, the garden and peristyle garden, and finally the kitchens and toilets. It is in this way that Platts reflects on how sensorial experiences would have varied depending on the status of the person, their gender, social class, and age, while also considering that sensorial experiences are affected by times of day, seasons, as well as what events might be happening within a city. Platts (2021) ultimately intertwines varied sensorial experiences in her examination of Roman domestic dwellings, offering vivid reflections that resist any compartmentalisation of the senses.

A good example of the analysis conducted by Platts is that of the connection between domestic space and its surrounding environment, studying how sensorial experiences from outside the house can affect the interior, and vice versa. In particular, Platts analyses the possible multisensory experiences of Pompeii homeowners in terms of performances in the nearby amphitheatre/palaestra. Platts explores how residents might have sought to control the sensorial impact these events had on their day-to-day experiences, which would have included the sounds of the crowds, particularly affecting neighbouring residents (2021: 54, 57). Here, an analysis of the floor plans of houses in nearby areas reveals that none of them have entrances towards the amphitheatre/palaestra, indicating how residents attempted to distance themselves from the sensorial intrusion of the events. Specifically visual impacts would have included the artificial lighting used after dark, such as candles, braziers,

and torches. The position of the amphitheatre at the lowest point of the city would have made this illumination visible from a distance (Platts 2021: 59). Street vendors in the amphitheatre/palaestra would have also had an impact on residents' olfactory experiences, chiefly through the smell of food and drinks. In all cases, these experiences would have varied depending on the proximity of the houses to the venue. Platts explains succinctly:

> Change the time of year or day, the activity, the year, the city, the inhabitants in terms of their ages, gender, ethnicity, abilities or disabilities and social status, and the sensoryscape of the amphitheatre/palaestra and its impact upon the lived experience of homes across the city will also alter. As such, it is important to be aware that each person's experience of the home, whether they are visitor or inhabitant, will vary. There is no single multisensory experience of the gladiatorial arena, either on or off game days, to be had within the Roman home.
>
> *(2021: 61–62)*

A final example of the relationship between the home and the outside world focuses on the impacts generated by a lack of division between domestic and commercial city areas across Pompeii itself (Platts 2021: 67–68). Platts mentions how the small street-facing windows found in residential houses would allow to control how much passers-by could see inside the residence from outside, as well as controlling the myriad smells and sounds coming in from the outside (2021: 67–68). Another way in which this exchange of sensorial experiences was controlled was through establishing "sensory buffering zones" (Platts 2021: 68), that is, storage areas and gardens adjacent to any neighbouring business.

Referring to the study of ancient Roman houses and streets, Platts mentions that when considering sensorial experiences it is crucial to bear in mind that every city would have had a unique "multisensory streetscape" (2021: 51) due to its own physical characteristics (such as the size), population density, as well as its location (closer or further away from the coast), with further changes being a consequence of different weather conditions, seasonal differences, and times of day. It is, therefore, not possible to generalise and assume that one ancient city afforded the same sensorial experiences as any other, and it is also crucial to consider the overall variability of experiences in relation to changing seasons. For example: "The arrival of autumn and winter…brings about visual, haptic, and olfactory changes, as fires, braziers, candles and lamps are lit, and partitions or windows are shut, closing off sections of houses to block out inclement weather" (Platts 2021: 52).

Another example of the importance of considering variability in sensorial studies is provided by Silva (2017), in his study of the soundscapes of the streets of Lisbon. Silva (2017: 243) reflects on the presence of street vendors' cries, with

practices recorded since the sixteenth century, and cries varying depending on the products being on sale, which would also change throughout the day and depending on the seasons, and with cries changing from one neighbourhood to the other. Although not the focus of Silva's study, it is worth noting that there would have also been olfactory changes as the products sold changed.

Audio Technology and Acoustical Heritage Studies

Biddle and Gibson (2019) in *Cultural Histories of Noise, Sound and Listening in Europe 1300–1918*, explain that aural remains of the past can be traced back to a variety of primary sources which they list as including "literature, treatises, scientific writings, newspapers, letters, diaries, account books, legislative documents, musical scores, civic records and parish registers" (2019: 2). All tangible evidence. It is hard, however, not to notice their omission of buildings, environments, and sound-making (including musical) instruments – although some of these aspects are covered in the other chapters included in their collection, which represent primary sources for many studies in the field of acoustical heritage and historical soundscapes. These omissions provide a perfect example of the implicit divide that often exists between what are considered humanities and social sciences approaches to sound (such as the ones explored in previous sections) and those associated with acoustic and audio engineering. The thesis of this book is that such division is not necessary and that the conscious pursuit of crossovers and interdisciplinarity is more likely to combine the best of both worlds. Acoustical heritage studies should embrace cultural approaches to sound and acoustics if they are to understand and interpret the significance of their findings more fully, while cultural approaches also have a lot to benefit from what technological advances have to offer in the form of acoustic measurements and computer recreations, as well as approaches on how to share findings.

Biddle and Gibson also refer to "historians of sound" (2019: 2) which aligns studies on sounds throughout history with a specific discipline, that of history, with the word "historian" coming with its own baggage. As a specialist in sound and acoustics, I personally struggle to feel included in such terminology, given I do not have training as a historian. However, Biddle and Gibson (2019: 2) do highlight a point that is key to all disciplines studying the sounds of the past, which concerns the need to reach a balance between imagining what the aural past might have been like when scarce material evidence is available (especially when focusing on the pre-phonographic era) and carrying out rigorous scholarship. Similarly, Corbin (2005: 131) reflects on the transient nature of sensorial experiences, which poses a challenge for their historical study. While Corbin highlights the importance of referring to written sources of the period being studied, he also highlights some scholarly issues that might subsequently arise, such as the need to consider that any

remaining records will not be representative of the whole of their society (Corbin 2005: 131). Moreover, what was written might be influenced by the social context itself, such as the perceived need for a writer to distance themselves from the lower social classes whose senses they are discussing (Corbin 2005: 133). This particular consideration is echoed in Platts' multisensory study of the Roman home, where existing accounts of sensorial experiences are deemed to have been influenced by the social status of the person writing, as well as how they wished to be perceived by the reader (2021: 24, 165). Historians, Corbin concludes, should thus be careful on how they interpret the presence or omission of something in records

> The noise of traffic is today tending to disappear from the evocation or description of big cities, although it is not clear whether it is no longer noticed because of its omnipresence and the fact that no one heeds it, or whether its extreme banality leads insidiously to its being passed over.
>
> *(2005: 135)*

The following section will now explore the history of approaches to heritage sites that utilise acoustic measurements and computer modelling, in particular by looking at a field commonly referred to as Archaeoacoustics. The consideration of this field will also include a discussion of the assumptions and connections that have been established throughout the last few decades in relation to the field and its name, which I will argue might present a limitation to the use of the term.

A Brief History of Acoustical Heritage Studies: An Engineering Approach

Tracing the history of acoustical studies of heritage sites is no simple feat and it hinges on what we consider to be "the past" at any one time, as well as why something is being studied. This section will therefore provide a selective snapshot of some early studies in the field, while also providing an introductory overview of the methods utilised in modern studies.

Let us start by going as far back as Vitruvius and his *De Architectura*, a treatise in ten volumes from mid-20s BC, which sets out architectural principles focusing on the quality of existing buildings and those to be built, and which draws on both Greek and Roman examples. Vitruvius considers music to be key to the education of architects, and he makes extensive references to Greek music theorists such as Aristoxemus (Walden 2014). Vitruvius approaches music and sound in relation to several aspects, ranging from water organs, to catapults, the cosmos, and the acoustics of theatres (Walden 2014; *De Architectura*, Book V, Chapter VI). It is his work on theatre acoustics especially that is the most relevant to this book.

To explain further, it is in Book V of *De Architectura* that Vitruvius discusses theatre acoustics, including the importance of speech intelligibility for audience members in different seating areas, and he refers to Greek architecture specifically when doing so. Vitruvius discusses especially the role of "bronze vessels" or "echea", which are hollow and placed in niches under audience seats and whose positions vary depending on the size of the theatre and key musical scales. Vitruvius highlights their value for increasing clarity and establishing a harmonious sound, and so achieving the perfect theatrical sound experience. He also remarks that such vessels are better suited for theatres made out of materials such as stone and marble, whereas theatres made of wood contain resonant boarding that endows them with an equivalent effect to the vessels.

Nevertheless, the chief aim of Vitruvius' exploration of both Greek and Roman construction and its acoustics was to delineate what he deemed to be excellent design, rather than offer an exploration of past sites. As explained in the Preface to *De Architectura*, its aim was to provide a body of work on architecture, as a response to the scattered and fragmented texts existing at that point in history. *De Architectura* was thus considered, until late in the eighteenth century, as a key architectural text, before then turning into mostly a reference on architecture from antiquity, and not escaping criticism on its veracity (McEwen 2003: 1–2). To scholars of Greek architecture, due to its use primarily of Greek sources, it constitutes a way into the study of the period, albeit from a Roman perspective (McEwen 2003: 5). Vitruvius only demonstrates a very tangential interest in the acoustics of the past, given his focus was on the present – that is, how the study of past structures can solidify our present architectural principles.

Wallace Clement Sabine is often referred to as a pioneer of architectural acoustics. However, similar to Vitruvius, he was interested in what made excellent acoustical design, rather than how acoustics can be a gateway into the past. In the 1890s, while a physics professor in Harvard, Sabine developed what is known as the Sabine reverberation equation to calculate the reverberation time of a room. It was published in 1900 and was the first reverberation time equation (Everest and Pohlmann 2015; Sabine 1922). The equation was the result of his understanding of the impact of the size of a room and its sound absorption characteristics on reverberation time – a concept we will explore in further detail in the subsequent sections of this chapter. Sabine's approach was experimental and originated when, in 1895, he was tasked with determining how the acoustics of the Fogg Lecture Theatre could be improved. The theatre had then a reverberation time when empty of 5.62 seconds, rendering speech unintelligible, and Sabine was asked to consider how it compared to the highly regarded acoustics of the Sanders Theatre (Roberts n.d; Sabine 1922). Equipped with organ pipes, a stopwatch, and seat cushions borrowed from the Sanders Theatre, he used his

ears to calculate the sound decay time of the Fogg Lecture Theatre as the absorption of the space changed by adding or removing seat cushions, as well as changing their position (Everest and Pohlmann 2015; Roberts n.d.). He also worked with other materials such as curtains and rugs, and explored the effect of people on absorption, all while comparing them to the effects of Sanders Theatre's cushions (in meters) in order to establish their absorption qualities (Sabine 1922). Although reverberation time in acoustical heritage studies is now mostly derived from either captured or simulated impulse responses (IRs) (as will be seen in further sections), it is still one of the most quoted parameters in the study of acoustics.

Modern studies which investigate the acoustics of ancient theatres can be found from the 1960s (Girón, Álvarez-Corbacho and Zamarreño 2020), with Papathanasopoulos (1965) focusing on the theatre of Epidaurus, and with work also being conducted on Greek and Roman theatres by Shankland (1968, 1973), and with work also published in 1967 by Canac.

Moving beyond theatre acoustics, and looking into the study of that of churches, we can note that such investigations can be traced back to the 1950s (Girón, Álvarez-Morales, Zamarreño 2017). Studies include Parkin and Taylor's work on the reinforcement system of St. Paul's Cathedral (1952) and Raes and Sacerdote's study of acoustic properties in churches in Rome (1953). Further work into the 1970s includes Shankland and Shankland's research (1971) on acoustic measurements of four basilicas in Rome, and Fearn's 1975 work on the calculation of reverberation time, through balloon pops, of English and Catalan parish churches.

It is worth noting here an even earlier article by Hope Banegal, in which the author discusses Lutheran church acoustics in relation to Bach's compositions. Banegal reflects on Bach's awareness of the room acoustics of the spaces he worked in, and his liking of Thomaskirche in Leipzig (Banegal 1930). Banegal subsequently considers the choice of St Margaret's, Westminster by the Bach Cantata Club in 1929 as a satisfactory solution to the need to choose a space that suited the composition style. At the back of the article Banegal includes reverberation tables for both Thomaskirche and St. Margaret's, whose reverberation times seem to have been calculated using the Sabine formula. Although the acoustical analysis is brief, it presents an early example of an interest in exploring how pieces from the past can be performed in spaces other than those that they were originally composed for, and in its presentation of how such explorations can be an advantage (Banegal 1930).

In a similar vein, Harold Burris-Meyer, whose work will be further explored in Chapter 5, experimented with the recreation of reverberation for performances in the second of his "Sound Shows" (Ouzounian 2020: 91). Burris-Meyer's "Sound Shows" were showcases of his different experiments on sound control and an opportunity to gather feedback (Ouzounian 2020: 88).

In the 1941 event at the Stevens Theatre in New Jersey, together with colleagues, he recreated the reverberation of the Église Saint-Sulpice in Paris for the performance of the 1879 *Toccata in F* from Charles-Marie Widor's *Symphony for Organ No.5*, which was the space the piece had been composed for (Ouzounian 2020: 91). This experiment provides an early example of acoustics recreation, but it is worth highlighting that Burris-Meyer's interest was not rooted in sound heritage but instead in the possibilities of sound control.

The connection between music repertoire and the buildings it was created for is one that is also explored in later writing by Leo Beranek (1962, 1996, 2004) in which he argues that musical compositions often sound best in the spaces they were specifically composed for. Beranek also provides an analysis of the acoustic characteristics of 100 concert halls and opera houses in 31 countries, while also analysing how their acoustic characteristics are connected to the perceived quality of the halls as based on interviews and questionnaires with conductors, music critics, and other experts.

Michael Forsyth in his 1985 book *Buildings for Music* also explores the interconnection between musical compositions and architectural styles throughout history, pointing out how composers adapted their compositions to suit the spaces they would be performed in. Forsyth (1985: 9) also mentions the reverse, cases in which the acoustic needs of a type of event, such as the Protestant service with its focus on sermons, triggered the need for new churches with smaller volumes to be built or existing churches to be adapted, for example, through the addition of drapes, or galleries closer to the pulpit. Such changes were aimed to increase speech intelligibility. This was the case of Thomaskirche, referred to earlier in relation to Banegal's work, with such changes having influenced Bach's compositions.

The next section will explore how a growing number of studies on acoustical heritage eventually resulted in a field named Archaeoacoustics, before detailing the key methods followed in studies associated with this field.

Archaeoacoustics

Archaeoacoustics is a term used to refer to the study of the acoustics of archaeological sites, which is usually conducted through Impulse Response (IR) capture and/or computer modelling (Till 2014). However, the term has also been used more widely to refer to the study of "the role of sound in human behaviour" (Scarre and Lawson 2006: vii) and including the study of sound-making objects, as in music archaeology (Holmes 2006; Zubrow and Blake 2006). Furthermore, the term originated in connection to the study of paleolithic caves, prehistoric stone monuments, and rock-art panels and has been indicated as pertaining only to sites up to the advent of audio recording technology (Scarre and Lawson 2006: vii).

Such associations and limitations are the reason why I often avoid using this term to refer to my own work and have opted instead for *acoustical heritage* and *historical soundscapes*. By opting to use different terminology I expand the scope of the acoustics and soundscapes studies referred to in this book to include all periods. In addition to this, I have often felt that as a non-archaeologist, the term archaeoacoustics is devoid of the broader inter-disciplinarity I prefer to adopt.

As referred to above, *music archaeology* is closely linked to archaeoacoustics and focuses on the use of literature, archaeological findings, iconography, and experimental approaches, such as the reconstruction of musical instruments and performances, to study the use of musical instruments and music by past cultures (Till 2014).

Another such field that lies adjacent to archaeoacoustics is that of *auditory archaeology* (Mills 2014). This field focuses on increasing our awareness of *contemporary* sounds in archaeological and landscape contexts in order to stimulate thinking about the meaning of sounds in the past, examining the varying connections between places, people, and animals. The field also encourages researchers to consider the ambient sounds that would have also existed in the past (rivers, animals, weather) and what meanings they would have had for ancestors.

Till (2014) ultimately prefers the more encompassing term of *sound archaeology*, which considers sound as part of the context of the archaeological site, as intrinsic to the environment being studied. Sound archaeology thus includes the study of sound-making objects (not necessarily just music-making objects) such as bow and arrow, and ambient environmental sounds.

Having now outlined the basic tenets of archaeoacoustics, the sections ahead will explore the specific use of acoustic measurement techniques and computer modelling in heritage studies. These consist in the adaptation of methods first devised for architectural design to spot problems and suggest solutions, as well as, in the case of computer models, anticipating problems before a building is completed (Barron 2009). When explaining different methods and acoustical theories, I have attempted to do so in a manner that is accessible to readers from different disciplinary backgrounds. In this sense, the explanations below might read in a way that differs from those typically found in books dedicated to acousticians or audio engineers, but the scientific basis is the same.

The "How to" of Acoustic Measurements

The term "acoustic measurements" here refers to IR capture, the study of how a space reacts to an "impulsive" sound – a sound of short duration and with a wide frequency range. IRs can be thought of as snapshots of the

acoustics of a space, from which a deeper understanding of the behaviour of sound can be derived. The acoustician excites the space with a signal and audio records the reaction of the space to study aspects such as speech intelligibility, musical clarity, and envelopment, among others (see Figure 2.1).

Different types of audio signals can be used as sound sources for IR capture. For example, starter pistols (van Tonder 2021; Waller, Lubman and Kiser 1999), balloon pops (Pentcheva and Abel 2017) and even firecrackers have been utilised (Astolfi et al. 2020; Bevilacqua et al. 2022). However, these signals often (1) struggle to produce enough energy at low frequencies; (2) are not necessarily omnidirectional at all frequency bands – which means that they cannot excite the space equally in all directions (a requirement of the ISO 3382 standard on acoustic measurements); and (3) their repeatability cannot be assumed or is difficult to obtain (Griesinger 1996; Papadakis and Stavroulakis 2019). It would be incredibly challenging to get two balloon pops, for instance, to sound exactly the same, so every time we do an IR measurement with a balloon pop we are using a slightly different sound, although Papadakis and Stavroulakis (2019) suggest that issues of repeatability are less prominent specifically when using starter pistols or firecrackers. In order to overcome these challenges, researchers often use deterministic signals

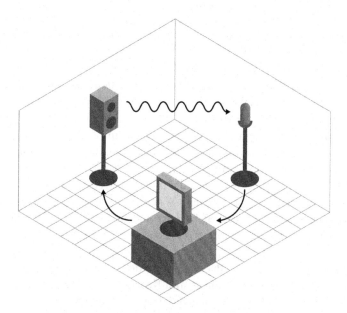

FIGURE 2.1 The basic process of Impulse Response (IR) measurement with a deterministic signal. A signal is sent to a loudspeaker (source) from a system, such as a Digital Audio Workstation (DAW) on a laptop. The signal excites the space and is recorded back through a microphone (receiver) into the system. Credit: Richard A. Carter.

(signals that are repeatable) and that can be played over a loudspeaker – generally an omnidirectional dodecahedron (ISO 3382 1997). The key advantages of this approach include a better signal-to-noise ratio (SNR) across frequency bands and a greater robustness in the presence of extraneous noise (ISO18233, 2006). To recap, repeatability of the signal, an omnidirectional source, and a good SNR are all considered essential for a successful IR capture. Importantly, the IR capture approach assumes that spaces are linear and time-invariant systems, that is, their response to an audio signal does not change over time (they are invariant) and if we double the intensity of the input to the system, the output will double as well (they are linear).

Most studies use exponential sine sweeps with a pink spectrum (equal energy per octave band), which are then linearly deconvolved using an inverse filter, that is, a time-reversal of the test signal used. By deconvolved here, I mean the process by which we separate the original signal from the response of the space to that signal. When this method is used on weakly non-linear systems it can separate the harmonic distortion (caused by the loudspeaker) and turn it into pre-delayed signals at the start of the IR, which can then be easily removed. This method is also more robust in the presence of changes during the measurements, such as air temperature or passers-by – the latter being particularly relevant when measuring outdoor sites or sites that cannot be closed to visitors (Lopez and Pauletto 2012) – and presents a better SNR than other methods using deterministic signals (Farina 2000; Farina 2007; Müller and Massarani 2001).

A key consideration when using exponential sine sweeps is the length of the signal. There are different ways in which it can be calculated (ISO 18233, 2006; Kessler 2005), but the basic premise is that the sine sweep employed needs to be long enough to allow for the decay of low frequencies while the excitation signal is sweeping through (Müller and Massarani 2001). This requires the researcher to make an estimation on the decay time of the space being studied, which can be done by, for example, clapping in the space and listening to the decay. Moreover, the sine sweep needs to be followed by silence to allow the high frequencies to decay completely. When doing acoustic measurements in environments with high levels of background noise that might compromise the SNR, it is possible to use longer sine sweeps to reduce the negative impact of noise on the measurements – a doubling of the length of the sweep increases the SNR by 3 dB and can be effective both indoors and outdoors (ISO 18233, 2006; Farina 2007; Lopez, Pauletto and Kearney 2013). The sine sweep also needs to excite the relevant frequency bands, that is, the frequency range of human hearing, which is why signals often range from 20 Hz to 20 kHz.

It is worth noting that, although measurements using sine sweeps are generally recommended, when studying heritage sites operating a loudspeaker might just not be possible. This could be due to environmental conditions that would damage the equipment, as well as the difficulty of carrying heavy

equipment to a remote site. Furthermore, it might also be the case that the research team simply does not have access to a loudspeaker that is powerful enough to do the measurements, and in those cases the use of a starter pistol can be a good option. When I worked with Cobi van Tonder as part of her *Acoustic Atlas* project, we conducted measurements in Dowkabottom Cave in the Yorkshire Dales (van Tonder 2021). Having done most of my prior work with loudspeakers, I was at first sceptical about using a starter pistol. A 40-minute walk carrying equipment uphill in a field made me change my mind! More specifically, the slippery surfaces and scrambling needed to get into some of the chambers would have made carrying the loudspeaker a risk to people and equipment. I was thus relieved that we were not carrying a loud-speaker and I am now rather less judgemental about sound source choices. Overall, while there can be an ideal setup, we sometimes need to adapt if we want to diversify the types of sites explored. Additionally, a diversification and normalisation of careful and rigorous use of other sound sources can help make methods of acoustic measurements available to a wider number of research teams – beyond those in wealthier organisations.

So far, we have focused on sound sources, but IR measurements also require a "receiver", that is, a microphone or microphones that represent the listener. An IR is captured for each source-receiver combination, and one combination is rarely enough to capture the full characteristics of a whole building or environment, as acoustic qualities vary depending on where the sound source and the listener are located. Therefore, it is common for acoustic measurement sessions to involve the capture of IRs across various source-receiver combinations. When working with heritage sites, it is advisable for the source-receiver combinations to be matched to historical findings on where speakers/singers/musicians or other sound sources and audiences/listeners would have been located – although how readily available that information is will of course depend on the space being studied. For example, if studying an opera house, one could quite safely position the sound source in the stage area and the listener in the audience area. However, if, for example, you were interested in how the sounds of medieval pigs were affected by the acoustics of the streets and how that might have impacted their inhabitants (I mean, who would not be interested in this?), you would certainly have to estimate (or outright guess) where those pigs might have been positioned at the time in which they were making sounds. You can potentially use the presence of pig remains to determine their existence in a period and in a particular area (O'Connor 2013) but one can safely assume that they moved around. This might appear a silly example, but it becomes a consideration when study-ing outdoor medieval drama, in which drama performances coexisted with everyday sounds. One could even use this example to question why it is that acoustic measurements focus on anthropocentric experiences, leaving aside the impact of spaces on other beings.

There are different microphone types that can be used for IR capture, and choices might be influenced by the aim of the acoustic measurements, as well as availability and cost, and, once more, the location of the site and its conditions both environmentally (e.g. humidity) and in terms of access. B-format Ambisonics microphones are a popular choice among researchers, as they allow the recording of four channels (W, X, Y, and Z) simultaneously with one microphone. The W-channel is omnidirectional, the X-channel records front/back, the Y-channel captures left-right, and the Z-channel captures up-down. This allows the study of several acoustical parameters (see *Objective Data: Acoustical Parameters* later in this chapter) with only one microphone. For example, reverberation time and clarity parameters can be calculated with the W-channel, whereas the W and Y channels can be combined to calculate LF (Early Lateral Energy Fraction). In addition to this, some researchers might opt to use a binaural dummy head, to allow for the recording of Binaural IRs, which can be used for the calculation of IACC (Interaural Cross-Correlation Coefficient) parameters (see *Objective Data: Acoustical Parameters* later on), that require the study of the different signals arriving at a person's ears. A binaural dummy head has omnidirectional microphone capsules inside artificial ears attached to a human shaped head, which can then be either left on its own or attached to a torso. It allows for recordings that simulate human hearing and is particularly useful for headphone experiences.

In addition to the sound source and receiver, a laptop and a soundcard are also needed in order to play back the sine sweep and record it back simultaneously. If using a starter pistol as a sound source it is possible to do the recordings with a portable recorder, reducing the amount of kit used.

However, acoustic measurements on-site are not the only way in which the acoustics of a space can be studied, and what's more, the reliance on acoustic measurements would limit the sites that can be explored. Let us now move on to discuss key considerations in the use of acoustic computer modelling.

Acoustic Computer Models

Although IR measurements are a common method in the study of heritage sites, there are circumstances in which it might not be possible or advisable to enter a site to do measurements. For example, a site might be in a war zone with entry posing a risk to the research team, or the very presence of the research team might risk the deterioration of the site. There are also cases in which the site to be studied might not exist anymore (Cooper 2019) or is in ruins, or is so far removed structurally from what the team wishes to study that a measurement of the site might not result in usable data (Rindel and Nielsen 2006; Rindel 2011, 2013). An example of this is the study of medieval abbeys in England, of which, in many cases only some walls

remain, insufficient to gather any useful data from. Furthermore, researchers might wish to study how a site has changed over time (Álvarez-Morales, Álvarez-Corbacho, Lopez and Bustamante 2021) or the different possible ways in which a site might have been used in the past (Lopez 2015a, 2015b). In those cases, acoustic computer modelling or a combination of IR capture and computer modelling can be used instead.

The use of computer modelling to study the acoustics of sites is also referred to as virtual acoustics, and involves the simulation of the sound source, the space, and the listener (Savioja 1999). When working with virtual acoustics the first step is the creation of a computer model of the site, which can be carried out using specialised software directly (e.g. CATT-Acoustic or ODEON), or by using general 3D modelling software before importing it into specialised acoustic software. The space is drawn by inputting data on its geometry, as well as that of any objects within it, in an x-y-z coordinate system to create a three-dimensional model. Appropriate materials are assigned to all surfaces and objects by entering their absorption and scattering coefficients. Once the space has been modelled, source and receiver positions are added, with accompanying data on their directivity, aim, and level. IRs are then derived from those source-receiver combinations.

There are different approaches to room acoustic modelling, with the most commonly used being Geometrical Acoustics (GA), within which there are several different modelling techniques. An in-depth discussion on GA and its modelling techniques is beyond the scope of this book, but it is worth introducing the basics so as to encourage reflection on the importance of acknowledging the affordances and limitations of GA as a research tool. For more thorough discussions on the topic, I would suggest Kuttruff's book *Room Acoustics* (1973), as well as Savioja's 2015 review article, which introduces several modelling techniques.

GA investigates sound propagation by considering sound waves as rays that carry energy and travel in straight lines. Kuttruff explains that a sound ray is "a small portion of a spherical wave with vanishing aperture [that becomes zero], which originates from a certain point" (1973: 78). The point from which the rays originate is the sound source to be modelled. GA is based on specular reflections, that is, those whose angle of incidence and angle of reflection are equal. It also considers the loss of energy carried by the rays in relation to the absorption coefficients of the surfaces they encounter, as well as air absorption in relation to the distance travelled (Murphy 2000: 49). Sound rays continue travelling in the space until all their energy has been absorbed.

GA entails certain assumptions that result in certain limitations. First, it works on the premise that the wavelength of sound (its size) is small in relation to the dimensions of the surfaces of the space studied (Vorländer 2013). As a result, it can be less reliable when studying the behaviour of low frequencies

(which have larger wavelengths), although the frequency bands at which it is affected will depend on the dimensions of the space studied. This limitation also means that high levels of detail in GA models are better avoided, which does however have the advantage of reducing the computation time (Vorländer 2013). Second, GA represents sound propagation with straight lines, and so it does not take into account phenomena specifically related to the behaviour of waves such as diffraction and interference (Vorländer 2013). Diffraction is the phenomenon by which a sound wave bends when encountering an obstacle because its wavelength is larger than the object encountered, while interference is the effect resulting from the relation between the phases of different sound waves, which can result in wave cancellation. Finally, GA assumes that surfaces are smooth or that the irregularities in the surfaces are larger than the sound wavelength. If the irregularities in a surface are smaller than the sound wavelength, reflections off that surface are no longer specular, they are diffuse or scattered (the angle of reflection is no longer the same as the angle of incidence). Scattered reflections are not taken into account by GA, but a scattering coefficient can be utilised instead.

In addition to the limitations posed by GA-based models, it is also worth noting that the use of published data tables of acoustic absorption coefficients for different materials is not always ideal for the modelling of historical sites, with the particular characteristics of historical materials not always matching those used today (Álvarez-Morales, Lopez and Álvarez-Corbacho 2020).

An alternative to acoustic computer modelling is the use of acoustic scale models – a technique dating back to the 1930s, and which has the advantage of being able to simulate wave effects as in the full-size version of a space, with sizes ranging from 1:8 to 1:50 (Barron 1983, 2009). Scale models require finding appropriate surface materials and the use of specialised equipment for the measurement of ultrasonic signals (Blesser and Salter 2007; Kleiner, Orlowski and Kirszenstein 1993; Rindel 1995). Moreover, physical models, especially those at greater scales, can take up considerable space, and are costly and time consuming to build (Barron 1983, 2009). When compared to virtual models, the latter provide greater flexibility for the study of the acoustics of spaces, as fast changes in geometry are possible, together with changes in the acoustic properties of surface materials, by modifying the data inputted (Barron 1983). These characteristics might explain the greater popularity of computer modelling. An example of the application of physical models to heritage investigations is the work on Stonehenge (Cox, Fazenda and Greaney 2020), in which a 1:12 model demonstrated that the amplification of speech and the reverberation time were higher within the circle, compared to outside it, while also discarding any significant acoustical changes resulting from its different configurations, allowing to hypothesise that changes to the configuration of Stonehenge are unlikely to have been connected to sound and acoustics.

A project which used a combination of acoustic measurements and computer modelling (GA) is Lidia Álvarez-Morales' *Cathedral Acoustics*, which focused on studying the acoustics of four cathedrals in the UK: Bristol, Ely, Ripon, and York (Álvarez-Morales, Lopez and Álvarez-Corbacho 2019; Álvarez-Morales et al. 2019; Álvarez-Morales, Lopez and Álvarez-Corbacho 2020; Álvarez-Morales et al. 2021). For each of these sites, the first stage was to take acoustic measurements when the buildings were empty. This was followed by the creation of computer models that presented the same architectural and furnishing characteristics as those at the time of the measurements. The creation of a computer model that reflects the modern characteristics of a site is crucial, as it allows for the validation of the computer model as a tool for investigation. This is achieved by comparing the results of different objective parameters (see *Objective Data: Acoustical Parameters* in the following section) derived from the IRs captured on-site with those derived from the IRs from the computer model (which would correspond to the same source-receiver locations) and checking whether any differences in the results are significant enough to indicate an issue with the computer model. If a significant difference is found, the computer model will be calibrated up to a point in which it is as similar to the "real" building as possible, at which point it is considered validated and the research team can continue to use it. The significance in difference between the acoustic measurement and the virtual model results are calculated in terms of Just Noticeable Differences (JNDs) for different parameters (Bradley, Reich and Norcross 1999; Cox 1993; ISO 3382-1, 2009; Galindo, Zamarreño and Girón 2009; Niaounakis and Davies 2002; Vorländer 1995; Vorländer 2008). This validation can then be followed by the use of the computer model to study the space more thoroughly than what was possible through the acoustic measurements alone – potentially a consequence of limited availability for measurements in the site, and so reducing the number of source-receiver combinations possible, for example (Álvarez-Morales et al. 2019). Additionally, the validated model can also then be used as a starting point to make changes to reflect the different architecture, furnishings, and uses of the space throughout history (Álvarez-Morales et al. 2021).

The following section will now explore in more detail what I have referred to above as objective parameters or acoustical parameters. This is the numerical data derived from IRs, providing information on the different ways in which a space has an impact on sound.

Objective Data: Acoustical Parameters

This section will explore some of the most commonly used acoustical parameters derived from IRs and found in acoustical heritage studies. Before detailing these, however, it will be useful to consider the components of the

received sound in the context of room acoustics, which will set the stage for a better understanding of the different parameters we might use and what they indicate.

Components of the Received Sound: Direct Sound, Early Reflections, and Reverberant Sound

Direct sound is the sound that travels in a straight line, which is the shortest path between the source and receiver (see Figure 2.2). It is heard first and provides information about the location of the sound source while also being key to its intelligibility (Howard and Angus 2009), as it follows the inverse square law. The inverse square law can be used to study direct sound as it is unaffected by room boundaries and objects, consequently behaving in the same way as in a free field (i.e., a space in which there are no reflections). The inverse square law itself is the phenomenon by which sound in a free field is attenuated because of the increased distance between the source and listener.

Early reflections are the discrete sounds that arrive at the listener after the direct sound, and which have reflected off one or more surfaces, such as walls and ceiling. Early reflections are highly dependent on the position of the source and listener, as well as the shape of the room. Although a drop in the level of early reflections can be related to the distance travelled, they are also affected by sound absorption. Sound absorption is the removal of acoustic energy from a space due to the presence of different surface materials. The amount of absorption by a material is indicated by the absorption coefficient, which may vary at different frequency bands. Early reflections are thought to affect sound by increasing the sense of loudness, augmenting the sense of spaciousness (if arriving at the side of the listener), increasing intelligibility, and providing a sense of intimacy (Barron 1993).

Reverberant sound also referred to as *late reflections* is the sound arriving after the early reflections and which has travelled through numerous reflection paths. Reflections arrive at the listener very close one from the other and from all directions. "The listener has the sensuous experience of feeling bathed in a sea of sound" (Beranek 1962: 23). The reflections also drop in level as a result of the acoustic absorption that takes place at the numerous surfaces they have bounced off. Whereas early reflections are greatly affected by changes in source and listener positions, reverberant sound remains constant regardless of such changes. This is a result of reverberant sound being diffuse, that is, there is equal probability of it visiting any of the parts of the room.

The description of reverberant sound presented corresponds to the use of a short impulsive sound, but when considering sounds with a longer duration, such as speech and music, the space receives a constant input of acoustic energy and the reverberant sound creates a reverberant field (Howard and

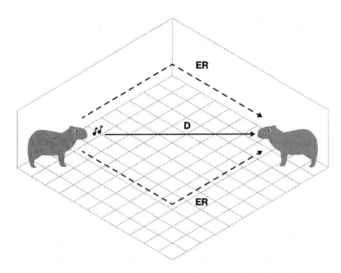

FIGURE 2.2 A representation of direct sound (D) and early reflections (ERs). In this case two *carpinchos* (also known as capybaras) are used to represent the sound source and the listener. Why use humanoid representations when you can use *carpinchos*? Credit: Richard A. Carter.

Angus 2009; Howard and Murphy 2008). The reverberant or diffuse field presents three different stages: *the build up*, *the steady state*, and the *decay* (Howard and Angus 2009; Howard and Murphy 2008). The *build up* is the time it takes for the reverberant field to reach its highest sound level. The *steady state* is the state in which the sound that is being emitted in a space is equal to the sound that is being absorbed. Finally, the *decay* stage takes place when the sound source stops emitting sound and the acoustic energy decays because sound absorption takes place in each surface reflection. Howard and Murphy (2008: 76) explain that the reverberant field gives a space its "acoustic *signature*", it characterises it, allowing us to become familiar with its sound.

Now that we have covered the basics, we can move on to specific room acoustic parameters that are used in the field. The following sections will discuss reverberation time, clarity, and spatial impression. When discussing acoustical parameters, it is usual to encounter "optimum" values listed in the literature. However, when listing such values, authors often refer to spaces linked to the Western European musical canon and consider modern Western predilections. But, as was discussed earlier in this chapter, sensorial experiences, including sonic ones, are tied to specific contexts in time and space, and are thus linked to particular cultural frameworks. Therefore, any such "preferences" need to be taken with some caution. For example, values discussed often refer to concert halls and sometimes also

to theatres (Barron 1993; Beranek 1962, 1996), which are not necessarily comparable to other sonic experiences and their venues. That is, the optimum values for modern theatre performances might be of limited use when studying outdoor medieval drama, except to establish a basis for comparison and reflection. Similarly, it is worth reflecting on the fact that the measurements and modelling guidelines and techniques discussed earlier in this chapter are also a legacy from auditorium and concert hall design and are not particularly attuned to acoustical heritage work. One attempt to customise guidelines to a specific type of cultural heritage site can be found in the work by Martellotta et al. (2009), who developed guidelines for researching Christian church acoustics, offering recommendations on source and receiver locations, as well as hardware, while also taking into consideration practicalities, the architectural features of the sites themselves, and aspects linked to the Christian liturgy. The aim was to encourage teams to carry out measurements that would be more easily comparable across sites.

Reverberation Time

Reverberation time, which is often referred to as RT60, can be defined as the time, expressed in seconds, that it takes for sound to decay by 60 dB after the sound source has stopped emitting sound. Although, as discussed earlier in this chapter, reverberation time can be calculated through the Sabine equation, it can also be derived from IRs (ISO 3382, 1997). Moreover, although the definition of reverberation time considers a 60 dB dynamic range, values are often measured over a narrower range of 20 or 30 dB and referred to as T20 and T30, respectively. Whereas T20 calculates the reverberation time from the decay curve ranging from 5 to 25 dB, requiring the decay curve to start 35 dB above the background noise level, T30 considers the 5 to 35 dB range and the decay curve needs to start at 45 dB above the background noise level (ISO 3382, 1997). When analysing IRs captured on-site, a choice between the analysis of T20 or T30 could be a consequence of the background noise level and the resulting SNR.

A related parameter is Early Decay Time (EDT), which calculates reverberation time considering the first 10 dB of the decay curve. EDT is the parameter more closely related to the perception of reverberation (Jordan 1970, 1981). EDT values are greatly affected by the position of the listener and are often shorter than the reverberation time (Barron 1995). As a result of the sensitivity of EDT to the listener position, spaces might present a wide range of values (Barron 1995). Moreover, since EDT is more strongly correlated to the perception of reverberation in spaces, such a variance in values would cause a space with a constant reverberation time to be perceived as having non-uniform reverberation (Barron 1995).

If a space is used mainly for the spoken word, then speech intelligibility might be particularly valuable, therefore, short reverberation times might be preferred. The ideal reverberation time for speech has been considered as 1 s, although theatres analysed have been found to range between 0.7 and 1.2 s (Barron 1993). Below 0.5 s, although speech will be intelligible, listeners might feel aural discomfort (Barron 1993). Such aural discomfort is related to the fact that most spectators are used to inhabiting and frequenting spaces with reverberation times of 0.5 s or above. As a result, spaces with very low reverberation times might be perceived as unnatural. Blesser and Salter (2007) point out initially that if reverberation is excessive it might degrade speech intelligibility, increase the background noise level, and make a space unpleasant – although, I need to add here, that what is considered to be unpleasant is always relative and cannot be generalised. Nevertheless, Blesser and Salter also point out that if the reverberation is inadequate, the space will be perceived as "aurally dead, unresponsive, and uninviting" (Blesser and Salter 2007: 61). Although Blesser and Salter's reflections are of great use for the consideration of space and acoustics, it is worth noting that their generalisations might not be suitable for acoustical heritage work. Furthermore, the optimum values quoted here might be of only relative relevance.

If a space is used for music performances the optimum reverberation time may depend on the type of music performed, and the preferences of the period in relation to specific musical cultures. Music that is characterised by short notes and complex rhythmic patterns might benefit from short reverberation times that will enable the listener to distinguish every note, while music that is slow and rhythmically simple can benefit from longer reverberation times (Beranek 1962). Optimum values of reverberation time at mid frequencies for concert halls have been considered between 1.8 and 2.2 s (Barron 1993). Beranek (1962) provides more specific values by establishing the ideal reverberation time at mid frequencies for different types of music: 1.5 s for Baroque music, 1.7 s for Classical music and Wagnerian opera, 1.9 s for symphonic music, and 2.2 s for Romantic music. Due to the close correlation between EDT and the subjective perception of reverberation, any deviations from the optimum values by the measured EDT should be considered of more relevance than deviations in the reverberation time (Barron 2005).

Clarity

Clarity is an early-to-late arriving energy ratio expressed in decibels, which can be calculated using C50 or C80. C50 considers the division between early and late energy as 50ms and gives an indication of speech intelligibility and definition in a space, whereas C80 is more suitable for the analysis of music and uses 80 ms to divide early from late energy. Both direct sound and early reflections are considered within the early energy, whereas reverberant

sound constitutes the late arriving energy. A preponderance of early energy will result in higher clarity values since early reflections fuse with the direct sound and provide higher definition (Soulodre and Bradley 1995), resulting in better speech intelligibility and the perception of musical detail. Furthermore, clarity is higher when the listener is nearer to the source due to the prominence of the direct sound. Clarity is inversely proportional to the reverberation time, this is particularly true when considering EDT values, higher clarity resulting in a lower EDT and vice versa (Barron 1995, 2005).

Optimum values are highly dependent on the use of the space and are influenced by subjective preference (Barron 1993). In the case of rhythmically complex musical items high levels of clarity might be preferable since each sound will be more distinct, whereas in the case of performances of, for instance, plainchant items, which present slow melodic lines, lower values of C80 might be beneficial. Barron (1993) indicates that optimum values of C50 and C80 for concert halls are within the range of –2 dB to +2 dB. Although it is unlikely that higher values would indicate an excess of clarity, it is necessary to assess whether higher values are not indicating very low results in other parameters, such as reverberation time (Barron 2005). Beranek (1996) relates preferences on clarity values to different contexts, for instance, a conductor rehearsing for a performance might prefer C80 values at 500 Hz–2 kHz to range between 1 and 5 dB to hear as much detail as possible, whereas in the context of a performance values between 1 and 4 dB might be preferred.

Spatial Impression

When referring to spatial impression, we can refer to the Apparent Source Width (ASW) and Listener Envelopment (LEV) (Soulodre and Bradley 1995). The ASW is associated with the perceptual broadening of the sound source, whereas LEV is the effect by which listeners feel surrounded by sound, "the sensation of spatial impression [listener envelopment] corresponds to the difference between feeling *inside* the music and looking at it, as through a window" (Barron and Marshall 1981: 214).

Whereas the ASW is determined by the presence of early lateral reflections, LEV is affected by the late lateral reflections, with 80 ms after the arrival of the direct sound used to differentiate early from late reflections (Soulodre and Bradley 1995). The connection between an increase in the ASW and early lateral reflections is a result of the phenomenon described as the Haas effect. Direct sound and early reflections are fused, resulting in an increase in the perceived level of the direct sound (Soulodre and Bradley 1995). On the other hand, late reflections are not fused with the direct sound and are perceived as separate events that are distributed around the space (Soulodre and Bradley 1995).

Barron and Marshall (1981) studied the factors influencing lateral reflections and causing the broadening of the ASW. It was determined that changes in the direction of the reflections had an influence on ASW, with reflections arriving at the sides of the listener (90°) resulting in the most prominent effects (Barron and Marshall 1981). Changes in the level of the reflections as well as variations in listening level both produced changes in relation to spatial impression (Barron and Marshall 1981). Higher listening levels resulted in an increase of ASW to the extent that differences were detected even within musical items with soft and loud passages (Barron and Marshall 1981).

Soulodre and Bradley (1995) studied the influence of late arriving reflections on LEV and determined that an increase in envelopment was the result of the direction of the reflections, with the largest effect being produced by reflections arriving at 90° (at the sides of the listener). Furthermore, they established that an increase in reverberation time and a decrease in clarity values resulted in higher levels of LEV (Soulodre and Bradley 1995). Finally, late arriving energy was shown to hinder the perception of early lateral energy and as a result the ability to differentiate changes in the ASW.

Changes in the ASW can be analysed by using the parameters $IACC_E$ (Interaural Cross-Correlation Coefficient – Early) and LF (Early Lateral Energy Fraction). The $IACC_E$ parameter measures the dissimilarity of signals arriving at both ears considering the first 80 ms of the IR. It has been identified as being of importance for the subjective preference of concert halls, with audiences preferring lower values of $IACC_E$, which correspond to a greater dissimilarity between the signals (Schroeder, Gottlob and Siebrasse 1974; Ando 1985) and indicate a perceptual broadening of the source.

The LF parameter is the ratio between early lateral energy (5–80 ms, early reflections) and early omnidirectional energy (0–80 ms, direct sound and early reflections). Small values of LF are often associated with the proximity of the listener to the source, which is a consequence of the predominance, at those positions, of the direct sound (Barron 2000). Nevertheless, when analysing such results it is necessary to bear in mind that although source broadening will be minimal, the physical proximity of the listener to the source will act as compensation (Barron 2000).

LEV can be studied by considering $IACC_L$ (Interaural Cross-Correlation Coefficient – Late) which takes into account the sound arriving 80 ms or more after the direct sound, with lower values indicating a greater sense of envelopment, meaning that the sound arrives uniformly at the listeners from all directions (Beranek 1996).

Both the $IACC_E$ and $IACC_L$ parameters can be calculated as $IACC_{E3}$ and $IACC_{L3}$ when the results are the mean across 500 Hz–2 kHz (Barron 2000). These frequencies are used because their wavelength is similar or smaller than the dimensions of the head of an average listener (Okano, Beranek and Hidaka 1998). Studies on LF have determined that low frequencies

are essential for perceptual source broadening, whereas frequencies above 1.5 kHz do not seem to contribute to the process (Barron and Marshall 1981). As a result, it is possible to study LF values as LF_{E4}, which is the mean across 125 Hz–1 kHz (Hidaka, Beranek and Okano 1995).

Okano, Beranek and Hidaka (1998) provide the values of IACC and LF parameters for concert halls ranked as being of different quality. "Superior" and "Excellent" concert halls present $IACC_{E3}$ values in the range of 0.36–0.46 and LF_{E4} values between 0.16 and 0.20, whereas "Good to Excellent" halls have values of $IACC_{E3}$ of 0.38–0.54 and LF_{E4} of 0.13–0.23, and finally, the halls categorised as "Good" have values of 0.53–0.59 for $IACC_{E3}$ and 0.08–0.17 for LF_{E4} (Okano, Beranek and Hidaka 1998). Barron indicates that acceptable values for LF could be considered as being between 0.1 and 0.35 (Barron 1993), which seems to correspond to the values indicated for "Superior", "Excellent", and "Good to Excellent" concert halls (Okano, Beranek and Hidaka 1998). $IACC_{E3}$ measurements have been considered as providing a better match with subjective categorisations of concert halls than the LF_{E4} values (Okano, Beranek and Hidaka 1998).

Regarding the $IACC_{L3}$ parameter, Beranek (1996) indicates values within the range of 0.10–0.16 for "Superior" and "Excellent" concert halls, 0.12–0.22 for those ranked as "Good to Excellent", and 0.12–0.28 for those ranked as "Good" and "Fair to Good". As these ranges demonstrate, there are overlaps in values among halls that have different rankings, which might be an indication that this parameter is not sensitive enough to be significant to these classifications (Beranek 1996) and reference values should be used with caution.

But the calculation of objective parameters and the study of numerical data are not the only ways in which we can engage with the past. We can also *listen* to the sites, which provides a more direct way to engage non-specialist audiences by demonstrating sonic differences across sites and across settings within the same context.

Auralisations: Listening to the Past

Auralisation describes a computer-aided process that renders audible a particular sound field, that is, it allows the user to hear the way sound is modified by the characteristics of an indoor or outdoor space (Kleiner, Dalenbäck and Svensson 1993). In the case of acoustical heritage, it allows us, for example, to model a space through computer simulation and listen to how it has changed throughout history, experiencing the impact of its changing acoustic characteristics on sound. It can also be used to listen to the results of the on-site acoustic measurements and share the sonic experience with others, remotely. For example, the *Acoustic Atlas* project by Cobi van Tonder is an online interactive site that hosts IRs and environmental sounds from heritage

sites around the world, enabling users to hear themselves in those spaces by using their own microphones to carry out real-time auralisations, (van Tonder and Lopez 2021) which can be combined with the provided sound effects and downloaded by the user (van Tonder 2020). Another project that sought to facilitate auralisation processes is *The Open Acoustic Impulse Response (OpenAIR) Library*, which allows the user to browse the repository in search for IRs linked to different sites and download the IRs available, as well as anechoic recordings (Murphy and Stevens, n.d.). Furthermore, information on the different acoustic parameters and their corresponding data are also included for consideration. *OpenAIR* permits users to use IRs for their creative work, in order to generate their own auralisations, while also serving as a repository for the preservation of the acoustics of the measured sites (Murphy et al. 2017).

When auralisations are used as part of research projects, it is often the case that researchers will carry out audio recordings in an anechoic chamber, which is a room that is especially designed to eliminate all sound reflections through the use of sound absorbing material. Recordings performed in an anechoic chamber are "dry", which means that they do not contain any spatial information, which might conflict with the acoustic information of the IR.

Once the audio material has been recorded, to produce an auralisation, it is necessary to convolve this material with the IR that was either captured on-site or derived from a computer model. Convolution is a mathematical operation that can be used to apply the acoustic characteristics of a space to an audio signal (see Figure 2.3). The operation of convolution determines how an input signal is modified when it passes through a linear time-invariant system.

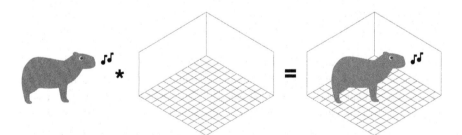

FIGURE 2.3 An illustration of the convolution process. Our carpincho/capybara friend is on the left singing outside of any physical spaces, which is not actually possible but is meant to represent an anechoic recording with no spatial acoustic characteristics. In the middle we have a generic space which we would have an IR for. On the right the result of the convolution process is the carpincho/capybara sounding as if it were singing in that space, even though it was never there. Credit: Richard A. Carter.

When the input audio signal is convolved with the IR of a site it results in an audio signal that sounds as if it had been recorded in the acoustic space being simulated. In other words, the dry recording will now exhibit the acoustic characteristics of the space.

The terms auralisation and convolution reverb are often used interchangeably, with the main difference being that auralisation is often used to refer to the recreation of the sound of a specific event or space, and is often connected to a desire for as much accuracy as possible, whereas convolution reverb is often used more flexibly for creative productions, in which accurate recreations might not be a concern (Murphy et al. 2017).

Some Concluding Thoughts

This chapter has explored the very many different approaches to studying the sounds of the past. It started by discussing sensorial studies in general, and what cultural studies in the field have taught us about the specificity of sensorial experiences, while connecting this back to specific sound studies. It then introduced approaches linked to engineering, and how these have been incorporated to the field of archaeoacoustics. When exploring the latter I have summarised some of the main methods used in acoustics studies through IR measurements and simulations, and the type of data that can be derived from such work. While doing so I have also provided some notes of caution on the risks of an overreliance on assumptions on sonic preferences by past cultures based on a modern legacy of concert hall and theatre research and design.

The next chapter will explore the place of sound and acoustics in intangible heritage considerations, by looking more closely at the UNESCO Convention for the Safeguarding of the Intangible Cultural Heritage (ICH), and reflecting on a potential mismatch between what the UNESCO considers to be intangible heritage and what acoustics and soundscapes researchers have presented in their work. This will be tied in with considerations based on postcolonial studies, as well as discussions on how classism and sexism (among others) have impacted the study of sound heritage – an intersection rarely discussed in connection to acoustical work.

References

Álvarez-Morales, Lidia, Lopez, Mariana and Álvarez-Corbacho, Ángel (2019) "Cathedral Acoustics: Bristol Cathedral as a Case Study," *Conference Proceedings of Internoise 2019*, Madrid, Spain.
Álvarez-Morales Lidia, Lopez, Mariana and Álvarez-Corbacho, Ángel (2020) "The Acoustic Environment of York Minster's Chapter House," *Acoustics*, 2:1, 13–36. DOI: 10.3390/acoustics2010003.

Álvarez-Morales, Lidia, Lopez, Mariana, Álvarez-Corbacho, Ángel and Bustamante, Pedro (2019) "Mapping the Acoustics of Ripon Cathedral," *Proceedings of the 23rd International Congress on Acoustics, integrating 4th EAA Euroregio 2019, ICA 2019,* 2335–2342.

Álvarez-Morales, Lidia, Álvarez-Corbacho, Ángel, Lopez, Mariana and Bustamante, Pedro, (2021) "The Acoustics of Ely Cathedral's Lady Chapel: A Study of Its Changes throughout History," *2021 Immersive and 3D Audio: From Architecture to Automotive (I3DA),* Bologna, Italy, 2021, 1–9, DOI: 10.1109/I3DA48870.2021.9610837.

Ando, Yoichi (1985) *Concert Hall Acoustics.* Berlin: Springer-Verlag.

Astolfi, Arianna, Bo, Elena, Aletta, Francesco and Shtrepi, Louena (2020) "Measurements of Acoustical Parameters in the Ancient Open-Air Theatre of Tyndaris (Sicily, Italy)," *Applied Sciences,* 10:16, 5680. DOI: 10.3390/app10165680.

Banegal, Hope (1930) "Bach's Music and Church Acoustics," *Music & Letters,* 11:2, 146–155.

Barron, Michael (1983) "Auditorium Acoustic Modelling Now," *Applied Acoustics,* 16, 279–290.

Barron, Michael (1993) *Auditorium Acoustics and Architectural Design.* London: E & FN Spon.

Barron, Michael (1995) "Interpretation of Early Decay Times in Concert Auditoria," *Acustica,* 81:4, 320–331.

Barron, Michael (2000) "Measured Early Lateral Energy Fractions in Concert Halls and Opera Houses," *Journal of Sound and Vibration,* 232:1, 79–100.

Barron, Michael (2005) "Using the Standard on Objective Measures for Concert Auditoria, ISO 3382, to Give Reliable Results," *Acoustical Science and Technology,* 26:2, 162–169.

Barron, Michael (2009) *Auditorium Acoustics and Architectural Design* [electronic resource], (2nd ed.). London; New York: Taylor & Francis.

Barron, Michael and Marshall, A. (1981) "Spatial Impression due to Early Lateral Reflections in Concert Halls: The Derivation of a Physical Measure," *Journal of Sound and Vibration,* 77:2, 211–232.

Bennett, Tony (1995) *The Birth of the Museum: History, Theory, Politics.* London: Routledge.

Beranek, Leo (1962) *Music, Acoustics & Architecture.* New York and London: John Wiley & Sons, Inc.

Beranek, Leo (1996) *Concert and Opera Halls: How They Sound,* New York: Acoustical Society of America.

Beranek, Leo (2004) *Concert Halls and Opera Houses: Music, Acoustics, and Architecture,* Second edition. New York: Springer.

Bevilacqua, Antonella, Ciaburro, Giuseppe, Iannace, Gino, Lombardi, Ilaria and Trematerra, Amelia (2022) "Acoustic Design of a New Shell To Be Placed in the Roman Amphitheater Located in Santa Maria Capua Vetere," *Applied Acoustics,* 187, DOI: 10.1016/j.apacoust.2021.108524.

Biddle, Ian and Gibson, Kirsten (2019) "Introduction," in Ian Biddle and Kirsten Gibson (eds) *Cultural Histories of Noise, Sound and Listening in Europe, 1300–1918.* Oxon: Routledge. pp. 1–14.

Blesser, Barry and Salter, Linda-Ruth (2007) *Spaces Speak, Are You Listening?* Massachusetts: MIT Press.

Bradley, J.S., Reich, R., and Norcross, S.G. (1999) "A Just Noticeable Difference in C50 for speech," *Applied Acoustics*, 58, 99–108.

Bude, Tekla (2022) *Sonic Bodies: Text, Music, and Silence in Late Medieval England*. Philadelphia: University of Pennsylvania Press.

Bull, Michael, Gilroy, Paul, Howes, David, and Kahn, Douglas (2006) "Introducing Sensory Studies," *The Senses and Society*, 1:1, 5–7, DOI: 10.2752/174589206778055655

Canac, F. (1967) *The Acoustics of Ancient Theatres: Their Teaching* [in French: *L'Acoustique des Theatres Antiques: Ses Enseignements*]. Paris: CNRS.

CATT-Acoustic, https://www.catt.se/ [Last accessed 8th March 2024].

Classen, Constance (1997) "Foundations for an Anthropology of the Senses." *International Social Science Journal*, 49:3, 401.

Classen, Constance (2005a) "McLuhan in the Rainforest: The Sensory Worlds of Oral Cultures," in David Howes (ed) *Empire of the Senses: The Sensual Cultural Reader*. Oxford, New York: Berg. pp. 147–163.

Classen, Constance (2005b) "The Witch's Senses: Sensory Ideologies and Transgressive Femininities from the Renaissance to Modernity," in David Howes (ed) *Empire of the Senses: The Sensual Cultural Reader*. Oxford, New York: Berg. pp. 70–84.

Classen, Constance (2017) *The Museum of the Senses: Experiencing Art and Collections*. London: Bloomsbury.

Cooper, Catriona (2019) "The Sound of Debate in Georgian England: Auralising the House of Commons," *Parliamentary History*, 38:1, February 2019, DOI: 10.1111/1750-0206.12413.

Corbin, Alain (1998) *Village Bells: Sound and Meaning in the Nineteenth Century French Countryside*. New York: Columbia University Press.

Corbin, Alain (2005) "Charting the Cultural History of the Senses," in David Howes (ed) *Empire of the Senses: The Sensual Cultural Reader*. Oxford, New York: Berg. pp. 128–139.

Cox, Trevor (1993) "The Sensitivity of Listeners to Early Sound Field Changes in Auditoria," *Acustica*, 79, 28–41.

Cox, Trevor J., Fazenda, Bruno M., and Greaney, Susan E. (2020) "Using Scale Modelling to Assess the Prehistoric Acoustics of Stonehenge," *Journal of Archaeological Science*, 122, 105218, DOI: 10.1016/j.jas.2020.105218.

Everest, F. Alton and Pohlmann, Ken C. (2015) *Master Handbook of Acoustics*. Sixth edition. London: McGraw-Hill.

Farina, Angelo (2000) "Simultaneous Measurements of Impulse Response and Distortion with a Swept-Sine Technique," *Audio Engineering Society 108th Convention*, Paris, France, February 18–22.

Farina, Angelo (2007) "Advancements in Impulse Response Measurements by Sine Sweeps," *Audio Engineering Society 122nd Convention*, Vienna, Austria, May 5–8.

Fearn, R.W. (1975) "Reverberation in Spanish, English and French churches", *Journal of Sound and Vibration*, 43:3, 562–567.

Feld, Steven (2005) "Places Sensed, Senses Placed: Toward a Sensuous Epistemology of Environments," in David Howes (ed) *Empire of the Senses: The Sensual Cultural Reader*. Oxford, New York: Berg. pp. 179–191.

Feld, Steven (2015) "Acoustemology," in D. Novak and Matt Sakakeeny (eds) *Keywords in Sound*. Durham and London: Duke University Press. pp. 12–21.

Forsyth, Michael (1985) *Buildings for Music: The Architect, the Musician, and the Listener from the Seventeenth Century to the Present Day*, Cambridge: The MIT Press.

Galindo, Miguel, Zamarreño, Teófilo and Girón, Sara (2009) "Acoustic Simulations of Mudejar-Gothic Churches," *Journal of Acoustical Society of America*, 126, 1207–1218.

Girón, Sara, Álvarez-Corbacho, Ángel and Zamarreño, Teófilo (2020) "Exploring the Acoustics of Ancient Open-Air Theatres," *Archives of Acoustics*, 45:2, 181–208. DOI: 10.24425/aoa.2020.132494.

Girón, Sara, Álvarez-Morales, Lidia and Zamarreño, Teófilo (2017) "Church Acoustics: A State-of-the-Art Review after Several Decades of Research," *Journal of Sound and Vibration*, 411, 378–408, DOI: 10.1016/j.jsv.2017.09.015.

Griesinger, David (1996) "Beyond MLS – Occupied Hall Measurement with FFT Techniques, *Audio Engineering Society's 101st Convention*, Los Angeles, USA, November 8–11.

Hamilakis, Yannis (2015) *Archaeology of the Senses: Human Experience, Memory, and Affect*. New York: Cambridge University Press.

Hidaka, Takayuki, Beranek, Leo and Okano, Toshiyuki (1995) "Interaural Cross-Correlation, Lateral Fraction and Low- and High-Frequency Sound Levels as Measures of Acoustical Quality in Concert Halls," *Journal of the Acoustical Society of America*, 98:2, 988–1007.

Holmes, Peter (2006) "The Scandinavian Bronze Lurs: Accident or Intent?" in Chris Scarre and Graeme Lawson (eds) *Archaeoacoustics*. Cambridge: Cambridge University Press. pp. 59–69.

Howard, David and Angus, Jamie (2009) *Acoustics and Psychoacoustics*. Oxford: Focal Press.

Howard, David and Murphy, Damian (2008) *Voice Science, Acoustics and Recording*. Oxford: Plural Publishing.

Howes, David (2005a) "Introduction: Empires of the Senses," in David Howes (ed) *Empire of the Senses: The Sensual Cultural Reader*. Oxford, New York: Berg. pp. 1–17.

Howes, David (2005b) "Sensation in Cultural Context," in David Howes (ed) *Empire of the Senses: The Sensual Cultural Reader*. Oxford, New York: Berg. pp. 143–146.

Howes, David (2017) "Music to the Eyes. Intersensoriality, Culture, and the Arts," in Marcel Cobussen, Vincent Meelberg and Barry Truax (eds) *The Routledge Companion to Sounding Art*, Oxon: Routledge. pp. 159–168.

Howes, David (2020) "Digging Up the Sensorium: On the Sensory Revolution in Archaeology," in Robin Skeates and Jo Day (eds) *The Routledge Handbook of Sensory Archaeology*. Oxon: Routledge. pp. 21–34.

Howes, David (2021) "Afterword: The Sensory Revolution Comes of Age," *The Cambridge Journal of Anthropology*, 39:2, 128–137.

ISO 3382 (1997) *Acoustics Measurement of Reverberation Time of Rooms with Reference to Other Acoustical Parameters*. ISO.

ISO 3382-1 (2009) *Acoustics – Measurement of Room Acoustic Parameters. Part 1: Performance Spaces*. ISO.

ISO 18233 (2006) *Acoustics – Application of New Measurement Methods in Building and Room Acoustics*, BS EN ISO 18233.

Jordan, V.L. (1970) "Acoustical Criteria for Auditoriums and Their Relation to Model Techniques," *Journal of the Acoustical Society of America*, 47: 2A, 408–412.

Jordan, V.L. (1981) "A Group of Objective Acoustical Criteria for Concert Halls," *Applied Acoustics*, 14:4, 253–266.

Kahn, Douglas (2002) *Digits in the Historical Pulse. Being a Way to Think about How So Much Is Happening and Has Happened in Sound in the Arts*. https://www.mediaarthistory.org/wp-content/uploads/2011/05/Kahn.pdf. pp. 1–9.

Kessler, Ralph (2005) "An Optimised Method for Capturing Multidimensional "Acoustic Fingerprints"," *Audio Engineering Society 118th Convention*, Barcelona, Spain, 28–31 May.

Kleiner, Mendel, Dalenbäck, Bengt-Inge and Svensson, Peter (1993) "Auralization – An Overview," *Journal of the Audio Engineering Society*, 41:11, 861–875.

Kleiner, Mendel, Orlowski, R. and Kirszenstein, J. (1993) "A Comparison between Results from a Physical Scale Model and a Computer Image Source Model for Architectural Acoustics," *Applied Acoustics*, 38:2–4, 245–265.

Kuttruff, Heinrich (1973) *Room Acoustics*. London: Applied Science Publishers.

Lopez, Mariana (2015a) "Using Multiple Computer Models to Study the Acoustics of a Sixteenth-Century Performance Space," *Applied Acoustics*, 94, 14–19, DOI: 10.1016/j.apacoust.2015.02.002.

Lopez, Mariana (2015b) "An Acoustical Approach to the Study of the Wagons of the York Mystery Plays: Structure and Orientation," *Early Theatre*, 18:2, DOI: 10.12745/et.18.2.2447.

López, Mariana (2022) "Bude, Sonic Bodies," *The Medieval Review*, 22.11.05, https://scholarworks.iu.edu/journals/index.php/tmr/article/view/35673/38699.

Lopez, Mariana and Pauletto, Sandra (2012) "Acoustic Measurement Methods for Outdoor Sites: A Comparative Study," *Proceedings of the 15th International Conference of Digital Audio Effects (DAFx)*, York, UK, September 17–21.

Lopez, Mariana, Pauletto, Sandra and Kearney, Gavin (2013) "The Application of Impulse Response Measurement Techniques to the Study of the Acoustics of *Stonegate*, a Performance Space Used in Medieval English Drama," *Acta Acustica united with Acustica*, 99, 98–109.

Martellotta, Francesco, Cirillo, Ettore, Carbonari, Antonio and Ricciardi, Paola, (2009) "Guidelines for Acoustical Measurements in Churches," *Applied Acoustics*, 70:2, 378–388, DOI: 10.1016/j.apacoust.2008.04.004.

McEwen, Indra Kagis (2003) *Vitruvius: Writing the Body of Architecture*. Cambridge: MIT Press.

McLuhan, Marshall (1962) *The Gutenberg Galaxy: The Making of Typographic Man*, Toronto: University of Toronto Press.

Miller Frank, Felicia (1995) *The Mechanical Song: Women, Voice, and the Artificial in Nineteenth-Century French Narrative*. Stanford: Stanford University Press.

Mills, Steve (2014) *Auditory Archaeology: Understanding Sound and Hearing in the Past*. London: Routledge.

Müller, Swen and Massarani, Paulo (2001) "Transfer-Function Measurement with Sweeps," *Journal of the Audio Engineering Society*, 49:6, 443–471.

Murphy, Damian (2000) *Digital Waveguide Mesh Topologies in Room Acoustics Modelling*. PhD Thesis. University of York.

Murphy, Damian and Stevens, Frank (n.d.) Open Acoustic Impulse Response (OpenAIR) Library, https://www.openair.hosted.york.ac.uk/. [Last accessed 19th March 2024].

Murphy, Damian, Shelley, Simon, Foteinou, Aglaia, Brereton, Jude and Daffern, Helena (2017) "Acoustic Heritage and Audio Creativity: The Creative Application

of Sound in the Representation, Understanding and Experience of Past Environments," *Internet Archaeology*, 44, DOI: 10.11141/ia.44.12.

Niaounakis, T.I. and Davies, W.J. (2002) "Perception of Reverberation Time in Small Listening Rooms," *Journal of Audio Engineering Society*, 50, 343–350.

O'Connor, Terry (2013) *Animals in Medieval Urban Lives: York as a Case Study* (unpublished article provided by the author).

Ochoa Gautier, Ana María (2014) *Aurality: Listening & Knowledge in Nineteenth-Century Colombia*. Durham and London: Duke University Press.

Odeon, https://odeon.dk/ [Last accessed 8th March 2024].

Okano, Toshiyuki, Beranek, Leo and Hidaka, Takayuki (1998) "Relations among Interaural Cross-Correlation Coefficient (IACCE), Lateral Fraction (LFE), and Apparent Source Width (ASW) in Concert Halls," *Journal of the Acoustical Society of America*, 104:1, 255–265.

Ouzounian, Gascia (2020) *Stereophonica: Sound and Space in Science, Technology, and the Arts*. Cambridge, MA: MIT Press.

Papadakis, Nikolaos M. and Stavroulakis, Georgios E. (2019) "Review of Acoustic Sources Alternatives to a Dodecahedron Speaker," *Applied Sciences*, 9:18, 3705, DOI: 10.3390/app9183705.

Papathanasopoulos, B. (1965) *Acoustical Measurements in the theatre of Epidauros*, [in German] *Acoustiche messungen in theater von Epidauros*, Proceedings of 5th ICA, Liege.

Parkin, P. and Taylor, J.H. (1952) "Speech Reinforcement in St. Paul's Cathedral. Experimental System Using Line-Source Loudspeakers and Time Delays," *Wireless World*, 58:2, 54–57.

Pentcheva, Bissera V. and Abel, Jonathan S. (2017) "Icons of Sound: Auralizing the Lost Voice of Hagia Sophia," *Speculum*, 92:S1, S336–S360.

Platts, Hannah (2021) *Multisensory Living in Ancient Rome: Power and Space in Roman Houses*. London: Bloomsbury Academic.

Raes, Auguste C. and Sacerdote, Gino (1953) "Measurement of the Acoustical Properties of Two Roman Basilicas", *Journal of Acoustical Society of America*, 25, 925–961.

Ramirez, Janina (2022) *Femina. A New History of the Middle Ages, Through the Women Written Out of It*. London: WH Allen.

Rindel, Jens Holger (1995) "Computer Simulation Techniques for Acoustical Design of Rooms," *Acoustics Australia*, 23:3, 81–86.

Rindel, Jens Holger (2011) "The ERATO Project and Its Contribution to Our Understanding of the Acoustics of Ancient Theatres," *The Acoustics of Ancient Theatres Conference*, Patras, September 18–21, 2011, https://tinyurl.com/yn8hwzys.

Rindel, Jens Holger (2013) "Roman Theatres and Revival of Their Acoustics in the ERATO Project," *Acta Acustica United with Acustica*, 99, 21–29, DOI: 10.3813/AAA.918584.

Rindel, Jens Holger and Nielsen, Martin Lisa (2006) "The ERATO Project and Its Contribution to Our Understanding of the Acoustics of Ancient Greek and Roman Theatres," *ERATO Project Symposium, Proceedings*, 1–10, https://tinyurl.com/yn8hwzys.

Roberts, Brian (n.d.) Wallace Clement Ware Sabine, *Acoustics Pioneer, CIBSE Heritage Group*, https://www.hevac-heritage.org/built_environment/pioneers_revisited/surnames_m-w/sabine.pdf [Last accessed 19th March 2024].

Salter, Linda-Ruth (2019) "What You Hear Is Where You Are," in Mark Grimshaw-Aagaard, Mads Walther-Hansen and Martin Knakkergaard (eds), *The Oxford Handbook of Sound and Imagination*, New York. pp. 765–787.

Sabine, Wallace Clement (1922) *Collected Papers on Acoustics*. Cambridge, MA: Harvard University Press.

Savioja, Lauri (1999) *Modelling Techniques for Virtual Acoustics*. Dissertation for the Degree of Doctor of Science in Technology, Helsinki University of Technology (Espoo, Finland).

Savioja, Lauri (2015) "Overview of Geometrical Room Acoustic Modeling Techniques," *Journal of the Acoustical Society of America*, 138:708, DOI: 10.1121/1.4926438.

Scarre, Chris and Lawson, Graeme (2006) "Preface," in Chris Scarre and Graeme Lawson (eds) *Archaeoacoustics*, Cambridge: University of Cambridge. pp. vii–ix.

Schroeder, M.R., Gottlob, D. and Siebrasse, K.F. (1974) "Comparative Study of European Concert Halls: Correlation of Subjective Preference with Geometric and Acoustic Parameters," *Journal of the Acoustical Society of America*, 56:4, 1195–1201.

Shankland, Robert S. (1968) "Acoustical Observations in Greek and Roman Theatres," *Journal of Acoustical Society of America*, 44:1, 367 (meeting abstract), DOI: 10.1121/1.1970428.

Shankland, Robert S. (1973) "Acoustics of Greek Theatres," *Physics Today*, 26, 30–35.

Shankland, Robert S. and Shankland, H.K. (1971) "Acoustics of St. Peter's and Patriarchal Basilicas in Rome," *Journal of Acoustical Society of America*, 50, 389–396.

Silva, João (2017) "Porosity and Modernity. Lisbon's Auditory Landscape from 1864 to 1908," in Ian Biddle and Kirsten Gibson (eds), *Cultural Histories of Noise, Sound and Listening in Europe 1300–1918*. Oxon: Routledge. pp. 235–251.

Skeates, Robin and Day, Jo (2020) "Sensory Archaeology: Key Concepts and Debates," in Robin Skeates and Jo Day (eds) *The Routledge Handbook of Sensory Archaeology*. Oxon: Routledge. pp. 1–17.

Smith, Bruce R. (1999) *The Acoustic World of Early Modern England: Attending to the O-Factor*. Chicago: The University of Chicago Press.

Smith, Mark (2007) *Sensory History*. Oxford: Bloomsbury.

Soulodre, Gilbert and Bradley, John S. (1995) "Subjective Evaluation of New Room Acoustic Measures," *Journal of the Acoustical Society of America*, 98:1, 294–301.

Stoller, Paul (1989) *The Taste of Ethnographic Things: The Senses in Anthropology*. Philadelphia: University of Pennsylvania Press.

Stoever, Jennifer Lynn (2016) *The Sonic Color Line: Race and the Cultural Politics of Listening*. New York: New York University Press.

Till, Rupert (2014) "Sound Archaeology: Terminology, Palaeolithic Cave Art and the Soundscape," *World Archaeology*, 46:3, 292–304, DOI: 10.1080/00438243.2014.909106.

Tilley, Christopher (2020) "How Does It Feel? Phenomenology, Excavation and Sensory Experience: Notes for a New Ethnographic Field Practice," in Robin Skeates and Jo Day (eds) *The Routledge Handbook of Sensory Archaeology*. Oxon: Routledge. pp. 76–93.

Thompson, Emily (2004) *The Soundscape of Modernity: Architectural Acoustics and the Culture of Listening in America, 1900–1933*. Cambridge, MA: MIT Press.

Truax, Barry (2017) "Acoustic Space, Community, and Virtual Soundscapes," in Marcel Cobussen, Vincent Meelberg and Barry Truax (eds) *The Routledge Companion to Sounding Art*, Oxon: Routledge. pp. 253–263.

van Tonder, Cobi, (2020) Acoustic Atlas, https://www.acousticatlas.de/ [Last accessed 19th March 2024].

van Tonder, Cobi (2021) *Measurements at Dowkabottom* Cave, 26th June 2021, https://www.acousticatlas.de/blog/2021-06-28-fieldwork-dowkabottom-cave [Last accessed 5th March 2023).

van Tonder, Cobi and Lopez, Mariana (2021) "Acoustic Atlas - Auralisation in the Browser," *2021 Immersive and 3D Audio: from Architecture to Automotive (I3DA)*, Bologna, Italy. DOI: 10.1109/I3DA48870.2021.9610909.

Vierestraete, Pieter and Ylva, Söderfeldt (2018) "Deaf-Blindness and the Institutionalization of Special Education in Nineteenth-Century Europe," in Michael Rembis, Catherine Kudlick, and Kim E. Nielsen (eds) *The Oxford Handbook of Disability History*. New York: Oxford University Press. pp. 265–280.

Vitruvius, *Ten Books on Architecture*, The Project Gutenberg Ebook, 2006, https://www.gutenberg.org/files/20239/20239-h/20239-h.htm [Last accessed 8th March 2024].

Vorländer, Michael (1995) "International Round Robin on Room Acoustical Computer Simulations," *15th International Congress on Acoustics*, Trodheim, Norway, June 26–30.

Vorländer, Michael (2008) *Auralization: Fundamentals of Acoustics, Modelling, Simulation, Algorithms and Acoustic Virtual Reality*. Berlin, Heidelberg: Springer-Verlag.

Vorländer, Michael (2013) "Computer Simulations in Room Acoustics: Concepts and Uncertainties," *Journal of Acoustical Society of America*, 133, 1203–1213.

Walden, Daniel (2014) "Frozen Music: Music and Architecture in Vitruvius' De Architectura," *Greek and Roman Musical Studies*, 2, 124–145.

Waller, S.J., Lubman, D. and Kiser, B., (1999) "Digital Acoustic Recording Techniques Applied to Rock Art Sites," *American Indian Rock Art*, 25, 179–190.

Zubrow, Ezra B.W. and Blake, Elizabeth C. (2006) "The Origin of Music and Rhythm," in Chris Scarre and Graeme Lawson (eds) *Archaeoacoustics*. Cambridge: Cambridge University Press. pp. 117–126.

3
THE INTANGIBILITY OF IT ALL

Introduction

The study of acoustical heritage and historical soundscapes is often associated with the concept of intangible heritage (see e.g. Álvarez-Morales, López and Álvarez-Corbacho 2020; Bartalucci and Luzzi 2020; Fırat 2021; Katz, Murphy and Farina 2020; Murphy et al. 2017; Suarez, Alonso and Sendra 2015, 2016; Yelmi 2016). Consequently, it has been connected to the UNE-SCO Convention for the Safeguarding of the Intangible Cultural Heritage. UNESCO defines Intangible Cultural Heritage, from this point onwards referred to as ICH, as:

> the practices, representations, expressions, knowledge, skills – as well as the instruments, objects, artefacts and cultural spaces associated therewith – that communities, groups and, in some cases, individuals recognize as part of their cultural heritage. This intangible cultural heritage, transmitted from generation to generation, is constantly recreated by communities and groups in response to their environment, their interaction with nature and their history, and provides them with a sense of identity and continuity, thus promoting respect for cultural diversity and human creativity.
>
> *(UNESCO 2022b: 5)*

The ICH Convention was first adopted in 2003, and took effect on 20th April 2006, three months after the 30th state (Romania) ratified it (Smeets 2006). This chapter discusses the ICH Convention, including its origins, its remit, and its limited addressing of acoustical and soundscape-related heritage. In so

DOI: 10.4324/b22976-3

doing, a mismatch is revealed between the listings within the ICH Convention and its invocation by researchers in the field of acoustical heritage and sound-scapes. In the process, I will also consider aspects of social and cultural diversity, which were at the root of the establishment of the ICH Convention.

UNESCO ICH Convention: The Origin Story

At the time of writing UNESCO's ICH Convention is supported by 183 states[1] and emerged from the slow and progressive recognition of cultural heritage beyond objects and monuments and, hence, beyond tangibility. The ICH Convention was also an acknowledgement that the 1972 World Heritage Convention presented a large imbalance in terms of geographical locations, privileging those in the Northern hemisphere, and, thus, focused on Western heritage and its surrounding value systems (Matsura 2004: 4; Smith and Akagawa 2009: 1). The ICH Convention thus sought instead to recognise "the living cultural expressions of the 'South'" (Matsura 2004: 4), while also being a response to growing concerns around the impact of globalisation on local traditions (Kurin 2004: 68). The Convention did not receive any dissension votes (Matsura 2004: 4), but some states abstained, including Australia, Canada, UK, USA, and Switzerland (Kurin 2004: 66). At the time of writing, both Switzerland and the UK have become signatories. The UK announced in December 2023 that it intended to ratify the Convention and launched a public consultation, indicating that the aim was to focus on assembling an inventory of UK intangible heritage without seeking its formal inclusion within the UNESCO ICH lists (House of Lords 2024).

UNESCO's work on ICH dates back to the 1950s, a period marked by a focus on folklore (Kirshenblatt-Gimblett 2004: 53) and copyright (Kurin 2004: 67). Kurin (2004: 67–68) highlights other precedents of a more nationalistic nature, notably Japan's "Law for the Protection of Cultural Properties" (1950, revised in 1954), in which both tangible and intangible expressions of culture, as well as people themselves, are considered "living treasures". Later, in 1973, Bolivia argued, unsuccessfully, for the protection of folklore by adding a protocol to the *Universal Copyright Convention*, which nevertheless helped to raise awareness around intangible cultural expressions (Bouchenaki 2004: 7; UNESCO 2001a: 1). It was not until 1989 that UNESCO formally adopted *The Recommendation on the Safeguarding of Traditional Culture and Folklore*, the first document on ICH (Ruggles and Silverman 2009: 8). This document was the product of a UNESCO committee, "Committee of Experts on the Safeguarding of Folklore", whose "Section for the Non-Physical Heritage" was set up in 1982 (Bouchenaki 2004: 7). *The Recommendation* highlighted the "fragility" (UNESCO 1990: 238) of folklore, especially the folklore linked to oral traditions, and the need for governments to safeguard it from disappearance, particularly at a time in

which mass media was seen as a risk to local traditions (UNESCO 1990: 238, 240). The document covers several aspects of conservation, including documenting processes; preservation, through protection measures such as the establishment of learning opportunities; and dissemination, through, for example, events and press coverage (UNESCO 1990: 239–241). However, *The Recommendation* had only a limited impact, with very few Member States putting into practice the safeguarding measures recommended (Kurin 2004: 68; UNESCO 2001a: 4).

A recognition of different heritage categories can also be seen in the 1992 addition of the category of "cultural landscapes" to the World Heritage Convention, recognising landscapes that are characteristically representative of different regions and exhibit humankind's connection to the natural environment. The landscape categories include: "landscape designed and created intentionally by man", "organically evolved landscape", and "associative cultural landscape" (Matsura 2004: 4, UNESCO 2008: 86). The latter has a strong connection to intangible heritage, as it encompasses natural sites that are recognisable due to their "religious, artistic or cultural associations" (UNESCO 2008: 86). At the time of writing, the general "cultural landscapes" category is illustrated on the UNESCO website by Argentina's entry for Quebrada de Humahuaca, a cultural route (Camino Inca) along the valley of Río Grande, which has been in use for over 10,000 years, and includes evidence of traversal by prehistoric communities, the Inca Empire, and during independence fights in the nineteenth century (UNESCO 2003).

Sinamai (2022) expresses scepticism regarding the concept of *cultural landscapes*, arguing that, as most concepts in heritage and archaeology, it is embedded within a Western knowledge system. The term, Sinamai argues, considers the landscape as an object that serves human needs, whereas in African and indigenous contexts it is the landscape that is at the centre and humans adapt to it and build connections. The imposition of Western frameworks to other contexts, Sinamai argues, ends up missing some key connections for local communities, including the links between sounds and spaces. Said connections will be explored further in Chapter 4 when discussing the World Heritage List entry of *Great Zimbabwe*.

In 1993, as a result of a proposal by the Republic of Korea, UNESCO established the *Living Human Treasures* programme, now discontinued and replaced by the 2003 ICH Convention (UNESCO, n.d.d). The *Living Human Treasures* programme was aimed at Member States' official recognition of talented "tradition bearers and practitioners" (UNESCO, n.d.d), as well as encouraging the transmission of their skills to younger generations (Bouchenaki 2004: 9; UNESCO, n.d.d). In addition to official recognition, UNESCO encouraged Member States to support "Living Human Treasures", which could be individuals or groups, with grants and subsidies that allowed them to work on safeguarding ICH, including the further development of

skills, the establishing of formal or informal training programmes for new generations, the documentation of ICH, and its eventual dissemination (UNESCO, n.d.d).

Ruggles and Silverman (2009: 5) also mention ICOMOS' (International Council on Monuments and Sites) 1994 *The NARA document on authenticity*. ICOMOS' document is a result of concerns regarding "globalization and homogenization" (ICOMOS 2012), and a desire to "bring greater respect for cultural and heritage diversity to conservation practice", and it acknowledges both tangible and intangible heritage (ICOMOS 2012).[2] *The NARA document* incorporated the need for conservation practices to be rooted in the values attributed to heritage, including notions of authenticity, in its own cultural context, rather than trying to impose global conservation practices (ICOMOS 2012), and so moving explicitly away from privileging Western conservation practices (Ruggles and Silverman 2009: 5). It is here that Ruggles and Silverman (2009: 6) highlight *The NARA document*'s embrace of the ephemeral, breaking away from associating permanence with authenticity. By valuing ephemerality and renewal, people were valued as key to heritage practices (Ruggles and Silverman 2009: 6).

Concurrent to the publishing of *The NARA document* in 1994 was the report of an Expert Meeting assessing representation in the UNESCO World Heritage List. The report concluded that the List was based on an outdated concept of "monumental" cultural heritage (UNESCO 1994); was lacking in diversity; privileged "elitist" architecture over the vernacular; had an over-representation of historic, European sites, including towns and religious buildings (particularly those linked to Christianity), compared to global contemporary and prehistoric sites; and was marked by a paucity of living heritage (Arizpe 2000; UNESCO 1994). The report suggested:

> The world heritage should thus consider the products of culture by means of several new thematic approaches: modes of occupation of land and space, including nomadism and migration, industrial technology, subsistence strategies, water management, routes for people and goods, traditional settlements and their environments, etc.

It is worth noting that although 30 years have passed since these issues of over and under-representation were pointed out, imbalances still exist today, with the World Heritage List (which contains cultural, natural, and mixed sites) listing 1,154 sites at the time of writing, of which 47% are in Europe and North America (i.e. 44% in Europe and 4% in North America); 24% in Asia and the Pacific; 13% in Latin America and The Caribbean; 8% in Africa; and 8% in the Arab States.[3]

A key milestone was the 1998 UNESCO programme *Proclamation of Masterpieces of the Oral and Intangible Heritage*, with the first entries being

included in 2001 (Kurin 2004: 69), and with further additions in 2003 and 2005 (UNESCO, n.d.f). The programme had several aims: to raise awareness and establish safeguarding measures for ICH; to evaluate and list items of oral and intangible heritage from around the world; to propel Member States to establish national inventories and involve communities in the identification and protection of ICH, whether specifically oral or otherwise (UNESCO, n.d.f). Kurin (2004: 69) considers the programme's main merits to be its acknowledgement of diversity issues in the World Heritage List, as well as bringing attention to the varied traditions listed and the overall importance of safeguarding. The items proclaimed as Masterpieces have been incorporated to the *Representative List of the Intangible Cultural Heritage of Humanity* (Kurin 2004: 74; UNESCO 2022: 18) and are listed as 2008 entries (UNESCO, n.d.f).

Kurin (2004: 68) discusses the importance of the 1999 conference *A Global Assessment of the 1989 Recommendation on the Safeguarding of Traditional Culture and Folklore: Local Empowerment and International Cooperation*, which took place in the Smithsonian Institution in Washington, and was organised together with UNESCO. Kurin (2004: 68) sees it as a catalyst for the 2003 ICH Convention, with the event critiquing the 1989 *Recommendation*, as an "ill-construed, 'top-down', state-oriented, 'soft' international instrument that defined traditional culture in essentialist, tangible, archival terms, and had little impact around the globe upon cultural communities and practitioners" (Kurin 2004: 68). By contrast, the conference highlighted the need to centre safeguarding processes around community involvement (Kurin 2004: 68). The conference outcomes were also reflected on subsequently in the 2001 *Report on the Preliminary Study of the Advisability of Regulating Internationally, through a New Standard-Setting Instrument, the Protection of Traditional Culture and Folklore*, which Kirshenblatt-Gimblett (2004: 53) sees as inaugurating a shift towards recognising the fundamental role played by "tradition-bearers" (UNESCO 2001a: 1) in heritage, as well as highlighting the need to replace the term "folklore" for ICH (UNESCO 2001a: 6). The *Report* also recognised that intellectual property laws are ill-suited to the protection of ICH and that a bespoke instrument of protection was instead needed (UNESCO 2001a: 3). Finally, the *Report* conceded that there was a need for a more inclusive consideration of intangible heritage, beyond artistic outputs, in order to properly account for the "knowledge and values enabling their production, the creative processes that bring the products into existence and the modes of interaction by which these products are appropriately received and appreciatively acknowledged" (UNESCO 2001a: 1).

It was this recognition of the need to better respect cultural diversity that informed UNESCO's 2001 *Universal Declaration on Cultural Diversity* (Ruggles and Silverman 2009: 8–9), in which cultural diversity is noted "as necessary for humankind as biodiversity is for nature. In this sense, it is the

common heritage of humanity and should be recognized and affirmed for the benefit of present and future generations" (UNESCO 2001b). Furthermore, the *Declaration* emphasised the importance of respecting "traditional knowledge", particularly in relation to indigenous communities (UNESCO 2001b), as being key to ICH.

Defining ICH: The Role of Sound in ICH

The definition of ICH within the ICH Convention accommodates a wide variety of manifestations, with examples given for five domains: "oral traditions and expressions, including language as a vehicle of the intangible cultural heritage", "performing arts", "social practices, rituals and festive events", "knowledge and practices concerning nature and the universe", and "traditional craftmanship" (UNESCO 2022: 5–6). These are then grouped into three different lists: the *Representative List of the Intangible Cultural Heritage of Humanity*, the *List of Intangible Cultural Heritage in Need of Urgent Safeguarding*, and the *Register of Good Safeguarding Practices*. In all instances, ICH listed items need to be compatible with "international human rights instruments", "mutual respect among communities, groups and individuals", and "sustainable development" (UNESCO 2022: 5).

At the time of writing there are 676 items listed across five regions (Africa; Arab States; Asia and the Pacific; Europe and North America; Latin America and the Caribbean) and from 140 countries.[4] It is worth noting that although Europe and North America are considered to be the same region, the region only includes European entries as neither the USA or Canada are signatories. Moreover, although the geographical distribution, in terms of regions, is slightly better than that of the earlier World Heritage Convention, there are still some prominent imbalances, with Europe representing 38% of the listed items across all three lists, followed by Asia and the Pacific with 36%, Africa with 14%, Latin America and the Caribbean with 13%, and Arab States with 10%.[5] These statistics indicate that although the ICH Convention went some way into recognising the cultural heritage of regions outside of Europe by expanding its definition of heritage, European heritage remains dominant and, as will be explored later, this over-representation is also evident in studies on acoustics and soundscapes.

Reflecting on the five domains of the ICH Convention, de Oliveira Pinto (2018: 50) expresses surprise that none include music explicitly (and one could extend this surprise to the omission of sound in general), but concludes that this is largely a consequence of music's ambivalent connection to tangible and intangible heritage simultaneously, as well as the fact that music is linked to all five categories listed in the ICH Convention. de Oliveira Pinto (2018) reflects subsequently on the arbitrary dichotomy between tangible and intangible heritage, a dichotomy that can be easily rejected when

considering musical expressions (2018: 41). Materiality in music can be found in notated scores, musical instruments, and music recordings, but they are all closely linked to the intangible (de Oliveira Pinto 2018). de Oliveira Pinto observes nevertheless that while music instruments are tangible, the crafts skills involved in their making, and the uniqueness of each instrument, as well as the symbolic meaning they might have for a community, are all part of the intangible heritage surrounding that instrument and musical expression. It is for this reason that the ICH Convention includes crafting and performance skills linked to musical instruments, with entries featuring instances such as the Oud (Iran, Syrian Arab Republic); the practice of playing the M'Bolon (Mali); and the practice of playing Dutar (Turkmenistan), among many others.

Another important aspect of the tangible/intangible dichotomy in music relates to notated music and recordings. Notated music and recordings might be tangible, but they do not capture the uniqueness of each performance. de Oliveira Pinto (2018) illustrates this by reminding the reader that there are very many recordings of Vivaldi's *Four Seasons*, but they are all different, and it is in that difference, in that interpretation and uniqueness of each performance, that we find the intangible. Museums may be able to store and exhibit the tangible elements of music but not its intangibility (de Oliveira Pinto 2018: 102).

The ICH Convention was never meant to focus on musical expressions reliant on notated music, but instead on those relying on oral transmission (de Oliveira Pinto 2018). de Oliveira Pinto (2018) mentions that the inclusion of "Organ craftsmanship and music" is an interesting example, chiefly due to the large number of written outputs linked to organ music. However, the specialised skills involved, which are still transmitted from one generation to the other, as well as the organ music repertory, which includes a strong tradition of improvisation, were ultimately considered an example of intangible heritage (de Oliveira Pinto 2018, 127–134).

It can be observed here that the performance of notated Western music does not change the underlying piece as a result: it remains stable and referable, being linked to its materiality, even though the performance itself is intangible. Nevertheless, while orally transmitted music does not depend on a documented score (de Oliveira Pinto 2018), this does not mean that there are no rules, for it is the "recognition of these musical rules, their maintenance, their realization in a proper setting, their social acceptance and recognition, and their performance practice determine what living heritage is about" (de Oliveira Pinto 2018: 93). Similarly, when musical expression is part of a ritual, a dance, for example, the performance creates a new piece each time, which instead of following a score follows a set of rules linked to the event in question (de Oliveira Pinto 2018: 168–169). It is this living heritage that the ICH Convention is ultimately keen to safeguard through the

communities involved. The fragility of intangible heritage lies on the fact that it does not assume a final, fixed form (de Oliveira Pinto 2018: 151–152), and it is dependent on oral cross-generational transmission (Kearney 2009: 222), which is key to its safeguarding. Intangible heritage is thus highly dynamic: it is an engagement with traditional practices that also seeks to keep them relevant to modern generations and in which communities themselves determine what authenticity means in their own contexts (Alivizatou 2012: 191).

An insightful reflection on the connection between tangible and intangible in the realm of sound more generally, beyond musical expressions, is provided by Yelmi (2016), who illustrates this through tea culture in Turkey (2016: 304). The mode of preparation for tea, the drinking habits surrounding it, and the sounds associated with these activities, are all intangible, with the evident exception of the tangible teapot and cups. In this case, both tangible and intangible are deeply connected, needing each other to exist as components of cultural expression (Yelmi 2016). Liu-Rosenbaum (2015) similarly debates the impossibility of clear divisions between tangible and intangible by taking the practice of soundwalking as an example in which cultural significance is attained through a combination of the physical spaces traversed and the sounds associated with this (2015: 118). *Soundwalking* is a practice associated with Hildegard Westerkamp and the late 1960s, early 1970s World Soundscape Project in which participants are encouraged to walk around environments and focus on their sonic experiences,[6] with the aim to raise awareness on the sonic environment and the importance of its preservation (Westerkamp 2001). Away from the world of sound conservation and into the realm of sound art, Max Neuhaus also developed sound focused walks titled LISTEN in the 1960s and 1970s in which he guided people outdoors, after stamping the word LISTEN on their hands, and encouraged them to focus on listening, hoping to impact their everyday experiences (Ouzounian 2013: 82).

Another aspect to the tangible/intangible dichotomy includes acoustical considerations. These are not forgotten in de Oliveira Pinto's musical reflections, as he connects acoustics with discussions surrounding sound quality of performance venues, mostly referring to concert halls, pointing out that the acoustics of a venue might itself be a point of attraction for visitors (2018: 162–163). The appreciation of a venue due to its sonic characteristics is, for de Oliveira Pinto, a reflection on the appreciation of the intangible, whose material counterpart is the concert hall or venue itself (2018: 166). He reflects that "no notation or other form of materializing sound will ever be able to capture what musical sound in its genuine acoustical environment is like" (2018: 166). What is meant by "genuine acoustical environment", though, is left unelaborated. However, the use of the term "genuine", in the context of acoustical heritage considerations, can be considered as connected to the specificity of performing musical expressions in the environments they

were first originated to be performed in, either be it indoors or outdoors, in a fixed or itinerary format. As discussed in Chapter 2, through the work of Beranek (1996, 2004) and Forsyth (1985), there have been historically close connections between musical composition styles and the buildings those compositions were performed in. Their relationship is symbiotic, with compositions being created to suit the spaces available at the time of creation, thereby displaying the space and the piece, while also sometimes the pieces themselves have triggered changes in venue construction to suit new compositional styles. An example of the latter is provided in the work of Howard and Moretti (2009) on St Mark's Basilica in Venice. In an earlier work, Moretti (2004) suggested that the addition of a second *pergolo* (a marble balcony) to St Mark's between 1541 and 1544, in addition to the already existing one – resulting in two *pergoli* facing each other on each side of the chancel – was a response by architect Jacopo Sansovino to the use of the *cori-spezzato* formation (split choir) by *maestro di cappella* Adrian Willaert. The addition was thus intended to accommodate the division of the choir into two parts, one in each balcony. Subsequent acoustical and performance work on-site has determined that the splitting of the choir, a one four-part choir in each *pergolo*, resulted in a clear sound and impressive spatial separation, indicating that a connection between music leading architectural changes is likely to have existed (Howard and Moretti 2009: 39, 202).

Some final perspectives on acoustics and the tangible/intangible debate are presented by Katz, Murphy, and Farina (2020: 92), who identify the acoustics of heritage sites as an intangible product of a tangible site, which encompasses the built or natural environment itself, and its furnishings. By contrast, Fırat (2021) presents a different perspective, arguing that the mere ability to preserve sound and acoustics through digital means makes them tangible (2021: 3).

Having now established some of the main discourses surrounding the definition of intangible heritage in the context of sonic experiences, I now want to proceed specifically onto their actual representation, or lack thereof, in the UNESCO ICH listings.

Beyond Music: The Presence (and Absence) of Sound and Acoustics in the ICH Convention

There is no shortage of representation of sonic elements in the ICH Convention lists, but the majority are associated with musical expressions (de Oliveira Pinto 2018), with soundscapes and environmental acoustics (natural or built) being much more elusive (see also Fırat 2021). An online search through the ICH lists,[7] using keywords including "sound/s", and "acoustic/s", revealed 53 entries when entering the keyword "sound", and four with the keyword "acoustic". Additional searches for "silent" and "silence" brought

up four entries. No entries included the keyword "noise", and searching with "tranquil" as a keyword did not output any relevant entries – that is, out of three results, only one was related to sound and this concerned a musical expression. No entries included the keyword "quiet" or "loud".

The discussion below is a result of an analysis of the entries returned using these keywords, as well as linear search through the full listings, which was conducted in case anything relevant appeared to be missing. In general, across the entries explored, sound was linked to different forms of cultural expression, primarily musical traditions, but it was also described as a constitutive element within wider cultural practices – although, in these cases, it was not the main reason for a given entry to be included. The following sections will reflect on some of the entries I found of particular relevance to this volume, and these will serve as a starting point for a reflection on a potential clash concerning how sound heritage practitioners view the role of soundscapes and acoustics in ICH, as compared to how this is reflected in the current Convention entries.

This musical emphasis has been identified by Fırat (2021) as a limitation of the ICH Convention when it comes to sound, and he has subsequently urged the consideration of non-musical sound sources as having cultural properties affected by different social and cultural contexts (2021: 9). Fırat exemplifies this with the sound of cannon fire and its varying meanings throughout history in the Muslim world (2021: 10). Cultural significance, Fırat reminds us, might be related to an individual sound source, or to a combination of sound sources, as well as the environment in which a sound or sounds are propagated, along with its consequent impact on sound perception, which in turn affects how distinctive it might be to a community (2021: 10).

Both Yelmi (2016) and Liu-Rosenbaum (2015) similarly provide insightful studies of non-musical sounds as instances of ICH and their varying cultural significance for communities, focusing on Istanbul and Quebec, respectively. It is in this regard that Liu-Rosenbaum (2015) highlights that even sounds deemed unpleasant by a community can still form part of their cultural heritage, and so the creation of sound maps exemplifies how a community selects sounds that they feel are representative of their heritage and worth preserving, with the caveat that sound selection might not necessarily have to do with the sounds themselves, but with the space they are heard in, or with a theme that connects sound and space. Sound maps will be discussed later in this chapter, together with caveats on whether sounds included are representative, for example, of different genders and socioeconomic contexts.

In my search through the Convention lists for evidence of the presence of sonic ICH beyond music, I came across entries that can be classified as *acoustic communication*; *festivities and processions*; *ceremonies*; and *non-musical sound making objects*.

Acoustic Communication

One of the non-musical sonic-centric entries in the ICH lists, is the inscription in 2022 of *Manual Bell Ringing* practices from Spain.[8] The entry describes it as "the soundscape that, for centuries, has spoken of everything and for everyone, in every town and city".[9] Bell ringing is highlighted "as a means of acoustic communication" due to the shared meaning different melodies, chimes, and peals have for a community, with even the same sounds having differentiated meanings across villages. In addition to these coded messages, which can convey the time of day, as well as warning of fires and floods, and accompany funeral processions, among many other functions, the entry also highlights the techniques involved in bell ringing; the work of the bell ringers; the casting of bells; and the acoustic characteristics of the bells, bell towers, and belfries. The individuality of each bell and their meaning to different members of the community is also included, as well as the emotional connection the community feels to their own bells: "if bells don't ring in a village…it's as if the village has died". Manual Bell Ringing as living heritage is emphasised, with the connection between medieval practices and contemporary times summarised by referring to bell ringing as "the WhatsApp of the Middle Ages". The action of climbing the spiral staircase to reach the bell tower to be surrounded by old stone structures while working on maintaining a tradition spanning across centuries is mentioned as providing a direct connection to the past. In addition to this, the nomination file makes explicit mention of bell ringing being part of "the acoustic landscape" that the State Party (Spain) wishes to preserve, and the efforts being made to oppose any ordinances that have tried to label it as "noise pollution".[10] Manual Bell Ringing is, thus, one of the very few examples in which sonic ICH is listed as having value on its own, rather than as part of a larger ICH expression: it is its combined role as part of the acoustic landscape and as an acoustic event in itself that is the focus.

The inclusion of Manual Bell Ringing in the ICH lists is not particularly surprising considering the vast amounts of academic literature on the importance of bells in pre-modern European communities and their soundscapes. Atkinson (2016) has discussed the importance of bells in urban settings, with their impact extending from spiritual to civic, including their role in the definition of urban spaces and the forging of connections between communities and the built environment. Bells can be considered as a pre-modern means of mass communication, undeterred by walls and other boundaries, but at the same time helping define the latter (Atkinson 2016: 12). Their functions included regulating work and sleep as well as calling people to prayer, meals, celebrations, councils, and executions, among others. Sacred bells were also considered a means of protecting a community, with their power being a consequence of them being treated with holy water, having

psalms and prayers recited over them, applying oils, and dedicating saints to protect them (Atkinson 2016: 87). The importance of bells is reflected on the practice of taking them as war trophies to remind communities of their victory, while the loss of a bell could threaten the cultural identity of a community (Atkinson 2016: 105).

The influence of bells is also found in much more recent historical periods, both at the centre of religious disputes and in the use of soundscapes to maintain colonial power. Pennanen (2017) discusses the changes in the Bosnian soundscape in relation to the Ottoman Empire, the Austro-Hungarian rule and the First World War, and the connection of those periods to the sounds of bells, as well as rifle fusillades and cannon signals. Pennanen (2017: 155) points out that, prior to the mid-nineteenth century, Bosnia had very few metal bells which were publicly audible due to the Ottoman authorities limiting the use of metal church bells by Christians. Instead, the soundscapes of towns centred around a *Sahat kula* (an Islamic clock tower) that included a chiming bell indicating lunar hours for daily prayers as well as hours of fast during Ramadan. Moreover, the *ezan*, the Islamic call to prayer, was a prominent soundscape feature. However, the soundscape changed during a period of reforms, including a decree in 1856 by Sultan Abdülmecid I which sought to protect the rights of different religious communities, although this was not always enforced, with some provinces declining permission for Christians to ring their metal bells, rather than wooden ones. Nevertheless, Pennanen (2017) explores how there were significant changes to the soundscapes in mixed religious areas. In 1860, for example, the building of a bell tower for the church of St John the Baptist in Kraljeva Sutjeska, with its new metal bells, was permitted. A new Orthodox cathedral, which also had metal bells, was finalised in 1872 in Sarajevo. The Austro-Hungarian empire changed the soundscape further with an increase in the construction of new Catholic and Orthodox churches with belfries. Pennanen (2017) emphasises that these changes in the soundscape, which were not necessarily limited to bell sounds, were a direct result of a move towards religious equality that itself was part of colonial efforts and part of a move to gain acceptance from different groups. However, the First World War changed the soundscape of Bosnia once more as bells were confiscated, and the *ezan* once again became more dominant than bell ringing. Soundscapes and bells are therefore presented as central to political matters, a topic that will be revisited in Chapter 4.

Other examples of the political use of bells are given by Corbin (1998) within the French context, who mentions that the use of bells as alarm systems and also to summon people could be seen as a threat by government authorities, who might respond to an insurrection by a community by destroying its bells. This was the case in 1548 in France when the Constable of Montmorency ordered the smashing of the bells of Vars, Charente as a punishment for people revolting against the salt tax (Corbin 1998: 9). Moreover, Corbin

(1998: 92) reflects on how the leaders of the First Republic in France sought to control the use of bells by minimising their religious use, while also secularising and municipalising their sound. In his study on the uses and meanings attached to bells in nineteenth century France, Corbin reflects on how the disputes over bells reflect communities' attachment to them as symbolic objects. Furthermore, he argues that bells were central to power struggles, with the control over bell ringing and the access to bell tower keys being a form of acoustic domination over a territory.

There are other entries, in addition to *Manual Bell Ringing*, in which acoustic communication is highlighted. This is the case of another entry from Spain, *Whistled Language of the Island of La Gomera (Canary Islands), the Silbo Gomero*.[11] This entry concerns a whistled language of pre-hispanic origin that was used among the Guanches, the indigenous people of the Canary Islands, who were driven to extinction by the fifteenth century Spanish conquest (Crosby 2004: 80). The language survived this extinction, but it is important to note that it is not a code: it is a compressed language that reproduces the language spoken by its users. As inhabitants in La Gomera now speak Spanish, El Silbo reproduces this language, but it can work with other languages as well. It is used for communicating across distances, with 1 km distances being common and distances of 8 km also having been studied (Meyer 2015). As a consequence of these distances, El Silbo is strongly affected by the acoustics of the natural environments in which it is emitted and heard, with these acoustics being intrinsic to the experience. Although the acoustic aspect that connects each whistle to its environment is not explicitly mentioned, it is hinted at in the UNESCO entry by mentioning that the whistle and the landscape are connected, and that "with the arrival of man, the solitary song of the birds merged with a new sound, a voice of its own, loud and musical", – that is, it is a part of the prevailing soundscape. Research on El Silbo has connected the language's emergence with the geographical features of the region and highlighted its usefulness in battles against Spanish conquistadores (Crosby 2004: 86). Other whistled languages exist around the world, as found in Mexico, Greece, Turkey, Papua New Guinea, Vietnam, Guyana, China, Nepal, and Senegal, all developed in mountainous or densely forested areas (Matos 2011, 2014; Meyer 2015), and similarly work to facilitate communication, for example, across canyons (Crosby 2004: 86). In addition to answering a need for communicating across large distances, the regions in which whistled languages have been used also coincide with activities in which individuals might be isolated, and this applies in particular to shepherds and goat herders, as well as people cultivating hills and hunting for game. Research by Matos (2011) has highlighted the inseparable nature between El Silbo and the environment, indicating that expert whistlers use knowledge of their surroundings to adapt their techniques of projection to more effectively transmit their whistled utterances (2011: 51). Furthermore,

different dialects have been identified, which coincide with parts of the island that have different geographical characteristics (Meyer 2015).

The Convention entry highlights various uses for El Silbo, for example, to announce celebrations and festivities, as well as funerals, while historically it was also used to warn island inhabitants of approaching ships in search of slaves. From the 1950s its use has shifted from people working the land to classroom settings, the latter forming a key part of safeguarding this intangible heritage, and providing opportunities to reflect on the challenges of incorporating indigenous practices and knowledge into traditional and contemporary classroom settings (Matos 2011). Although references to environmental acoustics or soundscapes are not found in the Convention entry, it is evident that El Silbo Gomero is part of La Gomera's distinctive soundscape and that it is impacted by the acoustic characteristics and other sounds of the island, coming together as a sonic experience.

Another Convention entry in which sonic communication and its connection to the landscape is highlighted is *Alheda'a, Oral Traditions of Calling Camel Flocks* (Saudi Arabia, Oman, and United Arab Emirates), which was included in 2022.[12] Alheda'a involves a series of vocal sounds made by camel herders to guide their flock, leading them towards areas for feeding and drinking, as well as being able to assemble them quickly in case of an emergency, such as a sandstorm. Camels are trained to respond to those sounds and recognise their herder's voice, developing a bond between human and camels. The nomination file highlights the practice of Alheda'a as an example of connection between humans, animals, and the environment and, although not explicitly mentioned in the file, Alheda'a also forms part of the desert soundscape and is impacted by the environment itself.

Reflecting on non-musical sonic ICH, Kato (2009) investigates the soundscapes of women divers (*ama*, sea women) in Japan, and their sea whistle (*Isobue*). *Ama* are free divers who harvest the sea and produce a whistling sound as part of their breathing technique, as they emerge from the water in between dives. The practice is from the coastal areas of Japan, Korea, and China (Kato 2009), with the *Culture of Jeju Haenyeo (Women Divers)* in Jeju Island having been inscribed in 2016 in the *Representative List of the Intangible Cultural Heritage of Humanity* after being nominated by the Republic of Korea. The whistling sound emitted as part of the Jeju Haenyeo's breathing technique is called "Sumbi-sori", and it is also a way for divers to acknowledge one another's presence.[13] Although sound is intrinsic to this inscription, it is part of a greater cultural practice, a trend that is found in most UNESCO ICH entries that include non-musical sounds.

Kato, whose research focuses on the island of Sugashima in Japan, reflects on sound as "a symbolic representation of their connectivity with the ocean environment" (2009: 81), an example of a deep connection between humans and their environment, which Kato connects to the definition of "cultural

landscape" (2009: 81–82). Kato explains how divers were resistant to the incorporation of diving suits and masks in the twentieth century, as they feared easier diving conditions would lead to overharvesting – an issue of great importance to a community that sees the restriction of harvesting as a sign of respect towards the ocean and a sign of gratitude (2009: 86–87). Kato explains:

> The whistle, as a sound in place, represents diverse meanings: the divers' spirituality, their connection to the ocean environment, their sense of ethics, their community, histories, stories, their joy, sadness and hardship. The *ama* soundscape can be seen as a cultural landscape within which a sustainable human-nature relationship, mythology, ritual, festivities, community life and present stories, are imbedded.
>
> *(2009: 88)*

Festivities and Processions

There are several listed Convention entries in which sound forms part of a larger whole. That is, sound contributes to the intangible heritage expression that is being protected but is not the main reason for inclusion. Prevalent among these entries are traditions linked to both secular and religious practices.

Holy Week processions are particularly prominent in this group, for example, *Holy Week Processions in Popayán* in Colombia, which was inscribed in 2009.[14] These Holy Week processions date from 1556 and consist of five different processions taking place on each evening (8–11 pm) on Tuesday to Saturday before Easter and focusing on different elements: the Lady of Sorrow, Jesus Christ, the Holy Cross, the Laying in the Tomb, and the Resurrection. Floats (*pasos*) with life-size wooden statues decorated with flowers are carried on the shoulders of the bearers who follow a 2 km route in the shape of a Latin Cross, with processions having between nine to 16 *pasos*. To each side of the procession people align themselves holding lighted candles as they follow the floats. Sound is mentioned in the entry both in terms of musical and non-musical elements. Musical expressions can be seen in the video accompanying the inscription, through marching percussion and stringed instruments, while the nomination file also makes reference to compositions that are bespoke to the processions. However, there are also mentions of non-musical sounds referred to in relation to the atmosphere that they create. The sonic nature of the event is mentioned by referring to "the sound of the alcayatas on the ground and the shuffling of alpargatas on the streets".[15] *Alcayatas* are pitchforks with a wooden handle used by the bearers of the floats to support the float when it is stationary, whereas *alpargatas* are cord-soled cloth sandals. In addition to this, the nomination file also

mentions that the processions vary their sonic characteristics depending on their sorrowful or joyous nature, with the first four processions featuring the sound of the matracas ("mobile iron handles attached to a plank of wood that produce a dull sound"), whereas the Resurrection procession features "joyous peals of bells".[16] It is worth noting that the summary provided in the ICH Convention site did not quite showcase the importance of sound, and it was only by closer inspection of the nomination file that I could access these reflections on the aural aspects of the Holy Week processions. This was not the only case in which wider sonic elements were only gleamed through a more detailed inspection, as they had not made it to the general summary.

The *Holy Week Processions in Mendrisio*, inscribed in 2019 as part of Switzerland's heritage, include sonic references of a slightly different nature, as they focus on the contrast between sound and silence.[17] The Holy Week processions take place on Holy Thursday and Good Friday, with the former staging the Passion of Christ and the Stations of the Cross, and the latter known as *enterro* (burial). The Thursday procession centres around Jesus carrying the cross and includes 270 extras, featuring horse riders, Roman soldiers, and biblical figures. The Good Friday procession is larger with around 700 participants, and approximately 320 lanterns, as well as the statues of the dead Christ and the Sorrowful Virgin. The processions follow a circular 4 km route, lights are switched off and illumination is provided via lanterns as well as *transparenti*, translucent back-lit paintings mounted on wooden frames along the procession route. Both silence and sound are reflected on and considered key to "a contemplative atmosphere".[18] Trumpets and drums are mentioned in relation to the Thursday procession, whereas the Good Friday procession is centred around silence, which is punctuated by horses' hooves and brass bands. Silence is emphasised in relation to its religious meaning and as a sign of prayer and contemplation.

Holy Week in Guatemala is an entry in which the connection to the senses is highlighted, with sound featured in relation mostly to musical expression, including funeral marches, as well as the use of drums and the tzijolaj (a pre-Hispanic flute made of cane), but with reference to "the murmuring of the multitude and the ringing of the bells" meshing with those musical elements.[19] Inscribed in 2022, it dates back to the sixteenth century, is a result of the amalgamation of Christian faith and pre-Hispanic customs, and is the commemoration of Christ's Passion, Death, and Resurrection. It includes the use of public spaces for processions with *andas* (floats), vigils, the elaboration of carpets (made of a variety of materials, such as dyed sawdust), orchards, altars, and the composition and interpretation of funeral marches.

Fiesta of the Patios in Cordova, inscribed in 2012 as part of Spain's heritage, is an example of a more secular nature.[20] The Fiesta refers to the annual opening to the public, for 12 days in the beginning of May, of the patios in Cordova's historical quarter, with patio houses being a series of houses

with a communal patio. The patios (which change from year to year) are decorated with abundant flowers, and practices of sharing food and drink are displayed, together with music and dance, including flamenco guitar playing and dancing. In the nomination file we can find that sonic elements mentioned and given significance go beyond the musical ones, and the yearlong effort of preparing for the Fiesta is expressed as,

> materialising in the luxuriant, floral, chromatic, acoustic (murmuring water, birds chirping), aromatic and compositional creativity of each patio, the expression of the wisdom, symbolism and traditions of Cordovan community and especially the residents who dwell in these patio houses.[21]

Here we can see that the natural sound elements are highlighted together with other sensorial experiences as being key to the event coming together. It is only through the careful examination of the nomination file that this non-musical sonic reference was uncovered.

Another example is that of the *Carnival of Binche*, which refers to festivities in the town of Binche (Belgium) in the three days leading to Lent.[22] The *Carnival of Binche* has its roots in the Middle Ages and its central characters are the Gilles, costumed in red, yellow, and black and wearing ostrich feather hats, as well as wax masks with small spectacles. They also wear bells around their belts and wooden clogs, and parade to the beat of the drums. Although the focus of its entry is not a sonic one, there is mention of bells and drums, and these are prominent in the video entry, and are featured as intrinsic to the carnival soundscape. Once more an example of sound being indispensable to a heritage experience but not necessarily highlighted as such. Although the sound of the wooden clogs is not mentioned per se, they would indeed have their own particular sonority as the participants march along the streets. In addition to these non-musical sound elements, the entry also refers to brass and clarinet bands, and violas.

Ceremonies

2014 saw the entry of the *Male-child Cleansing Ceremony of the Lango of Central Northern Uganda* to the *List of ICH in Need of Urgent Safeguarding*.[23] The healing ritual is performed to restore manhood to a child believed to have lost it, something believed to occur in the first three days of life. The ceremony includes several stages throughout three days, including the preparation of unsweetened millet porridge eaten by the mother and the child during the three days spent in the house, which are marked by ficus leaves being placed at the house door. Upon exiting the house on the third day the mother and child are accompanied by the father or a paternal cousin,[24] with

the rituals performed including cutting the child's hair and weaving it into strands mixed with ficus bark and shea butter and tying it around the neck, wrists, and waist of the child. The child and parents are also smeared with shea butter and served pea-paste, millet bread, and a millet-yeast brew. While the mother and child eat, sitting in front of the house, the father or paternal cousin eats behind the house before then throwing the mingling sticks used to prepare and serve the food away from the house. The ceremony restores the social status of the child and ends with singing and dancing. Ululations are a distinctive part of the ceremony and form an important aspect of the overall sonic experience, being mentioned in the entry and heard throughout the accompanying video. This is a clear example in which sonic experiences beyond music form part of the cultural experience being recorded, although is not the primary reason for the entry's inclusion, and so is easily missed on viewing it.

Non-Musical Sound Making Objects

There are a very small number of entries in which sound is emphasised as part of an experience linked to a non-musical object used as part of a wider practice. One of these is *Oxherding and Oxcart Traditions in Costa Rica*, which was originally inscribed as part of the *List of the 90 Masterpieces of the Oral and Intangible Heritage of Humanity*. Oxcarts (*carretas*) were used from the mid-nineteenth century to transport coffee beans in journeys that would take from ten to 15 days.[25] The tradition of painting and decorating the carts started in the early twentieth century, with designs representing different regions and becoming gradually more complex, with competitions rewarding creativity. Oxcarts are now a symbol of a rural past and feature in both religious and secular celebrations. The sound of the oxcarts is featured in the entry, which explains that,

> Each oxcart is designed to make its own 'song', a unique chime produced by a metal ring striking the hubnut of the wheel as the cart bumped along. Once the oxcart had become a source of individual pride, greater care was taken in their construction, and the highest-quality woods were selected to make the best sounds.

Another example of sound properties linked to an object, but this time with sacred significance, is represented in the listed entry *Buklog, Thanksgiving Ritual System of the Subanen* inscribed in 2019 as part of Southern Philippines' heritage under the *List of ICH in Need of Urgent Safeguarding*.[26] Buklog is a thanksgiving ritual system whose aim is to ensure harmony among the natural, human, and spirit worlds. It takes its name from an elevated wooden structure with a flexible platform that is built as part of the ritual,

and which has a pole (*petaw*) at its centre, which connects to a hollowed-out log called *dulugan* placed in a trench under the structure and at its centre, which it hits, creating a percussive sound as the *gbat*, a community dance, takes place on the platform. "The 'dulugan' is the Buklog's musical icon and serves as aural embodiment of Subanen's cosmology".[27] The sound of the Buklog is believed to please the spirits and it indicates the culmination of the festivity. The gathering of materials for the construction of the Buklog structure is in itself a ritual (*Kanu Gulangan*) and during which *Giloy* (a chant of praise) is chanted. Chanting is also mentioned in the entry video to highlight the ritual's connection to nature, indicating that "chants weave through the gurgle of the river and rustle of the forest".

Culture Bearers: Tensions and Resolutions

A crucial aspect of the ICH Convention is its focus on culture or tradition bearers, on the communities involved with the intangible heritage being listed. There can be no safeguarding without them, for they are the ones keeping that heritage alive (de Oliveira Pinto 2018). It is through cultural practitioners that ICH exists and can continue to exist (Blake 2009: 65). The ICH Convention promotes community involvement, which opens up the question of what the role of community has been in acoustical heritage and soundscapes projects, and whether this is an area that requires a further acknowledgement from the acoustical and soundscapes research and practice community.

Yelmi (2016) provides an excellent example of community involvement when reflecting on sounds of cultural significance in Istanbul, with local consultation being considered central to the process of sound identification, collection, and archiving. Bendrups (2015) also reflects on how the return of items of cultural heritage to the community of origin, for example an archival recording, does not only symbolise respect for that culture, but it can also be a catalyst for reflection among the community in question, which in turn may lead to safeguarding initiatives.

However, examples of community involvement in acoustical heritage and historical soundscapes research are scarce, particularly if projects are rooted in acoustic and audio engineering principles rather than those found in the humanities and social sciences. This indicates that although the concept of intangible heritage and the ICH Convention are utilised and referred to within academic articles, the conceptions at their core are not always embraced. It is possible that researchers have used the ICH Convention in relation to their work due to a belief that the importance of this work needs to be justified, rather than because they intended to commit to engaging more fully with its meaning. In a similar vein, Fırat has argued that the categorisation of sound heritage work as intangible heritage has

been popular with scholars mainly as a way of legitimising their work as part of the wider cultural heritage field (2021: 5).

In 2016 I led a project titled *The Soundscapes of the York Mystery Plays*.[28] As part of its exploration of the acoustical settings and soundscapes linked to the York Mystery Plays, a local medieval drama cycle, the project included a series of interviews with culture bearers – that is, performers, directors, and producers who have been involved in the contemporary recreation of these medieval performances. The interviews focused on discussing participants' sonic experiences, including reflections on their auditory memories of the plays, including what sounds they associated with particular performances and the particular roles played by those sounds, as well as any other acoustical considerations that came to mind. The aim of the interviews was to draw attention to the York Mystery Plays as a living tradition, one kept alive thanks to the efforts of those participants, while also serving to draw parallels between the medieval and modern settings and, from this, highlight the wider relevance of medieval studies and medieval sounds in modern times. Extracts from the interviews were used in an installation in Bedern Hall, a medieval hall in York city centre (UK), and as part of an interactive website which highlights the connections between the past and present, and in which the extracts from the interviews were mapped to different topics (wagons, animals, bells, audiences, weather, town). Asking the interviewees to focus on their aural experiences enabled them to spotlight their role, drawing attention to their significance in a way that is quite unlike the passing commentary offered in some of the ICH Convention entries explored above. Allowing space and time to explore sonic experiences can uncover their centrality and intrinsic value, despite any apparent sidelining when first characterising a given instance of cultural heritage. I will be discussing *The Soundscapes of the York Mystery Plays* further in Chapter 5.

One other useful example of the importance of oral histories for soundscapes research that I would like to highlight is the project *A Sonic Palimpsest: Revisiting Chatham Historic Dockyards*.[29] The project combined the exploration of written documents, the capture of impulse responses (IRs), and the use of sound composition techniques. The project also conducted an exploration of the Oral History Archives from the Chatham Historic Dockyard Trust (with the earliest of these going back to 1983) alongside the recording of new oral histories (Pasoulas, Knight-Hill and Martin 2022b). The focus of the project, the Chatham dockyard, was a working yard from 1547 to 1984, inclusive of its use as a hulk station in the nineteenth century (Pasoulas, Knight-Hill and Martin 2022b). The term hulk station refers to the docking of what used to be a warship but had been turned into a prison, whose inhabitants, most of them petty offenders, undertook forced labour in atrocious conditions that invariably resulted in many of them dying (Pasoulas, Knight-Hill and Martin 2022b). In addition to exploring these

histories of oppression from the hulk prisons, the project team investigated the experiences of those who worked at the dockyards and had done apprenticeships from the 1950s to the 1970s (Pasoulas, Knight-Hill and Martin 2022b). Alongside exploring and digitising already existing recordings, which included 170 tapes, the team conducted new interviews in which they sought to go beyond sonic memories and examine the role of sound in the different professions available in the dockyard (Pasoulas, Knight-Hill and Martin 2022b). In this regard, the research also explored the roles of women in the dockyards, as these were found to be under-represented in the archives. It was understood that women would have had very different sonic experiences and uses of sound as a consequence of the divergent daily roles they played in comparison to their male counterparts (Pasoulas, Knight-Hill and Martin 2022a).

In the search for the importance of sound in culture bearers' experiences it might be of use to look into what Järviluoma (2017) refers to as "sensory memory walks", that is, an experience in which a person chooses to walk a path that is meaningful to their past and while doing so reminisces out loud while making reference to the sensorial experiences they associate with those spaces and activities. This could provide a way into the challenges of exploring what sounds are central to the experiences of cultural sites but are being left out from descriptions.

Whose Heritage? Biases and Marginalisation

The tensions brought about by the lack of engagement with culture bearers are not the only such to be considered. The preponderance of studies on European acoustical heritage is another key issue. As seen throughout this chapter, the ICH Convention sought to address the lack of representation of heritage outside of Europe as well as tackle the conservational privileging of heritage based on its apparent monumentality. Nevertheless, the field of acoustical heritage, which has been noted across several publications to align itself through its scholars to the ICH Convention, is far from a beacon of hope for equality and diversity. An analysis of conference proceedings in the field reveals this salient issue. A study of the papers included in the publications of the *International Multidisciplinary Conference on Archaeoacoustics* (Eneix 2014, 2016, 2018), which includes three volumes, revealed that only 21% of sites analysed are outside of Europe, and included Australia, India, Indonesia, Iran, Mexico, Palestine, and the USA. An even more striking illustration is found in the conference series *The Acoustics of Ancient Theatres*, which first ran in 2011 in Patras (Greece), and then again in Verona (Italy) in 2022. In the 2011 installment, out of the 40 presentations delivered (including keynotes, papers, and posters) that referred to specific sites, only one such site was located outside of Europe, in Chichén Itzá, Mexico.[30] The 2022

iteration extended this trend: out of a total of 33 presentations focusing on specific sites, only two of these were found outside of Europe, in Argentina and Japan, respectively.[31]

A glance at the online *OpenAIR* impulse response database shows a similar tendency.[32] Out of the 52 recorded sites at the time of writing, only four are outside of Europe, including three in the USA and one in Argentina. The *Acoustic Atlas* platform,[33] in which researchers are invited to upload their sound heritage data, including IRs and environmental sounds, also falls into this trend. Out of the 58 locations listed, there is only one site outside of Europe that has an IR attached to it, the Taj Mahal in India. There is also only one other that has environmental sounds, the Waenhuiskrans Cave in South Africa. There are, however, an additional four compositions linked to non-European sites, including Cape Town in South Africa, the Nurana Islands in Bahrain, Kyoto in Japan, and the Taj Mahal. At the time of writing, there are no audio entries at all for South, Central or North America, the Middle East or Oceania.

It is worth noting that it is likely that over-representation of certain regions in conferences and online platforms is partly explained by the networks in which organisers and researchers are embedded, as well as the difficulty for scholars in certain regions to access these same networks and their associated events. Additionally, the predominance of English as the main language for sharing academic knowledge is likely to put certain researchers at a disadvantage. However, these aspects appear also to be indicative of an underlying bias that is echoed within the ICH and World Heritage Lists. These imbalances are rooted in constructions of heritage value that, while challenged by UNESCO, are still vivid in the selection of sites for study and preservation. These constructions can be connected to notions of the "Orient" in opposition to the "Occident". A key theorist in this regard is Edward Said (1979), who charted the Western construction of a vision of "the Orient", which characterised nations, peoples, and cultures outside of Europe. Said understood the Orient as a concept that developed throughout the centuries, with its own distinct history, imagery, and vocabulary, and became a construction so deeply entrenched in thought that it became the perceived reality acted on by Western powers, influencing all perspectives on cultural phenomena that might be characterised as Oriental including, one could argue, notions on heritage and sounds. Said contended that the construction of the Orient had little basis in reality and was instead a reflection of the desire of Western powers to elevate their own culture and values above those of "others". Imaginary boundaries were therefore set to determine a hierarchy of political, social, cultural, and racial relations, using these as a vehicle to justify colonial rule, with all aspects relatable to the Orient being rendered as backward, degenerate, and inferior. Imperialism was therefore justified in the eyes of its supporters by a belief that some societies and races were

inherently advanced while others were irredeemably backward and needed to be paternally conquered.

Evidently enough, the reality of peoples and cultures deemed to be a part of the Orient were wholly absent from Orientalist discourse. Nevertheless, Said cautioned that the critical issue at stake is whether a true representation of anything is ever at all possible, or always collapses back into a reflection of those doing the representation. These discussions are of continuing relevance to heritage studies, sonic and otherwise, in how we approach non-Western sites and the reasoning behind their lack of representation, as well as how they are represented when they are included. A question as to whether we are still, as a field, exercising the same Orientalist thought processes when delineating our studies is a question worth asking, and will be revisited in Chapter 4.

Linked to this are Sinamai's (2022) reflections on the research and interpretation of heritage. Sinamai argues that the heritage field is dominated by a Western framework of knowledge which is imposed to the analysis of heritage in non-Western regions, failing to acknowledge local ways of knowing and hence limiting the interpretation of sites. Sinamai reflects on this being part of the impact of colonisation, which did not just conquer lands but also imposed cultural frameworks onto local communities, frameworks which now need to be unlearnt in order to interpret heritage landscapes. Moreover, Sinamai explains, those Western frameworks are embedded in fields of studies such as those of archaeology, and then normalised as the "right" way of working within a field. We cannot understand the past – or its sounds – if we are not willing to accept that academic disciplines are based on Western principles that are not universal. It is not until we abandon these knowledge systems to embrace the understanding of local ways of knowing that the interpretation of sites and their sounds is possible.

A bias towards monumentality in acoustical heritage studies is another issue that undermines the connection of the field to the ICH Convention. Early on in my research on acoustics and medieval drama, I noted a huge gap in the historiography of the acoustics of drama performances (Lopez, Pauletto and Kearney 2013). Books and other published work would jump from Greek and Roman theatres (often with a sense of awe at the magnificence of their acoustics) to Elizabethan drama (see e.g. Barron 1993). The Middle Ages was skipped entirely, as if no drama performances worthy of acoustical analysis had ever taken place. The focus had been and continues to be on drama that is linked to fixed and, often, architecturally impressive structures, with medieval acoustical studies often centred around places of worship. As I have argued elsewhere (López, Hardin and Wan 2022), and here once more, preconceptions on the performance and performance spaces of medieval drama, based on their use of outdoor settings and temporary structures, have determined them to be unworthy of acoustical studies, and so resulting in a significant gap in our knowledge of the impact of acoustical settings on the performances. However,

and in relation to Lefebvre's (1974) discussions on space as a social product, the use of the street space for medieval drama provides a unique opportunity to reclaim it as worthy of study, with its own unique acoustical settings and a domain in which everyday life was mixed with dramatic performances. In short, the "worthiness" of spaces is expanded to include this interaction between performances and the everyday spaces of their occurrence. A space does not need to be monumental in order to be worthy, but acoustical heritage studies have tended to replicate narrow conceptions of heritage – despite this being an issue that both the ICH Convention, and the inclusion of cultural landscapes within the World Heritage List, had hoped to challenge. Acoustical heritage studies, ironically, considering their focus on intangibility, have struggled with ephemerality. This leads to the question of how ephemeral researchers truly believe their subject of research to be, considering this seeming need to cling onto structural permanence.

Biases towards monumentality can be linked to beauty biases identified in ecological studies and wildlife preservation. Kovacs et al. (2006) reflect on how visual appeal is a factor affecting the selection of sites chosen for ecological studies, that is, pristine sites, unaffected by human activity are often chosen above those that are more urban, more heavily impacted by human activity. "Beautiful" sites are recipients of more care and attention than the "ugly" ones, while of course recognising that concepts of beauty are a cultural construction. Furthermore, Kovacs et al. (2006) also hint at public perception of the beauty of sites and species as crucial to their support towards conservation enterprises. Kellert (1980: 100) indicates aesthetics as a main factor affecting public's support for the conservation of a species, together with several others which include the reason for the endangerment (indicating that they are more likely to have support if their endangerment is seen as a direct consequence of human activity), their economic value, and their cultural and historical significance. Conservation organisations, as a result, have often focused their efforts on those species that humans are more likely to be sympathetic towards, including those that are deemed to be beautiful, entertaining and charismatic (e.g. pandas, orangutans, penguins), as well as useful (e.g. bees) (Small 2011). Apparently, our capacity to be moved to action by the endangerment of a spider or snake is much less. Likewise, Small (2011) indicates that governments' choices of areas for conservation are sometimes due to their picturesque nature rather than their value for biodiversity. Similarly, acoustical heritage has focused on "beautiful" sites, as deemed so by European standards, leaving aside non-European ones which, when included, take on an air of exoticism. Even within European sites, those connected to "regular" people and of a more everyday nature have been cast aside as uninteresting. This thread of thought will be further developed in Chapter 4 when discussing, for example, the rhetoric surrounding the Notre Dame fire in April 2019.

Central to discussions on the future of the field should be the role of gender in assumptions and interpretations made by researchers. It is worth noting that the nomination files submitted by state parties for the ICH lists need to include gender-related information at various points, for example "any specific roles, including gender-related ones or categories of persons with special responsibilities towards the element"; "How have communities, groups or individuals been involved in planning the proposed safeguarding measures, including in terms of gender roles, and how will they be involved in their implementation?" and by asking state parties to "Describe how the community, group or, if applicable, individuals concerned have actively participated in all stages of the preparation of the nomination, including in terms of the role of gender".[34]

Annie Goh (2017) explores problematic notions on gender in heritage acoustics studies and traces notions of the archetypical listener as masculine, white and European, to work such as that of Schafer (1994) and Jean-Luc Nancy (2007). Goh (2017: 294) points out that early archaeoacoustics work, such as that of Reznikoff and Devereux, has gender biases at its core, with the former having stated that only men explored caves with their voices due to the dangers caves would have posed for women (Goh 2017: 294), and the latter who used findings on acoustic resonances in megalithic tombs in Neolithic Europe to conclude that they were used by men. More specifically, Devereux (2001) discusses acoustic research done in a sample of Neolithic sites through which they explored sites' resonant frequencies. Research showed that in the sites studied these resonances were in the range of 95–120 Hz, which Devereux explains coincides with the male vocal range. Although the section in Devereux's book which discusses these findings starts by telling the reader that we do not have much knowledge on the societies that built these sites or what they were used for (2001: 77, 79), by the end of the section he has tried to convince us that (1) those resonant frequencies indicate that the sites were used for singing and chanting, (2) that said resonances would have been key for rituals by contributing to the sense of the supernatural and commandeering by increasing the sound level of voices, and (3) that due to the resonances corresponding to the vocal range of male voices, ritual activities were conducted by men (2001: 88–89). One can only wonder, had they found the resonant frequencies to be those corresponding to the female voice, would they have drawn a similar conclusion about the commandeering voices of women in rituals? The evidence is tenuous, but it is imbued with gender biases that then result in the conclusion that it is likely that it was men that used the caves for ritual purposes. This conclusion is drawn because it coincides with their preconceived notions of gender in society (any society apparently). The conclusions were likely drawn by looking for evidence that reaffirmed pre-existing beliefs on gender roles. The danger of such biased interpretations, besides finding the evidence they were looking for in the first

place, is that they risk being used in subsequent studies to "find" proof of similar phenomena in other sites. Anecdotally, when undertaking work on the York Mystery Plays as a doctoral researcher the question of whether I had found acoustics to benefit the male voice was featured within a number of conversations about my research, a specific topic always instigated by others. It is worth also adding that there is a large predominance of male researchers in the field of acoustical heritage, and in the wider audio and acoustics fields that might have helped these biases go unchecked.

Gender biases in the study of archaeological sites are not exclusive to the field of acoustical heritage, they are also found more widely. An example of this is the controversy surrounding the Birka Warrior. Birka, a Viking town active in the period between AD 750 and 950, is home to burial Bj 581, a grave containing weapons and two horses, signalling the role of the individual as a professional warrior, and of a board game, indicating knowledge of military strategy. First discovered in 1878 the individual was assumed to be male due to the association between masculinity and leadership in battle. However, this was debunked in 2017 after a DNA analysis revealed the warrior to be a woman (Hedenstierna-Jonson et al. 2017). It was the patriarchal frameworks in which the findings were first analysed that led to an erroneous conclusion. Even in the face of the DNA results the findings were still questioned. The research team have addressed questioning surrounding whether maybe the weapons did not belong to the individual and instead were heirlooms or symbolic of the status of their family rather than their own individual role, and also explained that a second male body missing from the burial was not a plausible explanation (Hedenstierna-Jonson et al. 2017). Very importantly the researchers have raised awareness of the fact that such doubts do not seem to be cast when the skeletons are male. "As long as the sex is male, the weaponry in the grave not only belong to the interred but also reflects his status as warrior, whereas a female sex has raised doubts, not only regarding her ascribed role but also in her association to the grave goods" (Hedenstierna-Jonson et al. 2017: 858). As the research by Goh (2017) and that of Hedenstierna-Jonson et al. (2017) exemplify, heritage findings have been tainted by patriarchal frameworks, with studies arguably concluding what they thought would be "right" in the first place and with a lack of consideration of other possibilities.

In terms of soundscapes research, work on sound maps, that is, the uploading and hosting of recordings of different sounds related to different geographical areas in interactive sites open to individuals, has also been deemed to be highly gendered (Waldock 2011). Waldock highlights gender divides in this field noting the predominance of soundmapping interfaces being edited by men, as well as the predominance of male contributors (over 70%), and with a predominance of the 20–50 age range. Waldock (2011) reflects on whether male dominance in this area has limited the variety of what is recorded.

This dominance, together with the fact that these maps present themselves as archives into the past, and as sonic resources and a representation of an area, result in "a male-dominated record of sound, an insight into the significance of sound in a male-dominated resource" (Waldock 2011). The model listener is once more, as noted by Goh (2017), encoded as male. The more a particular type of recording is added, argues Waldock (2011), the more this is crystallised as the type of recording that needs to be added.

In addition to the gender divide, Waldock (2011) also reflects on the under-representation of people from poorer backgrounds due to the lack of access to the technology needed to record and upload sounds to sound maps, especially in light of some sound maps moving towards, for example, binaural recordings. The exclusion of contributors based on social class also has an impact on what is recorded and further excludes the representation of certain domestic settings, which are already more generally under-represented in comparison to public spaces (Waldock 2011). Waldock (2011) highlights the importance of community work, through workshops and provision of technology, in expanding the sounds available and allowing more diverse communities to be represented.

Back in 2015–2016 I led one such community project titled *The Sound of Cambridge*, funded through a partnership grant from The Royal Society, and in collaboration with Parkside Federation, a school in Cambridge, UK.[35] The project aimed to introduce younger generations to the importance of sound as a vehicle to understanding the built environment, going beyond the regular focus on tangible aspects and introducing them to the more intangible acoustics and sounds of sites. For my role in the partnership, I delivered sessions on soundwalking, room acoustics, IR capture, and convolution reverb to students from Years 7, 9, and 12, customising the sessions and activities to the different levels. One of the main things I taught was how to capture IRs using balloon pops and what they could learn from those IRs. The grant was used to cover the purchase of kit for the school to continue to train their students beyond the lifetime of the project, by purchasing omnidirectional mics with windshields, microphone stands, hand recorders, sound level meters, and ear defenders, as well as allowing for student groups to bid for expenses to visit sites they would like to do acoustical measurements in, allowing them the choice on what spaces to study depending on their own interests. Furthermore, throughout the project I produced exercise sheets that were handed over to the school in the hope that they would continue using them in the future, making the introduction of the topics sustainable beyond my involvement. In addition to introducing aspects of acoustics, less developed in the school curricula compared to other science topics, I also hoped to provide a representation of diversity in science by placing myself as a representative of women in audio. The IRs captured were showcased, together with others, in March 2016 as part of the Cambridge Science Festival, with a listening stall

that allowed visitors to speak into a mic and hear, through headphones, their voice in real-time in different sites through a convolution reverb plug-in.

Disability is another area routinely left aside in acoustical heritage and soundscapes work. A reader acquainting themselves with history through sound heritage work could not be blamed if they believed there were no disabled people in the past. The omission of considerations of disability in the field is blatant. In addition to the preconceptions of listeners as white and male discussed above, we should add the assumption of a non-disabled listener, and with what is considered, by modern standards, a "normal" hearing range. However, it is not just the lack of consideration of the experiences of disabled people in past acoustic settings that we should reflect on, we should also consider how discussions on the ways in which sound heritage could be a vehicle for access, for example in museum settings, are often absent, as well as conversations on how it can be made accessible.

Acoustical heritage and soundscapes research have often considered listeners as a homogeneous group, while we should be asking ourselves, for example, what impact the acoustical settings and soundscapes we study might have had for a blind or visually impaired person or a deaf or hard of hearing person. A researcher in the field could benefit from acquainting themselves with disability history, which first emerged in the 1980s (Rembis, Kudlick, and Nielsen 2018), as well as key concepts from disability studies. It should be considered that any definition of disability is context-specific: it is not an immutable concept, but one that has changed throughout history (Metzler 2011), across cultures, and can be dependent on other characteristics such as socioeconomic status (Rembis, Kudlick, Nielsen 2018) and whose boundaries can be affected by technology (Ott 2018). Buckingham (2018) has explored the role of socioeconomic status in stigma surrounding disability, exploring the history of India and the West and indicating how disability stigma is closely linked in both cases to an inability to work that results in a drop of socioeconomic status. If the inability to work does not have that result then the stigma is much less pronounced (Buckingham 2018).

To embrace this relativity, it is crucial to refer to the difference between impairment and disability supported by the social model of disability (Barnes 2012; Oliver 2009). This model considers disability to be the result of barriers set by society; it is the environment and social structures that are disabling. A visually impaired person might have an impairment, but is only disabled by society. This is in opposition to a medical model of disability in which the focus is on the individual as needing "fixing" (Oliver 2009; Rembis, Kudlick, and Nielsen 2018). By considering the social model, the researcher of acoustical heritage and soundscapes could ask themselves what opportunities an environment afforded and which limitations it presented, and what that might have meant for the construction of disability in that particular culture at that particular time.

Rembis, Kudlick, and Nielsen (2018: 10) reflect on the argument of a "lack of resources" as an excuse not to engage with the experiences of disabled people in the past and as a reflection of discriminatory biases that question disabled people's ability to leave behind meaningful traces of their experiences. "Once historians started looking…sources seemed to abound with references to disability and disabled people…" (Rembis, Kudlick, and Nielsen 2018: 11). Although these sources remain largely unexplored or ignored by acoustical heritage and soundscapes researchers.

When analysing the past through a disability history lens the researcher might also benefit from considering the notion of *crip time* (Kafer 2013) as influencing people's experiences of soundscapes and acoustics. "…crip time involves an awareness that disabled people might need more time to accomplish something or to arrive somewhere" (Kafer 2013: 26). But this is not only because of a slower pace but due to ableist barriers that they will have little control over. Crip time is about flexible time and a questioning of the normative expectations surrounding time, pace, and scheduling (Kafer 2013) – expectations that can also affect how we think about the experiences of people in the past.

Some Concluding Thoughts

Connections between sound heritage work and the ICH Convention have been drawn by several researchers in the field, but engagement with the core values of the Convention is often lacking, leaving a sense that the ICH Convention is evoked to bring status to a field that feels the need to justify its own existence in the presence of ocularcentric heritage. Aspects of diversity were at the heart of the establishment of the ICH Convention, but it is the lack of diversity that has tainted much of the work in the field of acoustical heritage, with most studies focusing on European and monumental heritage, echoing the issues that triggered the need for the ICH Convention in the first place. The lack of diversity in such studies has also uncovered a bias that has become intrinsic to the field and is linked to a prevalence of studies on white, middle-class, male-dominated sites inhabited by non-disabled people, which in turn are rooted in assumptions on the characteristics of listeners as well as those who used these spaces and how.

In addition, this chapter has questioned the engagement of the ICH Convention with sound heritage beyond musical expression, with entries revealing a culture of equating sound with music or of subduing sound to larger heritage experiences rather than imbuing it with centrality. A thorough analysis of entries exposed only limited numbers of non-musical sonic entries that can be classified in terms of acoustic communication; festivities and processions; ceremonies, and non-musical sounding objects.

In summary, the ICH Convention is lacking in its engagement with sound as a cultural heritage expression beyond music, whereas researchers have latched to the notion of ICH while failing to engage with its true meaning.

Chapter 4 will investigate the World Heritage Convention lists for a study on the representation of sound within "tangible" heritage, and while doing so will continue the thread of thought initiated here.

Notes

1 An official list of state parties can be found here: https://www.unesco.org/en/legal-affairs/convention-safeguarding-intangible-cultural-heritage#item-2 [last accessed on 1st May 2024].
2 ICOMOS is a non-governmental international organisation associated with UNESCO whose remit is the promotion of conservation, protection, use, and enhancement of monuments, https://www.icomos.org/en [last accessed on 1st May 2024].
3 The percentages have been rounded up or down as appropriate and the calculations were performed based on the database provided by UNESCO and their own statistical data, https://whc.unesco.org/en/list/&&order=year [last accessed on 16th April 2023].
4 The analysis in this chapter was conducted and written up in May 2023 based on the items listed at the time in the UNESCO ICH lists, https://ich.unesco.org/en/lists.
5 It is worth noting that some entries are listed as pertaining to more than one region.
6 *The World Soundscape Project*, https://www.sfu.ca/sonic-studio/worldsoundscaperoject.html [last accessed on 21st June 2024].
7 The search through the lists on the UNESCO site (https://ich.unesco.org/en/lists) was last carried out in May 2023.
8 *Manual Bell Ringing*, https://ich.unesco.org/en/RL/manual-bell-ringing-01873 [last accessed on 7th May 2023].
9 *Manual Bell Ringing*, https://ich.unesco.org/en/RL/manual-bell-ringing-01873 [last accessed on 7th May 2023]. All subsequent quotes regarding Manual Bell Ringing are from this same site, which includes the entry video and textual documentation.
10 The nomination file can be found in https://ich.unesco.org/en/RL/manual-bell-ringing-01873 [last accessed on 7th May 2023].
11 *Whistled Language of the Island of La Gomera (Canary Islands), the Silbo Gomero*, https://ich.unesco.org/en/RL/whistled-language-of-the-island-of-la-gomera-canary-islands-the-silbo-gomero-00172 [last accessed on 7th May 2023]. All subsequent quotes and information regarding El Silbo Gomero are from this same site, which includes the entry video and textual documentation.
12 *Alheda'a, Oral Traditions of Calling Camel Flocks*, https://ich.unesco.org/en/RL/alheda-a-oral-traditions-of-calling-camel-flocks-01717 [last accessed on 7th May 2023].
13 *Culture of Jeju Haenyeo (Women Divers)*, https://ich.unesco.org/en/RL/culture-of-jeju-haenyeo-women-divers-01068 [last accessed on 7th May 2023].
14 *Holy Week Processions in Popayán*, https://ich.unesco.org/en/RL/holy-week-processions-in-popayn-00259 [last accessed on 8th May 2023]. All subsequent quotes and information regarding Holy Week processions in Popayán are from this same site, which includes the entry video and textual documentation.

15 *Holy Week Processions in Popayán*, Nomination File No. 00259, p. 2, https://ich.unesco.org/en/RL/holy-week-processions-in-popayn-00259 [last accessed on 8th May 2023].

16 *Holy Week Processions in Popayán*, Nomination File No. 00259, p. 3, https://ich.unesco.org/en/RL/holy-week-processions-in-popayn-00259 [last accessed on 8th May 2023].

17 *Holy Week Processions in Mendrisio*, https://ich.unesco.org/en/RL/holy-week-processions-in-mendrisio-01460 [last accessed on 8th May 2023] All subsequent quotes and information regarding Holy Week Processions in Mendrisio are from this same site, which includes the entry video and textual documentation.

18 *Holy Week Processions in Mendrisio*, Nomination File No. 01460, p. 5 https://ich.unesco.org/en/RL/holy-week-processions-in-mendrisio-01460 [last accessed on 8th May 2023]

19 *Holy Week in Guatemala*, https://ich.unesco.org/en/RL/holy-week-in-guatemala-01854 [last accessed on 21st May 2023]. All subsequent quotes and information regarding Holy Week in Guatemala are from this same site, which includes the entry video and textual documentation.

20 *Fiesta of the Patios in Cordova*, https://ich.unesco.org/en/RL/fiesta-of-the-patios-in-cordova-00846 [last accessed on 8th May 2023]. All subsequent quotes and information regarding the Fiesta of the Patios are from this same site, which includes the entry video and textual documentation.

21 *Fiesta of the Patios in Cordova*, Nomination File No. 00846, p. 4, https://ich.unesco.org/en/RL/fiesta-of-the-patios-in-cordova-00846 [last accessed on 8th May 2023].

22 *Carnival of Binche*, https://ich.unesco.org/en/RL/carnival-of-binche-00033 [last accessed on 8th August 2023]. All subsequent information regarding Carnival of Binche is from this same site, which includes the summary of the entry and the video.

23 *Male-Child Cleansing Ceremony of the Lango of Central Northern Uganda*, https://ich.unesco.org/en/USL/male-child-cleansing-ceremony-of-the-lango-of-central-northern-uganda-00982 [last accessed on 6th August 2023]. All subsequent information is from this same site, which includes the entry video and textual documentation, including the nomination file.

24 The text, nomination file, and the video in the UNESCO inscription provided different information, with the nomination file and summary referring to a paternal cousin, whereas the nomination file also mentions an uncle, and the video referring to the father of the child. As the use of the word cousin is more predominant in the nomination file, and is also included in the summary, I have included it here, and I have included mention of the father as part of the ceremony as this is mentioned throughout the nomination video.

25 *Oxherding and Oxcart Traditions in Costa Rica*, https://ich.unesco.org/en/RL/oxherding-and-oxcart-traditions-in-costa-rica-00103 [last accessed on 8th May 2023]. All subsequent quotes and information regarding Oxherding and Oxcart Traditions in Costa Rica are from this same site, which includes the entry video and textual documentation.

26 *Buklog, Thanksgiving Ritual System of the Subanen*, https://ich.unesco.org/en/USL/buklog-thanksgiving-ritual-system-of-the-subanen-01495 [last accessed on 21st May 2023]. All subsequent quotes and information regarding the Buklog are from this same site, which includes the entry video and textual documentation.

27 *Buklog, Thanksgiving Ritual System of the Subanen*, Nomination File No. 01495, p. 4, https://ich.unesco.org/en/USL/buklog-thanksgiving-ritual-system-of-the-subanen-01495 [last accessed on 21st May 2023].

28 *The Soundscapes of the York Mystery Plays* was funded by the British Academy (SG152109) and the Priming Funds initiative by University of York.

29 https://research.kent.ac.uk/sonic-palimpsest/ [last accessed on 10th November 2023].
30 The analysis was based on the programme for the event, http://www. ancientacoustics2011.upatras.gr/Files/Conference%20Booklet%20Program%20 v8c_with%20chairmen_.pdf [last accessed on 30th March 2024].
31 The analysis was based on the programme for the event, https://acustica-aia.it/ wp-content/uploads/2022/07/SAT_-program_05072022.pdf [last accessed on 30th March 2024].
32 https://www.openair.hosted.york.ac.uk/ [last accessed on 19th March 2024].
33 https://www.acousticatlas.de/experience [last accessed on 19th March 2024].
34 The questions included were found in the nomination files on the ICH Convention lists online, https://ich.unesco.org/en/lists [last accessed on 10th November 2023].
35 *CoDE Wins Royal Society Partnership Grant*, https://www.aru.ac.uk/ storylab/news/the-sound-of-cambridge [Last accessed 3 December 2023]; *The Sound of Cambridge*, https://marianajlopez.com/enhancing-audio-description/ the-sound-of-cambridge/ [last accessed on 3rd December 2023].

References

Alivizatou, Marilena (2012) *Intangible Heritage and the Museum: New Perspectives on Cultural Preservation*. Oxon: Taylor & Francis Group.

Álvarez-Morales, Lidia, Lopez, Mariana and Álvarez-Corbacho, Ángel, (2020) "The Acoustic Environment of York Minster's Chapter House," *Acoustics*, 2:1, 13–36. DOI: 10.3390/acoustics2010003.

Arizpe, Lourdes (2000) "Cultural Heritage and Globalization," in Erica Avrami, Randall Mason and Marta de la Torre (eds) *Values and Heritage Conservation*, Research Report, Los Angeles: The Getty Conservation Institute.

Atkinson, Niall (2016) *The Noisy Renaissance: Sound, Architecture, and Florentine Urban Life*. University Park: The Pennsylvania State University Press.

Barnes, Colin (2012) "Understanding the Social Model of Disability: Past, Present and Future," in Nick Watson, Alan Roulstone, and Carol Thomas (eds) *Routledge Handbook of Disability Studies*. Oxon: Routledge. pp. 12–29.

Barron, Michael (1993) *Auditorium Acoustics and Architectural Design*. London: E & FN Spon.

Bartalucci, Chiara and Luzzi, Sergio (2020) "The Soundscape in Cultural Heritage." *IOP Conference Series: Materials Science and Engineering*, 949. 012050, DOI: 10.1088/1757-899X/949/1/012050.

Bendrups, Dan (2015) "Sound Recordings and Cultural Heritage: The Fonck Museum, the Felbermayer Collection, and Its Relevance to Contemporary Easter Island Culture," *International Journal of Heritage Studies*, 21:2, 166–176, DOI: 10.1080/13527258.2013.838983.

Beranek, Leo (1996) *Concert and Opera Halls: How They Sound*, New York: Acoustical Society of America.

Beranek, Leo (2004) *Concert Halls and Opera Houses: Music, Acoustics, and Architecture*, Second edition. New York: Springer.

Blake, Janet (2009) "UNESCO's 2003 Convention on Intangible Cultural Heritage: The Implications of Community Involvement in 'Safeguarding,'" in Laurajane Smith and Natsuko Akagawa (eds) *Intangible Heritage*. London: Routledge. pp. 45–73.

Bouchenaki, Mounir (2004) "Editorial," *Museum International, Intangible Heritage*, Vol. LVI:1–2, May 2004.

Buckingham, Jane (2018) "Disability and Work in South Asia and the United Kingdom," in Michael Rembis, Catherine Kudlick, and Kim E. Nielsen (eds) *The Oxford Handbook of Disability History*, United States: Oxford Handbooks. pp. 197–212.

Corbin, Alain (1998). *Village Bells: Sound and Meaning in the Nineteenth Century French Countryside*. New York: Columbia University Press.

Crosby, Alfred W. (2004), *Ecological Imperialism: The Biological Expansion of Europe, 900–1900* (Second edition). Cambridge, New York: Cambridge University Press.

de Oliveira Pinto, Tiago (2018). *Music as Living Heritage: An Essay on Intangible Culture*. Berlin: Edition EMVAS.

Devereux, Paul (2001) *Stone Age Soundtracks: The Acoustic Archaeology of Ancient Sites*. London: Vega.

Eneix, Linda C. (2014) *Archaeoacoustics: The Archaeology of Sound. Publication of the 2014 Conference in Malta*. Florida: The OTS Foundation.

Eneix, Linda C. (2016) *Archaeoacoustics II: The Archaeology of Sound. Publication of the 2015 Conference in Istambul*. Florida: The OTS Foundation.

Eneix, Linda C. (2018) *Archaeoacoustics III: The Archaeology of Sound. Publication of the 2017 Conference in Portugal*. Florida: The OTS Foundation.

Fırat, Hasan Baran (2021) "Acoustics as Tangible Heritage: Re-embodying the Sensory Heritage in the Boundless Reign of Sight," *Preservation, Digital Technology & Culture*, 50:1, 3–14. DOI: 10.1515/pdtc-2020-0028.

Forsyth, Michael (1985*) Buildings for Music: The Architect, the Musician, and the Listener from the Seventeenth Century to the Present Day*. Cambridge: The MIT Press.

Goh, Annie (2017), "Sounding Situated Knowledges: Echo in Archaeoacoustics," *Parallax*, 23:3, 283–304, DOI: 10.1080/13534645.2017.1339968.

Hedenstierna-Jonson, Charlotte, Kjellström, Anna, Zachrisson, Torun, Krzewińska, Maja, Sobrado, Veronica, Price, Neil, Günther, Torsten, Jakobsson, Mattias, Götherström, Anders and Storå, Jan (2017) "A Female Viking Warrior Confirmed by Genomics," *American Journal of Physical Anthropology*, 164, 853–860. DOI: 10.1002/ajpa.23308.

House of Lords, International Agreements Committee (2024), 5th *Report of Session 2023-24 (2024) Scrutiny of international agreements: UNESCO Convention of Intangible Cultural Heritage*, 21 February 2024, https://committees.parliament. uk/publications/43438/documents/216057/default/#:~:text=The%20 Convention%20for%20the%20Safeguarding,expires%20on%2022%20 February%202024. [Last accessed 19th March 2024].

Howard, Deborah and Moretti, Laura (2009) *Sound and Space in Renaissance Venice: Architecture, Music, Acoustics*. New Haven and London: Yale University Press.

ICOMOS (2012) *The NARA Document on Authenticity (1994)*, ICOMOS, https:// www.icomos.org/en/charters-and-texts/179-articles-en-francais/ressources/ charters-and-standards/386-the-nara-document-on-authenticity-1994 [Last accessed 15th April 2023]

Järviluoma, Helmi (2017) "The Art and Science of Sensory Memory Walking," in Marcel Cobussen, Vincent Meelberg and Barry Truax (eds) *The Routledge Companion to Sounding Art*. Oxon: Routledge. pp. 191–204.

Kafer, Alison (2013) *Feminist, Queer, Crip*. Bloomington: Indiana University Press.

Kato, Kumi (2009) "Soundscape, Cultural Landscape and Connectivity," *Sites: A Journal of Social Anthropology and Cultural Studies*, 6:2, 80–91.

Katz, Brian F.G., Murphy, Damian, Farina, Angelo (2020) "The Past Has Ears (PHE): XR Explorations of Acoustic Spaces as Cultural Heritage," in Lucio Tommaso De Paolis and Patrick Bourdot (eds) *Augmented Reality, Virtual Reality, and Computer Graphics. AVR 2020. Lecture Notes in Computer Science*, 12243. Springer, Cham, DOI: 10.1007/978-3-030-58468-9_7.

Kearney, Amanda (2009) "Intangible Cultural Heritage: Global Awareness and Local Interest," in Laurajane Smith and Natsuko Akagawa (eds) *Intangible Heritage*. London: Routledge. pp. 209–225.

Kellert, Stephen R. (1980) "American Attitudes toward and Knowledge of Animals: An Update," *International Journal for the Study of Animal Problems*, 1, 87–119.

Kirshenblatt-Gimblett, Barbara, "Intangible Heritage as Metacultural Production," *Museum International*, 56:1–2, 2004.

Kovacs, Zsuzsi I., LeRoy, Carri J., Fischer, Dylan G., Lubarsky, Sandra, and Burke, William (2006) "How Do Aesthetics Affect Our Ecology?," *Journal of Ecological Anthropology*, 10:1, 61–65.

Kurin, Richard (2004) "Safeguarding Intangible Cultural Heritage in the 2003 UNESCO Convention: A Critical Appraisal." *Museum International*, 56:1–2, 66–77, DOI: 10.1111/j.1350-0775.2004.00459.x.

Lefebvre, Henri (1974) *The Production of Space*, trans. Donald Nicholson-Smith, Oxford: Blackwell Publishing.

Liu-Rosenbaum, Aaron (2015) "Listening to Noise: An Interactive Soundscape Installation that Transforms Place in the Service of Intangible Cultural Heritage," *Material Culture Review*, 82, 113–130.

López, Mariana (2016) *The Soundscapes of the York Mystery Plays*, https://soundscapesyorkmysteryplays.com/soundscape/ [Last accessed 30th March 2024].

López, Mariana, Hardin, Marques and Wan, Wenqi (2022) "The Soundscapes of the York Mystery Plays: Playing with Medieval Sonic Histories," in Robert Houghton (ed) *Teaching the Middle Ages through Modern Games: Using, Modding and Creating Games for Education and Impact*. Berlin/Boston: De Gruyter.

Lopez, Mariana, Pauletto, Sandra and Kearney, Gavin (2013) "The Application of Impulse Response Measurement Techniques to the Study of the Acoustics of Stonegate, a Performance Space Used in Medieval English Drama," *Acta Acustica United with Acustica*, 99:1, 98–108.

Matos, Sónia (2011) *Here we don't speak, here we whistle. Mobilizing a cultural reading of cognition, sound and ecology in the design of a language support system for the Silbo Gomero*, PhD, Goldsmiths College, University of London.

Matos, Sónia (2014) "Here We Don't Speak, Here We Whistle: Designing a Language Support System for the Silbo Gomero," *8th Conference of the International Committee for Design History & Design Studies*, Blucher Design Proceedings, 1, 209–213, DOI: 10.1016/design-icdhs-046.

Matsura, Koïchiro (2004) "Preface," *Museum International, Intangible Heritage*, Vol. LVI:1–2, May 2004.

Metzler, Irina (2011) "Disability in the Middle Ages: Impairment at the Intersection of Historical Inquiry and Disability Studies," *History Compass*, 9, 45–60. DOI: 10.1111/j.1478-0542.2010.00746.x.

Meyer, Julien (2015) *Whistled Languages: A Worldwide Inquiry on Human Whistled Speech*. Berlin, Heidelberg: Springer.

Moretti, Laura (2004) "Architectural Spaces for Music: Jacopo Sansovino and Adrian Willaert at St Mark's," *Early Music History*, 23, 153–84. https://www.jstor.org/stable/3874768.

Murphy, Damian and Stevens, Frank (n.d.) Open Acoustic Impulse Response (OpenAIR) Library, https://www.openair.hosted.york.ac.uk/. [Last accessed 19th March 2024]

Murphy, Damian, Shelley, Simon, Foteinou, Aglaia, Brereton, Jude and Daffern, Helena (2017) "Acoustic Heritage and Audio Creativity: The Creative Application of Sound in the Representation, Understanding and Experience of Past Environments," *Internet Archaeology*, 44, DOI: 10.11141/ia.44.12.

Nancy, Jean-Luc (2007) *Listening*. Translated by Charlotte Mandell. New York: Fordham University Press.

Oliver, Michael (2009) *Understanding Disability: From Theory to Practice*. second edition. London: Palgrave Macmillan.

Ott, Katherine (2018) "Material Culture, Technology, and the Body in Disability History," in Michael Rembis, Catherine Kudlick, and Kim E. Nielsen (eds) *The Oxford Handbook of Disability History*. United States: Oxford Handbooks. pp. 125–140.

Ouzounian, Gascia (2013) "Sound Installation Art: From Spatial Poetics to Politics, Aesthetics to Ethics," in Georgina Born (ed) *Music, Sound and Space: Transformations of Public and Private Experience*. Cambridge: Cambridge University Press. pp. 73–89.

Pasoulas, Aki (2022) *A Sonic Palimpsest: Revisiting Chatham Historic Dockyards*, https://research.kent.ac.uk/sonic-palimpsest/ [Last accessed 30th March 2024].

Pasoulas, Aki, Knight-Hill, Andrew and Martin, Brona, (2022a) "Sonic Heritage – Listening to the Past," in *(In)tangible Heritage(s), A Conference on Technology, Culture and Design*. https://drive.google.com/file/d/1kOgOEeWq0kcCXWC2w GKGSohXnalwHg7A/view [Last accessed 10th November 2023].

Pasoulas, Aki, Knight-Hill, Andrew and Martin, Brona, (2022b) "Soundscapes of the Past: Historical Imaginings," in *Proceedings of the ICMC*. https://drive.google.com/file/d/1dQwveGcirbFkSmffTFjyrhANjTOiaI67/view [Last accessed 10th November 2023].

Pennanen, Risto Pekka (2017) "Cannons, Church Bells and Colonial Policies: The Soundscape in Habsburg Bosnia-Herzegovina," in Ian Biddle and Kirsten Gibson (eds) *Cultural Histories of Noise, Sound and Listening in Europe, 1300–1918*. Abingdon: Routledge. pp. 152–166.

Rembis, Michael, Kudlick, Catherine and Nielsen, Kim E. (2018) "Introduction," in Michael Rembis, Catherine Kudlick, and Kim E. Nielsen (eds) *The Oxford Handbook of Disability History*. United States: Oxford Handbooks. pp. 1–18.

Ruggles, D. Fairchild and Silverman, Helaine (2009) "From Tangible to Intangible Heritage," in D. Fairchild Ruggles and Helaine Silverman (eds) *Intangible Heritage Embodied*. New York: Springer. pp. 1–14.

Said, Edward W. (1979). *Orientalism*. New York: Vintage Books.

Schafer, R. Murray (1994), *The Soundscape: Our Sonic Environment and the Tuning of the World*. Rochester: Destiny.

Simon Fraser University, *World Soundscape Project*, https://www.sfu.ca/sonic-studio/worldsoundscaperoject.html [last accessed 6th October 2024].

Sinamai, Ashton (2022) "Ivhu rinotsamwa: Landscape Memory and Cultural Land-scapes in Zimbabwe and Tropical Africa," *ETropic: Electronic Journal of Studies in the Tropics*, 21:1, 51–69, DOI: 10.25120/etropic.21.1.2022.3836.

Small, Ernest (2011) "The New Noah's Ark: Beautiful and Useful Species Only. Part 1. Biodiversity Conservation Issues and Priorities," *Biodiversity*, 12:4, 232–247, DOI: 10.1080/14888386.2011.642663.

Smeets, Rieks (2006) "The Intangible Heritage Convention," *The Intangible Heritage Messenger*, 1, February 2006, https://unesdoc.unesco.org/ark:/48223/pf0000144569/PDF/144569eng.pdf.multi [Last accessed 15th April 2023]

Smith, Laurajane and Akagawa, Natsuko (2009) "Introduction," in Laurajane Smith and Natsuko Akagawa (eds) *Intangible Heritage*. London: Routledge. pp. 1–9.

Suárez, Rafael, Alonso, Alicia and Sendra, Juan J. (2015), "Intangible Cultural Herit-age: The Sound of the Romanesque Cathedral of Santiago de Compostela," *Journal of Cultural Heritage*, 16:2, 239–243, DOI: 10.1016/j.culher.2014.05.008.

Suárez, Rafael, Alonso, Alicia and Sendra, Juan J. (2016), "Archaeoacoustics of Intangible Cultural Heritage: The Sound of the Maior Ecclesia of Cluny," *Journal of Cultural Heritage*, 19, 567–572, DOI: 10.1016/j.culher.2015.12.003.

UNESCO (1990), "The Recommendation on the Safeguarding of Traditional Culture and Folklore," *Records of the General Conference, Twenty-Fifth Session*, Paris, 17 October to 16 November 1989, Vol. 1, Resolutions, https://unesdoc.unesco.org/ark:/48223/pf0000084696/PDF/084696engb.pdf.multi.page=242 [Last accessed 20th March 2024].

UNESCO (1994) *Convention Concerning the Protection of the World Cultural and Natural Heritage, World Heritage Committee, Eighteenth session*, Phuket, Thai-land, 12–17 November 1994, *Expert Meeting on the "Global Strategy" and the-matic studies for a representative World Heritage List*, UNESCO Headquarters, 20–22 June 1994, https://whc.unesco.org/archive/global94.htm [Last accessed 20th March 2024].

UNESCO (2001a) Executive Board, Hundred and sixty-first session, *Report on the Preliminary Study of the Advisability of Regulating Internationally, through a New Standard-Setting Instrument, the Protection of Traditional Culture and Folk-lore*, https://unesdoc.unesco.org/ark:/48223/pf0000122585/PDF/122585eng.pdf.multi [Last accessed 15th April 2023].

UNESCO (2001b) *UNESCO Universal Declaration on Cultural Diversity*, https://en.unesco.org/about-us/legal-affairs/unesco-universal-declaration-cultural-diversity [Last accessed 15th April 2023].

UNESCO (2003, 2008) *Carnival of Binche*, https://ich.unesco.org/en/RL/carnival-of-binche-00033 [Last accessed 8th August 2023].

UNESCO (2003) *Quebrada de Humahuaca*, https://whc.unesco.org/en/list/1116 [Last accessed 14th April 2023].

UNESCO (2005, 2008) *Oxherding and Oxcart Traditions in Costa Rica*, https://ich.unesco.org/en/RL/oxherding-and-oxcart-traditions-in-costa-rica-00103 [Last accessed 8th May 2023].

UNESCO (2008) *Operational Guidelines for the Implementation of the World Heritage Convention, Annex 3*, https://whc.unesco.org/archive/opguide08-en.pdf#annex3 [Last accessed 20th March 2024].

UNESCO (2009a) *Holy Week processions in Popayán*, https://ich.unesco.org/en/RL/holy-week-processions-in-popayn-00259 [Last accessed 8th May 2023].

UNESCO (2009b) *Whistled Language of the Island of La Gomera (Canary Islands), the Silbo Gomero*, https://ich.unesco.org/en/RL/whistled-language-of-the-island-of-la-gomera-canary-islands-the-silbo-gomero-00172 [Last accessed 7th May 2023].

UNESCO (2012) *Fiesta of the Patios in Cordova*, https://ich.unesco.org/en/RL/fiesta-of-the-patios-in-cordova-00846 [Last accessed 8th May 2023].

UNESCO (2014) *Male-Child Cleansing Ceremony of the Lango of Central Northern Uganda*, https://ich.unesco.org/en/USL/male-child-cleansing-ceremony-of-the-lango-of-central-northern-uganda-00982 [Last accessed 6th August 2023].

UNESCO (2016) *Culture of Jeju Haenyeo (Women Divers)*, https://ich.unesco.org/en/RL/culture-of-jeju-haenyeo-women-divers-01068 [Last accessed 7th May 2023].

UNESCO (2019a), *Buklog, Thanksgiving Ritual System of the Subanen*, https://ich.unesco.org/en/USL/buklog-thanksgiving-ritual-system-of-the-subanen-01495 [Last accessed 21st May 2023].

UNESCO (2019b) *Holy Week Processions in Mendrisio*, https://ich.unesco.org/en/RL/holy-week-processions-in-mendrisio-01460 [Last accessed 8th May 2023].

UNESCO (2022a) *Alheda'a, Oral Traditions of Calling Camel Flocks*, https://ich.unesco.org/en/RL/alheda-a-oral-traditions-of-calling-camel-flocks-01717 [Last accessed 7th May 2023]

UNESCO (2022b) *Basic Texts of the 2003 Convention for the Safeguarding of the Intangible Cultural Heritage*, 2022 Edition. France, https://ich.unesco.org/doc/src/2003_Convention_Basic_Texts-_2022_version-EN_.pdf [Last accessed 19th March 2024].

UNESCO (2022c) *Manual Bell Ringing*, https://ich.unesco.org/en/RL/manual-bell-ringing-01873 [Last accessed 7th May 2023].

UNESCO (2022d) *Holy Week in Guatemala*, https://ich.unesco.org/en/RL/holy-week-in-guatemala-01854 [Last accessed 21st May 2023].

UNESCO (n.d.a) *Browse the Lists of Intangible Cultural Heritage and the Register of Good Safeguarding Practices*, https://ich.unesco.org/en/lists [Last accessed 5th October 2024]

UNESCO (n.d.b) *Convention for the Safeguarding of the Intangible Cultural Heritage*, https://www.unesco.org/en/legal-affairs/convention-safeguarding-intangible-cultural-heritage#item-2 [Last accessed 14th April 2023].

UNESCO (n.d.c) *Cultural Landscapes*, https://whc.unesco.org/en/culturallandscape/ [Last accessed 14th April 2023].

UNESCO (n.d.d) *Living Human Treasures: a Former Programme of UNESCO*, https://ich.unesco.org/en/living-human-treasures [Last accessed 14th April 2023].

UNESCO (n.d.e) *List of the 90 Masterpieces of the Oral and Intangible Heritage of Humanity*, https://ich.unesco.org/doc/src/00264-EN.pdf [Last accessed 8th May 2023].

UNESCO (n.d.f) *Proclamation of the Masterpieces of the Oral and Intangible Heritage of Humanity* (2001–2005), https://ich.unesco.org/en/proclamation-of-masterpieces-00103 [Last accessed 14th April 2023].

UNESCO (n.d.g) *World Heritage List*, https://whc.unesco.org/en/list [Last accessed 16th April 2023].

van Tonder, Cobi, (2020) *Acoustic Atlas*, https://www.acousticatlas.de/ [Last accessed 19th March 2024].

Waldock, Jacqueline (2011) "Soundmapping: Critiques and reflections on This New Publicly Engaging Medium," *Journal of Sonic Studies*, https://www.researchcatalogue.net/view/214583/214584/0/2094.

Westerkamp, Hildegard (2001) Soundwalking, https://www.hildegardwesterkamp.ca/writings/?post_id=13&title=soundwalking [Last accessed 22nd April 2024].

Yelmi, Pinar (2016) "Protecting Contemporary Cultural Soundscapes as Intangible Cultural Heritage: Sounds of Istanbul," *International Journal of Heritage Studies*, 22:4, 302–311, DOI: 10.1080/13527258.2016.1138237.

4

THE INTANGIBLE IN THE TANGIBLE

Introduction

Although the UNESCO Intangible Cultural Heritage (ICH) Convention and its Lists are often invoked when discussing acoustical heritage as well as soundscapes research, it is also informative to consider the 1972 World Heritage Convention. Under its criteria for "Outstanding Universal Value", the World Heritage Convention has allowed for the listing of sites due to their associated intangible heritage, with *criterion vi* being the most closely connected to intangible matters (Beazley and Deacon 2007). In this regard, the 1977 Operational Guidelines explicitly recognised sites "most importantly associated with ideas or beliefs, with events or with persons, of outstanding historical importance or significance" (UNESCO 1977: 3). Nevertheless, a failed nomination of the *Edison National Historic Site* prompted UNESCO to reconsider the wording of *criterion vi*, owing to concerns about the potential for a large number of nominations being put forward (Beazley and Deacon 2007; UNESCO 1979a: 3). At the time of the failed Edison nomination, UNESCO stated that it was best to avoid being overrun by nominations based solely on their association with people of note and that the focus should instead be on the sites themselves rather than individuals associated with them (UNESCO 1979a: 22). Therefore, in 1980 the wording of *criterion vi* was changed to sites "directly or tangibly associated with events or with ideas or beliefs of outstanding universal significance" (UNESCO 1980: 5). An additional line was also added stating "the Committee considered that this criterion should justify the inclusion in the List only in exceptional circumstances or in conjunction with other criteria" (UNESCO 1980: 5). In 1994 a further adjustment to *criterion vi* retained this caveat, but edited the main

DOI: 10.4324/b22976-4

clause for nominations to "be directly or tangibly associated with events or living traditions, with ideas, or with beliefs, with artistic and literary works of outstanding universal significance" (UNESCO 1994: 10). In 2005, the Operational Guidelines reduced the strength of the caveat for *criterion vi*, stating that "The Committee considers that this criterion should preferably be used in conjunction with other criteria" (UNESCO 2005b: 20).

Beazley and Deacon (2007) analyse some of the challenges raised by *criterion vi* and discuss the addition of *Auschwitz Birkenau. German Nazi Concentration and Extermination Camp (1940–1945)* to the World Heritage List (WHL) in 1979, with the main challenge being that the site was attached to horrific events, whereas the typical association of World Heritage Sites was with positive experiences and values. Such sites are thus referred to as *sites of conscience and memory* and can be described as spaces in which violations of human rights and other abuses have taken place (Cameron 2010). There are few such entries in the WHL, which is possibly a reflection of nominating states viewing the List as an opportunity to celebrate achievements, rather than focus on commemoration (Cameron 2010: 117). Such attitudes prevail despite the recognition of sites of conscience as providing an opportunity for dialogue on a traumatic past and a brighter, more peaceful future (Cameron 2010: 117–118). I will return to aspects of "negative" cultural heritage in Chapter 5, when looking into sound installations that reflect on horrific events and the ethical challenges these experiences present. More importantly, I will discuss what seems to have been a reluctance in the field of acoustical heritage and historical soundscapes to explore the sonic elements of horrific experiences through recreations, resulting in sanitised accounts and recreations that pose further ethical challenges.

Another reason for paying attention to the World Heritage Convention is its category of "Cultural Landscapes", which, though not specified explicitly, does encompass relevant sonic elements. With these considerations in mind, I searched the WHL across natural, cultural, and mixed sites, using the keywords *sound/s*, *acoustic/s*, *silence/silent*, *quiet*, *loud*, *tranquil*, and *noise*, to explore in what contexts sonic elements were mentioned and what this might reveal subsequently about different perspectives on the role of sound in heritage. In addition to this, I employed the same search terms to investigate entries on Tentative Lists, which feature the sites that State Parties are considering for nomination. Across the WHL,[1] sonic references were found in 5% of the entries for natural sites (ten out of 218 sites), 4% (33 out of 897) of cultural sites, and 8% of mixed sites (natural and cultural), that is, three out of 39 sites. In the Tentative Lists 1% of the entries had any sonic references (11 out of 1,713 sites, two were natural, nine were cultural, and none was mixed). The small percentages indicated here suggest that the vast majority of entries did not consider sound to be a notable aspect of the sites they were seeking to protect, indicating the greater overall importance awarded to

other sensorial experiences. This chapter will explore these few existing sonic references,[2] reflecting on what the choices made by nominating State Parties might indicate about the value assigned to sound heritage.

Following this analysis, I will use the WHL as an entry point for discussing the politics of sound and noise, the role of social class, race, and ethnicity in the construction of imagined heritage experiences, and the influence of digital technology. I will also reflect on the prevailing Western-centric perspectives that have significantly limited the study of acoustical and soundscapes heritage, continuing on from the discussion concerning the lack of diversity in the field which commenced in Chapter 3.

Sounds of Nature

Sound as intrinsic to the natural environment and as something to be treasured is found in only a few entries for the varied natural sites included within the WHL. Out of the ten sites listed that include sonic references, only four actually refer to the sounds of nature directly, both in terms of geography and wildlife, while the rest are focused on noise control – albeit without necessarily expressing what the site is left with once the noise is suitably controlled, other than equating quietness with desirability. In most instances, it is compliance that drives the sonic references, rather than a holistic reflection on the multisensoriality of heritage sites. The sites included below are the only ones in which references to the sounds of nature were found, although with varying levels of prominence. This does not mean that no references to noise control were included, but that they demonstrate an interest in sound beyond exercising control over it.

The entry for the *Ilulissat Icefjord* in Greenland gives sound importance on a par with the visual spectacle: "The combination of a huge ice-sheet and the dramatic sounds of a fast-moving glacial ice-stream calving into a fjord covered by icebergs makes for a dramatic and awe-inspiring natural phenomenon".[3] The *Morne Trois Pitons National Park* in Dominica also brings sound to the forefront. The site includes five live volcanic centres, and the List entry includes references to a "Boiling Lake", a hot water spring at about 95°C, which is characterised as one that "constantly bubbles and churns, with steam emitting an almost surreal sound".[4]

Among the listed sites focusing on wildlife sounds is the *French Austral Lands and Seas*, which is marked as one of the last areas of true wilderness in existence, as well as being a home to the world's largest populations of king penguins and yellow-nosed albatrosses. Sound is mentioned here, albeit in passing, as being intrinsic to the site: "They feature a unique concentration of marine birds and mammals in the sub-Antarctic region, with enormous colonies where an abundance of species, sounds, colours and scents blend harmoniously".[5]

The *Monarch Butterfly Biosphere Reserve* in Mexico, a pine and fir forest, is an overwintering site for the monarch butterfly, with potentially up to a billion butterflies travelling annually over 4,500 km from North America and then clustering in small areas between November and March. The entry describes the sounds made by the butterflies, and while this is not central to the case being made, it is still featured as part of the phenomenon of insect migration. The entry reads

> The millions of monarch butterflies that return to the property every year bend tree branches by their weight, fill the sky when they take flight, and make a sound like light rain with the beating of their wings. Witnessing this unique phenomenon is an exceptional experience of nature.[6]

The WHL entry for *St. Kilda*, the uninhabited volcanic archipelago off the coast of the Scottish Hebrides, observes its status as a site with mixed natural and cultural heritage. It has some of the highest cliffs in Europe and is subsequently home to large colonies of rare and endangered bird species. Sound is by no means at the centre of this entry, but as seen in the others, there is a brief mention of sounds as forming part of the experience of the site, specifically its natural aspects: "The sight and sound of these myriad seabirds adds significantly to the scenic value and to the experience of the archipelago during the breeding season".[7]

The inclusion of the sounds of nature in WHL entries is not restricted to natural sites, it can also be observed in cultural sites. For example, the *West Lake Cultural Landscape of Hangzhou* (China),[8] a site which includes the West Lake and the hills surrounding it along three sides, as well as its temples, pagodas, pavilions, gardens, ornamental trees, causeways, and artificial islands, has exerted an influence on garden design in China and beyond. The entry text describes how, since the thirteenth century, "ten poetically named scenic places" within the site have been identified that are considered excellent examples of the fusion between people and nature. Two of these have sound at their centre: A6 "Orioles Singing in the Willows", and A10 "Evening Bell Ringing at Nanping Hill", which will be discussed specifically later in this chapter. The text of A6 depicts the sound of the orioles singing in the willows as a feature for appreciation and a demonstration of nature's vitality.

Aasivissuit – Nipisat. Inuit Hunting Ground between Ice and Sea, is a WHL cultural landscape entry in West Greenland, featuring remains representing 4,200 years of history, with archaeological sites connected with both Paleo-Inuit and Inuit cultures, including evidence of ancient caribou hunting.[9] The site entry includes a mention of sound as a cause for failed hunting enterprises and how those sounds connect to the weather. Specifically,

it relates a hunting story by Rasmus Müller, from a trip taken in 1898 with Sarfannguit hunters as guides. The entry states:

> Müller and company had presumably hoped for a nice, crisp Indian sum-mer, but unfortunately they experienced a great deal of rain, slush and snow, which had a considerable adverse effect on both their enjoyment and their hunting fortunes. At night, an ice crust formed on the newly fallen snow. Ice crust cracks and make [sic] a noise when sneaking up on game animals and thereby reduced their hunting fortunes.[10]

Namhansanseong (Republic of Korea), inscribed in 2014, was an emer-gency capital for the Joseon dynasty (1392–1910), built and defended by Buddhist monk-soldiers, whose earliest remains date from the seventh cen-tury, although it was rebuilt several times thereafter.[11] Sound is mentioned in relation to the "Mt. Cheongryangsan Fortress Trail Program", a series of planned activities for visitors, and more specifically as part of the "Natural ecological experience". The entry describes the activity as: "Development and operation of experience programs of natural resort forests based on a colony of pine trees rich in natural scent, pine scent, the howl of wind and sound of singing birds".[12]

One entry of particular interest is that of *Kulangsu, a Historic International Settlement* (China), an island that became an international settlement in 1903 and which presents a fusion of Chinese, South East Asian, and European architectural styles, representing the consequent place of origin for the Amoy Decoy Style of architecture.[13] Sound is not mentioned in this entry, beyond the need for monitoring the noise generated by tourism, but it nonethe-less appears connected to the name of the site itself. Specifically, the name Kulangsu is believed to be linked to the sense of hearing, as it was said that a rock with a hole in it, located along the southwest coast of the island, pro-duced a drum-like sound every time the waves hit against it. As a result, the rock was named "Kulang Stone", "drum wave stone" and the island became named Kulangsu.[14] There are other competing, non-auditory theories for the name of the island, including that when viewed from above the waves hitting the rocks resemble the beating of drums.

Also deriving its name from aural properties rooted in nature is *Xinjiang Yardang* (China), an entry submitted to the Tentative Lists in 2015.[15] The entry refers to sound, very briefly, in relation to Yardangs in Urhe, stating: "Strong winds blow through and across the Yardangs in Urhe throughout the year, making a sound like the wail of a ghost. Thus, Urhe is given the name of ghost city". Similarly, *The Djavolja Varos (Devil's Town) Natural Landmark*, submitted by Serbia in 2002 and in the Tentative Lists, refers to a site along the southern slopes of Mt. Radan which is characterised by stone pyramids, 2–15 m in height, formed as a result of water erosion.[16] The

entry explains that "the wind which hums between the pyramids crestes [sic] strange murmurs, howling, sighs, squeaking, which has frightened the local population for centuries and is behind their superstitious lore".

A final entry in the Tentative Lists (cultural) that features a name linked to sound (or, rather, a lack thereof), is *Mdina (Citta' Vecchia)*, submitted by Malta in 1998. Mdina is a fortified city on a hill-top, first established in the Bronze Age, and once formed the political and administrative capital of the Maltese Islands for two millennia until 1530.[17] Between the seventh and the twelfth centuries it was occupied variously by the Byzantines, Arabs, and Normans, who all left their mark on the layout of the city. The entry mentions that Mdina is also referred to as the *Silent City* "since it inspires tranquillity at any time of the day or night", but gives no further information on its sonic characteristics or the reasons for this apparent tranquillity.

Sound or the Lack of Noise: A Search for Quiet and Tranquillity

Across the various WHL entries (natural, cultural, and mixed) which include sound references, the majority are about noise control, many times linked to legal compliance, but with very little detail as to what the noise control measures are protecting, and what kind of sonic experience the nominating State Parties believe visitors should be having. Such entries, and their predominance, seem to indicate that it is the actual noise removal that is valued and not sound heritage, with a higher value being assigned to silence, quietness, and tranquillity, above any other sonic experiences.

The Grand Canyon in Arizona (USA), a 1.5 km deep gorge with width ranging from 500 m to 30 km, is one such site whose entry text focuses on silence and the impact of extraneous noise: "Natural quiet, an important component of the visitor experience, is impacted by aircraft overflights and other human caused sounds in some parts of the property". Here sound is reflected on in terms of an a priori quiet that needs protecting from sound pollution, an issue that is highlighted in the 2014 periodic report on the site concerning the impact of aircraft noise.[18]

Keoladeo National Park in Rajasthan state, India,[19] is a major wintering area for aquatic birds, and the entry text leaves aside any mention of sound beyond a focus on noise management, pointing out that birdwatchers visiting the site are taken by trained local guides on bicycle rickshaws, reducing noise pollution. The entry also emphasises that the noise pollution from neighbouring sites such as Bharatpur city and the National Highway is minimal.

Purnululu National Park in Western Australia contains the Bungle Bungle Range, which features beehive-shaped karst sandstone rising 250 m above the ground and with black and orange banded appearance. Noise control is specifically mentioned in relation to aerial tours, with licensees having specific flight paths and operation times they need to follow.[20]

The entry for *Wulingyuan Scenic and Historic Interest Area*, a site in China's Hunan province featuring over 3,000 narrow quartz sandstone pillars and peaks, briefly mentions noise control monitoring, together with the management of other factors such as water and air quality, in order to comply with international and national laws and regulations.[21]

Fanjingshan is within the Wuling mountain range in southwest China, an area of high biodiversity that is home to endangered plant and animal species.[22] Despite this ecological richness, sound is not highlighted in the entry text, but it is once more the control of noise that is at the forefront, primarily in relation to noise from tourists and the importance of avoiding animals being disturbed. Similarly, there is a cursory reference to sound in relation to noise for the entry *Migratory Bird Sanctuaries along the Coast of Yellow Sea-Bohai Gulf of China*, the largest intertidal mudflat system in the world, and a gathering for numerous migratory bird species. Mention is thus made in relation to pollution and being vigilant of visitor noise.[23]

Kujataa Greenland: Norse and Inuit Farming at the Edge of the Ice Cap is a cultural landscape that features the earliest introduction to farming in the Arctic and represents the farming and grazing traditions of the Norse Greenlandic people (tenth to fifteenth centuries) and modern Inuit farmers (eighteenth century to the present). As with the above entries, sound is only discussed in relation to noise and the need for management initiatives to protect the area from acoustic threats, including noise pollution.[24]

Upper Middle Rhine Valley, a cultural landscape that stretches over 65 km and includes over 40 hill-top castles and fortresses (most of them now in ruins), as well as historic towns and vineyards,[25] only references noise control, in particular the noise pollution being generated by the railway that runs along the valley.

Archaeological Site of Olympia in Greece, a site which in tenth century BC became the centre for the worship of Zeus and that contains the remains of temples as well as sport structures used for the Olympic Games,[26] also only refers to noise, specifically the traffic restrictions in place since 2008 which have helped reduce interference, vibrations, and pollution of the site.

Historic Centre of San Gimignano in Tuscany, Italy, was a relay point for pilgrims travelling to or from Rome in the Middle Ages.[27] It features 14 surviving towers out of the 72 built by the nobility and various wealthy merchants between the eleventh and thirteenth centuries as demonstrations of wealth and power. This entry does not refer to sound at all besides a fleeting reference to noise being controlled together with other factors that might affect the site.

Quseir Amra (Jordan),[28] an eighth century fortress with garrison and a residence of the Umayyad caliphs, only references the noise from a nearby highway, noting this stands in opposition to the site's former status as a haven for wildlife visits.

Historic City of Vigan (Philippines), a planned Spanish colonial town dating from the sixteenth century and with features representing the coming together of cultural elements from the Philippines, China, Europe, and Mexico,[29] also only mentions noise, and the need to control it – more specifically issues of noise from motorised passenger tricycles, which not only produce noise pollution but also smoke emissions and vibrations.

The entry for *Royal Domain of Drottningholm* (Sweden), which is located in the island of Lovön, near Stockholm, includes a generic caution around the noise issues generated by traffic infrastructure developments.[30] A similarly generic observation is found in *Historic Quarter of the City of Colonia del Sacramento* (Uruguay). Founded by the Portuguese in 1680 and the site of several battles over control between the Spanish and Portuguese, resulting in a blend of Portuguese, Spanish, and post-colonial styles.[31] The entry's sonic references are confined only to an explanation of the remit of municipal decrees to manage several matters such as acceptable noise levels.

The focus on noise protection is also the sole sonic reference in *Complex of Hué Monuments* (Viet Nam), inscribed in 1993.[32] Hué was established in 1802 as the capital of unified Viet Nam and was the political, cultural, and religious centre under the Nguyen dynasty until 1945. Similarly, *Citadel of the Ho Dynasty* (Viet Nam), the fourteenth century citadel which was constructed following *feng shui* principles, does not acknowledge sound itself in terms of its heritage value, but once more refers to noise control and regulations both in the heritage area and buffer zone.[33]

This overarching focus on compliance is also the case in the mixed (natural and cultural) site *Mount Wuyi*, in China's Fujian province, which features the Nine-Bend River along which are temples and monasteries, many of them now in ruins, which were key to the development and spread of Neo-Confucianism. The area is also key for biodiversity conservation. Compliance is the key emphasis within a very brief description of the rafting services provided to visitors, clarifying that there are no identified issues in connection to noise, congestion, or water and air pollution.[34]

The *Historic Centre of Macao*, a Chinese port that served as a Portuguese settlement from the mid-sixteenth century up to 1999, and which features a combination of Western and Eastern architectural features, shows no interest in sounds native to this area, but focuses on noise control, namely in relation to traffic as well as the need for preventing projects within the protected area unless there is clear evidence of no air or noise pollution.[35] This is similar to the entry for *The Grand Canal* in China, a waterway whose construction started in the fifth century, and which runs from north to south and has been a main means of communication since the seventh century.[36] Reference is made here to an acoustic environment conservation plan, within which there is a discussion on prevention and control of noise pollution.

The entry for *Mount Wutai*, a sacred Buddhist mountain in China and home to a number of temples built from the first century AD up to the early twentieth century, emphasises noise control in terms of the frequency of its monitoring, as well as the prohibition of sound amplification that could drive noise pollution. Like many of the entries above, it also draws attention to issues of traffic noise and a specific ban on noise polluting factories. It also states that visitors are informed not to make any noise in the temples.[37]

The *Trang An Landscape Complex* in Vietnam, a landscape of limestone karst peaks featuring evidence of human activity going back over 30,000 years, is more nuanced in its described sonic approach.[38] It is the quiet and tranquillity that are valued most of all: "The blend of towering mountains draped in natural rain forest, with large internal basins and narrow cave passages containing quietly flowing waters, creates an extraordinarily beautiful and tranquil landscape". The nomination text also highlights quiet as a key part of the aesthetic values of the site: "Much of Trang An is, in essence, a natural wilderness largely unaffected by adverse human presence or impact. The waters are often crystal clear, the air is clean and the countryside is everywhere silent, save for the sounds of nature"[39]. The need to protect the site from extraneous noise thus features in the nomination text, which notes that areas adjacent to the site are quarried for limestone, carrying a risk of noise pollution.

In the entry for the *Cultural Landscape of Sintra* (Portugal), which in the nineteenth century was a centre for European Romantic architecture and includes a variety of sites, there is an allusion to sound in relation to The Trinity Convent of the Arrabalde, founded by monks in 1374 "in a quiet valley of the Serra" and turned into a monastery in 1400, and then reconstructed after the 1755 earthquake. In referring to its current state the entry reads: "The present small cloister dates from 1570 and the church largely from the late 18th century. It has retained the tranquillity that attracted the first monastic community to this site".[40]

It is also quiet that is featured in the only sound related comment in the entry *Ancient Villages in Southern Anhui – Xidi and Hongcun*, two Chinese villages which maintain features related to the layout, landscape, architecture, decoration, and construction techniques developed in the period between the fourteenth and twentieth centuries. The nomination file reads: "They [the ancient villages of Anhui] are usually located at the base of a mountain, alongside rivers or lakes, they have regular spatial layouts of quiet, narrow alleys, and picturesque gardens at the mouths of the rivers".[41]

Equating silence with solemnity is found in the entry for *Imperial Tombs of the Ming and Qing Dynasties*.[42] The tombs themselves feature decorations of stone statues and carvings as well as decorated tiling, following the principles of *feng shui*. Noise is mentioned in terms of standards and regulations and the need for control, with the only positive mention of sound being

The Intangible in the Tangible **101**

made in relation to silence: "The stone sculptures along the Sacred Avenue of the Xiaoling Tomb of the Ming Dynasty and the subordinate tombs stand in solemn silence and are extremely lifelike"[43]. It is likely that it is just this sort of silence that the site is eager to protect from extraneous noise. This need for quiet is also highlighted in a section of the nomination file relating to design plans:

> an earth mound with a peak of about 2.4 meter will be made in the south side of the square to restore the historical layout, as well as to prevent the vehicles on the roads to affect the historical appearances. Meanwhile, it will also protect the mausoleum area from…traffic noise from Dongling Road, create a relatively quiet and secluded area in front of the mausoleum and enhance the historical atmosphere of the imperial mausoleum.[44]

A Tentative List (cultural) entry, *Lalish Temple*, submitted by Iraq in 2020,[45] the main temple of the Yazidi religion and a site of pilgrimage, connects silence to spirituality, characterising it as a place of "silence and calm, fresh air, greenery, trees and domes above the heights that extend on both sides of the holy valley…" Further sonic references to spirituality in the WHLs will be explored later in this chapter.

One exception to the focus on quiet, without further specificity, is the entry for *The Persian Garden* by Iran, which features sound as being central to aesthetic considerations. The entry refers to nine gardens across nine regional provinces of Iran that symbolise Eden and the four Zoroastrian elements (sky, earth, water, and plants), and which all feature a combination of natural and built components. The entry summary refers to "sound effects" generically, with the nomination file offering description of water sounds, stating that "Iranians use the sound of running water for making the ambience calm and refreshing"[46] as well as mentioning how the course of the water is changed to make sure its sound can affect all parts of the garden. The nomination file also alludes, briefly, to the specific choice of tiles in the watercourses being connected to their impact on the sound of the water.[47] Overall, while tranquillity and the role of sound in perpetuating it are still central to this entry, there is considerably greater specificity as to how sound contributes to this experience, as opposed to the typical focus on the removal of extraneous noise.

Another inscription that describes the importance of quiet in a more detailed and contextually specific way is *Christiansfeld, a Moravian Church Settlement*.[48] Founded in 1773 in South Jutland (Denmark), it is the most complete and best-preserved example of a European Morovian Church settlement, with homogenous architecture organised around a central church square. The importance of silence – which, in this case, is also emphasised

by a specific opposition to loudness – is mentioned in relation to the Easter morning service

> A half hour before sunrise, the congregation meets in church for the Easter Morning liturgy. The church hall is silent: no bell ringing, no prelude on the organ. The reverend enters and walks quickly to the liturgical table while loudly announcing that "The Lord is resurrected." The congregation answers, "Yes, he is truly resurrected."[49]

Another description of the importance of quiet is in relation to the customs of the choir houses, which were the different houses assigned to different sections of the congregation. "Choirs" were organised in relation to age, gender, and marital status, and had an elder in charge. The nomination file refers to how house elders would make sure that loud conversation and unnecessary noise was avoided.[50] Additionally, although noise, as in other entries, is generally expressed in relation to modern control measures, there is one reference to noise that sets this entry apart from others, as it specifically refers to historic noise control measures as part of the heritage of the site. The nomination file discusses a house/workshop for tile stove production, which was built sometime between 1777 and 1786, and whose position was carefully planned by the community

> The positioning of the tile stove factory was also carefully planned. Because there is a prevailing west wind in Denmark, all industry was situated east of the centre (church square), so that smoke, steam and noise did not cause a nuisance.[51]

All these different WHL entries exhibit a tendency to treat sound in terms of a noise – quiet binary. There is one listed heritage site, however, that demonstrates this opposition and its tensions to a far greater and more striking extent: Stonehenge – a site in which the politics of noise, and the perspectives, needs, and assumptions of different groups, can be seen to operate in relation to a number of suggested alterations to the site throughout the years. Such is the complexity and often fraught nature of the debates generated, that it is worth discussing this entry as a stand-alone, central case study, establishing key points of consideration for the rest of this chapter.

Politics of Noise: Stonehenge

Stonehenge, Avebury and Associated Sites (UK), inscribed in 1986, includes two of the most significant prehistoric stone circles in the world, Stonehenge being the most sophisticated architecturally, and Avebury being the largest.[52] Although attracting a fair amount of academic interest in relation to

its acoustic characteristics (e.g. Cox 2021; Cox, Fazenda and Greaney 2020; Fazenda and Drumm 2013; Till 2019), the entry does not feature any reference to sound or acoustics. There is a reference to noise, however, as part of the negative impact of road infrastructure on the site's integrity.

It is this road infrastructure that has been central to discussions on the conservation of Stonehenge for over a decade. Berkaak (2019) provides an insightful analysis on "The Stonehenge Environment Improvement Project", which was completed in 2013 and led jointly by English Heritage (a charity in charge of over 400 buildings, monuments, and sites across England) and the National Trust (a conservation charity whose remit includes coastlines, historic sites, the countryside, and other green spaces in England, Wales, and Northern Ireland). The project had three main aims: the closure of the A344 to traffic and the return of that area to grass; the removal of then-existing car parks and buildings and returning the area to grass; and the creation of a new visitor centre with opportunities for education and interpretation, together with a car and coach park, away from the main site, but with access to the stone circle being made available via shuttle or on foot, and so allowing for an appreciation of the surrounding landscape.[53] Berkaak discusses the focus that the heritage organisations put on returning the site to a "tranquil" state as a way of restoring "the dignity of the stones" (2019: 313). Berkaak argues that at the centre of this attempt is an imaginary and constructed notion of tranquillity linked to the English middle class and transmitted through the mediums of poetry, painting, outdoor culture, archaeology, and the school curriculum, and which dates back to the late eighteenth century as a response to industrialisation (2019: 314). These "sonic imaginations of tranquility and noise" argues Berkaak (2019: 314), when disseminated by heritage organisations, help to crystallise them as being the "right" ways of engaging with a site, and with those notions defining what is noise and what is not. Heritage management therefore promotes certain sensorial experiences (quiet, tranquillity) as being positive, whereas others (noise) are framed as negative, with these hierarchical values being imposed further through frameworks and legislation, defining which sensorial practices are deemed suitable or unsuitable for certain sites (Berkaak 2019: 316). In the case of Stonehenge, different "acoustic constructions of the past...and ways of imagining value and dignity" (Berkaak 2019: 318) are brought to the fore by the ongoing tensions between the specific conceptions and prerogatives of heritage management versus those held by spiritual groups that wish to actively use the site, particularly during solstices and equinoxes (Berkaak 2019: 315).

In more recent times, controversies have arisen once more in relation to proposed changes to the site, specifically due to UK Government plans to work with the National Highways agency and turn the single carriageway that goes past Stonehenge into a dual carriageway, with part of this running under a 3.2 km tunnel, 200 m away from the stone circle, with the express

aim of reducing congestion and journey times.[54] National Highways has also developed plans to turn the old road into a path for cyclists, horse riders and walkers, which they characterise as a step towards "restoring Stonehenge to something like its original setting"[55] – I would assume they do not mean Neolithic cyclists, though!

Different groups have demonstrated differing levels of support or condemnation of these plans, and the discussions have once more – in part – included the rhetoric concerning noise in relation to the World Heritage Site. The plans have been in motion since 2014, and have the support of English Heritage, the National Trust, and Historic England (a public body which works on heritage identification and conservation). The English Heritage website for Stonehenge summarises the problem as

> Tens of thousands of vehicles *thunder* past Stonehenge on the A303 every day. The heavy traffic and *constant noise* from the road compromises our enjoyment and understanding of the monument and the road cuts the stones off from much of the surrounding ancient landscape and many prehistoric monuments.[56]

The quote above (italics are mine) presents a bleak scenario in which the connection of each individual and, maybe even humanity, to heritage, is compromised by traffic noise: the site cannot be enjoyed if traffic, both visually and sonically, exists, quiet is needed to fully experience the site. English Heritage believes the construction of the tunnel "would reunite the ancient landscape and allow people to better appreciate, enjoy and understand Stonehenge, without the experience being ruined by traffic".[57] They state that their vision is for it to be returned "to its intended landscape setting".[58]

Quiet, both sonic and beyond, is also crucial to the mission statement of the National Trust, founded in 1895, whose co-founder Octavia Hill noted that "We all want quiet. We all want beauty...We all need space. Unless we have it, we cannot reach that sense of quiet in which whispers of better things come to us gently".[59] Quiet as a measure for quality of life and experience, and even a right everyone has, a right to the quiet countryside. However, who "we" refers to is not delved into. Research by Neal (2002) reflects on the connection between race and rurality, by which rural spaces have been historically constructed as bastions of Englishness, or rather "white" Englishness, in opposition to multicultural urban spaces, and with ethnic minorities being denied a connection to the countryside. A 2021 report by CPRE, the countryside charity (formerly known as 'The Campaign to Protect Rural England'), has also acknowledged the impact of background and identity in accessing the countryside, an issue that is particularly salient in relation to race. Research has revealed that ethnic minorities feel they do not belong and are often fearful of visiting remote areas on their own or in small

groups due to previous experiences of racism (CPRE 2021). There have also been accounts from Muslim women who have shared their concerns on what to wear, sometimes basing their decisions on what might make white countryside visitors more at ease with their presence (CPRE 2021). When referring to Stonehenge and values of quiet and tranquillity being constructed, we need to ask ourselves who they are constructed for and where these constructions come from.

These associations between nature and quiet are also featured in an explanatory video by National Highways,[60] which discusses the potential of the plans to increase chalk grass habitat areas, as well as for the area above the tunnel to provide safe passage for wildlife – at which point the animated video exhibits a fox and a group of rabbits moving merrily around the area.

The supportive views by these organisations have been confronted by groups who have argued that the government plans will have a negative impact on the site, as well as costing £1.6bn.[61] On 12 November 2020 the Secretary of State for Transport confirmed that plans for the dual carriageway and tunnel would go ahead, but in July 2021 the plans had to be halted as a result of a judicial review sought after by the Stonehenge Alliance – a group who runs the Save Stonehenge World Heritage Site campaign and who challenged the plans in the High Court. The judicial review concluded that there was a lack of evidence presented on the impact of the plans on each individual asset at the site, along with the fact that alternative schemes had not been adequately considered.[62] However, in July 2023 the scheme was once again approved after further consultations had been carried out.[63] Campaigners have argued subsequently that, in addition to possible damage to the site, the plans would increase carbon emissions at a time in which fighting climate change should be at the forefront of government plans.[64] Moreover, archaeologists have argued that archaeological findings yet to be discovered would ultimately be lost if the roadworks go ahead. This point was given weight by the activities of the Stonehenge Hidden Landscape Project, which in June 2020 discovered around 20 giant Neolithic shafts forming a circle of over 2 km in diameter, 3 km northeast from Stonehenge.[65] Separately, archaeologist Mike Parker Pearson has described his "concern that the vibrations will actually impact on archaeological deposits, causing the ground to crack". Highways England have responded that the latest discoveries are outside the working area of construction, having already carried out geophysical surveys following Historic England standards, as well as using trial trenching and test pits.[66]

UNESCO has expressed concerns surrounding the plans, particularly in relation to the tunnel length being inadequate to protect the site's Outstanding Universal Value, and has suggested the complete or partial removal of the open dual carriageway, as they consider the proposed changes will profoundly affect the settings of the monuments and the relationships between

them, as well as the integrity of the site by affecting the spatial relationships between the monuments.[67] They have warned that if the plans are upheld the property might need to be inscribed in the List of World Heritage sites in Danger. The State Party has argued that the costs involved in lengthening the tunnel to respond to UNESCO's concerns outweigh the benefits. At the time of writing a new crowdfunding campaign has been launched by Stonehenge Alliance to request a judicial review of the July 2023 decision.[68]

Bells

Outside of the binary between noise and quiet, another recurring sonic element present in the few WHL entries referencing sound is bells, and their variety of functions. This topic has already been partially explored in Chapter 3 in relation to the ICH Convention entry on *Manual Bell Ringing*, but is worth further consideration here.[69]

The entry *Historic Monuments of Dengfeng in "The Centre of Heaven and Earth"* (China), which includes eight clusters of buildings over a 40 km² circle at the foot of Mount Songshang, describes an iron bell from the thirteenth century, part of the Shaolin Temple, whose sound is noted as being heard at a distance of 15 km.[70] There are other bells mentioned here, but this is the only one whose sound is described specifically.[71]

Already discussed briefly in this chapter is the entry *West Lake Cultural Landscape of Hangzhou* (China)[72] which, among its "ten poetically named scenic places", includes A10 "Evening Bell Ringing at Nanping Hill". A10 is described as "the echo of the bell sounds from the temple in the evening"[73] and "It is characterized by the aesthetic atmosphere fostered by [sic] sound of the bell from Jingci Temple on the north slope of the Nanping Hill, which can be heard all over the lake".[74] Later on in the nomination file, this sound is reflected on more insightfully and in connection to the acoustics of the site:

> The lingering sound of the evening bell resonates against the limestone hills that abound in caves and towering cliffs. The sound travels to the opposite shore and echoes when it meets Geling Hill of igneous stone, resulting in a long and resonant sound. Nowadays it is the very place that citizens of Hangzhou come to ring the bell on the Chinese New Year's Eve to welcome the new year.[75]

Furthermore, the importance of the bell and its sound is also connected to its meaning and its position as a heritage item that connects past to present:

> Although the famous bell was damaged and recast repeatedly along with the temple, the chime has maintained unbroken throughout the times. Recently, local citizens and tourists gather outside the bell tower in the

Temple on each eve of the Chinese New Year to peal the bell to ring out the old year and ring in the new, and the deep and extending sound of the bell is considered a symbol of auspice, happiness and stability.[76]

Melaka and George Town, Historic Cities of the Straits of Malacca (Malaysia), two historic colonial towns featuring the result of trading and cultural exchanges between East and West,[77] is an entry also featuring bells. The entry mentions Jalan Tukang Emas (Goldsmith Road), Jalan Tukang Besi (Blacksmith Road), and Jalan Tokong (Temple Street), as being at the heart of the old town of Melaka and being home to three different places of worship

> There is a high degree of sensory experience as a person walks along the street due to the smell of incense, fresh cut flowers and the sound of bells ringing and the call for prayers that comes out from the minaret.[78]

It is worth noting that whereas mentions of bells in these entries are positive and so is the consideration of bell sounds in Spain's ICH Convention entry *Manual Bell Ringing*, the latter entry refers to concerns that bell sounds might be classed as noise pollution – reinforcing once more the context-specific construction of the concept of "noise". Moreover, across the three WHL entries, the sound of bells is associated primarily with practices of spiritual worship. However, this is not the case with all bell-related mentions in the WHL. Notable here is the case of the Big Ben, an iconic bell whose use, as will be explored below, neatly exemplifies how sonic elements can form a key aspect of political debate.

The Big Ben: From the British Empire to Brexit

Palace of Westminster and Westminster Abbey including Saint Margaret's Church is also inscribed under cultural sites in the WHL. Westminster Palace, the seat of UK Parliament, was rebuilt after 1840 and is an expression of neo-Gothic architecture. Westminster Abbey has been a place of worship for over 1,000 years and has been the site for the crowning of sovereigns since the eleventh century. St Margaret's church is a medieval church built in the perpendicular Gothic style. These sites are immediately adjacent to the River Thames in London and the home of Big Ben, a 13.5-ton bell which strikes to the note of E every hour. The chimes of this bell, as a key part of the site, are reflected on strongly in the nomination text: "The iconic silhouette of the ensemble is an intrinsic part of its identity, which is recognised internationally with the sound of '"Big Ben"' being broadcast regularly around the world". When discussing authenticity, the entry reads: "The Palace of Westminster, the clock tower and "Big Ben's" distinctive sound have become internationally recognised symbols of Britain and democracy".[79]

The importance of Big Ben's chiming, as an instance of sound heritage, as well as its use as a national symbol of the UK, can be explored when considering those instances in which it lay silent. Major restoration work of the Elizabeth Tower (the actual home of Big Ben, which forms its main bell) took place between 2017 and 2022, during which the bell lay mostly silent to protect workers' hearing.[80] Big Ben was initially "silenced" after the noon chimes on 21st August 2017, an event which the public was encouraged to attend by gathering in Parliament Square.[81] The bell then returned to its usual sonic service on Remembrance Sunday on 13th November 2022.

That Big Ben is considered a symbol of British resilience is encompassed in the UK Parliament's announcement of the completion of the restoration work, which places Big Ben as key to Britain's past, present, and future:

> The bells of Big Ben have been ringing for over 160 years, despite the effects on the building of bombing during the Second World War, as well as weather and pollution.
>
> The clock tower was built by the Victorians to the highest possible standards, using the best craftspeople and the finest materials. But like other buildings of a similar age, the Elizabeth Tower suffered from problems that needed to be overcome. Now that the restoration is complete, the clock tower can continue to tell time for centuries to come.[82]

Big Ben as a symbol of resilience is also reinforced in the B1M video (an industry video channel on architecture and construction), *Restoring an Icon: Inside Big Ben's Makeover*, which states that the Elizabeth Tower stood "as a symbol of resilience through two World Wars to emerge as an enduring beacon of democracy".[83]

Work on the Elizabeth Tower cost £80m – far more than had been initially anticipated, in part due to the discovery of additional historic damage from a World War II bombing raid.[84] The restoration project included the renovation of the building's external fabric, the clock itself, some improvement of the tower's internal areas, the installation of an elevator, and the addition of energy-efficient lighting.[85] The rhetoric around the refurbishment emphasised the need to ensure that the tower bells (i.e. Big Ben, which rings every hour, as well as the four smaller bells which ring every 15 minutes) would retain their original Victorian sound by making sure that historical records were consulted:

> Working without the use of modern technology, the engineers will rely on the same techniques as their Victorian predecessors to ensure the notes that the bells produce an authentic sound [sic]. They will be guided, in part, by a document written by engineer Jabez James in 1859 which specified the amount of lift required from each hammer to sound the bells correctly.[86]

Moreover, even the known "defects" of the bell were left as they were – if deemed to have been present since Victorian times and behind Big Ben's characteristic sound:

> But one aspect won't be repaired: a crack that has been in Big Ben since shortly after the bell began ringing in 1859. Caused by an over-powerful striking hammer, this unexpected imperfection subtly altered the properties of the bell – and is thought to be a key element in its distinctive bong.[87]

Big Ben first rang the hour when the tower was completed in 1859, and, up until the 2017–2022 restoration project, had been marked by relatively few periods of silence: in August 1976 for nine months due to a breakdown; in the period between 1983 and 1985 when refurbishment work was being carried out, and in 2007 for seven weeks due to maintenance.[88] However, even during the 2017–2022 restoration, Big Ben was not completely silent, ringing to mark the New Year as well as on Remembrance Sunday.[89] Additionally, it rang as part of the commemoration and funeral services for Queen Elizabeth II on 19th September 2022, ringing once every minute for 96 minutes to mark each year of the Queen's life as the funeral procession departed from Westminster Abbey, and also tolling at 11.55 am to mark a two-minute moment of silence to indicate the ending of the funeral services.[90] Big Ben was also meant to chime on Sunday, 18th September 2022 at 8 pm to mark a one-minute "National Moment of Reflection",[91] by chiming before and after the minute of silence, but a technical error prevented this – an error that was, of course, reported in the news and to which a parliament spokesperson responded that it was being investigated "as a matter of urgency".[92] Although this particular error was of significance due to the commemoration services, it is not unusual for failings of the Big Ben to ring to be reported in national news.[93]

A plan to ring the Big Ben to mark the UK's exit from the European Union, officially at 11 pm on 31 January 2020 – what one could suggest was an attempt at co-opting sound heritage for a political aim – was cancelled due to it costing around £0.5m, with the Chair of the House of Commons Commission (Lindsay Hoyle) stating that it would cost "about £50,000 a bong".[94] Conservative MP (Mark Francois) offered to go up the tower himself to ring the bell to save money, as well as suggesting the option of using a BBC recording to mark the moment, and even was part of a crowdfunding page to raise money to cover the costs.[95] The Prime Minister at the time, Boris Johnson, even stated that the government was "working up a plan so people can bung a bob for a Big Ben bong", but this turned out not to be true.[96]

Even before the restoration work had begun, political debates were already ongoing on the matter of Big Ben's silence. This included the then Prime Minister Theresa May, who criticised the length of time Big Ben would be silent

for, while other politicians were reported to have described the plans to be "mad" and others enquiring as to whether there were options for the bells to ring more frequently than twice a year.[97] There were those who also felt that a replacement sound should be played, with ideas for having recordings of Big Ben played back, or even use the sounds of other bells throughout the UK.[98] The matter of which bells the BBC would use was also an item for concern, with several replacements having been discussed.[99] BBC Radio 4 broadcasts live the Big Ben chimes for different news bulletins and programmes, and in previous periods of silence they have used the Greenwich Time Signal ("the pips") and even birdsong to replace the sounds from the Big Ben, but on this occasion they decided to use a recording of the bell instead.[100]

The role of the sound of Big Ben in the BBC is relevant to its status as a symbol of Britishness as well as a key representative of national sound heritage. Big Ben was first broadcast in BBC radio for New Year's Eve in 1923, when the midnight chimes were transmitted from a rooftop opposite the Houses of Parliament by engineer AG Dryland.[101] Due to the position of the microphone not only Big Ben was captured, but also other atmospheric sounds such as traffic. The radio series, *Scrapbook*, a BBC series which was broadcast from 1932 to 1974, and which focused each episode on events and highlights from a specific year from a British perspective,[102] featured the first live broadcast of Big Ben in its episode on 1924, which was aired in May 1936 stating: "Thus we started what has proved the most famous feature of the BBC programmes, those chimes that link Britishers together the world over".[103]

It is worth noting that the political use of the Big Ben chimes, particularly the political use of their broadcast, has a long history. Emma Robertson's work (2008) explores the role of the BBC Empire Service (now the BBC World Service) and its "white British" exiled listeners (2008: 461) in constructing aural representations of Britishness, a process the chimes of Big Ben played a key role in. Robertson discusses how the chimes in the 1930s came top in listener preference surveys for the BBC Empire Service and, as a result, ended up becoming a regular feature. In addition to the sentimental meaning they had for listeners, they helped regulate time in the colonies to a "British" standard: "The clock was thus a fitting symbol of the power of the imperial metropolis and an emblem of 'Britishness'" (Robertson 2008: 463).

The New Year broadcasts of the Big Ben chimes have also been noted due to their significance throughout World War II. A July 1958 BBC radio programme, *These Foolish Things*, explores the impact of the sound on people within Nazi-occupied France.[104] Ginette Spanier (1904–1988), director of the Paris fashion house Pierre Balmain, discusses the sacred nature the sound of Big Ben has for her:

This is nothing one can be funny about, because it was one of the most sacred sounds that we heard during the war. We who were in occupied France. It was our lifeblood, and it was our comfort and it kept us sane.[105]

She discusses the New Year's Eve broadcast in 1943, as her and her husband lived in fear of the Gestapo: "As Big Ben sounded, we lifted our glasses with the water in it and we drank into the New Year, and we said, 'One day we will hear Big Ben in England,' and we have".[106]

Spanier's emotional response to the sound is echoed in the same programme by Alain Bombard (1924–2005), French physician, biologist, and politician, and there is also a comment by the host, Claude Bourdet, on how the sound became, in some respect, more meaningful to the French than the British during wartime.[107]

Similarly to the case of Stonehenge, the politics of sound are ever-present in the rhetoric surrounding Big Ben, and constructions of Britishness are at the centre of both.

Sound and Security Systems

References to sound as an alert system and as part of security measures are also present in the WHL. *Kaiping Diaolou and Villages*, an entry from China, features the *diaolou*, a series of multi-storeyed defensive buildings found in villages across Kaiping, which were constructed at the beginning of the twentieth century in response to local bandits as well as for protection from floods. The nomination file refers to sound in relation to one of the types of *diaolou*, the watch towers, stating that they were equipped with a searchlight on the top floor, which was lit if bandits were spotted, at the same time as a siren would be sounded to alert the villagers.[108]

Another Chinese entry, the *Cultural Landscape of Honghe Hani Rice Terraces*, references the rice terraces that follow the slopes of the Ailao Mountains towards the banks of the Hong River, which form part of a farming system for red rice created by the Hani people.[109] Sound is only mentioned in passing, concerning both noise and noise management that is typical of many other entries, but also as part of measures for protecting the unhusked rice from animals

> They take different protective measures for different crops: they'll build a small shed at the corner of the field to guard the fields day and night, or knock the bamboo plates, or play the ox horn, or erect a jackstraw in the field; someone even builds a simple bamboo and wood waterwheel by the spring to frighten away the wild animals through the piercing noise made by the impact of water, so as to guarantee the harvest of grains.[110]

The entry *Central Sector of the Imperial Citadel of Thang Long – Hanoi* (Viet Nam) also refers to sound in a security context, in this case relating to war.[111] The Thang Long Imperial Citadel dates from the eleventh century and was the centre of regional power for centuries. Sound does not play any crucial role in the entry but, in addition to notes on noise measurements, there

is a note on a building dating from 1967 which housed the headquarters of the North Vietnamese Armed Forces during the Vietnam War and which had soundproofed walls, among other features.[112] We will return to sonic aspects of the Vietnam War in Chapter 5.

Sound and Spirituality

Sound in connection to spiritual practices has already been partially covered in this chapter through the WHL entries related to bells, and also in connection to references to silence, but there are also a variety of sounds connected specifically to *spirituality* in the entries, and these are all found in the Tentative Lists.

Yalo, Apialo and the sacred geography of Northwest Malakula (Vanuatu) was submitted in 2004 and refers to two spirit caves.[113] The caves are a site of connection with the spiritual world and are visited by pilgrims in order to greet their ancestors, whose imprints are believed to be in the caves in the form of rock-markings. Sound is deemed part of the spiritual realm; in this case it relates to specific rules that visitors must follow in their visits to the caves. At Yalo, for example, "they must…signal to the spirits that they wish to enter by blowing into a natural hole (bubu) in the rock which makes a deep trumpeting sound that resonates throughout the site".

Shwedagon Pagoda on Singuttara Hill's submission by Myanmar in 2018, features both sound and silence.[114] It is regarded as the most sacred Buddhist stupa in Myanmar and believed to have been built between the sixth and tenth century AD, with expansions and repairs being made throughout the centuries. The site includes the hill where the stupa is located, the stupa itself and its reliquaries, along with associated buildings, sacred statues, bells, and emblems across the surrounding area. The design of the site recreates the Hindu-Buddhist cosmos and among the enshrined relics are eight hair strands from the head of Gautama Buddha. Devotees visiting the site circumambulate the hill and its stupa in a clockwise direction and while doing so will recite "sacred prayers either silently or aloud". The entry states that it is a sacred space open to pilgrims to "participate in communal rituals, chanting sermons and silent prayers, connecting the physical icon and the intangible experience". Although bells are mentioned, their actual sound is not discussed.

Mfangano Island Rock Art Sites, submitted by Kenya in 2023, refers to the ancient rock art sites and sacred sites in the Mfangano Island in Lake Victoria, inhabited by the Abasuba people.[115] The rock art can be found in two distinct sites, a cave known as Mawanga, and a rock shelter known as Kwitone. The rock art comprises of concentric circles with colours used being red, white, and black. There are 19 intact sacred sites that can be located and

they are mostly linked to rain making traditions. The sonic reference made in the submission is in relation to these sacred sites:

> The local people believe that the sacred groves...warn the people of the impending danger, usually by producing a distinct noise or by having a fog overcast. The community would then acknowledge the warnings and appease the spirits through offerings of animal sacrifices.

Arochkwu Long Juju Slave Route (Cave Temple Complex) is a 2007 entry by Nigeria and refers to the oracle named Ibn Ukpabi, which is found in a cave, and in which members of the Igbo community went to settle differences, and which resulted in those found guilty being sold as slaves or becoming property of the priests.[116] The entry mentions a waterfall of spiritual significance within the cave complex as its "loud sound...from a distance is regarded as the prophetic voice of Ibn Ukpabi". This provides an example in which natural sounds are linked to aspects of spirituality. It is worth noting that "Long Juju" is the name that was given by British colonial powers,[117] and its use here is copied verbatim from the submission made to the Tentative List.

Sound and Medicine

Only one entry was found that related to sound in the context of medical and wellbeing practices: *Sultan Bayezid II Complex: A Center of Medical Treatment* (Türkiye), which was submitted in 2016 and is part of the Tentative Lists.[118] The entry refers to a Külliyesi (complex) which was focused on a holistic medical approach and constructed between 1484 and 1488, encompassing a hospital, medical school, mosque, and guest-houses, among other facilities. The entry emphasises the use of sound, including music, as part of a holistic approach to medical treatments. The darüşşifa (the hospital) includes:

> a polygonal marble şadırvan (water tank with a fountain) right under the dome. It is also thought that the şadırvan is placed right at the center not only to provide water but also to ensure that patients can benefit from its relaxing sound during their treatment.

The entry also mentions that a stage was built for musicians, whose sound was meant to accompany that of flowing water. Central to the entry is the role of acoustics in maximising the benefits of sound for patients: "The building also has excellent acoustics because music and water sounds from the fountain were used in the treatment of mentally ill patients. The acoustic characteristics allow the music to be heard through the patient rooms". It is

worth noting that, similar to the other entries that will be explored below, acoustics are categorised as "excellent" but no details are provided on what "excellent" actually means.

Acoustics

Some of the entries in the WHL highlight the acoustics of sites as part of the actual heritage being protected. Nonetheless, out of these entries, only two (*Great Zimbabwe National Monument* and *Syracuse and the Rocky Necropolis of Pantalica*) reflect on acoustical features that are not those of theatres or auditoria.

Great Zimbabwe National Monument was inscribed in 1986. Great Zimbabwe was founded in the eleventh century by the Shona people and, in the fourteenth century, was the principal city of a major state, with a population exceeding 10,000 people.[119] The city was an important trading centre but in 1450 the capital was abandoned due to difficulties in finding food and firewood in nearby areas. The site entry includes The Hill Ruins, a "royal city" inhabited from the eleventh century; The Great Enclosure, dating back from the fourteenth century, and with an elliptical shape that includes a series of living quarters; and The Valley Ruins, which was the site of a town. The video accompanying the entry refers to a cave, although it does not indicate its name or specific location. As the video pauses at the site, the voiceover reads: "This was also one of the important places. A shout from here would have echoed right to the bottom of the hill. It was useful for passing on messages". Sinamai (2018: 22) locates the cave below the Eastern Enclosure of the Hill Complex and identifies it as one of the most sacred spaces in the site.

The role of sound and acoustics in this site, however, goes considerably beyond what the UNESCO entry reveals. Sinamai (2018) has explored the crucial role of sound for local communities in Great Zimbabwe and has argued that for those communities the conservation of sounds is of greater relevance than the preservation of any material aspects, such as stone structures. Sinamai's work with three clans from the nearby areas and for whom Great Zimbabwe is central to their cosmology, and in particular with their elders, brought to light the communities' differentiation between "sound" and "noise" (2018). Certain sounds are considered intrinsic to the environment and the sanctity of the space, whereas other sounds are seen to desecrate it, driving away the voices of the landscape. Sinamai (2018) highlights how the use of Great Zimbabwe for music galas in 2001 and 2002, as well as for the celebration of the then president, Robert Mugabe, in 2016, were resisted by the local communities as desecrations of the landscape. In addition to the physical disturbance of the space caused by these events, such as through littering, it was the "noise" produced, in the form of modern Zimbabwean music, that was considered responsible for compromising the sanctity of the

space by driving away ancestral voices. In these instances, it is modern music that represents noise, by introducing sounds considered to not belong to the site and disrespecting its significance. In contrast, the established sounds of the *mbira* and the *ngoma* (musical instruments), used for rituals, in conjunction with animal sounds, and the ancestral voices themselves, are all considered to constitute the sacred soundscape. Regarding those sounds, Sinamai writes:

> Every participant who contributed to my research narrated the question of 'voices' which could be heard from the Hill Complex. They narrated that 'voices' could be heard calling from the eastern enclosure of the Hill Complex. These voices were also accompanied by whistling and sound from domestic animals like cattle. One voice shouting *Huya nehwedza iwe* (Bring me a milking container) was quoted verbatim by all participants... Participants also mentioned the roar of lions, which, they say, can still be heard from a cave to the east of the Hill Complex, and the cry of sacred birds like the Fish and the Bateleur Eagles, which they associated with departed ancestral spirits. Older participants above the age of 90 years reported hearing drums and *mbira* music being played on the Hill Complex before the site became a popular tourist destination. These voices and sounds are said to have since disappeared, resulting in a landscape emptied of the messages that directed life within it.
>
> *(2018, 21–22)*

The loss of those voices, explains Sinamai (2018), is a loss of a deep communication with the landscape. In this regard, Sinamai also observes that it is not just the music galas that have compromised the sites: towers for air navigation, radio, and telephone communication, together with tourists, are also blamed (Sinamai 2018: 22).

Sinamai (2018) finally argues that established heritage conservation priorities and processes are at odds with the values of the local communities, offering little consideration for the soundscape, and lacking the structures necessary to protect intangible heritage, focusing instead on materiality, which is linked to visual aspects. A greater recognition of traditional knowledge, argues Sinamai (2018), is crucial for the preservation of intangible heritage. In this case we see a site being listed but with very little consideration of what its intangible properties mean to the local communities, putting it at risk of being inundated by extraneous noises.

Turning now to the entry *Syracuse and the Rocky Necropolis of Pantalica* (Italy), there are two elements of note included: the Necropolis of Pantalica which contains over 5,000 tombs cut into the rock and dating back from thirteenth to seventh century BC; and Ancient Syracuse, which includes the remains of a Greek theatre and Roman amphitheatre.[120] In the context of this

book, it is relevant that this entry mentions acoustical features in relation to Dionysius' Ear, a large artificial grotto about 23 m high, 5–11 m wide and 65 m deep. The entry states

> Thanks to its form, the grotto has extraordinary acoustic properties, amplifying sounds up to 16 times, thus Caravaggio was induced to call it 'Dionysius' Ear' upholding the legend that the tyrant Dionysius had the grotto made as a prison, imprisoning his enemies and listening to their words.[121]

The quote above refers to a legend that tells the story of Dionysius using a secret listening chamber towards the upper part of the cavern to listen to prisoners' whispers (Cox 2015: 164). An account from a visit by George French Angas in 1841 reveals that the listening chamber used to be open to visitors who could ascend through a chair, rope, and pulley mechanism. Angas mentions that it was also possible to listen to the demonstration of a small cannon fired in the space in order to showcase its acoustics. Angas was seemingly not tempted enough to engage with the precarious ascent mechanism, contenting himself with the cannon demonstration – quite reasonable in my opinion. However, in the twenty-first century a group of acoustic researchers were able to gain (rather safer) access to the site (Iannace, Marletta, Sicurella, and Ianniello 2010). The researchers' acoustical studies of the grotto and the listening chamber put the legend into question, as they demonstrated that intelligibility was heavily compromised by the long reverberation times.

The acoustics of the site has not escaped popular culture and (spoiler alert!) it is featured as a key turning point in the 2023 film *Indiana Jones and the Dial of Destiny* directed by James Mangold. In the film, Indy and his goddaughter Helena Shaw find out that Archimedes hid half of the dial of destiny in the Ear of Dionysius, with the key to finding it being acoustics! As Indy and Helena enter the grotto, they use their voices and the acoustics of the space to find the spot in which it has been hidden, following the clue "Search where Dionysius hears each whisper like a hurricane". This prompts them to vocalise, even employing the opening of Beethoven's Fifth Symphony, until they hear their voices the loudest – a form of acoustic measurement.

Ancient Theatre Acoustics

The WHL entry for *Sanctuary of Asklepios at Epidaurus* in the Peloponnesus, considers acoustics to be central to the heritage value of the site, in particular in relation to the Theatre of Epidaurus. The site, including the Theatre, as well as the Temple of Asklepios and the Tholos, dates from fourth century BCE. The Theatre is noted as having "exemplary acoustics" and is described as representing "a unique artistic achievement through its

admirable integration into the site as well as the perfection of its proportions and acoustics".[122] The Theatre of Epidaurus, as many other ancient theatres, has been at the centre of several acoustical studies involving both on-site measurements and acoustic computer modelling (see e.g. Angelakis, Rindel, and Gade 2011; Lokki et al. 2013; Psarras et al. 2013; Shankland 1973; Vassilantonopoulos et al. 2011). The Tentative Lists also include an entry for *Ancient Greek Theatres*, submitted in 2014, and encompasses a total of 15 theatres, including Epidaurus.[123] The entry highlights acoustics as a key reason for inscription and describes the acoustics of the included theatres as "excellent", as detailed in the quote below

> The variation in height between each row and the next prevented degradation of the sound waves, while the shape of the cavea [audience seating area] enabled a good concentration of sound. The tall stage building with its parascenia, and the smooth surface of the orchestra, which was paved from a certain point onward, also functioned as sound amplifiers.[124]

In addition to the general mention of "excellent acoustics" for the sites as a group, when mentioning the sites of Epidaurus and Oeniadae, acoustics is mentioned in relation to these two specific theatres, although only in Epidaurus' case is the reader offered a reason for this excellence:

> The cavea is delimited by two poros-stone retaining walls and is divided by staircases into wedge-shaped cunei [wedge-shaped sections of seats], which radiate out from the orchestra, drawn from three centres, an invention to which the excellent acoustics of the theatre are due.

Another example, also linked to acoustics, is *The Theatre and Aqueducts of the Ancient City of Aspendos*, an entry submitted by Türkiye in 2015.[125] The Theatre of Aspendos, built between 160 and 180 AD, is the best-preserved example of an ancient Roman theatre. The entry's only mention of acoustics is a statement that the "monument is also of extreme importance for understanding the use of acoustics in ancient theatres". It is not explained why, although it might be assumed that it is because of the state of preservation of the site, which facilitates more thorough acoustical studies. Indeed, studies on the acoustics of Aspendos' Theatre were conducted as part of the ERATO project ("Identification, Evaluation and Revival of the Acoustical Heritage of Ancient Theatre and Odea"). The ERATO project has been arguably one of the largest and most influential acoustical heritage projects of the twenty-first century. As a doctoral student starting in the field back in 2009, I found ERATO inspiring in terms of the technical expertise deployed and the creativity of how it disseminated its findings, which included audio-visual simulations. The project was funded by the European Commission and took

place between February 2003 and January 2006, under the coordination of the Technical University of Denmark, and in collaboration with organisations in France, Jordan, Switzerland, Italy, and Türkiye, and with a total cost of €1,665,005.[126]

ERATO focused on five Roman theatres and odea: Aspendos Theatre, Jerash South Theatre, Syracuse Theatre, Aosta Odeon, and Aphrodisias Odeon (Rindel and Nielsen 2006; Rindel 2011, 2013). It studied the sites through acoustic measurements and acoustic computer modelling – the method chosen depended on the site itself and its state of conservation (Rindel and Nielsen 2006; Rindel 2011, 2013), and integrated visual and acoustical simulations. ERATO compared the acoustics of open-air theatres – which often included a *velum*, a textile that was used as a sunshield – to those of the smaller roofed theatres (odea). The project used the methodology I discussed in Chapter 2, in which acoustic measurements on-site were used to validate computer acoustic models by adjusting the acoustical data of the surface materials (Rindel and Nielsen 2006; Rindel 2011, 2013). Acoustic measurements were only conducted on those sites that were best preserved, Aspendos and Jerash South Theatre (Rindel and Nielsen 2006; Rindel 2011, 2013).

The project concluded that the acoustic characteristics of the different types of structure, open-air versus roofed odea, were intrinsically linked to the uses of each type of site. Roman open-air theatres had high clarity values which would make speech more intelligible, and it was these spaces that were used for speech-based events, such as plays (Rindel and Nielsen 2006; Rindel 2011, 2013). Nevertheless, it is worth noting that sound strength in those structures was found to be low, particularly as the distance between the sound source and listener increased, and if there was no colonnade (Rindel and Nielsen 2006; Rindel 2011, 2013). Odea, instead, had lower clarity due to their higher reverberation time, which was described as being "like a concert hall" (Rindel and Nielsen 2006: 1), and had higher sound strength. These characteristics matched its intended use, for song and music, and would have benefitted quiet musical instruments such as the lyre (Rindel and Nielsen 2006; Rindel 2011, 2013).

An analysis of the preponderance of studies on Greco-Roman structures and in particular the use of the term "ancient" in combination with heritage studies on acoustics will be explored at the close of this chapter, alongside a consideration of the apparent need for acoustical heritage work to compare past acoustical settings to contemporary ones.

Theatre Acoustics: Beyond the Ancient Ones

In the WHL, listed theatres outside of Greco-Roman sites also include references to their acoustical properties. *Historical Theatres of the Marche Region* (in the Tentative Lists under cultural sites), an entry submitted by Italy in

2021, includes 61 theatres across the provinces of Pesaro-Urbino, Ancona, Macerata, Fermo, and Ascoli Piceno.[127] Acoustics is mentioned in relation to two different halls specifically. The first is the Pedrotti Auditorium, part of the Palazzo Olivieri, a rectangular hall with 500 seats and with acoustics described as "exceptional". The second is the Rossini Theatre (1816–1818), a horseshoe-shaped hall, with four tiers of boxes, a large gallery, 826 seats and a 353 square meters stage, which is noted as having "excellent acoustics". However, there are no details provided as to the reasons behind those assessments.

Another relevant entry, this time related to an auditorium, is *Head Office and Garden of the Calouste Gulbenkian Foundation*, a 2017 entry by Portugal.[128] The Calouste Gulbenkian Foundation, a private philanthropic institution, was established in 1956, with the site opening to the public in 1969 in Lisbon and is considered an example of modern architecture, with a harmonic relationship between interior and external landscape. Acoustics is mentioned as part of the expertise of the specialists involved in the design, and noise is mentioned in relation to the Grand Auditorium, explaining that it "is located at the far south of the complex and in the centre of the surrounding park, which protects it from external noise". Interestingly, no notes on the acoustics of the Grand Auditorium are given and there is no description of the activities carried out in the space.

The most prominent mention of acoustics in the WHL, in terms of the emphasis placed on acoustics as part of the heritage value of a site, is the entry for *Margravial Opera House Bayreuth* (Germany), inscribed in 2012. The Margravial Opera House, built between 1745 and 1750, is an example of Baroque theatre architecture, and it is the only fully preserved example of a court opera house. Its construction style, that of a loge theatre with a wooden interior and with large areas covered in canvas (such as the rear walls of the loges and the coffered ceiling), is of particular note, as the entry highlights that the choice of materials was the product of specific acoustical considerations, seeking to move away from the less acoustically appropriate stone construction that was typical of theatres. The extant property retains these construction materials and, hence, the entry highlights, it provides a unique and authentic acoustical experience, made even more affecting by the fact that this type of construction was only meant to be temporary: "Due to its historical construction from wood and canvas, it permits the unique experience of the original acoustics. In this way it offers a complete 'insight into the past'".[129]

Acoustic measurements of the Margravial Opera House were conducted in 2018, using a combination of hand claps and balloons as part of a study that sought to explore the acoustics of the building after renovation work between 2013 and 2018 (Krauss et al. 2019). The renovation sought to reverse changes incorporated in 1935–1936, during which the proscenium

area had been modified, including the replacement of the wooden railing with a curving balustrade, new stairs, and a reduced size of the stage opening; the reversal of these features seeking to bring the building closer to its original design (Krauss et al. 2019). The study concluded that after the renovations, the acoustics of the space matched the characteristics of Italian-style historical opera houses (Krauss et al. 2019). That is, it matched opera houses built in Italy between the seventeenth and nineteenth centuries, and which shared several design concepts to Margravial, such as the audience area being separated into stalls, boxes, and a gallery – with the stalls being configured initially in a U-shape, before transitioning to bell-shaped and semi-elliptic, and then finally to a horseshoe shape. Furthermore, these buildings also had a stage and an orchestra pit, with the latter separated from the stalls through a wooden balustrade or an open transparent rail (Prodi et al. 2015). The results from the acoustic measurements (Krauss et al. 2019), therefore, indicated that the renovation work had been successful in conserving the acoustics of the site.

Aspects of the conservation of Italian-style historical opera houses are highlighted by Prodi et al. (2015), whose analysis of the data relating to a number of buildings sharing these characteristics found that they all have distinctive acoustic features that separate them from the acoustic characteristics of modern theatres, leading the authors to argue that any changes seeking to upgrade the acoustics to modern standards might risk a loss of the original, intentional qualities. It is worth noting that it was the need for conservation that prompted an interest in the acoustical heritage of these sites, leading to their widespread study under the National Interest Research Project (PRIN) (Prodi et al. 2015), a campaign involving nine acoustic teams across nine Italian universities with the aim of putting together an acoustic catalogue of representative theatres (Ianniello 2005). This renewal of interest was catalysed by fires in Teatro "Petruzzelli" (Bari) and Teatro "La Fenice" (Venezia) in 1991 and 1996 respectively (Prodi et al. 2015; Tronchin, Merli and Manfren 2021). In the case of "La Fenice" there were already acoustic measurements available, taken only months before the fire across October/November 1995. These were made in an empty theatre with the stage curtain open and with no scenery in place, using only one sound source (starter pistol) in a position at the centre of the proscenium and with 27 receiver positions across the main hall and on the balconies on the right-hand side (Tronchin and Farina 1997). These limited measurements compromised the possibility of using them as a guide to the subsequent repair and renovation work, which aimed to restore "La Fenice" to *how it was*, while introducing necessary changes such as greater safety from fire, and modern air conditioning (Commins 1998). However, it has been pointed out that a feature which had been observed during the study as compromising clear audibility between the orchestra in the pit and the singers on the stage was then rectified during the renovation works, adding slits to improve communication (Schwartz et al. 2023)

Computer Models to the Rescue

Italian-style historical opera houses are not the only type of building for which acoustic measurements have been considered key to their conservation. Interest in the topic has more recently been brought to the fore as a consequence of the Notre Dame fire on April 15, 2019, a property listed in the WHL as part of *Paris, Banks of the Seine*. The fire brought with it further discussions as to what version of the building should be restored. After some controversy as to whether "a contemporary architectural gesture" to replace the spire was the way forward, a decision was made to restore the cathedral exactly the way it was prior to the fire, including the mid-nineteenth century restorations by Viollet-le-Duc.[130]

Acoustic measurements of Notre Dame were carried out back in 1987 and 2015, the former with balloon bursts and the latter with a combination of balloon bursts and sine sweeps (Postma and Katz 2016). The 2015 measurements revealed a decrease in reverberation time compared to the 1987 measurements, which was partially explained by the placement of carpets in the space, which was explored in more detail through the use of the measurements as a basis to build and calibrate a geometrical acoustics computer model (Katz and Weber 2020; Postma and Katz 2016). These acoustic measurements have proven key to the renovation work being conducted, enabling the assessment of how the fire damage has changed the acoustic characteristics of the building, which was observed following a new set of measurements in June 2020 that was then compared with the original dataset, revealing that reverberation times had been significantly reduced (by about 20%) (Katz and Weber 2020; Schwartz et al. 2023). Changes being made during the ongoing renovation work are being assessed continually through the acoustic computer model, with consideration of how the acoustical experience of the renovated building might better cater for different user needs through the introduction of alterations. An example of this involves taking into account the difficulties reported by singers in hearing one another, requiring more time for rehearsals when in the space (Schwartz et al. 2023). However, these difficulties have not been concomitant with an actual desire for the space to change (De Muynke et al. 2024). De Muynke et al. (2024) explored the sound perceptions of the cathedral prior to the fire by interviewing people whose role in Notre Dame was linked to its acoustics, such as organists, singers, choirmasters, organ builders, stage managers, chaplains, and composers. The research revealed that the acoustics of Notre Dame was perceived by some as being difficult to work with and hence far from ideal, with concert singers requiring longer times for concert rehearsals at the podium due to the time it takes to get used to performing in the space and finding the right articulation to ensure clarity. These impacts were not the same however when singing in the choir area as part of daily religious services – likely due to the regularity of the

choral work within the space versus podium performances for concerts, for which the preparation usually takes place outside of the venue, in acoustically drier spaces. De Muynke et al. (2024) reflect subsequently on the fact that the space was designed with the aim of singing taking place in the choir and not in the podium, which resulted in different acoustical characteristics. However, although the singers interviewed indicated their difficulties, there was no mention of them wishing the space to be redesigned for greater ease, likely due to the heritage value attached to it, which can also contribute to the perceived quality of the acoustics, as well as welcoming the challenge and gaining professional satisfaction from it (De Muynke et al. 2024). Finally, the study indicated that the acoustic properties of the building could not be separated from its soundscape, with the latter including the sounds of visiting tourists as well as the machinery and electrical circuits in the building, (De Muynke et al. 2024: 176), which offers a salient reminder of the difficulty of separating acoustical heritage from soundscapes research.

Acoustical models were not the only type of model that attracted attention after the fire, with Ubisoft's *Assassin's Creed* (AC): *Unity* being considered – briefly, it seems, and not by the game designers, as a key towards restoration.[131] *Assassin's Creed: Unity*, an action/adventure game by Ubisoft and part of a larger series, was released in 2014. It is set in Paris during the French Revolution and includes a virtual model of Notre Dame. It is this virtual model that fuelled speculation as to its potential use for reconstructing the real Notre Dame. Surely Ubisoft could save the day, some thought. Shortly after the fire, Ubisoft stated that they had no involvement in the reconstruction of the cathedral,[132] but that they would be donating €500,000 to the reconstruction funds and that they would be making the game free for one week, in order to allow players to explore Notre Dame.[133] The game accrued around 3 million downloads during that week.[134] Upon announcement of their free offer Ubisoft stated that "Video games can enable us to explore places in ways we never could have otherwise imagined. We hope, with this small gesture, we can provide everyone an opportunity to appreciate our virtual homage to this monumental piece of architecture".[135] The connection between the digital, the imagined, and the real is deeply intertwined in this statement, while also inadvertently diminishing the multi-sensorial experience involved in visiting a heritage site.

Ubisoft did clarify that their model was not a scientific one and that they had taken creative licenses for the purpose of the game.[136] Level designer Caroline Miousse, who worked on the Notre Dame model, made use of blueprints as well as consultations with Maxime Durand, Production Coordinator and Historical Researcher for the game.[137] Miousse refers to the work on Notre Dame as a cover song: there is an amount of interpretation that goes into the job, and the model needs to be functional to the gameplay, including it needing to be fun to navigate.[138] Changes included, for example,

the addition of cables and incense to allow players to navigate the building above ground. Moreover, some changes were due to copyright laws for some of the elements in Notre Dame, such as the organ.[139] Finally, although the starting point for the model was Notre Dame during the French Revolution, some contemporary elements that were deemed to be strongly associated with people's memories of Notre Dame were added, such as the nineteenth century spire.[140]

In addition to making the game freely available for a week, Ubisoft used the virtual model from *AC: Unity* for the creation of a virtual reality (VR) experience to which organ music, recorded in Notre Dame six months before the fire, was added.[141] The aim was to make the model available beyond the gaming community, allowing people to experience the site while it was closed to visitors.[142] The fact that the game had included contemporary Notre Dame elements was viewed as desirable, but the designers did not feel there was a need to modernise other elements from the game (such as the horses and carriages), as the aim was exploration of the monument and surrounding areas.[143] Discussions on the VR experience only include the mention of the organ music, without further consideration of the use of virtual tools to simulate the listening experience from different points in the building. This is also true from the discussions on the potential use of the game for reconstruction work, it is the visuals that are emphasised, without any mention on the acoustic or other sonic properties of the site. Such omissions are not surprising, as there have been very few scholarly studies on sound and acoustics in historical games that go beyond their musical aspects (López 2023).

The creation of the VR experience was not the end of Ubisoft's exploration of the Notre Dame model in connection to the fire. In 2022 they released the location-based multiplayer VR Escape Room experience *Save Notre-Dame on Fire*, in collaboration with Pathé Films and Jean-Jacques Annaud, director of the 2022 film *Notre-Dame Brûle* ("Notre-Dame on Fire").[144] This new VR experience re-utilised the VR model and placed the players in the position of firefighters in charge of extinguishing the fire and saving the holy relics.[145] For this latest experience they added elements to the *AC* model, including the north belfry, the statue of the Virgin and the baby, the modern altar, and the scaffolding that was in place when the building caught fire.[146] Ubisoft involved the firefighters who tackled the real fire in the design and testing process, and took notes of their suggestions, while also considering the experience a celebration of their efforts.[147] Furthermore, a percentage of the earnings was then donated to support the reconstruction work, which might have helped dissuade any comments on the seemingly opportunistic nature of the endeavour.[148]

Ubisoft's connection to heritage recreations through VR can also be seen in their involvement with the travelling exhibition *Age Old Cities: A Virtual Journey from Palmyra to Mosul*, which was organised by the Arab

World Institute in Paris in partnership with UNESCO and shown there from October 2018 to February 2019.[149] The aim was to raise awareness of the danger to heritage sites in the Arab world by focusing on five sites in Syria and Iraq. Ubisoft used the 3D scans and photographs provided by Iconem, a Paris-based startup specialising in the 3D digitisation of endangered cultural heritage,[150] to create their VR experience, which included a soundscape which Ubisoft created based on people's experiences of visiting the sites.[151] The exhibition was inaugurated in the USA in 2020 at the Smithsonian's National Museum of Asian Art, and was located in its Arthur M. Sackler Gallery.[152] This latter aspect, as will be discussed shortly, a source of controversy in itself. Since 2019, the VR portion of this experience has been made available for free on Steam for those who could not access the exhibition.

The involvement of Ubisoft in these digital experiences can be seen as a general attempt by the company to position itself as more than an entertainment developer, associating itself with aspects of preservation and education, which then feed into the perception of the accuracy of its games. This is exemplified by the creation of the stand-alone *Discovery Tours* that have accompanied later titles in the *AC* series, *Odyssey*, *Origins* and *Valhalla*, all of which allow the player to experience, without the threat of violence or the intrusion of gameplay, recreations of Ancient Greece, Ancient Egypt, and the Viking Age, respectively – these being marketed as educational tools.[153] Catros and Leblanc (2021) reflect on the issues of Ubisoft being portrayed as a main player in the creation of historically accurate experiences, whereas what they are creating instead are plausible versions of historical environments that are playable and visually striking. So long as there are a sufficient number of recognisable elements in Reconstructive Game Models (RGMs), this can lead to them being perceived as historically accurate, especially when accompanied by a brand that has built its name on making claims of historical accuracy, which can ultimately create a blurring between reality and fiction (Catros and Leblanc 2021). It is this blurring that can be framed through the philosophical observations of Jean Baudrillard (1981), in which he discusses how simulations of "the real" have now been transformed into the new "hyperreal". That is, the reality of the past and its environments, as popularly understood, is currently what was once deemed a simulation, for the repetition of stereotyped versions of the past has now turned those simulations into a new perceived reality. Such an effect is reflected on by Dow (2013) who discusses the impact playing *AC* could have on players' perceptions of the represented cities, while also arguing that this effect is not restricted to the impact of games but can be traced as far back as the eighteenth century and the influence of printed reproductions on visitor perceptions of different sites. Catros and Leblanc (2021) argue that Ubisoft is trying to encourage a form of intrinsic motivation, one in which players are motivated to find out more about history outside of the gameplay, but caution that this is an

undirected form of learning that might be tainted by the essential blurring between fiction and reality that the games promote through their designs. In addition to this, one could also argue that if players are interpreting RGMs as referential to the real then they might not ultimately feel the need to explore further – after all some commentators did believe that the Notre Dame *AC* model would aid real life reconstruction.

Not All Heritage Is Equal

The fire in Notre Dame and the donations resulting from it threw a spotlight on another key discussion in cultural heritage, which is the inequalities of how different cultural and societal emergencies are treated, both in relation to heritage and beyond. Notre Dame's fire was immediately met with pledges of donations from the most wealthy in France and beyond, with the French government even offering additional fiscal incentives,[154] triggering debates on social media channels and in the press. One of the biggest debates was a questioning of why people had rushed to pledge money for the restoration of Notre Dame but were far less willing to support other causes, such as the migrant crisis, homelessness, and climate change,[155] – although this has been countered with the argument that billionaires often support several projects.[156] Environmental activist Greta Thunberg suggested that humanity should activate "cathedral mode" by showing the same urgency towards climate change that was shown towards the restoration of Notre Dame.[157] In this regard, we can note that there is a close connection between the provenance of the donations to Notre Dame and activities that are considered key drivers of climate change. For example, TotalEnergies, a French oil company, donated €100m to the restoration process,[158] inviting questions about the ethics of receiving money from oil companies whose role in climate change will have devasting effect on cultural heritage – leaving aside the many other devastating effects generated. A 2019 report by International Council on Monuments and Sites (ICOMOS) has identified climate change as one of the most significant threats to cultural heritage, both tangible and intangible, with coastal sites being at risk of rising sea levels, natural landscapes losing their biodiversity, and heavy rains and wildfires increasing erosion, among other effects. However, this does not seem to stop heritage sites from accepting these donations. The British Museum has been a long-time recipient of sponsorship from oil company BP, which has been recently met with protests and dissent.[159] Particularly controversial was BP's sponsorship of the exhibition *I am Ashurbanipal: king of the world, king of Assyria* (Nov. 2018–Feb. 2019), which included artefacts from modern day Iraq. This was due to BP's involvement in and profiting from oil extraction in Iraq during the war.[160]

Drawing from the discussion in Chapter 3 on the greater importance given to Western sites in heritage work and the orientalist perspectives that

underpin it, as well as other biases discussed, it is worth noting that although greenhouse gas emissions are mostly the responsibility of industrialised countries, it is the least wealthy regions and the most vulnerable groups that are far more likely to be affected by the consequences (ICOMOS 2019). It is an unsettling irony that the acoustics of Notre Dame, and other such sites, can only be preserved and used for restoration due to the energy powering the array of equipment used for measurements and computer models – energy that is still largely derived from fossil fuels. It is these patterns of energy consumption that will likely result in irreparable damage to the soundscapes and acoustics of the non-Western world, who receive far less interest and resources dedicated to their preservation – and this includes the loss of natural sounds, such as those belonging to animal species rendered extinct by their collapsing local ecologies.

The disproportionately large attention granted to Notre Dame is, overall, in stark contrast to the interest and empathy granted to sites at risk in the so-called Global South, which is entirely a consequence of its status as an icon of Western and Christian cultural heritage.[161] Underlining this point is an event that took place only a few weeks before the Notre Dame fire, in March and April 2019, in which three black churches in Louisiana (USA) were set on fire. It was only when the discrepancy in interest was pointed out online that there was a spike in donations towards the affected sites.[162]

Ongoing discussions about the ethics of donations have been central to several cultural institutions. In the UK in 2019, the Tate galleries (which include Tate Modern and Tate Britain in London, as well as Tate St. Ives and Tate Liverpool), and the National Portrait Gallery, rejected donations from the Sackler family, the owners of Purdue Pharma, the maker of Oxy-Contin, which has formed a key driver of the ongoing opioid crisis in the USA.[163] As mentioned earlier in this chapter, the *Age Old Cities* exhibition in Washington, DC, was held at the Arthur M. Sackler Gallery. Upon visiting the gallery's website, a link to a document of acknowledgement is found, upon which it is explained that the gallery was named in this way due to a 1982 gift of $4 million and 1,000 objects, upon the condition that the gallery would retain its name for perpetuity. The gallery acknowledges the controversy of its name, states that it no longer receives gifts from the Sackler family, but indicates that the change of name would put the collection at risk, and hence a change is not forthcoming.

Soundscapes of Trauma and Acoustics of Torture

As explored earlier in this chapter, the inscription of heritage sites related to traumatic events has been rare, but in 2023 the *ESMA Museum and Site of Memory – Former Clandestine Centre of Detention, Torture and Extermination* in Buenos Aires (Argentina) was inscribed,[164] with specific descriptions

of what I will refer to here as *soundscapes of trauma* and *acoustics of torture* – concepts that will also feature in greater detail in Chapter 5.[165] ESMA stands for Escuela Superior de Mecánica de la Armada (Navy School of Mechanics) and it served as a clandestine detention centre, one of many, where opponents of the military government of 1976–1983 were taken to after being kidnapped, with torture and, for many, death awaiting. It was also a site in which the theft of babies born in detention was planned, as well as a site of forced labour.

References to sound and acoustics are made in relation to different spaces within the premises. "Capuchita" (Little Hood Room) was an attic on the fourth floor, and although prisoners did not know where the detention centre was, sonic clues were gathered when they were taken to this specific space. The inscription document refers to the space amplifying outside sounds, which allowed detainees to hear the sounds of trains, and planes, as well as cars.[166] Furthermore, they could hear the sounds of football fans from nearby clubs (River Plate and Defensores de Belgrano), as well as that of students going to the nearby school, Raggio.[167] The nomination file also refers to the "Capucha" room (Hood Room) where prisoners testified on the "atrocious" noise of the exhaust fans hanging from the ceiling, which nevertheless brought with them the advantage of conversations with fellow detainees going unnoticed by repressors.[168] In addition to this, reference is made to "La Pecera" (Fishtank Room) in which prisoners conducted forced labour in a setup akin to a news agency, with tasks meant to serve their "recovery process" – that is, changing their values and ideologies.[169] Tasks included the translation of texts, the carrying out of political data analysis, and developing propaganda items. The museum has used sounds from typewriters and teleprinters to evoke the soundscape of this space, accompanied by a display of chairs.[170]

Reflections and Some Concluding Thoughts

The general importance of sound was acknowledged in the 39th session of UNESCO's General Conference in 2017, in which an agenda item on "The Importance of sound in today's world: promoting best practices" was requested by Argentina, France, Japan, and Lebanon. The focus was on "the sound environment", "health", "sound recording, reproduction and conservation technology", "the relation between image and sound", and "musical and sound expression". UNESCO was highlighted as the organisation best placed to promote best practice by raising awareness on the importance of sound, including among younger people, as well as to preserve sounds. It is worth noting, however, that there is much emphasis in the document on noise levels and their impact on health, and far less on the heritage value of sonic elements. This echoes the WHL entries analysed throughout this chapter,

in which noise control takes precedence over sound protection. Activities are also a focus of the document, with an acknowledgement of the importance of "The Week of Sound". The Charter of the Week of Sound does include a mention of heritage, but is focused on the development of archives as part of its main concern with "Techniques for recording and sound reinforcement".[171] Therefore, although this agenda item has been considered as an acknowledgement of the growing importance of sound in heritage considerations (Katz, Murphy and Farina 2020), the document's connection to the valuing of sound heritage as crucial is largely tenuous and connected mostly to archives and an acknowledgement of issues of noise.

As analysed throughout this chapter, sound is still often left aside entirely when considering the value of a heritage site. Moreover, as seen in Chapter 3 when exploring the ICH lists, it is music specifically that is valued over and above sound more generally. It thus appears that researchers of acoustical heritage and soundscapes are using the UNESCO documents as a means of justifying why their work is important, as can be noted, for example, in work by De Muynke et al. (2024) in which the "The Importance of sound in today's world" and UNESCO's ICH are entered as reasons why the study of acoustic environments deserves attention. This need for justification is likely a result of the hierarchisation of sight within Western heritage conservation environments and academic fields, which results in acoustical heritage and soundscapes researchers feeling the need to justify their areas of study. Nevertheless, it seems that despite an increase in studies in these fields, this is not necessarily changing how State Parties are characterising their own heritage, with sound still being mostly absent.

Many of the entries studied in this chapter featured noise removal, rather than sound heritage protection. Moreover, most entries that discuss noise and noise management do not make any reference as to what they are hoping to achieve when this noise is controlled. Notions of tranquillity and quiet are considered to be central to the experience of heritage and is thus implicit across the entries, demonstrating that although there have been attempts to expand notions of heritage by UNESCO, there is more work ahead of us, with a legitimisation of certain modes of experience over others still apparent. Berkaak's exploration of constructions of tranquillity linked to heritage in general, and Stonehenge in particular (2019), are closely connected to the hierarchisation of the senses and experiences discussed in the field of sensory anthropology in Chapter 2. Only the "right" way of experiencing the sites is approved of, with perceived deviations being denigrated and sidelined. Those experiencing heritage sites in a different way are thus less worthy of them, even though the legitimised experience (quiet, tranquillity) can often be at odds with how those sites were experienced originally. For instance, one might feel the urge to lower one's voice when walking past an outdoor performance of the York Mystery Plays, but this is unlikely to have been

what passers-by on a medieval street once felt. The York Mystery Plays were performed on Corpus Christi and were part of a celebration. Similar to how we now associate medieval cathedrals and sculptures with austere grey stone as their main visual signifier, forgetting their once brightly colourful paint-work (Ramirez 2022: 75), we have learnt to accept quiet as the privileged norm, without questioning the "noisy" origins of many heritage sites.

Even when dealing with sound, State Parties, as they completed their entries, assigned a hierarchy within their own sites: what is worth listening to within them and thus worth preserving, as compared to what is neither. There is a binary between noise and a lack thereof, but we can ask: what are we actually left with once the ostensive noise has been controlled to within legal standards? This part is far less clear. Heritage management appears to value a lack of noise, rather than the presence of sound. Similarly, the ICH lists have no entries flagged with the word "noise" in them, which is likely due to their focus on positive intangible experiences – within which, one assumes, noise is not a feature, or that the intangible experiences cannot be protected from noise. What is noise, however, and what is not, is culturally constructed, and this includes the expectation that heritage sites can only be experienced legitimately with reverential quiet. This can be connected back to notions of sound ecology and particularly the work of Schafer (1994), which was briefly discussed in Chapter 1. Schafer's work is closely connected to a binary opposition between quiet, represented by nature, and noise, which is represented by technology and modernity more broadly. Nature is quiet, tranquil, good, whereas noise is a corrupting influence. Thompson (2017: 102) argues that this distinction, based on a romanticised idea of nature, removes any nuances or any distinctions that are determined by context, entirely failing to reflect on who is doing the silencing and who is being silenced, and whether that silence is a choice or an imposition – and, in this regard, failing to acknowledge that both noise and silence have been used as means for punishment and torture, as will be further reflected on in Chapter 5. Thompson (2017) argues that the issue isn't the evaluation of the damaging effects of noise but the act of equating all noise with "bad". Thompson (2017: 106-107) also discusses the classist undertones connected to these sound ecology theories, which simply accept an implicit connection between what is referred to as hi-fi and lo-fi soundscape (Schafer 1994) with higher and lower social classes, respectively. In a UK context, these divisions date back to the late nineteenth century, with the move to the suburbs being associated with white middle classes (Thompson 2017: 106–107). As seen earlier in this chapter, these shifts and their ideological effects can also be connected to the exclusion of ethnic minority groups from the countryside and the heritage sites located within it.

Despite the growing importance of the field of sound ecology through-out the years through, for example, the work of Schafer and his World Soundscape Project founded in the late 1960s and early 1970s,[172] and more

recently the work of Bernie Krause (2013), it is worth noting that references to nature's sounds in the entries, although present, were very few and at points quite generic. When present the sounds of nature were not central to what was being protected and more like a complement to what was being more generally described. The lack of highlighting of nature's sounds seems to indicate that the findings from the work of sound ecology have not necessarily had an impact on heritage site considerations, beyond legalities, or at least that there is no record of their impact as there is no sense of a greater valuing of nature's sounds. Krause's (2013) explanation of the richness of nature's sonic fabric makes it surprising to encounter such silence in natural WHL entries.

Krause's work is a laudable and inspiring reflection on the importance of natural soundscapes and the destruction they are suffering because of human activities which have resulted in climate change, animal extinction, and habitat destruction. However, it is hard to ignore that his work does not fully acknowledge the barriers some might face in accessing or embracing natural environments and reduces the experiences of those people to less valuable. There is an air of judgement in some of the passages from *The Great Animal Orchestra*. To illustrate, here's an extract:

> Walking a wooded trail near our house on the morning of the day I wrote this paragraph, I found the spring dawn chorus especially enchanting. Yet there was a spandex-clad thirtysomething woman on the path, cell phone hard to her ear, oblivious to the world she was navigating and to the sound track performing for her. I felt bad about what she missed during that beautiful moment.
>
> *(Krause 2013: 221)*

The reference to this woman as "spandex-clad" is particularly alarming and one could argue has a sexist undertone. Ultimately, what does it matter what she is wearing, it does not tell us that much about her and it ends up being an example of the constant judgement women face by the gaze of male onlookers. We know nothing about the context of this woman's telephone conversation, but she has been turned into a cautionary tale of detachment from nature.

Before this specific paragraph, Krause had already retold an anecdote of a couple from New York that stayed at his and his wife's rental cottage, and his surprise as he found them checking out early

> ...I saw our guests, fully dressed, luggage piled at the bottom of the stairs, loading their car in the parking area and looking quite anxious. "What's wrong?" I asked, shocked to see them hustling to leave. "It's too quiet here," the female weighed in, a note of apprehension in her voice.

"We couldn't sleep and even with all the windows closed, all we could hear were those damned crickets.

(Krause 2013: 220)

Here Krause once more focuses on the experience of a woman, and once more we know very little about this person. One could argue that there is a reason behind her finding the silence or even the crickets disquieting and an anxiety trigger, but it is once more taken as an example of an inability to value nature. It could just be that she had different soundscape preferences, and that she found other soundscapes comforting. This is once more a patriarchal outlook on what is valuable, and of what is noise, and what isn't.

I must confess though to feeling rather hypocritical. A lot of the reading and thinking done for this book, including these paragraphs, were done in my house garden, which backs to a nature reserve, and while sitting taking these notes I rejoice in the very many different birdsongs I can hear, I even pause to wonder whether I should take my recording equipment out. Next to me the buzzing of a bumble bee perched on some flowers, which only a few days ago I was wondering if we should remove as I didn't find them very visually appealing, provides a peaceful writing environment. I make a mental note not to get rid of those flowers, if bees like them, let's keep them. But this is a privileged experience, and my sonic environment cannot be separated from aspects of class – I was able to afford a house backing onto a nature reserve because a mortgage provider considered me to be financially stable, and it probably didn't hurt that I have a PhD and the title of professor.

Coded in the WHL entries are a variety of definitions of noise. Thompson (2017) explores different definitions and conceptions, referring to *subject-oriented noise, object-oriented noise, noise connected to particular sound sources*, and *noise-as-loudness*. When referring to *subject-oriented noise*, Thompson (2017) refers to sounds that are judged to be noise, and therefore unpleasant and unwanted, by the listener. There is nothing intrinsic to the sound that makes it noise: anything can turn into noise depending on who is listening. As discussed in Chapter 2 in relation to different sensorial experiences, what is noise and what is not is a sociocultural construction that changes depending on time and place, and this can be used in turn to separate "desirable" from "undesirable" behaviours, which become connected to groups of people who are either privileged or marginalised. In opposition to this, *object-oriented noise* refers to definitions of noise that assign the label of noise to sounds with particular characteristics (complex, with wide-frequency bands, non-periodic, etc.), which is independent from any subjective judgements by a listener.

Thompson (2017) also traces a definition of *noise connected to specific sound sources*. Although there has often been an association between noise and machines, modernity and technology, opposing it to the sound of

nature, there have also been instances in which nature has been the source of noise (Thompson 2017). Thompson (2017) exemplifies this by referring to late-nineteenth-century cities in the USA and their rejection of the English house sparrow, which was introduced to the country in the 1850s. This foreign bird's sound was lumped together with other noise sources and separated from the natural, and pleasant sounds of native birds (Thompson 2017: 27). But associations between beings and noise do not stop with the sparrow, Thompson (2017: 27–28) discusses the use of noise references to refer to foreigners (human this time), working class people, and women. In addition, references to noise are also present in colonialist discourses. "In the archives of colonialism, noise often serves to differentiate colonizer from colonized, civil culture from barbarous nature, human from non-human" (Thompson 2017: 28). An example of this can be seen in Chapter 2, where I explored the work by Ochoa Gautier (2014) on the written records on the vocalisations of the bogas in nineteenth century Colombia. But noise, Thompson (2017: 28) argues, besides signalling a dismissal towards the "other" also carries the fear of disorder, disruption, and revolt from that same "other".

Finally, the consideration of *noise-as-loudness* and the focus on abatement, which has been found in several WHL entries, focusing on physical and psychological effects of high levels. Thompson (2017: 33–34) argues that loudness being measurable does not necessarily make it objective and questions whether loudness, either in terms of measurable levels or perception, can be equated to noise, as in certain situations loudness is sought after.

> While high-volume sounds may 'objectively' harm the human body at a particular level and potentially garner certain instinctual physiological responses, whether high-volume sounds register as loud sounds and, furthermore, whether loud sounds register as 'bad' sounds (in the sense that they are recognized to be unwanted, harmful, threatening or damaging) tends to vary according to context.
>
> *(Thompson 2017: 34)*

In August 2021 I headed to the North York Moors National Park in the UK to a site known as the Hole of Horcum. My task was to record the soundscape of the moors for a virtual reality experience titled *Monoliths* by Pilot Theatre, produced and directed by Lucy Hammond. My aim was to record quiet, to capture the sense of tranquillity myself, and others in the team, associated with the North York Moors. I aimed to do so by capturing the gentle birdsong, peppered with the sounds of the highland cows that inhabit that particular area. But noise was there throughout the process. Audio recording equipment does not cope well when recording quiet – to get any sound levels we need to amplify the signal, and the more we amplify the signal the more noise is introduced to the system, which then needs to be removed

in postproduction. During the recordings, I settled for accepting the system noise as an inevitable consequence of making the recordings. Once settled into my chosen spot, microphone set, recording rolling, headphones on, I hear *BANG! BANG! BANG!* Irritated, I turn to my recording companion and enquire what this is (I will now leave it to your imagination to wonder what the exact words uttered were). In response, I am informed that clay pigeon shooting takes place in the area. I am annoyed but relieved they are not real pigeons. Their hobby was, nevertheless, my noise.

Other sonic references within the UNESCO lists include bells, as well as different alert and security systems, with sound and its connection to spirituality also present, in particular in non-Western contexts. In addition to this, the connection between sound and medicine, although present, was limited to only one site.

Acoustic considerations were also found in several sites, although the focus was on performance sites (theatres and opera houses), with only two references on acoustics beyond these contexts. What's more, the focus was on ancient Greek and Roman structures, which echoes the greater attention these structures have received when compared to others.

This brings us back to the conference series "The Acoustics of Ancient Theatres" that was explored in Chapter 3. The title of the conference itself presents an interesting point for discussion, with its specific use of the word "ancient" and its accompanying logo (an amphitheatre), which strongly suggests a focus on Greco-Roman theatrical experiences. Indeed, an analysis of the 2011 event indicates that around 60% of the oral presentations and workshops were focused on Greek and Roman theatres. In terms of historical periods, there was work presented on prehistoric, medieval, and eighteenth-century heritage, and there was also some work not on theatre, for example, work on Chichén Itzá in Mexico.[173] An analysis of the titles from the 2022 edition indicates a similar trend,[174] although with a greater variety beyond Greek and Roman structures, which accounted for about 30% of the presentations. Other regions still had limited representation, and research presented included work on venues that one would struggle to categorise as "ancient", such as the Teatro Colón in Buenos Aires, a nineteenth century building, as well as non-theatre spaces, such as Notre Dame.

The name and branding of the conference awards value to "ancient" acoustics, mostly understood as Greek and Roman, above the acoustics of other time periods. In failing to define a specific historical period, it results in the use of the word "ancient" to signify "old", while also intermixing theatre structures with spiritual sites, which are very distinct propositions. The conference is, in truth, a conference on acoustical heritage, chiefly from an acoustical engineering perspective, with a focus on measurement, modelling, and testing, although built with a preconception that acoustics from a certain period and certain regions are more valuable than others. Academic

fields, which are partially built and reinforced through academic events, often work upon preconceptions on what is worth being studied, which invariably defines what is not considered worth studying. It is the resulting history of exclusion that helps sediment these imbalances and hierarchies further by replicating them at every iteration.

The chapter ahead will now move beyond the UNESCO lists to explore how acoustical heritage and historical soundscapes have been disseminated beyond academia and specialised circles and instead used more widely both online and in heritage sites.

Notes

1 The analysis presented here reflects the entries as they were when the analysis took place in August 2023.
2 Throughout this chapter, unless a different reference is specified, I have used the information in the UNESCO entries and the accompanying documents in each entry as a source of information and quotes for each site.
3 *Ilulissat Icefjord*, https://whc.unesco.org/en/list/1149/ [last accessed on 8th August 2023].
4 *Morne Trois Pitons National Park*, https://whc.unesco.org/en/list/814/ [last accessed on 8th August 2023].
5 *French Austral Lands and Seas*, https://whc.unesco.org/en/list/1603/ [last accessed on 9th August 2023].
6 *Monarch Butterfly Biosphere Reserve*, https://whc.unesco.org/en/list/1290 [last accessed on 8th August 2023].
7 *St Kilda*, https://whc.unesco.org/en/list/387 [last accessed on 8th August 2023].
8 *West Lake Cultural Landscape of Hangzhou*, https://whc.unesco.org/en/list/1334 [last accessed on 14th August 2023].
9 *Aasivissuit – Nipisat. Inuit Hunting Ground between Ice and Sea*, https://whc.unesco.org/en/list/1557 [last accessed on 7th April 2024].
10 *Aasivissuit – Nipisat. Inuit Hunting Ground between Ice and Sea*, https://whc.unesco.org/en/list/1557, Nomination File No. 1557, p. 58 [last accessed on 7th April 2024].
11 *Namhansanseong*, https://whc.unesco.org/en/list/1439/ [last accessed on 16th August 2023].
12 *Namhansanseong*, https://whc.unesco.org/en/list/1439/, Nomination File No. 1439,p. 215 [last accessed on 16th August 2023].
13 *Kulangsu, a Historic International Settlement*, https://whc.unesco.org/en/list/1541/ [last accessed on 14th August 2023].
14 *Kulangsu, a Historic International Settlement*, https://whc.unesco.org/en/list/1541/, Nomination File No. 1541, p.48 [last accessed on 14th August 2023].
15 *Xinjiang Yardang*, https://whc.unesco.org/en/tentativelists/5989/ [last accessed on 17th August 2023].
16 *The Djavolja Varos (Devil's Town) Natural Landmark*, https://whc.unesco.org/en/tentativelists/1700/ [last accessed on 20th August 2023].
17 *Mdina (Citta' Vecchia)*, https://whc.unesco.org/en/tentativelists/983/ [last accessed on 21st August 2023].
18 *Grand Canyon National Park*, https://whc.unesco.org/en/list/75/ [last accessed on 8th August 2023].
19 *Keoladeo National Park*, https://whc.unesco.org/en/list/340 [last accessed on 13th August 2023].

20 *Purnululu National Park,* https://whc.unesco.org/en/list/1094/ [last accessed on 13th August 2023].

21 *Wulingyuan Scenic and Historic Interest Area,* https://whc.unesco.org/en/list/640/ [last accessed on 13th August 2023].

22 *Fanjingshan,* https://whc.unesco.org/en/list/1559/ [last accessed on 14th August 2023].

23 *Migratory Bird Sanctuaries along the Coast of Yellow Sea-Bohai Gulf of China,* https://whc.unesco.org/en/list/1606/ [last accessed on 14th August 2023].

24 *Kujataa Greenland: Norse and Inuit Farming at the Edge of the Ice Cap,* https://whc.unesco.org/en/list/1536/ [last accessed on 15th August 2023].

25 *Upper Middle Rhine Valley,* https://whc.unesco.org/en/list/1066/ [last accessed on 15th August 2023].

26 *Archaeological Site of Olympia,* https://whc.unesco.org/en/list/517/ [last accessed on 15th August 2023].

27 *Historic Centre of San Gimignano,* https://whc.unesco.org/en/list/550/ [last accessed on 15th August 2023].

28 *Quseir Amra,* https://whc.unesco.org/en/list/327/ [last accessed on 15th August 2023].

29 *Historic City of Vigan,* https://whc.unesco.org/en/list/502/ [last accessed on 15th August 2023].

30 *Royal Domain of Drottningholm,* https://whc.unesco.org/en/list/559/ [last accessed on 16th August 2023].

31 *Historic Quarter of the City of Colonia del Sacramento,* https://whc.unesco.org/en/list/747/ [last accessed on 16th August 2023].

32 *Complex of Hué Monuments,* https://whc.unesco.org/en/list/678/ [last accessed on 16th August 2023].

33 *Citadel of the Ho Dynasty,* https://whc.unesco.org/en/list/1358/ [last accessed on 16th August 2023].

34 *Mount Wuyi,* https://whc.unesco.org/en/list/911/ [last accessed on 13th August 2023].

35 *Historic Centre of Macao,* https://whc.unesco.org/en/list/1110/ [last accessed on 13th August 2023].

36 *The Grand Canal,* https://whc.unesco.org/en/list/1443/ [last accessed on 14th August 2023].

37 *Mount Wutai,* https://whc.unesco.org/en/list/1279/ [last accessed on 13th August 2023].

38 *Trang An Landscape Complex,* https://whc.unesco.org/en/list/1438/ [last accessed on 13th August 2023].

39 *Trang An Landscape Complex,* https://whc.unesco.org/en/list/1438/, Nomination file No. 1438, p. 69 [last accessed on 13th August 2023].

40 *Cultural Landscape of Sintra,* https://whc.unesco.org/en/list/723/ [last accessed on 13th August 2023].

41 *Ancient Villages in Southern Anhui – Xidi and Hongcun,* https://whc.unesco.org/en/list/1002/, Nomination file No. 1002, p. 63 [last accessed on 13th August 2023].

42 *Imperial Tombs of the Ming and Qing Dynasties,* https://whc.unesco.org/en/list/1004/ [last accessed on 13th August 2023].

43 *Imperial Tombs of the Ming and Qing Dynasties,* https://whc.unesco.org/en/list/1004/, Nomination File No. 1004ter, p.6 [last accessed on 13th August 2023].

44 *Imperial Tombs of the Ming and Qing Dynasties,* https://whc.unesco.org/en/list/1004/, Nomination File No. 1004ter, p.101 [last accessed on 13th August 2023].

45 *Lalish Temple,* https://whc.unesco.org/en/tentativelists/6467/ [last accessed on 20th August 2023].

46 *The Persian Garden*, https://whc.unesco.org/en/list/1372/, Nomination File No. 1372, p.489 [last accessed on 8th August 2023].

47 *The Persian Garden*, https://whc.unesco.org/en/list/1372/ [last accessed on 8th August 2023].

48 *Christiansfeld, a Moravian Church Settlement*, https://whc.unesco.org/en/list/1468/ [last accessed on 15th August 2023].

49 *Christiansfeld, a Moravian Church Settlement*, https://whc.unesco.org/en/list/1468/, Nomination File No. 1468, p. 81 [last accessed on 15th August 2023].

50 *Christiansfeld, a Moravian Church Settlement*, https://whc.unesco.org/en/list/1468/, Nomination File No. 1468, p. 131 [last accessed on 15th August 2023].

51 *Christiansfeld, a Moravian Church Settlement*, https://whc.unesco.org/en/list/1468/, Nomination File No. 1468, p. 56 [last accessed on 15th August 2023].

52 *Stonehenge, Avebury and Associated Sites*, https://whc.unesco.org/en/list/373 [last accessed on 16th August 2023].

53 *Stonehenge Environmental Improvement Project*, https://www.youtube.com/watch?v=nbx3S7L7soU [last accessed on 23rd August 2023].

54 *A303 Stonehenge in 150 Seconds*, https://www.youtube.com/watch?v=CwF0qFew9Y8#CwF0qFew9Y8 [last accessed on 24th August 2023].

55 *A303 Stonehenge in 150 Seconds*, https://www.youtube.com/watch?v=CwF0qFew9Y8#CwF0qFew9Y8 [last accessed on 24th August 2023].

56 *Stonehenge & A303*, https://www.english-heritage.org.uk/about-us/search-news/stonehenge-tunnel/ [last accessed on 24th August 2023].

57 *Stonehenge & A303*, https://www.english-heritage.org.uk/about-us/search-news/stonehenge-tunnel/ [last accessed on 24th August 2023].

58 *Stonehenge & A303*, https://www.english-heritage.org.uk/about-us/search-news/stonehenge-tunnel/ [last accessed on 24th August 2023].

59 *About the National Trust Today*, https://www.nationaltrust.org.uk/who-we-are/about-us/about-the-national-trust-today [last accessed on 24th August 2023].

60 *A303 Stonehenge in 150 Seconds*, https://www.youtube.com/watch?v=CwF0qFew9Y8#CwF0qFew9Y8 [last accessed on 24th August 2023].

61 *Scrap Stonehenge Road Tunnel Plans, Say Archaeologists after Neolithic Discovery*, https://www.theguardian.com/uk-news/2020/jun/22/scrap-stonehenge-road-tunnel-say-archaeologists-neolithic-discovery [last accessed on 26th August 2023].

62 *Stonehenge Tunnel Campaigners Win Court Battle*, https://www.bbc.co.uk/news/uk-england-wiltshire-58024139 [last accessed on 24th August 2023].

63 *Stonehenge Tunnel Is Approved by Government*, https://www.bbc.co.uk/news/uk-england-wiltshire-66201424 [last accessed on 24th August 2023].

64 *Save Stonehenge World Heritage Site Again!* https://www.crowdjustice.com/case/save-stonehenge-world-heritage-site-again/ [last accessed on 26th August 2023]

65 *Scrap Stonehenge Road Tunnel Plans, Say Archaeologists after Neolithic Discovery*, https://www.theguardian.com/uk-news/2020/jun/22/scrap-stonehenge-road-tunnel-say-archaeologists-neolithic-discovery; *Stonehenge Hidden Landscape Project*, https://lbi-archpro.org/cs/stonehenge/index.html [last accessed on 26th August 2023].

66 *Scrap Stonehenge Road Tunnel Plans, Say Archaeologists after Neolithic Discovery*, https://www.theguardian.com/uk-news/2020/jun/22/scrap-stonehenge-road-tunnel-say-archaeologists-neolithic-discovery [last accessed on 26th August 2023].

67 *Factors Affecting the Property in 2021*, https://whc.unesco.org/en/soc/4109 [last accessed on 24th August 2023].

68 *Save Stonehenge World Heritage Site Again!* https://www.crowdjustice.com/case/save-stonehenge-world-heritage-site-again/ [last accessed on 26th August 2023]

69 *Manual Bell Ringing*, https://ich.unesco.org/en/RL/manual-bell-ringing-01873 [last accessed on 7th May 2023].

70 *Historic Monuments of Dengfeng in "The Centre of Heaven and Earth*, https://whc.unesco.org/en/list/1305/, Nomination File No. 1305rev, p. 83 [last accessed on 14th August 2023].

71 *Historic Monuments of Dengfeng in "The Centre of Heaven and Earth*, https://whc.unesco.org/en/list/1305/ [last accessed on 14th August 2023].

72 *West Lake Cultural Landscape of Hangzhou*, https://whc.unesco.org/en/list/1334 [last accessed on 14th August 2023].

73 *West Lake Cultural Landscape of Hangzhou*, https://whc.unesco.org/en/list/1334, Nomination File No. 1334, p. 73 [last accessed on 14th August 2023].

74 *West Lake Cultural Landscape of Hangzhou*, https://whc.unesco.org/en/list/1334, Nomination File No. 1334, p.160 [last accessed on 14th August 2023].

75 *West Lake Cultural Landscape of Hangzhou*, https://whc.unesco.org/en/list/1334, Nomination File No. 1334, p.160-161 [last accessed on 14th August 2023].

76 *West Lake Cultural Landscape of Hangzhou*, https://whc.unesco.org/en/list/1334, Nomination File No. 1334, p.161 [last accessed on 14th August 2023].

77 *Melaka and George Town, Historic Cities of the Straits of Malacca*, https://whc.unesco.org/en/list/1223/ [last accessed on 15th August 2023].

78 *Melaka and George Town, Historic Cities of the Straits of Malacca*, https://whc.unesco.org/en/list/1223/, Nomination File No. 1223bis, p. 28 [last accessed on 15th August 2023].

79 *Palace of Westminster and Westminster Abbey including Saint Margaret's Church*, https://whc.unesco.org/en/list/426 [last accessed on 8th August 2023].

80 *Inside Big Ben's Makeover*, https://www.youtube.com/watch?v=UCwZ1iI3pdw&t=55s, 15 April 2020 [last accessed on 27th August 2023].

81 *Big Ben to Be Silenced for Four Years for Maintenance*, https://www.theguardian.com/politics/2017/aug/14/big-ben-silenced-four-years-maintenance-chimes, 14 August 2017 [last accessed on 28th August 2023].

82 *Conservation of Elizabeth Tower and Big Ben*, https://www.parliament.uk/about/living-heritage/building/palace/big-ben/elizabeth-tower-and-big-ben-conservation-works-2017-/ [last accessed on 27th August 2023].

83 *Inside Big Ben's Makeover*, https://www.youtube.com/watch?v=UCwZ1iI3pdw&t=55s, 15 April 2020 [last accessed on 27th August 2023].

84 *Time Stands Still at Westminster as Big Ben Fails to Chime*, https://www.theguardian.com/uk-news/2023/may/10/time-stands-still-at-westminster-as-big-ben-fails-to-chime, 10 May 2023 [last accessed on 27th August 2023].

85 *Inside Big Ben's Makeover*, https://www.youtube.com/watch?v=UCwZ1iI3pdw&t=55s, 15 April 2020 [last accessed on 27th August 2023].

86 *Initial Tests to Begin on Big Ben and the Quarter Bells*, https://www.parliament.uk/about/living-heritage/building/palace/big-ben/news/initial-tests-to-begin-on-big-ben-and-the-quarter-bells/ [last accessed on 28th August 2023].

87 *Why Is Big Ben Falling Silent?*, https://www.bbc.com/future/article/20160704-the-big-ben-renovation-and-how-the-clock-works, 5 July 2016 [last accessed on 27th August 2023].

88 *Why Is Big Ben Falling Silent?* https://www.bbc.com/future/article/20160704-the-big-ben-renovation-and-how-the-clock-works, 5 July 2016; *Big Ben's bongs to fall silent until 2021 for repairs*, https://www.bbc.co.uk/news/uk-politics-40922169, 14 August 2017 [last accessed on 27th August 2023].

89 *Conserving a Clocktower in the Middle of a Working Parliament*, https://www.parliament.uk/about/living-heritage/building/palace/big-ben/elizabeth-tower-and-big-ben-conservation-works-2017-/conserving-a-clocktower-in-the-middle-of-a-working-parliament/ [last accessed on 27th August 2023].

90 *Big Ben Fails to Chime after Minute's Silence for the Queen,* https://www. independent.co.uk/news/uk/home-news/queen-elizabeth-silence-big-ben-b2170 064.html, 19 September 2022; *Big Ben tolled every minute for 96 minutes – once for every year of Queen Elizabeth II's life,* https://www.cbsnews. com/news/big-ben-queen-elizabeth-ii-funeral-tolled-every-minute-96-chimes-for-queens-life/, 19 September 2022, [last accessed on 27th August 2023]

91 *National Moment of Reflection,* https://www.gov.uk/government/news/national-moment-of-reflection [last accessed on 28th August 2023].

92 *Big Ben Fails to Chime after Minute's Silence for the Queen,* https://www. independent.co.uk/news/uk/home-news/queen-elizabeth-silence-big-ben-b2170064.html, 19 September 2022; *UK observes minute's silence in memory of Queen,* 18 September 2022, https://www.theguardian.com/uk-news/2022/sep/18/uk-observe-minutes-silence-in-memory-queen-8pm [last accessed on 28th August 2023].

93 *Time Stands Still at Westminster as Big Ben Fails to Chime,* https://www. theguardian.com/uk-news/2023/may/10/time-stands-still-at-westminster-as-big-ben-fails-to-chime, 10 May 2023 [last accessed on 28th August 2023].

94 *Boris Johnson's Big Ben Brexit Bong Plan Falls Flat,* https://www.theguardian. com/politics/2020/jan/14/boris-johnsons-big-ben-brexit-bong-plan-falls-flat, 14 January 2020 [last accessed on 27th August 2023].

95 *Big Ben Won't Ring Out to Mark Brexit because It Will Cost Too Much,* https:// www.standard.co.uk/news/politics/big-ben-to-remain-silent-for-brexit-as-symbolic-bong-dismissed-by-commons-commission-a4333506.html, 14 January 2020; *Boris Johnson saves face over failed bid for Big Ben Brexit chime,* https://www. theguardian.com/politics/2020/jan/17/boris-johnson-saves-face-over-failed-bid-for-big-ben-brexit-chime, 17 January 2020; *The Big Ben must bong for Brexit campaign,* https://www.gofundme.com/f/bigbenbongforbrexit [last accessed on 28th August 2023].

96 *Downing Street Kills Off Plans for Big Ben Brexit Bong,* https://www. theguardian.com/politics/2020/jan/16/big-ben-unlikely-to-chime-on-brexit-day-no-10-indicates, 16 January 2020 [last accessed on 27th August 2023].

97 *Officials Put Dampener on Theresa May's Call Not to Silence Big Ben,* https://www.theguardian.com/politics/2017/aug/16/big-ben-backlash-mps-review-plans-silence-bell-four-years, 16 August 2017 [last accessed on 28th August 2023].

98 *Officials Put Dampener on Theresa May's Call Not to Silence Big Ben,* https://www. theguardian.com/politics/2017/aug/16/big-ben-backlash-mps-review-plans-silence-bell-four-years, 16 August 2017 [last accessed on 28th August 2023].

99 *Ringing Endorsement: Which Bells Could Stand in for Big Ben?* https://www. theguardian.com/uk-news/shortcuts/2017/aug/15/which-bells-could-stand-in-big-ben-liverpool-great-george-olympic-bell, 15 August 2017 [last accessed on 28th August 2023].

100 *Ringing Endorsement: Which Bells Could Stand in for Big Ben?* https://www. theguardian.com/uk-news/shortcuts/2017/aug/15/which-bells-could-stand-in-big-ben-liverpool-great-george-olympic-bell, 15 August 2017; *Big Ben's bongs to fall silent until 2021 for repairs,* 14 August 2017, https://www.bbc.co.uk/news/uk-politics-40922169 [last accessed on 28th August 2023].

101 Nicole Hartland, *Broadcasting Big Ben,* 16 November 2020, https://archives. blog.parliament.uk/2020/11/16/broadcasting-big-ben/; *Scrapbook for 1924,* https://www.bbc.co.uk/archive/scrapbook-for-1924/zbxjbdm [last accessed on 29th August 2023].

102 *Scrapbook,* https://www.bbc.co.uk/programmes/p04hc5hh [last accessed on 29th August 2023].

103 *Scrapbook for 1924*, https://www.bbc.co.uk/archive/scrapbook-for-1924/zbxjbdm [last accessed on 29th August 2023].
104 *These Foolish Things*, https://www.bbc.co.uk/archive/these-foolish-things/zmcvmfr; Nicole Hartland, *Broadcasting Big Ben*, 16 November 2020, https://archives.blog.parliament.uk/2020/11/16/broadcasting-big-ben/ [last accessed on 29th August 2023].
105 *These Foolish Things*, https://www.bbc.co.uk/archive/these-foolish-things/zmcvmfr [last accessed on 29th August 2023].
106 *These Foolish Things*, https://www.bbc.co.uk/archive/these-foolish-things/zmcvmfr [last accessed on 29th August 2023].
107 *These Foolish Things*, https://www.bbc.co.uk/archive/these-foolish-things/zmcvmfr [last accessed on 29th August 2023].
108 *Kaiping Diaolou and Villages*, https://whc.unesco.org/en/list/1112/ [last accessed on 13th August 2023].
109 *Cultural Landscape of Honghe Hani Rice Terraces*, https://whc.unesco.org/en/list/1111/ [last accessed on 14th August 2023].
110 *Cultural Landscape of Honghe Hani Rice Terraces*, https://whc.unesco.org/en/list/1111/, Nomination File No. 1111, p. 98 [last accessed on 14th August 2023].
111 *Central Sector of the Imperial Citadel of Thang Long – Hanoi*, https://whc.unesco.org/en/list/1328/ [last accessed on 16th August 2023].
112 *Central Sector of the Imperial Citadel of Thang Long – Hanoi*, https://whc.unesco.org/en/list/1328/, Nomination File No. 1328, p. 49 [last accessed on 16th August 2023].
113 *Yalo, Apialo and the Sacred Geography of Northwest Malakula*, https://whc.unesco.org/en/tentativelists/1971/ [last accessed on 17th August 2023].
114 *Shwedagon Pagoda on Singuttara Hill*, https://whc.unesco.org/en/tentativelists/6367/ [last accessed on 21st August 2023].
115 *Mfangano Island Rock Art Sites*, https://whc.unesco.org/en/tentativelists/6682/ [last accessed on 21st August 2023].
116 *Arochkwu Long Juju Slave Route (Cave Temple Complex)*, https://whc.unesco.org/en/tentativelists/5170/ [last accessed on 17th August 2023].
117 *Arochukwu*, https://www.britishmuseum.org/collection/term/x108323 [last accessed on 17th August 2023].
118 *Sultan Bayezid II Complex: A Center of Medical Treatment*, https://whc.unesco.org/en/tentativelists/6117/ [last accessed on 17th August 2023].
119 *Great Zimbabwe National Monument*, https://whc.unesco.org/en/list/364/ [last accessed on 17th August 2023].
120 *Syracuse and the Rocky Necropolis of Pantalica*, https://whc.unesco.org/en/list/1200/ [last accessed on 15th August 2023].
121 *Syracuse and the Rocky Necropolis of Pantalica*, https://whc.unesco.org/en/list/1200/, Nomination File No. 1200, p. 115 [last accessed on 15th August 2023].
122 *Sanctuary of Asklepios at Epidaurus*, https://whc.unesco.org/en/list/491/ [last accessed on 8th August 2023]. It is worth noting, when comparing the prominence given to acoustics in the Epidaurus entry in relation to the Margravial Opera House entry, that the nomination file for the former was not found on the UNESCO site, whereas the Margravial Opera House entry, likely due to it being a newer entry, included the file on the website, which facilitated the perusal of further documentation.
123 *Ancient Greek Theatres*, https://whc.unesco.org/en/tentativelists/5869/ [last accessed on 20th August 2023].
124 *Ancient Greek Theatres*, https://whc.unesco.org/en/tentativelists/5869/ [last accessed on 20th August 2023].

125 *The Theatre and Aqueducts of the Ancient City of Aspendos,* https://whc.unesco.org/en/tentativelists/6036/ [last accessed on 20th August 2023].

126 *Identification, Evaluation and Revival of the Acoustical Heritage of Ancient Theatres and Odea,* https://cordis.europa.eu/project/id/ICA3-CT-2002-10031 [last accessed on 30th August 2023].

127 *Historical Theatres of the Marche Region,* https://whc.unesco.org/en/tentativelists/6556/ [last accessed on 20th August 2023].

128 *Head Office and Garden of the Calouste Gulbenkian Foundation,* https://whc.unesco.org/en/tentativelists/6228/ [last accessed on 21st August 2023].

129 *Margravial Opera House Bayreuth,* https://whc.unesco.org/en/list/1379, Nomination File 1379, p. 49 [last accessed on 8th August 2023].

130 *Notre Dame Spire Must Be Rebuilt Exactly as It Was, Says Chief Architect,* 9th July 2020, https://www.theguardian.com/world/2020/jul/09/notre-dame-spire-must-be-rebuilt-exactly-as-it-was-expert-tells-panel-restoration-fire-cathedral [last accessed on 24th September 2023].

131 *'Assassin's Creed' Could Be Used to Help Rebuild Notre Dame Cathedral,* 17th April 2019, https://www.nme.com/news/assassins-creed-could-be-used-to-help-rebuild-notre-dame-cathedral-2477854; *Assassin's Creed Creators Pledge €500,000 to Notre Dame,* 17th April 2019, https://www.theguardian.com/games/2019/apr/17/assassins-creed-creators-pledge-500000-notre-dame-restoration [last accessed on 11th October 2023].

132 *Assassin's Creed Creators Pledge €500,000 to Notre Dame,* 17th April 2019, https://www.theguardian.com/games/2019/apr/17/assassins-creed-creators-pledge-500000-notre-dame-restoration [last accessed on 11th October 2023].

133 Ubisoft, *Supporting Notre-Dame de Paris,* 17th April 2019, https://news.ubisoft.com/en-us/article/2Hh4JLkJ1GJIMEg0lk3Lfy/supporting-notredame-de-paris [last accessed on 11th October 2023].

134 *Ubisoft's 'Assassin's Creed: Unity' Downloaded 3M Times Following Notre Dame Fire,* 25th April 2019, https://www.hollywoodreporter.com/news/general-news/assassins-creed-unity-downloaded-3m-times-notre-dame-fire-1204686/ [last accessed on 11th October 2023].

135 Ubisoft, *Supporting Notre-Dame de Paris,* 17th April 2019, https://news.ubisoft.com/en-us/article/2Hh4JLkJ1GJIMEg0lk3Lfy/supporting-notredame-de-paris [last accessed on 11th October 2023].

136 *Assassin's Creed Creators pledge €500,000 to Notre Dame,* 17th April 2019, https://www.theguardian.com/games/2019/apr/17/assassins-creed-creators-pledge-500000-notre-dame-restoration [last accessed on 11th October 2023].

137 Anne Lewis, *How Ubisoft Re-created Notre Dame for 'Assassin's Creed Unity',* 2nd May 2019, https://blog.siggraph.org/2019/05/how-ubisoft-re-created-notre-dame-for-assassins-creed-unity.html/ [last accessed on 11th October 2023].

138 Anne Lewis, *How Ubisoft Re-created Notre Dame for 'Assassin's Creed Unity',* 2nd May 2019, https://blog.siggraph.org/2019/05/how-ubisoft-re-created-notre-dame-for-assassins-creed-unity.html/ [last accessed on 11th October 2023].

139 Anne Lewis, *How Ubisoft Re-created Notre Dame for 'Assassin's Creed Unity',* 2nd May 2019, https://blog.siggraph.org/2019/05/how-ubisoft-re-created-notre-dame-for-assassins-creed-unity.html/ [last accessed on 11th October 2023].

140 *Assassin's Creed Creators pledge €500,000 to Notre Dame,* 17th April 2019, https://www.theguardian.com/games/2019/apr/17/assassins-creed-creators-pledge-500000-notre-dame-restoration; Anne Lewis, *How Ubisoft Re-created Notre Dame for 'Assassin's Creed Unity',* 2nd May 2019, https://blog.siggraph.org/2019/05/how-ubisoft-re-created-notre-dame-for-assassins-creed-unity.html/ [last accessed on 11th October 2023].

141 Ubisoft Game Makers, *Real Worlds/Virtual Worlds,* https://news.ubisoft.com/en-gb/article/2XugZs3LNxhIoHlHSyhOzg/exploring-real-worlds-and-virtual-worlds--game-makers-podcast [last accessed on 11th October 2023]

142 Ubisoft Game Makers, *Real Worlds/Virtual Worlds*, https://news.ubisoft.com/en-gb/article/2XugZs3LNxhIoHlHSyhOzg/exploring-real-worlds-and-virtual-worlds--game-makers-podcast [last accessed 11th October 2023]

143 Ubisoft Game Makers, *Real Worlds/Virtual Worlds*, https://news.ubisoft.com/en-gb/article/2XugZs3LNxhIoHlHSyhOzg/exploring-real-worlds-and-virtual-worlds--game-makers-podcast [last accessed 11th October 2023]

144 Mikel Reparaz, *Save Notre-Dame on Fire Invites Players to Rescue Relics in a VR Escape Room*, 13th June 2022, https://news.ubisoft.com/en-us/article/3pd6wsYltA3mxaOFOwuLbX/save-notre-dame-on-fire-invites-players-to-rescue-relics-in-a-vr-escape-room; *Save Notre-Dame on Fire*, https://www.ubisoft.com/en-gb/entertainment/parks-experiences/escape-games/save-notre-dame-on-fire [last accessed on 11th October 2023].

145 Mikel Reparaz, *Save Notre-Dame on Fire Invites Players to Rescue Relics in a VR Escape Room*, 13th June 2022, https://news.ubisoft.com/en-us/article/3pd6wsYltA3mxaOFOwuLbX/save-notre-dame-on-fire-invites-players-to-rescue-relics-in-a-vr-escape-room; *Save Notre-Dame on Fire*, https://www.ubisoft.com/en-gb/entertainment/parks-experiences/escape-games/save-notre-dame-on-fire [last accessed on 11th October 2023].

146 Mikel Reparaz, *Save Notre-Dame on Fire Invites Players to Rescue Relics in a VR Escape Room*, 13th June 2022, https://news.ubisoft.com/en-us/article/3pd6wsYltA3mxaOFOwuLbX/save-notre-dame-on-fire-invites-players-to-rescue-relics-in-a-vr-escape-room; *Save Notre-Dame on Fire*, https://www.ubisoft.com/en-gb/entertainment/parks-experiences/escape-games/save-notre-dame-on-fire [last accessed on 11th October 2023].

147 Mikel Reparaz, *Save Notre-Dame on Fire Invites Players to Rescue Relics in a VR Escape Room*, 13th June 2022, https://news.ubisoft.com/en-us/article/3pd6wsYltA3mxaOFOwuLbX/save-notre-dame-on-fire-invites-players-to-rescue-relics-in-a-vr-escape-room; *Save Notre-Dame on Fire*, https://www.ubisoft.com/en-gb/entertainment/parks-experiences/escape-games/save-notre-dame-on-fire [last accessed on 11th October 2023].

148 Mikel Reparaz, *Save Notre-Dame on Fire Invites Players to Rescue Relics in a VR Escape Room*, 13th June 2022, https://news.ubisoft.com/en-us/article/3pd6wsYltA3mxaOFOwuLbX/save-notre-dame-on-fire-invites-players-to-rescue-relics-in-a-vr-escape-room; *Save Notre-Dame on Fire*, https://www.ubisoft.com/en-gb/entertainment/parks-experiences/escape-games/save-notre-dame-on-fire [last accessed on 11th October 2023].

149 Arab World Institute, *Exhibitions: Age Old Cities: A Virtual Journey from Palmyra to Mosul*, https://www.imarabe.org/en/exhibitions/age-old-cities [last accessed on 16th October 2023].

150 Iconem, https://iconem.com/ [last accessed on 16th October 2023].

151 Youssef Maguid, *Ubisoft Creates VR Experience at Smithsonian's Age-Old Cities Exhibition*, https://news.ubisoft.com/en-us/article/6OUATm5pVU1tO6O72rTAAA/ubisoft-creates-vr-experience-at-smithsonians-ageold-cities-exhibition [last accessed on 16th October 2023].

152 Smithsonian, *For the First Time in the US, Visitors Can Experience "Age Old Cities"—A Virtual Journey to the Devastated Sites of Mosul, Aleppo and Palmyra*, https://tinyurl.com/mrybfjbc [last accessed on 16th October 2023].

153 *Discovery Tour: A Ubisoft Original*, https://www.ubisoft.com/en-gb/game/assassins-creed/discovery-tour [last accessed on 16th October 2023].

154 France 24, *Notre-Dame Fire Donations Pour In, Spark Controversy*, 18th April 2019, https://www.france24.com/en/20190418-france-paris-notre-dame-cathedral-fire-donations-controversy [last accessed on 27th September 2023].

155 Ollie A. Williams, *Why Notre Dame Donations Are Provoking A Backlash against Billionaires*, 17th April 2019, https://www.forbes.com/sites/oliverwilliams1/

2019/04/17/why-notre-dame-donations-are-provoking-a-backlash-against-billionaires/?sh=41b189017f60; Jean-Noël Kapferer, *The Profane and the Sacred: Why Luxury Firms Rushed to Support Notre Dame*, 7th May 2019, https://theconversation.com/the-profane-and-the-sacred-why-luxury-firms-rushed-to-support-notre-dame-115739 [last accessed on 27th September 2023].

156 Ollie A. Williams, *Why Notre Dame Donations Are Provoking A Backlash against Billionaires*, 17th April 2019, https://www.forbes.com/sites/oliverwilliams1/2019/04/17/why-notre-dame-donations-are-provoking-a-backlash-against-billionaires/?sh=41b189017f60 [last accessed 27th September 2023].

157 Reuters, *Save the World like Notre-Dame, says Swedish Activist Thunberg*, 16th April, 2019, https://www.reuters.com/article/us-france-notredame-thunberg-idUSKCN1RS1TK [last accessed on 27th September 2023].

158 TotalEnergies Foundation, *A Joint Effort to Rebuild Notre-Dame Cathedral*, 26th June 2019, https://fondation.totalenergies.com/en/news/joint-effort-rebuild-notre-dame-cathedral [last accessed on 27 September 2023].

159 *Trustee Resigns from British Museum over BP Sponsorship and Artefacts Repatriation*, 16th July 2019, https://www.theguardian.com/culture/2019/jul/16/trustee-resigns-from-british-museum-over-bp-sponsorship-and-artefacts-repatriation; *Campaigners Protest against BP Sponsorship of British Museum*, 16th February 2023, https://www.theguardian.com/culture/2019/feb/16/campaigners-protest-against-bp-sponsorship-of-british-museum [last accessed on 27 September 2023].

160 *Campaigners Protest against BP Sponsorship of British Museum*, 16th February 2023, https://www.theguardian.com/culture/2019/feb/16/campaigners-protest-against-bp-sponsorship-of-british-museum [last accessed on 27 September 2023].

161 Azad Essa, *France's Notre Dame Outpouring Is a Metaphor for (In)humanity*, 22nd April 2019, https://www.middleeasteye.net/opinion/frances-notre-dame-outpouring-metaphor-inhumanity [last accessed on 27 September 2023].

162 France24, *Notre-Dame Fire Donations Pour In, Spark Controversy*, 18th April 2019, https://www.france24.com/en/20190418-france-paris-notre-dame-cathedral-fire-donations-controversy [last accessed on 27th September 2023].

163 *Tate Art Galleries Will No Longer Accept Donations from the Sackler Family*, 22nd March 2019, https://www.theguardian.com/artanddesign/2019/mar/21/tate-art-galleries-will-no-longer-accept-donations-from-the-sackler-family [last accessed on 27th September 2023].

164 *ESMA Museum and Site of Memory – Former Clandestine Centre of Detention, Torture and Extermination*, https://whc.unesco.org/en/list/1681/ [last accessed on 28th January 2024].

165 It is worth noting that the entry *Australian Convict Sites* (https://whc.unesco.org/en/list/1306/) inscribed in 2010 was not included in this analysis as it did not contain any keywords in its summary, but in its supporting documents contains references to the use of silence as punishment. The site will be explored in Chapter 5.

166 *ESMA Museum and Site of Memory – Former Clandestine Centre of Detention, Torture and Extermination*, https://whc.unesco.org/en/list/1681/, Nomination File No. 1681, p. 46 [last accessed on 28th January 2024].

167 *ESMA Museum and Site of Memory – Former Clandestine Centre of Detention, Torture and Extermination*, https://whc.unesco.org/en/list/1681/, Nomination File No. 1681, p. 46, 98 [last accessed on 28th January 2024].

168 *ESMA Museum and Site of Memory – Former Clandestine Centre of Detention, Torture and Extermination*, https://whc.unesco.org/en/list/1681/, Nomination File No. 1681, p. 44 [last accessed on 28th January 2024].

169 *ESMA Museum and Site of Memory – Former Clandestine Centre of Detention, Torture and Extermination*, https://whc.unesco.org/en/list/1681/, Nomination File No. 1681, p. 50 [last accessed on 28th January 2024].

170 *ESMA Museum and Site of Memory – Former Clandestine Centre of Detention, Torture and Extermination,* https://whc.unesco.org/en/list/1681/, Nomination File No. 1681, p. 50 [last accessed on 28th January 2024].
171 *The Charter of the Week of Sound,* https://www.lasemaineduson.org/the-charter-of-the-week-of-sound?lang=fr [last accessed on 1st May 2023].
172 *World Soundscape Project,* https://www.sfu.ca/sonic-studio/worldsound-scaperoject.html [last accessed on 21st June 2024].
173 The analysis was based on the programme for the event, http://www.ancientacoustics2011.upatras.gr/Files/Conference%20Booklet%20Program%20v8c_with%20chairmen_.pdf [last accessed on 30th March 2024].
174 The analysis was based on the programme for the event, https://acustica-aia.it/wp-content/uploads/2022/07/SAT_-program_05072022.pdf [last accessed on 30th March 2024].

References

Angas, George French (1842) *A Ramble of in Malta and Sicily, in the Autumn of 1841.* London: Smith, Elder, and Co., Cornhill.

Angelakis, Konstantinos, Rindel, Jens Holger and Gade, Anders Christian (2011) "Theatre of the Sanctuary of Asklepios at Epidaurus and the Theatre of Ancient Epidaurus: Objective Measurements and Computer Simulations," *The Acoustics of Ancient Theatres Conference,* Patras, Greece.

Baudrillard, Jean (1981) *Simulacra and Simulation,* trans. Sheila Faria Glaser. Ann Arbor: University of Michigan Press.

Beazley, Olwen and Deacon, Harriet (2007) "The Safeguarding of Intangible Heritage Values under the World Heritage Convention: Auschwitz, Hiroshima, and Robben Island," in Janet Blake (ed) *Safeguarding Intangible Cultural Heritage: Challenges and Approaches.* Builth Wells: Institute of Art and Law. pp. 93–107.

Berkaak, Odd Are (2019) "Noise and Tranquility at Stonehenge: The Political Acoustics of Cultural Heritage," in Mark Grimshaw-Aagaard, Mads Walther-Hansen and Martin Knakkergaard (eds) *The Oxford Handbook of Sound and Imagination,* Volume 1. New York: Oxford University Press. pp. 313–331.

Catros, Aurélien and Leblanc, Maxime (2021) "When Boston Isn't Boston: Useful Lies of Reconstructive Game Models", *Traditional Dwellings and Settlements Review (TDSR),* XXXII:II, 23–37.

Cameron, Christina (2010) "World Heritage Sites of Conscience and Memory," in Dieter Offenhäußer, Walther Ch. Zimmerli and Marie-Theres Albert (eds) *World* Heritage *and Cultural Diversity.* German Commission for UNESCO, https://www.unesco.de/sites/default/files/2018-07/world_heritage_and_cultural_diversity_2010.pdf [Last accessed 15th April 2024].

Commins, Daniel (1998) "The Restoration of La Fenice in Venice: The Consultant's Viewpoint," *Journal of the Acoustical* Society *of America,* 103:5, DOI: 10.1121/1.421601.

Cox, Trevor (2015) *Sonic Wonderland: A Scientific Odyssey of Sound.* London: Vintage.

Cox, Trevor J. (2021) "Modeling Sound at Stonehenge." *Physics Today,* 74:10, 74–75. DOI: 10.1063/PT.3.4865.

Cox, Trevor J., Fazenda, Bruno M. and Greaney, Susan E. (2020) "Using Scale Modelling to Assess the Prehistoric Acoustics of Stonehenge," *Journal of Archaeological Science,* 122, DOI: 10.1016/j.jas.2020.105218.

CPRE, The Countryside Charity (2021) *Access to Nature in the English Countryside: A Participant Led Research Project Exploring Inequalities in Access to the Countryside for People of Colour*, https://www.cpre.org.uk/wp-content/uploads/2021/08/August-2021_Access-to-nature-in-the-English-countryside_research-overview.pdf [Last accessed 9th April 2024].

De Muynke, Julien, Baltazar, Marie, Monferran, Martin, Voisenat, Claudie and Katz, Brian F.G. (2024) "Ears of the Past, an Inquiry into the Sonic Memory of the Acoustics of Notre-Dame Before the Fire of 2019," *Journal of Cultural Heritage*, 65, 169–176, DOI: 10.1016/j.culher.2022.09.006.

Dow, Douglas N. (2013) "Historical Veneers: Anachronism, Simulation, and Art History in Assassin's Creed II," in Matthew Wilhelm Kapell and Andrew B. R. Elliott (eds) *Playing with the Past: Digital Games and the Simulation of History*. London: Bloomsbury. pp. 215–231.

Fazenda, Bruno and Drumm, Ian (2013) "Recreating the Sound of Stonehenge," *Acta Acustica United with Acustica*, 99:1, 110–117. DOI: 10.3813/AAA.918594.

Iannace, G., Marletta, L., Sicurella, F. and Ianniello, E. (2010) "Acoustic Meausrements in the Ear of Dionysius at Syracuse (Italy)," *Internoise 2010*, 13–16 June 2010, Lisbon, Portugal, https://tinyurl.com/34bm4etv [Last accessed 10th April 2024].

Ianniello, Carmine (2005), "An Acoustic Catalogue of Historical Italian Theatres for Opera," *Forum Acusticum 2005. Proceedings of Forum Acusticum 2005*, Budapest, Hungary, September 2005.

ICOMOS (2019) *The Future of Our Pasts: Engaging Cultural Heritage in Climate Action. Outline of Climate Change and Cultural Heritage*, https://indd.adobe.com/view/a9a551e3-3b23-4127-99fd-a7a80d91a29e [Last accessed 14th April 2024].

Katz, Brian F.G., Murphy, Damian, Farina, Angelo (2020) "The Past Has Ears (PHE): XR Explorations of Acoustic Spaces as Cultural Heritage," in Lucio Tommaso De Paolis and Patrick Bourdot (eds) *Augmented Reality, Virtual Reality, and Computer Graphics. AVR 2020. Lecture Notes in Computer Science*, vol. 12243, Cham: Springer, DOI: 10.1007/978-3-030-58468-9_7.

Katz, Brian F.G. and Weber, Antoine (2020) "An Acoustic Survey of the Cathédrale Notre-Dame de Paris before and after the Fire of 2019," *Acoustics*, 2:4, 791–802. DOI: 10.3390/acoustics2040044.

Krause, Bernie (2013) *The Great Animal Orchestra. Finding the Origins of Music in the World's Wild Places*. London: Profile Books.

Krauss, Sebastian, Völkel, Simeon, Dobner, Christoph, Völkel, Alexandra and Huang, Kai (2019) "Acoustics of Margravial Opera House Bayreuth," *Fortschritte der Akustik - DAGA 2019*, DOI: 10.48550/arXiv.1905.13578.

Lokki, Tapio, Southern, Alex, Siltanen, Samuel and Savioja, Lauri (2013) "Acoustics of Epidaurus – Studies with Room Acoustic Modelling Methods," *Acta Acustica United with Acustica*, 99:1, 40–47, DOI: 10.3813/AAA.918586.

López, Mariana (2023) "Playing the Sonic Past: Reflections on Sound in Medieval-Themed Video Games," in Robert Houghton (ed) *Playing the Middle Ages: Pitfalls and Potential in Modern Games*. London: Bloomsbury. pp. 51–74.

Neal, Sarah (2002) "Rural Landscapes, Representations and Racism: Examining Multicultural Citizenship and Policy-Making in the English Countryside," *Ethnic and Racial Studies*, 25:3, 442–461.

Postma, Bart N.J. and Katz, Brian F.G. (2016) "Acoustics of Notre-Dame cathedral de Paris," *22nd International Congress on Acoustics*, Buenos Aires, 5–9 September 2016, http://www.ica2016.org.ar/ica2016proceedings/ica2016/ICA2016-0269.pdf.

Prodi, Nicola, Pompoli, Roberto, Martellotta, Francesco and Sato, Shin-ichi (2015) "Acoustics of Italian Historical Opera Houses," *Journal of Acoustical Society of America*, 138:2, 769–781. DOI: 10.1121/1.4926905.

Psarras, Sotirios, Hatziantoniou, Panagiotis, Kountouras, Mercury, Tatlas, Nicolas-Alexander, Mourjopoulos, John N., Skarlatos, Dimitrios (2013) "Measurements and Analysis of the Epidaurus Ancient Theatre Acoustics," *Acta Acustica United with Acustica*, 99:1, 30–39, DOI: 10.3813/AAA.918585.

Ramirez, Janina (2022) *Femina. A New History of the Middle Ages, Through the Women Written Out of It*. London: WH Allen.

Rindel, Jens Holger and Nielsen, Martin Lisa (2006) "The ERATO Project and Its Contribution to Our Understanding of the Acoustics of Ancient Greek and Roman Theatres," *ERATO Project Symposium, Proceedings*, 1–10. https://backend.orbit.dtu.dk/ws/portalfiles/portal/2457747/oersted-dtu2523.pdf.

Rindel, Jens Holger (2011) "The ERATO Project and Its Contribution to Our Understanding of the Acoustics of Ancient Theatres," *The Acoustics of Ancient Theatres Conference*, Patras, September 18–21, 2011, https://tinyurl.com/yn8hwzys.

Rindel, Jens Holger (2013) "Roman Theatres and Revival of Their Acoustics in the ERATO Project," *Acta Acustica United with Acustica*, 99, 21–29, DOI 10.3813/AAA.918584.

Robertson, Emma (2008) "I Get a Real Kick Out of Big Ben': BBC Versions of Britishness on the Empire and General Overseas Service, 1932–1948," *Historical Journal of Film, Radio and Television*, 28:4, 459–473, DOI: 10.1080/01439680802310274.

Schafer, R. Murray (1994). *The Soundscape: Our Sonic Environment and the Tuning of the World*. Rochester, Vt.: Destiny Books.

Schwartz, Madeleine, Khurana, Malika, Gröndahl, Mika and Parshina-Kottas, Yuliya (2023), "A Cathedral of Sound," Text by Madeleine Schwartz, March 3, 2023. *The New York Times Magazine*, https://www.nytimes.com/interactive/2023/03/03/magazine/notre-dame-cathedral-acoustics-sound.html [Last accessed 13 September 2023].

Shankland, Robert S. (1973), "Acoustics of Greek theatres," *Physics Today*, 26, 30–35.

Sinamai, Ashton (2018) "Melodies of God: The Significance of the Soundscape in Conserving the Great Zimbabwe Landscape," *Journal of Community Archaeology & Heritage*, 5:1, 17–29, DOI: 10.1080/20518196.2017.1323823.

The Week of Sound (n.d.) *The Charter of the Week of Sound*, https://www.lasemaineduson.org/the-charter-of-the-week-of-sound?lang=fr [Last accessed 1st May 2023].

Thompson, Marie (2017). *Beyond Unwanted Sound: Noise, Affect and Aesthetic Moralism*. New York: Bloomsbury Academic.

Till, Rupert (2019) "Sound Archaeology: A Study of the Acoustics of Three World Heritage Sites, Spanish Prehistoric Painted Caves, Stonehenge, and Paphos Theatre". *Acoustics*, 1: 3, 661–692. DOI: 10.3390/acoustics1030039.

Tronchin, Lamberto and Farina, Angelo (1997) "Acoustics of the Former Teatro "La Fenice" in Venice," *Journal of Audio Engineering Society*, 45: 12.

Tronchin, Lamberto, Merli, Francesca and Manfren, Massimiliano (2021), "On the Acoustics of the *Teatro 1763* in Bologna," *Applied Acoustics*, 172, 107598, DOI: 10.1016/j.apacoust.2020.107598.

UNESCO (1977) *Operational Guidelines for the Implementation of the World Heritage Convention*, https://whc.unesco.org/archive/1977/cc-77-conf001-8reve.pdf [Last accessed 30th April 2023].

UNESCO (1979a) Convention concerning the protection of the world cultural and natural heritage. Third session of the World Heritage Committee. *Item 6 of the Provisional Agenda: Principles and Criteria for Inclusion of Properties on World Heritage List*, https://whc.unesco.org/archive/1979/cc-79-conf003-11e.pdf [Last accessed 7th April 2024].

UNESCO (1979b) *Grand Canyon National Park*, https://whc.unesco.org/en/list/75/ [Last accessed 8th August 2023].

UNESCO (1980) *Operational Guidelines for the Implementation of the World Heritage Convention*, https://whc.unesco.org/archive/opguide80.pdf [Last accessed 30th April 2023].

UNESCO (1985a) *Keoladeo National Park*, https://whc.unesco.org/en/list/340 [Last accessed 13th August 2023].

UNESCO (1985b) *Quseir Amra*, https://whc.unesco.org/en/list/327/ [Last accessed 15th August 2023].

UNESCO (1986a) *Great Zimbabwe National Monument*, https://whc.unesco.org/en/list/364/ [Last accessed 17th August 2023].

UNESCO (1986b) *St Kilda*, https://whc.unesco.org/en/list/387 [Last accessed 8th August 2023].

UNESCO (1986c) *Stonehenge, Avebury and Associated Sites*, https://whc.unesco.org/en/list/373 [Last accessed 16th August 2023].

UNESCO (1987) *Palace of Westminster and Westminster Abbey including Saint Margaret's Church*, https://whc.unesco.org/en/list/426 [Last accessed 8th August 2023].

UNESCO (1988) *Sanctuary of Asklepios at Epidaurus*, https://whc.unesco.org/en/list/491/ [Last accessed 8th August 2023].

UNESCO (1989) *Archaeological Site of Olympia*, https://whc.unesco.org/en/list/517/ [Last accessed 15th August 2023].

UNESCO (1990) *Historic Centre of San Gimignano*, https://whc.unesco.org/en/list/550/ [Last accessed 15th August 2023].

UNESCO (1991) *Royal Domain of Drottningholm*, https://whc.unesco.org/en/list/559/ [Last accessed 16th August 2023].

UNESCO (1992) *Wulingyuan Scenic and Historic Interest Area*, https://whc.unesco.org/en/list/640/ [Last accessed 13th August 2023].

UNESCO (1993) *Complex of Hué Monuments*, https://whc.unesco.org/en/list/678/ [Last accessed 16th August 2023].

UNESCO (1994) *Operational Guidelines for the Implementation of the World Heritage Convention*, https://whc.unesco.org/archive/opguide94.pdf [Last accessed 30th April 2023].

UNESCO (1995a) *Cultural Landscape of Sintra*, https://whc.unesco.org/en/list/723/ [Last accessed 13th August 2023].

UNESCO (1995b) *Historic Quarter of the City of Colonia del Sacramento*, https://whc.unesco.org/en/list/747/ [Last accessed 16th August 2023].

UNESCO (1997) *Morne Trois Pitons National Park*, https://whc.unesco.org/en/list/814/ [Last accessed 8th August 2023].

UNESCO (1998) *Mdina (Citta' Vecchia)*, https://whc.unesco.org/en/tentativelists/983/ [Last accessed 21st August 2023].

UNESCO (1999a) *Historic City of Vigan*, https://whc.unesco.org/en/list/502/ [Last accessed 15th August 2023].

UNESCO (1999b) *Mount Wuyi*, https://whc.unesco.org/en/list/911/ [Last accessed 13th August 2023].

UNESCO (2000a) *Ancient Villages in Southern Anhui – Xidi and Hongcun*, https://whc.unesco.org/en/list/1002/ [Last accessed 13th August 2023].

UNESCO (2000b) *Imperial Tombs of the Ming and Qing Dynasties*, https://whc.unesco.org/en/list/1004/ [Last accessed 13th August 2023].

UNESCO (2002a) *The Djavolja Varos (Devil's Town) Natural Landmark*, https://whc.unesco.org/en/tentativelists/1700/ [Last accessed 20th August 2023].

UNESCO (2002b) *Upper Middle Rhine Valley*, https://whc.unesco.org/en/list/1066/ [Last accessed 15th August 2023].

UNESCO (2003) *Purnululu National Park*, https://whc.unesco.org/en/list/1094/ [Last accessed 13th August 2023].

UNESCO (2004a) *Ilulissat Icefjord*, https://whc.unesco.org/en/list/1149/ [Last accessed 8th August 2023].

UNESCO (2004b) *Yalo, Apialo and the Sacred Geography of Northwest Malakula*, https://whc.unesco.org/en/tentativelists/1971/ [Last accessed 17th August 2023].

UNESCO (2005a) *Historic Centre of Macao*, https://whc.unesco.org/en/list/1110/ [Last accessed 13th August 2023].

UNESCO (2005b) *Operational Guidelines for the Implementation of the World Heritage Convention*, https://whc.unesco.org/archive/opguide05-en.pdf [Last accessed 30th April 2023].

UNESCO (2005c) *Syracuse and the Rocky Necropolis of Pantalica*, https://whc.unesco.org/en/list/1200/ [Last accessed 15th August 2023].

UNESCO (2007a) *Arochkwu Long Juju Slave Route (Cave Temple Complex)*, https://whc.unesco.org/en/tentativelists/5170/ [Last accessed 17th August 2023].

UNESCO (2007b) *Kaiping Diaolou and Villages*, https://whc.unesco.org/en/list/1112/ [Last accessed 13th August 2023].

UNESCO (2008a) *Melaka and George Town, Historic Cities of the Straits of Malacca*, https://whc.unesco.org/en/list/1223/ [Last accessed 15th August 2023].

UNESCO (2008b) *Monarch Butterfly Biosphere Reserve*, https://whc.unesco.org/en/list/1290 [Last accessed 8th August 2023].

UNESCO (2009) *Mount Wutai*, https://whc.unesco.org/en/list/1279/ [Last accessed 13th August 2023].

UNESCO (2010a) *Central Sector of the Imperial Citadel of Thang Long – Hanoi*, https://whc.unesco.org/en/list/1328/ [Last accessed 16th August 2023].

UNESCO (2010b) *Historic Monuments of Dengfeng in "The Centre of Heaven and Earth,"* https://whc.unesco.org/en/list/1305/ [Last accessed 14th August 2023]

UNESCO (2011a) *Citadel of the Ho Dynasty*, https://whc.unesco.org/en/list/1358/ [Last accessed 16th August 2023].

UNESCO (2011b) *The Persian Garden*, https://whc.unesco.org/en/list/1372/ [Last accessed 8th August 2023].

UNESCO (2011c) *West Lake Cultural Landscape of Hangzhou*, https://whc.unesco.org/en/list/1334 [Last accessed 14th August 2023].

UNESCO (2012) *Margravial Opera House Bayreuth*, https://whc.unesco.org/en/list/1379 [Last accessed 8th August 2023].

UNESCO (2013) *Cultural Landscape of Honghe Hani Rice Terraces*, https://whc.unesco.org/en/list/1111/ [Last accessed 14th August 2023].

UNESCO (2014a) *Ancient Greek Theatres*, https://whc.unesco.org/en/tentativelists/5869/ [Last accessed 20th August 2023].

UNESCO (2014b) *Namhansanseong*, https://whc.unesco.org/en/list/1439/ [Last accessed 16th August 2023].

UNESCO (2014c) *The Grand Canal*, https://whc.unesco.org/en/list/1443/ [Last accessed 14th August 2023].

UNESCO (2014d) *Trang An Landscape Complex*, https://whc.unesco.org/en/list/1438/ [Last accessed 13th August 2023].

UNESCO (2015a) *Christiansfeld, a Moravian Church Settlement*, https://whc.unesco.org/en/list/1468/ [Last accessed 15th August 2023].

UNESCO (2015b) *The Theatre and Aqueducts of the Ancient City of Aspendos*, https://whc.unesco.org/en/tentativelists/6036/ [Last accessed 20th August 2023].

UNESCO (2015c) *Xinjiang Yardang*, https://whc.unesco.org/en/tentativelists/5989/ [Last accessed 17th August 2023].

UNESCO (2016) *Sultan Bayezid II Complex: A Center of Medical Treatment*, https://whc.unesco.org/en/tentativelists/6117/ [Last accessed 17th August 2023].

UNESCO (2017a) *Head Office and Garden of the Calouste Gulbenkian Foundation*, https://whc.unesco.org/en/tentativelists/6228/ [Last accessed 21st August 2023].

UNESCO (2017b) *Kujataa Greenland: Norse and Inuit Farming at the Edge of the Ice Cap*, https://whc.unesco.org/en/list/1536/ [Last accessed 15th August 2023].

UNESCO (2017c) *Kulangsu, a Historic International Settlement*, https://whc.unesco.org/en/list/1541/ [Last accessed 14th August 2023].

UNESCO (2017d) "The importance of sound in today's world: promoting best practices." Item 4.10 of the provisional agenda. *General Conference, 39th Session*, Paris, 2017, https://unesdoc.unesco.org/ark:/48223/pf0000259172/PDF/259172eng.pdf. multi [Last accessed 1st May 2023].

UNESCO (2018a) *Aasivissuit – Nipisat. Inuit Hunting Ground between Ice and Sea*, https://whc.unesco.org/en/list/1557 [Last accessed 7th April 2024].

UNESCO (2018b) *Fanjingshan*, https://whc.unesco.org/en/list/1559/ [Last accessed 14th August 2023].

UNESCO (2018c) *Shwedagon Pagoda on Singuttara Hill*, https://whc.unesco.org/en/tentativelists/6367/ [Last accessed 21st August 2023].

UNESCO (2019a) *French Austral Lands and Seas*, https://whc.unesco.org/en/list/1603/ [Last accessed 9th August 2023].

UNESCO (2019b) *Migratory Bird* Sanctuaries *along the Coast of Yellow Sea-Bohai Gulf of China*, https://whc.unesco.org/en/list/1606/ [Last accessed 14th August 2023].

UNESCO (2020) *Lalish Temple*, https://whc.unesco.org/en/tentativelists/6467/ [Last accessed 20th August 2023].

UNESCO (2021) *Historical Theatres of the Marche Region*, https://whc.unesco.org/en/tentativelists/6556/ [Last accessed 20th August 2023].

UNESCO (2022) *Manual Bell Ringing*, https://ich.unesco.org/en/RL/manual-bell-ringing-01873 [Last accessed on 7th May 2023].

UNESCO (2023a) *ESMA Museum and Site of Memory – Former Clandestine Centre of Detention, Torture and Extermination*, https://whc.unesco.org/en/list/1681/ [Last accessed 28th January 2024].

UNESCO (2023b) *Mfangano Island Rock* Art *Sites*, https://whc.unesco.org/en/tentativelists/6682/ [Last accessed 21st August 2023].

UNESCO (n.d.) *World Heritage List*, https://whc.unesco.org/en/list [Last accessed 1st September 2023].

Vassilantonopoulos, Stamatis, Hatziantoniou, Panagiotis, Tatlas, Nicolas-Alexander, Zakynthinos, Tilemachos, Skarlatos, Dimitrios, Mourjopoulos, John N. (2011) "Measurements and Analysis of the Acoustics of the Ancient Theatre of Epidaurus," *The Acoustics of Ancient Theatres Conference*, Patras, Greece, http://www.ancientacoustics2011.upatras.gr/Files/Vassilantonopoulos%20et%20al._Epidauros%20Measurements.pdf [Last accessed 10th April 2024].

5

SHARING THE SOUNDS OF THE PAST

Installations and Experiences

Introduction

The overreliance on sight and, as a result good visibility, for experiencing museums and heritage sites is a nineteenth century invention, one which we have come to accept as the norm (Bennett 1998; Classen 2017; Foster 2013). This has been accompanied by research language that focuses on "seeing" and visually oriented terminology, such as mapping, framing, visualising, representing, focusing, and shedding light (Hamilakis 2015: 52). This chapter explores the role of sound in interrogating this ocularcentric approach to heritage. It does so by focusing on sound installations and online experiences which are linked to acoustical heritage and historical soundscapes. These discussions will be used as a vehicle to explore what versions of the past those experiences are articulating and, critically, what they are leaving behind. I will be exploring the main techniques utilised for these experiences, examining their technical aspects and modes of presentation, as well as the ethos behind different types of production and the reasons why certain historical events have been underexplored within the sonic realm, especially in relation to heritage of trauma and sites of conscience and memory. The examples provided will be connected to a novel framework in which sound heritage work is reflected in terms of *evocation, recreation, dramatisation, artistic reflection, remote access,* and *trauma.* In so doing the discussion ahead will outline the opportunities and challenges presented by different approaches and reflect on paths towards good practice.

DOI: 10.4324/b22976-5

Sensoriality in Heritage Sites

Renaissance "Cabinets of Curiosities" were multisensory experiences: they were not governed by sight but were framed instead as opportunities to initiate conversations on the items on display (Bennett 1998). Speaking and listening *as well as* seeing were key to the experience (Bennett 1998; Stafford 1994), alongside taste, smell, and touch, with the handling of objects being a common practice (Classen 2017: 20–21). However, Cabinets of Curiosities are not the only examples of multisensory cultural experiences. Classen (2017) explores the seventeenth century Arundel collection, reflecting on how the pieces would have been experienced in scented environments, with some of the paintings and statues potentially even receiving incense tributes (2017: 109). Contemporary museums often separate the pieces they house from their original contexts, ignoring the sensorial experiences they were originally embedded and facilitated in. For example, medieval religious relics were commonly touched, kissed, and even licked: practices that were central to their religious significance (Classen 2017: 13). In contrast, when these artefacts (and those akin to them) are displayed beyond the reach of touch, relegated to being seen only from a distance, the dimensions of taste, touch, and smell are wholly erased, despite being crucial to their history, and so denying believers those connections they were otherwise meant to have with them (Classen 2017: 23). The contemporary museum has transformed these objects into ocular spectacles, divorced from their original contexts, and relegated to a domain of sight they were never meant to inhabit solely – impoverishing their sensual value (Classen 2017: 24).

The evolution of the contemporary museum has sanctioned this privileging of sight and the subjugation of other senses, for "these were deemed to detract from, even contaminate, the aesthetic experience" (Classen 2017: 114). *No touching* rules in the eighteenth century also very much depended on who was doing the touching, with class being at the forefront of such considerations (Classen 2017: 117). Higher classes were deemed worthy of object handling, whereas working classes (especially women) did not just threaten to ruin the objects before them but also threatened to turn those valuable objects into merely "ordinary" (Classen 2017: 117–118). In 1832 rules for those visiting the British Museum included no touching, no loud talking, and not being obtrusive, rules that were accompanied by an increase in the presence of guards (Classen 2017: 119). Rules on *no touching* expanded to all visitors, with higher classes accepting this change more easily than one would have expected, as sight had by this time become intellectually and aesthetically dominant, with the contaminating intimacies of touch deemed an undesirable association (Classen 2017: 120).

These historic trends aside, since the late twentieth century there has been a rise in multisensory experiences in museums, what Classen refers to as the

"sensationalization of cultural heritage" (2017: 117). Classen considers this is not so much a result of changes in museum curation practices – given objects deemed to be interesting to look at might still be prioritised over those engaging other senses (2017: 127) – but as a result of changes in the types of pieces that contemporary artists are creating, with museums thus wanting to be seen as on-trend (Classen 2017: 115–116, 137–138). As noted by Classen, such expansion on sensorial experiences can have various benefits (2017: 117). Firstly, it might result in the integration of different types of art, such as those previously considered too tactile to be included in fine art establishments, such as textile art – so often associated negatively with "craft" and women's work especially. Secondly, it can make cultural sites less intimidating, while helping evoke aspects of the pieces' original contexts. Thirdly, it can provide a wider experience at a time in which visual artworks and reproductions thereof are ubiquitous. Finally, it can help open opportunities for the provision of experiences for visually impaired visitors. On this point, however, Classen argues that museums themselves, by shying away from the centrality of tactile experiences, are effectively relegating touch tours for visually impaired people to the status of second-hand experiences – offering only a small sample of the holdings of a museum or gallery and generally those considered to be more durable and withstand touch (2017: 126, 127, 129). The effect is to further separate the general visitor experience from the accessible experience, rather than integrating them (Classen 2017: 126, 127, 129). Moreover, in cases where tactile experiences are positioned as being central to a museum or heritage site, these are generally just in the form of transient exhibitions, such as the 2005 V&A "Touch Me" exhibition in London,[1] or as hands-on stations installed somewhere within a gallery space (Classen 2017: 129).

Experiences beyond touch have also featured in different museums and galleries, although still as peripheral or circumstantial as those discussed above. Examples include the kinetic exhibition "Play Time" at the Toledo Museum of Art in the USA in 2015, which featured among other pieces Toshiko Horiuchi MacAdam's *Harmonic Motion*, a gigantic multi-person crocheted hammock (Classen 2017: 130).[2] Another example is found in the work of the curatorial group the Balloon Museum, which has been setting up inflatable art exhibitions since 2020.[3] At the time of writing (December 2023) their exhibition *EmotionAir: Art You Can Feel* has just opened in London, featuring work by 20 artists. It has been advertised as

artwork one can touch, exist with, and most importantly share the experience with those around them. A never still or static atmosphere that creates a special relationship with the user, giving life to a new experiential path of socialization.[4]

The exhibition includes the installation *Hyperfeeling* by Hyperstudio, Sila Sveta, and Kissmiklos, which invites visitors to immerse themselves in the

representation of human emotions through a combination of a pool of yellow balls, including some with representations of emojis, and a ceiling composed of yellow balloons, with both being experienced alongside a multisensory and multimedia show.[5] Although kinetic experiences are central to the Balloon Museum's ethos, it is worth mentioning that the exhibition still circles back to the visual, with a focus on "Instagrammable" moments. With the hashtag #emotionair being used, signs throughout the London exhibition encourage visitors to share images of their experience, and there is an exhibition room dedicated to booths for people to pose in.[6]

Turning briefly to olfactory experiences, one example is provided by Denver Art Museum's (USA) *The Impressionist Garden: Scent Experience*, as part of the 2015 *In Bloom: Painting Flowers in the Age of Impressionism* exhibition (Classen 2017: 133). This featured "olfactory art" by Dawn Spencer-Hurwitz, which sought to replicate the scents of the flowers in the paintings and to create a general olfactory experience of Impressionism as a whole.[7]

In terms of sonic experiences, Classen also describes the 2015 *Soundscapes* exhibition in London's National Gallery (Classen 2017: 1345), which sported the slogan "Hear the painting. See the sound". The exhibition invited six musicians and sound artists to select paintings from the Gallery's collection and compose a sonic response that could be experienced by visitors,[8] which is a type of sonic intervention that will be explored further on in this chapter.

An example of a wider multisensorial provision is the 2015 *Tate Sensorium* in Tate Britain, London. This was a temporary exhibition centred around four British paintings from the twentieth century, each presented in dark, spot-lit environments that also contained different sensorial experiences.[9] A taste experience was available through the use of especially created work by chocolatier Paul A. Young, which was inspired by Francis Bacon's *Figure in a Landscape*. Fragrances by Odette Toilette were created to explore Richard Hamilton's *Interior II*, tapping into the connection between smell and memory.[10] Haptics was also featured as part of an installation by *ultrahapticss* (now *ultraleap*), and, running throughout the exhibition, was audio by sound designer Nick Ryan. The audio changed in focus depending on the proximity of the visitor to a painting, with more realistic sounds, related to what can be seen, playing when a visitor came closer and becoming more abstract (related to the process of making the piece) when the visitor moved further away.[11] Visitors also wore a wristband which took their physiological measurements throughout their tour of the exhibition, before being asked to complete an online questionnaire at the conclusion of the visit, which, on answering, gave them a summary of their sensorial experiences and suggested what other artworks in the gallery they might enjoy based on their results – for example, whether they responded more strongly to tactile or auditory aspects.[12] However, it is

worth noting that the overriding aim of *Tate Sensorium* was to get visitors to focus on the visual qualities of the paintings featured, increasing dwell time, and so ultimately undermining its claims of celebrating the full human sensorium.[13]

Classen (2017) argues that exhibitions and their approaches to sensorial experiences are political, such as in how multimedia exhibitions are perceived in relation to the value assigned to collections (Classen 2017: 139–140). Ethnographic museums, she reflects, are often considered to be appropriate spaces for the use of multimedia material that immerses the visitor in the culture in question, chiefly because the work presented is not considered "high culture", with "exotic" collections requiring extra curatorial context – both aspects feeding into longstanding stereotypes surrounding indigenous populations as irrational, sensuously oriented groups (Classen 2017: 139–140). In contrast, the use of multimedia presentations in, for instance, exhibitions of Renaissance art might, Classen observes, meet resistance for the exact inverse of these reasons (Classen 2017: 139–140). One example of this can be found in reviews for the National Gallery's 2015 *Soundscapes* exhibition described above, with the negative reviews emphasising the irrelevance of sonic experiences for visual art, which is meant to be experienced in silence.[14] Positive reviews directed their praise mainly at the positioning of each painting in a separate, darkly lit room (the same configuration chosen for *Tate Sensorium*), along with the muffling of sounds from other visitors that was produced by the separation between spaces – with one reviewer arguing that it presented the "ideal viewing conditions" that are otherwise ruined by the inclusion of sound.[15] Further criticism contended that the National Gallery was engaging in a misguided effort at appearing cool and catering for younger audiences –[16] imagine the horror of wanting to do that! The choice of darkly lit rooms by both exhibitions is in itself an indicator of the preconceptions held by both galleries, both in terms of centring the visual experience, with sound as merely a complement, alongside the perceived need to remove distractions in non-verbal audio experiences.

Scepticism of non-verbal audio experiences (outside of music contexts) is not new and can be connected to Chion's theory of *vococentrism* which states that if voice is present, in an audio only or audio-visual piece, it takes precedence over all other sonic elements (1999). When it comes to sounds, there is the voice, and everything else (Chion 1999: 5–6). One could extend this concept and argue that when there is no voice in contexts in which audiences would expect one (audio experiences in art galleries tend to be based on verbal explanations), they may be experienced as incomplete. An example of this is the 1978 BBC Radio 3 drama *The Revenge*, a binaural radio play with no words, written and performed by Andrew Sachs. Both creators and reviewers seemed reluctant to accept that sound beyond words could actually provide a meaningful experience to audiences (Lopez and Pauletto

2010). When originally aired creators went as far as preceding the play with an interview with Andrew Sachs and head of radio drama Ronald Mason in which it was highlighted that *The Revenge* was just an experiment, and by no means a trend they were trying to establish (Lopez and Pauletto 2010). They were not looking to move away from the almighty voice! What is more, they included instructions on how people should listen to the piece, which highlighted their preconception of it as an unnatural media experience (Lopez and Pauletto 2010):

> I think the listener should listen in as quiet a room as possible, preferably the windows closed and if they can arrange so they are not distracted during the twenty odd minutes that the play runs, and there are as few extraneous sounds as possible. I think this will help them to enjoy *The Revenge* as a play, which is what it is after all.[17]

Similar tendencies have been found in work on film accessibility for visually impaired audiences. When the voice, through Audio Description (a verbal commentary), was present, audiences relied heavily on the words to gain access to a piece, even though other sound elements, such as sound effects and reverberation, might have conveyed the same meaning (Lopez, Kearney, and Hofstädter 2020). This lack of confidence in the interpretation of sounds beyond the voice is possibly due to an unfamiliarity with non-verbal formats, which is in turn a result (albeit partial) of their being fewer non-verbal audio creations beyond music in the popular media. Similarly, one analysis of audio games which have been designed with visually impaired players in mind has also shown an overreliance on the voice at the expense of richer sonic experiences, potentially hinting to a fear by designers of a lack of clarity and engagement resulting from non-verbal audio, which in turn results in a lack of opportunities for familiarisation and adaptation for gamers (López 2023a, 2023b).

Classen (2017) argues that another example of the political stance of sensorial exhibitions is their approach to gender and tactility. Classen (2017) argues that tactile art has struggled to attain high status precisely due to its association with women's work, textile work, for example. By comparison, artwork created using novel technologies that result in a tactile experience has been more easily embraced, due to its association with engineering complexity and, by extension, masculine mastery. This argument connects us back to *Tate Sensorium*, which was heavily focused on the technology involved, far more so than the National Gallery's *Soundscapes* exhibition, and was subsequently the winner of the 2015 IK Prize – a prize issued by the Tate institution and granted to proposals that use digital technology innovatively to engage visitors with its collections.[18] Although reviews for the *Soundscapes* exhibition tended to be particularly negative, reviews for

Tate Sensorium tended to be oddly neutral or mixed, descriptively factual in emphasis, and focusing on the technology driving the experience.[19] It is possible that the combination of digital technology and twentieth century abstract art, which can be deemed more difficult to engage with, resulted in a less controversial proposition than layering sound experiences onto more realistic, traditionally coded aesthetic practices.

The following section will now move away from this initial exploration of the politics of multisensoriality in heritage sites and focus specifically on the role of sound in heritage experiences more generally.

A New Theoretical and Practical Framework

In 2020 I set about developing a novel framework to classify different types of sound installations and online experiences which explored the acoustics and sounds of the past (López 2020). This framework sought to aid critical reflection on how these experiences deployed sound to generate meaning, chiefly in terms of (1) *sound as evocation*, (2) *sound as recreation of the past*, and (3) *sound as artistic reflection on the past*. In the sections ahead I will expand on these core categories while also outlining new ones. This expanded framework still aims to reflect on the use of sound in heritage sites, but it is neither exhaustive in scope nor closed in terms of the specific categories it develops. As it will be seen, some examples presented could potentially be situated across multiple categories depending on how they are analysed. The categorisations presented here are thus intended to serve the purpose of allowing researchers, designers, and curators to reflect on the advantages and disadvantages of different approaches, as well as how they might be combined to produce a desired effect, while also exploring why certain types of heritage have received less attention.

Before proceeding with this discussion, it is worth highlighting that there has been a wide spectrum of opinions in relation to attempts to recreate the sonic pasts. Smith (2007) indicates that the use of historical recreations should be approached with extreme caution and urges curators against claims that "history is brought to life". Smith's condemnation of such experiences stems from the fact that they often provide a one-sided recreation of sensorial experiences, lacking acknowledgement of the contextual specificity of the senses. Moreover, he contends that they might encourage visitors/listeners to believe those "are" the sounds of the past, rather than engage critically with the experience. Similarly, Hamilakis (2015: 64) remarks on the "experience economy" in heritage and how historical context is often considered of secondary importance, should it be even present, while Lacey (2017: 214) contends that there is a difference between recreating individual sounds or soundscapes and being actually able to capture the sensibilities of listeners from the past.

On the contrary, Mills (2014) considers the creation of immersive experiences as one of the key assets of auditory archaeology. Foster (2013) also presents a more positive outlook, considering how to present multisensory experiences in museums and do so ethically and contextually. Foster notes the importance of museums encouraging visitors to provide their own interpretation in multisensory exhibitions, supporting an understanding that sensorial experiences are personal and, as such, can be infinite. Hunter-Crawley (2020: 442) goes a step further and puts forward the idea that replica artefacts, re-enactments, and virtual models could be used for more than just heritage dissemination and could be central to the study of their sensorial affordances, by exploring the multiplicity of ways people might interact with them. The variety of uses and interactions that are likely to arise, Hunter-Crawley argues, are likely to help us reflect on ways in which they might have been used, and would represent a crowdsourcing of experiences.

It is worth noting at this point that the use of sound in museums and heritage sites invites the visitor to negotiate two main spaces and temporalities: the space of the site they are visiting and navigating, and the historical space and time that is being recreated and played through headphones or loudspeakers. Schulze (2013) comments on the irritation visitors may experience when a recreated soundscape is played over headphones and is consequently overlaid on the soundscape of the venue itself, limiting their ability to communicate with fellow visitors and so causing confusion and disorientation. Similarly, Whittington (2019) believes headphone use has a negative impact on social experiences in museums by masking the sounds of movement throughout the venue, the sounds that might result from navigating in a space with other visitors in it, and precluding conversations on what is being listened to. Schulze (2013) suggests instead that audio guide designers could learn from the techniques of soundwalking (Westerkamp 2001) – creating a synergy between the sounds of the space and the body's rhythms. However, it should be observed that bone-conducting headphones that leave the ears uncovered can also be used to negotiate those two sonic spaces and potentially even create playful overlaps between the past and present. Furthermore, the competing sound environments Schulze and Whittington reflect on are not the exclusive domain of site-specific installations and can occur also during online experiences, with listeners negotiating the concurrent sounds of their home, leisure, or work environment alongside the one being presented through an interactive interface.

This book argues that sonic experiences are crucial to sharing aspects of acoustical heritage and historical soundscapes beyond academic environments and are essential to moving away from ocularcentric approaches to heritage. Nevertheless, it also contends that ethical considerations are crucial to all these undertakings, extending into *what* history is being represented and *how*.

Sound as Evocation

In creating the category of *Sound as Evocation*, I am referring to sound installations and online experiences in which sound is designed primarily to evoke the past, working with popularly established preconceptions to facilitate this. These will involve sounds that visitors would readily associate with a historical period so as to encourage their sense of immersion within a site. An example here would be the playing of plainchant recordings as a means of cueing heritage site visitors into a medieval ecclesiastical setting. This particular association is founded on the real historical role of medieval period plainchant as a key mode of musical expression within ecclesiastical settings. Plainchant thus provides an effective means of invoking an array of images and atmospheres associated with the medieval period. However, individual sounds and combinations of sounds may be used that are not rooted in historical facts but are instead a consequence of the way contemporary media has represented a period. At this point, it should be observed that media representations of the past do not simply depict it but also transform its meaning (Elliott 2017). When referring to the Middle Ages, a period a lot of my work is focused on, these shifts are characterised as *medievalisms*: the appropriation and reinterpretation of the Middle Ages (Workman 1997). The medievalisms found across films, television, and videogames often themselves refer back to a longer history of medievalisms, rather than to the historical record of the Middle Ages (Haines 2014). Anachronisms might be used as an avenue to tell a story from the past to modern listeners, in the same way a film might exploit such anachronisms to render it more appealing to modern audiences (Pugh and Weisl 2013). As with these films, sound experiences can be thought of as a representation of what the creators believe is the version of the past that visitors would like to be presented with (Aberth 2003). Whether based on historical records or by taking a more liberal interpretation of the past, such uses of sound can provide a gateway to engage visitors with a heritage site and encourage them to explore further after their visit. Therefore, while such experiences cannot replace the historical knowledge present in academic texts, they might encourage visitors to learn more about the site and the period in question (see Aberth 2003 for a reflection on this in a film context). Nevertheless, this type of installation can also be more a reflection of a contemporary imaginary than anything linked to the period being represented – an imaginary which, when reproduced by experience after experience, establishes an illusion of historical "truth" that reinforces reductive and misleading stereotypes.

Evocative soundscapes always operate by taking visitor preconceptions of the past as their starting point. Although not necessarily accurate according to scholarly knowledge, these are nevertheless already crystallised in a visitor's mind, and so can assist the designer and curator in their efforts to

connect with modern audiences. However, we always need to ask ourselves whether such connection is done by reinforcing stereotypes at the expense of an opportunity for informative change. In the context of videogames, I have observed how a number of *sonic medievalisms* (Cook 2020) are recurrent, crystallising a version of the sounds of the Middle Ages that clouds diversity and embraces uniformity against evidence of sonic specificity across geographical regions (López 2023a). Such uniformity can help reinforce erroneous beliefs of medieval people as a monolithic group with uniform viewpoints, who are often characterised with disdain and a lack of empathy within contemporary popular thinking (Sturtevant 2018). For instance, we should consider how many times the word "medieval" is deployed as a pejorative within contemporary society, used without any referral or grounding in fact. We should also acknowledge that portrayals of violence (both visually and sonically) in medievalist games are also omnipresent (López 2023a). In this regard, there are often pointed sonic contrasts between the portrayal of medieval urban centres, as places of violence and pestilence, versus pastoral settings, which are cast as spaces of tranquillity – this being rooted in pastoralist conceptions of nature and quiet that can be traced back to the sixteenth century, rather than anything we might have seen in the Middle Ages specifically (Haines 2014). These observations aside, it is in the realm of voices that the greatest preponderance of stereotypes can be found, and where a desire to please audiences lies in stark contrast with a responsibility towards the representation of diversity. In many popular videogames that deploy medievalist settings and tropes, the use of accented English to denote "foreignness" is a common resource, reinforcing constructed connections between accent and geographical regions that players may then use to judge people they encounter in real life, whereas the reality of a multilingual past is rarely portrayed (López 2023a). By contrast, main characters are often restricted to English RP (received pronunciation) or North American accents, which appear to be widely accepted by audiences and players (Haines 2014; López 2023a; Sturtevant 2018). These design practices further align these ways of speaking to the normative, making everything else an "other". Earlier on in Chapter 2 I discussed Stoever's (2016) concept of the sonic colour line, that is, the way in which how someone sounds and the sounds associated to that person are used in discriminatory ways. Stoever (2010) reflects on this in relation to the Latin American community in the USA, with the Spanish language and accented English being used as a basis for investigating people as possible illegal immigrants. Historically themed videogames risk reinforcing that sonic colour line, further normalising certain ways of sounding, those associated with constructions of "whiteness", as ahistorical while marginalising others. I argue strongly that sound designers and heritage curators (as well as game developers, film producers, and other creators) have a moral obligation to break away from these narrow, impoverished, and

highly artificial portrayals, showcasing instead the rich multicultural spaces that were an entirely quotidian reality of past societies, such as medieval London (Ramirez 2022; Redfern and Hefner 2019).

A concrete instance of *sound as evocation* is provided by my own work on the *St Thomas Way*, a heritage route launched in 2018 as part of the research and impact work led by Project Director Professor Catherine A.M. Clarke and Research Fellow and Artist in Residence Project Leader Dr Chloë McKenzie.[20] The new heritage route, running from Swansea to Hereford, was inspired by the medieval pilgrimage of William Cragh, a Welsh outlaw who in 1290 was hanged in Swansea but miraculously came back to life, an act attributed to Saint Thomas Cantilupe (Clarke 2020). Once sufficiently recovered, the grateful Cragh went on a pilgrimage to the shrine of Thomas at Hereford Cathedral (Clarke 2020). The modern heritage route consists of not one single path but a collection of 13 circular routes at various points between Swansea and Hereford. The associated walks can be found on the St Thomas Way website, which also includes multimedia content that can be used to explore the sites while visiting, as well as remotely. For this project I was asked to design three evocative pieces, a medieval harbour soundscape (mapped to Newport and Swansea), an ecclesiastical soundscape (linked to Abergavenny, Ewenny, Hereford, Llancarfan, and Margam), and a medieval market soundscape (connected to Kilpeck, Longtown, St. Fagans, and Usk). The pieces use binaural audio, which can be summarised as three-dimensional audio played over headphones, meaning that listeners get more than just left and right cues for spatialisation, they also get a sense of front and back and height.

The soundscape of a medieval harbour was designed to give listeners the impression of following an imaginary character (whose voice we cannot hear) as they step aboard a boat. We can thus hear the footsteps of the character as well as the sounds of their interaction with a rope. In the background there is generic chatter and aural cues for a coastal setting, namely the sounds of seagulls and waves lapping against the hull of the boat.

The ecclesiastical soundscape includes two medieval plainchant pieces: *Alleluia Christus Resurgens* and the medieval sequence *Veni Creator Spiritus*. The pieces were performed in an anechoic chamber at the University of York by Pierre-Philippe Dechant and Christopher O'Gorman. The audio recordings were then processed to add a cathedral setting reverb – a generic one, rather than anything specifically tailored. The start of the soundscape, as well as the division between the two pieces, is punctuated by the addition of recordings of medieval bells which were carried out in the city of York, specifically the fifteenth century "Ring for Peace" bells in the city centre. Additionally, the *Veni Creator Spiritus* was edited to recreate an antiphonal setting, in which two different voices alternate and are panned to the left- and right-hand side to simulate their separation within the church space (Rastall 2001).

The medieval market soundscape combines varied sounds to recreate the atmosphere of a busy market town, layering a generic background sound of crowds, laughter effects, and recordings of a moving wagon – specifically a wagon used in modern performances of the York Mystery Plays. The soundscape also included pigs and sheep that may have roamed the markets at the time, as suggested by research on the medieval town of York (O'Connor 2013).

The project website for the St. Thomas Way, featuring extensive background information on the history of the sites themselves, as well as interviews with experts, provides context to the soundscapes. Furthermore, the captions that accompany the soundscapes refer to them as "a simple evocation" or "evoking", establishing explicitly that they are not attempting to be historically "authentic" but to provide instead the listener with some context on how the spaces visited during the pilgrimage might have sounded. They endeavour to provide an evocative aural representation of the past, while providing a suitable context within which visitors can interpret these sounds. Nevertheless, it should be acknowledged that the actual effectiveness of such approaches is not documented by current research, and whether the contextualisation resulted in visitors understanding that these sounds were not explicitly authentic is not known.

Sound as Recreation of the Past

By *sound as recreation of the past* I refer to cases in which the aural experiences are based on thorough research on a space and its historical context, an approach that is often linked to acoustical heritage and soundscapes research. Belonging to this category is my own research on the *York Mystery Plays* – a series of plays with a religious theme performed on wagons in the streets of York (England) from the fourteenth to the sixteenth century. My work sought to present acoustical and soundscapes research on medieval drama in York to non-specialist audiences, while simultaneously engaging these audiences with concepts concerning multiple interpretations of the past, the curation of history, and how acoustic and soundscape recreations (even when based on carefully researched material) represent only one possibility of what the past "might" have sounded like. The aim, and the challenge, was to present a multiplicity of acoustic simulations based on a variety of possible scenarios in an engaging manner.

Aberth (2003) explores a similar challenge in relation to historically set films, enquiring as to how multiple points of view linked to historical studies and recreations may be conveyed while still providing an enjoyable experience to audiences. Aberth (2003) contends, not unreasonably, that this is only possible in the realm of experimental filmmaking, in that providing different points of view, citing sources, and delineating critical methodology within a commercial film would very likely result in its failure. But can the same be

considered true for the heritage sector? Can we still provide immersive visitor experiences while also being transparent as to how these experiences are built? Scholars in the field of archaeology have discussed ethical considerations surrounding the visualisation of heritage sites, reflecting on how the use of only one computer model as a representation of a space tends to obscure the areas of uncertainty involved in the study of historical sites, and can sometimes be mistakenly interpreted as a reality (Denard 2009; Giles, Masinton, and Arnott 2012; Miller and Richards 1995). In the field of archaeology such concerns are not limited to the digital realm and are also relevant to the building of physical models. O'Neill and O'Sullivan (2020: 457–458) discuss Peter Reynolds' recreation of Iron Age roundhouses in Britain at the Butser Ancient Farm (UK). They argue that the decisions made in the construction cannot be fully supported or contradicted through archaeological evidence, but because these roundhouses have been used as the basis for other recreations they have become crystallised through repetition and have impacted our understanding of the period (O'Neill and O'Sullivan 2020: 457–458). In opposition, ethical concerns on the misinterpretation of acoustical recreations are rarely voiced in the field of acoustical heritage.

My first exploration of this topic was through a 2014 sound installation at All Saints Church, Pavement in York titled *Hearing the Mystery Plays*, as part of the Festival of Medieval Arts. The installation was based on my research on the acoustics of Stonegate, one of the performance sites of the *York Mystery Plays*, while also accounting for the acoustical impact of different types of wagon structures, wagon orientations, and performer and listener positions. The sound installation explored the unknowns related to the performance site and the performances and made a multiplicity of acoustical options available to the public. The sound installation included three different soundscapes based on the plays of *The Resurrection*, *Pentecost*, and *The Assumption of the Virgin*, which all played in a loop over headphones. The idea of soundscape in this context was limited to speech and music auralisations, as well as some generic environmental wind. A screen displayed images of the virtual models used for the acoustical recreations as well as the names of the plays and characters. QR codes were available on-site to encourage visitors to access web pages through their mobile devices that included information on the research behind the creative work. The installation had more than 100 visitors, who spent an average of four minutes listening (out of a total length of 13 minutes), and with only 8% interacting with the web pages, meaning that a low number of visitors accessed the context of the sound design. However, this low percentage does not represent a lack of interest in the research context, for 69% interacted with the research team on-site, expressing their thoughts on the project, asking questions, and leaving comments (Lopez 2019). However, these findings imply that the communication of contextual information was strongly dependent on the presence

of a facilitator and not on access to accompanying written material, which is problematic (both in terms of time and cost) for most exhibitions, especially if a large volume of visitors is to be expected. Although this sound installation had its merits, it had ultimately not fulfilled its core aim of promoting acoustical heritage while providing contextualising information that communicated to listeners the fact that there is a multiplicity of ways of listening to history. Indeed, the fact that it was situated in a church, which had no links to the plays being recreated, proved jarring, and may have misguided attendees while discouraging the visits of others.

Building up from this installation, the next step was to build an interactive experience outside of any physical space and contemporary associations, which was accomplished through the design of an online interface, *The Soundscapes of the York Mystery Plays* (López, Hardin and Wan 2022).[21] *The Soundscapes of the York Mystery Plays* is an interactive website for the simulation and exploration of acoustical settings and soundscapes linked to the performance of the *York Mystery Plays*, allowing the user to play with the sounds from the past, and acknowledge that there is not one version of what the past might have sounded like, but a multiplicity of options that are worth exploring.

The interactive interface allows users to choose among the same three plays available in 2014 and build their own soundscapes around them. They are encouraged to trigger a "Performance Audio" icon (which includes the spoken and sung parts of the plays) and then to click on different labels to hear how different acoustical settings affected the audio. They can then also trigger sound effects linked to the town, the wagons, animals, bells, audiences, and weather conditions, allowing them to reflect on how these frame the speech and music that were part of the performances. These sound effects were derived from research on the rich soundscape of the city of York during the plays, encompassing sounds that were intentionally produced during the performances (speech and music); those that were a result of the performances but were not part of the narrative (wagon wheels and audience sounds); and those sounds that were independent from the performances (bells, animals, and weather) (Davidson 2013; King 2013; Lopez 2016). The ability to create customised soundscapes using these elements was both an attempt at generating a fuller soundscape (compared to the 2014 installation, which only included the bare minimum), while also making audiences aware that a whole range of contingent sounds would have been present during the performances. These contingencies and variabilities – that given sounds may or may not have been present during any one performance – are represented by giving users the straightforward freedom to choose what sounds are playing and to modify their volume. In addition to these features, the interface also gives users the ability to access oral histories linked to the different sounds – these having been recorded especially for the project and discussed in Chapter 3.

The result is a system that presents users with a range of material that allows them to reflect on the similarities and differences between the medieval and the contemporary experience of the *York Mystery Plays*.

The visual design of the interface was equally important to the project, anchoring the listening experience by providing contextualisation to the acoustic renditions. Bijsterveld et al. (2013) reflect on the paradox presented by the connection between sounds and images in museums. They argue that sounds in museums without any visual reference might encourage guesswork by visitors or delimit their understanding of what those sounds would have meant in their original context. Conversely, however, simply informing visitors about sounds (or displaying varied sound making artefacts) and not actually playing them does not provide an engaging experience. *The Soundscapes of the York Mystery Plays* had the visual elements of its interface designed with significant care, borrowing cues and interaction mechanics from the domain of digital games, specifically role-playing (RPG) and strategy games – such as *The Elder Scrolls* (Bethesda Game Studios, 2014) and *Age of Empires* (Ensemble Studios, 1997). However, it should be emphasised that *The Soundscapes of the York Mystery Plays* is not a game in itself, as it has no goals to reach, or any obstacles to overcome, and there are no rewards in the form of points or trophies for those using it (Salen and Zimmerman, 2003: 80).

Whereas linear sound recreations would present one version of the past, the non-linear nature of digital videogames and interfaces encourages the exploration of different possibilities. The interactive environment, as pointed out by Holdenried and Trépanier (2013), lends itself to the experimentation of multiple scenarios. *The Soundscapes of the York Mystery Plays* therefore addresses the issue highlighted by Elliott and Kapell (2013: 6.), who note how the user's explorations are limited to those facts or details selected by the designer. Although the interface also presents the choices made by the research and design team, the multiplicity of possible sonic experiences it facilitates are far greater than could be achieved through a set version of a historical game with a single sonic simulation, or a defined soundscape in a historical film.

At the core of the design strategy for the interface was the desire to convey the multiplicity of possible acoustical settings based on historical and acoustical research. This resonates with work by Holter, Muth, and Schwesinger (2019), who reflected on how investigations on the acoustics of public assemblies in Late Republican Rome could be studied through different possible scenarios based on evidence and allowing comparisons, but a definite recreation could not be reached. Nevertheless, for *The Soundscapes of the York Mystery Plays*, it was also considered important to convey these experiences without overcrowding the interface with lengthy textual extracts that were unlikely to be read extensively by users. As Houghton (2018) warns, an

overreliance on textual explanations to provide information within historical digital games can end up occluding and diminishing the experience.

On first encountering the interface of *The Soundscapes of the York Mystery Plays*, the user is presented with an avatar next to a graphic representation of a page from an illuminated manuscript, which states

> Dear Friend, The Lord Mayor has issued the billets, we are bringing forth the wagons for the York Mystery Plays, will you join us in Stonegate?

The phrasing used is based on the terminology present in manuscripts linked to the *York Mystery Plays*, placing the user in the historical context of the performances, while also introducing the location as Stonegate. A manicule at the bottom of the page, accompanied by the phrase "Take me there", allows the user to progress further. Next to appear is a stylised, scroll map of York, indicating the position of the performance space in the intersection between Stonegate and Swinegate (now Little Stonegate), which is the area in Stonegate that the auralisations presented in the interface are based on. This choice was driven entirely by the fact that the acoustic measurements and computer models were focused on that particular part of the street, whose selection was itself informed by historical documents. Once the user clicks on the map, they are directed to a visual representation of the street space, featuring different choice of plays at the top, and a wagon wheel structure at the centre.

The main user interface is structured around a common background image that represents a generic medieval cobbled street with timber-framed structures to the sides – the layout being derived from a computer model of Stonegate. Several additions and adjustments can then be made to this scene depending on the acoustical settings selected by the user. These include: the actual wagon structure, whose design and orientation matches the chosen user setting; the performers themselves, who can be placed at varying positions (e.g. at street level, on top of the wagon, and at an upper "heaven" level of the wagon, to represent angelic singing); and the onlooking audience, who are also placeable at different locations. This variability enables the user to generate many different acoustic scenarios, ranging from abstract simulations involving only the performers themselves and a single listener (eliminating the effect of the audience on the acoustics), to more realistically complex settings in which audiences are present both standing in the street and on top of nearby scaffolds. Across all these instances, the listener position being simulated and played is indicated by highlighting the listening audience(s) in red. The resulting changes to the background image as the user explores the different options serves to clarify and contextualise the overall listening experience.

Analysis of the initial user feedback around this interface highlighted some of the challenges of *sound as recreation*.[22] One user mentioned that

they "couldn't access the actual plays, only some singing". This is possibly based on a notion that the Mystery Plays only included speech, even though research has demonstrated that the plays included a large number of musical items, including complex polyphonic pieces (musical items with more than one melodic line) (Rastall 1996, 2001). The Mystery Plays were complex performances in which many resources were invested. Preconceptions of the plays suggesting otherwise could have led this particular user to consider singing as not being a feature of the plays at all. We might hypothesise subsequently that their chief point of reference here might have been renditions of medieval drama shown in film or television productions, or, alternatively, the user might have even based their understanding of the plays from attending contemporary performances, where the spoken aspects are often predominant. On this point, another user raised a related concern that "it would be good to know what a 'typical' setting was!" This indicates that some users might be unsettled when confronted with multiple possibilities of what the historic acoustics of a space might have been, even though this complexity and dynamism is a more representative scenario than that of a fixed "typical" staging situation – one that would amount to little more than a fiction, as researchers cannot readily surmise "typical" conditions that, in all likelihood, never existed.

Meticulous recreations of the past based on historical evidence and involving cutting-edge technology may make for a more rigorous representation, but the key question is whether these are more acceptable to audiences than those that operate as simple evocations. Audiences encountering such meticulous recreations have potentially for many years "consumed" a version of the past that is presented to them in popular media, learning to interpret this as an authentic account. When a meticulously recreated past does not subsequently live up to audiences' established expectations, designers of heritage sites are placed in a dilemma as to what to do in response.

The Soundscapes of the York Mystery Plays project brought to the fore the uncertainty of historical acoustics and of historical research in general. It revealed the gaps in studies and welcomed uncertainty. As a result, it allowed the dissemination of acoustical heritage but also invited scholars to use the tool as a means of rediscovering and rethinking the performances overall. Interactive interfaces and digital games can be seen therefore as vehicles for the exploration of historical uncertainty and the curatorial work involved in historical research.

It is in such terms that *The Soundscapes of the York Mystery Plays* can be linked back to work on procedural rhetoric and persuasive games (Bogost 2007), as the interface is built to allow for reflection and acknowledgement of the curation process behind the presentation of sonic histories, while demonstrating the myriad possible scenarios suggested by historical and acoustical research. The aural past cannot be fixed, the details will never be truly

known. The interface hopes to encourage users to question their knowledge and beliefs about history, its curation, acoustical heritage, and the Mystery Plays overall. The processes facilitated by the interface are determined by the argument being put forward: that acoustical history is not a unified, linear history, but is instead dependent on a myriad of factors, although such unknowns should not stop us from considering its crucial value for medieval studies.

Sound as Dramatisation

A recurring theme across different sound experiences is the centring of the voice as the primary driver of the experience, relegating non-verbal sounds to background texture. Within these experiences, we can often find those that feature dramatisations of past events. These are different experiences to those in which voices feature as part of the more general soundscape, or as a vehicle to explore other sonic elements, such as environmental acoustics. Instead, they rely on the voice as the predominant means of conveying information as well as engaging audiences, reflecting the importance given to the voice across the wider media environment, as discussed earlier in this chapter.

To illustrate, we can turn back to the *Sonic Palimpsest* project, already discussed in Chapter 3 due to its work with culture bearers. The project focuses on the sonic experiences of the Chatham Historic Dockyard (UK) throughout the centuries, relying heavily on sound as dramatisation. The online experience allows the user to explore the sonic past through an interactive map that can be navigated either by selecting across a range of different historic periods, spanning from the sixteenth to the twentieth century, or by choosing a central theme: Community, Craftsmanship, Growth and Experience, International Relationships, and Technology.[23] When selecting to navigate century by century, the background map changes, whereas when interacting by theme the twentieth century map is used instead.

Dramatisations are key to the Chatham Historic Dockyard experience and include those that are focused on the recreation of past events, as well as those recreating exchanges between modern visitors exploring the site and reflecting on that past. The composition *Peter Pett* by Brona Martin features an imaginary intergenerational conversation among Peter Pett (master shipwright to Edward VI), Phineas Pett (Peter Pett's son and the commissioner of the dockyard under James I and Charles I), and Peter Pett (Phineas' son and commissioner of the dockyard under Charles II). The dramatisation includes their recollection of their personal histories and their connection to other historical characters and events, such as the 1642 Civil War and the 1660 Restoration. In addition to discussing historical events, the composition includes playful exchanges such as Peter Pett senior telling Peter Pett junior that his career was a bit of a mixed bag, after it is mentioned that he supported

Parliament during the Civil War but also the Restoration years later. Each voice is spatialised to a unique position to create the sense of the characters speaking to each other across different parts of a room. The dramatisation is paused as the characters mention a poem about the younger Peter Pett titled "Last instructions to a painter" by Andrew Marvell, at which point a female voice reads out the poem.

Another composition featured is *Strikes* by Aki Pasoulas, set in August 1739, which dramatises workers' private conversations as they prepare to strike. Their plans are contextualised with references to the recent declaration of war on Spain and the subsequent demands on their labour, making this an opportune moment for industrial action. Shouts and demands are then heard followed by another private conversation in which authorities agree to the demands of workers.

The Chatham Historic Dockyard experience also employs dramatisation to represent how modern visitors might interact with the site, incorporating information as well as reactions to that information. An example is the composition *The Ropery* by Brona Martin, which features two women discussing the history of the locality. One of them reads out information on the site, clarifying its specialised terminology and observing how women were brought in during the 1860s to mind the rope-making machines. Similarly, another composition titled *Saw Mills* by Aki Pasoulas features two visitors discussing the installation of a steam powered saw mill and the work carried out by Marc Isambard Brunel. The two friends hold opposing views, with one considering Brunel to have been a genius, while the other focuses on the negative aspects of the Industrial Revolution on both workers and the environment. These dialogues are held in between a reader providing information on the site, who at one point asks both men if she can continue uninterrupted, at which point they apologise and she continues providing information on the site. This represents another playful example of sound dramatisation, adding humour to the experience while reflecting on the different views modern visitors might hold.

The Chatham experience also deploys other forms of dramatisation, including the reading of diary entries and other written records, such as those by Samuel Pepys (1661), Celia Fiennes (1662–1741), and Charles Dickens (1869), as well as a newspaper article discussing a failed prison escape in 1838.

All of these compositions, as well as the other dramatisations within the Chatham experience, are accompanied by various sound effects and ambiences closely linked to what is being discussed. Furthermore, when clicking on the audio of different pieces the listener can also access some information on the historical episode each composition is linked to, alongside a related image and a list of sources that it is based on. It is worth noting that a small number of compositions in the Chatham experience are based on soundscapes in which voices are integrated as part of a general soundscape, which

is the case with *Draining Marshes* by Aki Pasoulas, recounting the forced labour carried out by dockyard hulks prisoners.

Continuing this maritime theme, The Mary Rose at the Portsmouth Historic Dockyard (UK) also makes use of dramatised recreations through its Augmented Reality (AR) experience, *Time Detectives: The Mystery of the Mary Rose*. This AR experience can be accessed both at home and on-site and invites the user to try to determine the reasons why the Mary Rose might have sunk to then report to Henry VIII. The user can choose to interact as one of two main characters, either Captain George Carew, or 17-year-old Henry, the latter being in charge of keeping the ship waterproof. The voices of each character are the main driver of the experience, expressed through one-to-one conversations and dialogues among crew members. The use of sound beyond the voice is minimal, with only a few effects and ambiences provided, which are often muffled in the background. During some episodes, such as the sinking of the ship, the sound effects become more prominent, with whistles, guns, shouting, and footsteps, as well as the sounds of the sea. It is worth noting that the sonic layer of the experience draws attention to the many countries the crew members of the *Mary Rose* came from, with different languages and accents being heard throughout. However, the overreliance on the voice often leaves less space for the development of other sonic aspects, which are largely sidelined.

Sound as Artistic Reflection on the Past

Another category of sound experiences encompasses creative pieces that, while being linked to heritage sites, represent a sound artist's own particular interpretation and reflection on the space and its history. There are no claims of "bringing history alive" or "authenticity", but instead there is interpretation, artistry, and creativity.

Pearse, Waltner and Godsoe (2017) discuss an artistic approach to the creation of soundscapes, but one that is historically informed and akin to practices in the field of early music performance. They engage with the need to embrace the impossibility of "authenticity" and instead welcome a combination of scholarship and performative experimentation, with steps along the way including the gathering of evidence (such as historical accounts); generating sound (maybe through field recordings); experimenting with sound (e.g. by listening back to recordings and editing them); and finally creating the soundscape (Pearse, Waltner, and Godsoe 2017). Borrowing from Joel Cohen – a specialist in early music interviewed in Shull (2006), who considers every performance of early music to be a hypothesis put forward to listeners, rather than a definite version – Pearse, Waltner, and Godsoe (2017) consider their soundscape creation work to be a hypothesis on the sounds of the past that is put forward to listeners, and one that is as much about

the present as it is about the past. This resonates with the influential work of Richard Taruskin and his argument that notions of authenticity in music performance are not much more than "time-travel nostalgia" (1995: 56) and a marketing strategy (1995: 90), and instead advocating for the adoption of a "possible" approach to performance among many other approaches.

One example of sound as artistic reflection on the past is the album *Echoes and Reflections* (2022a) by Cobi van Tonder,[24] which features nine musicians who developed compositions using acoustical heritage and soundscapes material, including the material available through the *Acoustic Atlas* site (see Chapter 2). Pieces include Juliana Venter and Cobi van Tonder's "Earth Eco", a vocal composition using the acoustics of Dowker-bottom cave in the Yorkshire Dales (UK) and Iti's sitar piece "Raga Todi", which uses the acoustic data from the Taj Mahal (India). The pieces aimed to reflect on the connections between acoustic data capture and the myth of Echo and Narcissus, with impulse response (IR) measurements being considered as a photographic record of Echo herself (van Tonder 2022a). In addition to this, Cobi van Tonder has been working on an album titled *Echoes of our Ancestors* where once more acoustical heritage data is used as compositional material, but in this case the focus being on percussion and its interaction with the acoustical data captured at caves in the Yorkshire Dales (van Tonder 2022b). The work carried out for these albums does not seek to transport people to the past through a realist aesthetic, what is more, it does not reference a particular past period. Instead, it uses modern composition techniques to engage with the sounds of the past, taking the sites as sources of inspiration, and one could easily argue that it is highly unlikely that modern listeners would hold beliefs of these being "authentic" recreations.

Another example is the 1984 piece by Bill Fontana, *Entfernte Züge (Distant Trains)*, in which he relocated the sound of Germany's busiest train station at the time, the Hauptbahnhof in Cologne, to an empty field that was the former site of Berlin's busiest train station before World War II, Anhalter Bahnhof. The recording of the train station in Cologne was played back in the field through eight loudspeakers, which were buried and located in two parallel rows that mimicked the position of the tracks and the platforms (Fontana, n.d.; Soria-Martínez 2017). The visitor was thus presented with the acoustic spirits of a train station that once was (Fontana, n.d.). Those familiar with the history of Anhalter Bahnhof would have been encouraged to reflect on its use in 1941 and 1942 to transport Jewish people to concentration camps (Presner 2009). Those unfamiliar with such history might have chosen instead to build their own connections, perhaps encouraged to think about their own journeys. It is the relocation of those sounds that gives them a new meaning, one that is not just determined by the space but also by the listener (Fontana, n.d.).

One final example in this category, which connects us back to aforementioned museum and gallery sites, is *Sonic Museum* at the Auckland War Memorial Museum in 2009, in which nine professional composers were asked to choose a gallery for which to create a musical piece. These galleries included: *Māori Court, Origins, Oceans, Ancient Worlds, Land, Volcanoes, World War I Sanctuary, World War II Memories*, and *Landmarks*. Visitors were then given the option, if they wished, to play the music back through headsets hired from the museum, or to download the tracks and play them through their personal devices. The aim was to encourage visitors to spend more time in the galleries and explore the changing perception of each space through the addition of a musical experience.[25]

Sound as Remote Access

In an online format, acoustical work has also been linked to the provision of remote access to heritage sites, in particular through the use of IRs and aural-isation techniques. An example of this is the previously mentioned *Acoustic Atlas* project by Cobi van Tonder,[26] which allows users to "visit" different heritage sites and hear their own sounds convolved with the IRs. In addition to this, in Chapter 3 I discussed the opportunities and challenges presented by online sound maps.

Another example of remote access is the use of the acoustic measurements of the Chapter House of the York Minster (UK), led by Lidia Álvarez Morales in May 2019, for the December 2020 *Virtual Carols by Candlelight* performance by the Chapter House Choir during the Covid-19 pandemic.[27] The 28-minute programme opens with a performance of *Silent Night* with a single singer performing from the Chapter House, who is then joined by singers performing remotely online from their own spaces and with their voices convolved with the IRs provided by Álvarez Morales. Musical director Benjamin Morris is seen conducting from the inside of the Chapter House, which is lit by candles. The result is an atmospheric and moving experience that demonstrates the importance of access to IRs, beyond the intended use at the time of capture.

Soundscapes of Trauma and Acoustics of Torture[28]

In June 2023 I had the pleasure of being invited to present at the event *Decolonising Sonic Heritage Spaces* organised by Laudan Nooshin and Maria Mendonça at City, University of London. As part of discussions on the day, the topic of traumatic heritage came to the fore. There were different opinions, with some arguing that sonic recreations of past horrors were invariably crass – surely one should not under any circumstances do that. These opinions were not always accompanied by their counterpoint: that the decision

to not represent trauma through sound, to always sanitise sound heritage, is, in both senses of the word, a form of silencing. We silence heritage when we refuse to engage sonically with sites of trauma, and potentially extend misjustice: marginalised groups who were silenced then are silenced now.

There were subsequent discussions surrounding the fear of "doing the wrong thing" and the need to make sound heritage palatable to modern audiences, for fear of upsetting visitors. Nevertheless, we might flatly observe, did horrific events ever sound anything less than outrightly horrifying? If we were to assess history through the perspective of the sound heritage experiences created thus far, we might come to the conclusion that all has been well.

The lack of engagement by sound heritage specialists with negative representations is especially puzzling given the long history of sound being employed explicitly for generating harm, including manipulation, control, and even torture. A contemporary example is the use of sound to limit access to spaces from groups deemed "undesirable". Devices such as *Mosquito* emit a high-pitched sound (around 17 kHz) at a high volume, which is mostly audible only to children and young people (adults having a reduced higher frequency range hearing), and are designed explicitly to make it uncomfortable for teenagers to linger in certain spaces (Thompson 2017: 72). Compound Security Systems, which manufactures the *Mosquito*, explains that it is to be used "for dispersing groups of teens and reducing incidents of vandalism in high-risk areas".[29] The *Mosquito* device was also marketed as a tool to enforce social distancing in the Covid-19 pandemic,[30] effectively claiming that only those with full frequency hearing range (the young) wished to be less than two metres apart, and would readily flout the requirements without physical enforcement.

A historical example of sound as control mechanism is found in the work of Harold Burris-Meyer, a theatre director and sound technician at the Stevens Institute of Technology in the USA, who was discussed briefly in Chapter 2. Burris-Meyer studied the use of sound, particularly infrasound in theatre, to generate involuntary reactions in listeners (Ouzounian 2020: 84). In 1938 he joined the Muzak corporation, whose premise was to use carefully programmed music to control the behaviour of industry workers, increasing their productivity (Ouzounian 2020: 94). Burris-Meyer also investigated the use of sound for warfare as part of *Project Polly* during World War II, working on an airborne public address system which broadcasted a programme consisting of propaganda messages, news items, and popular music, aiming to encourage enemy soldiers to surrender by having an aircraft play these items while circling the target area (Ouzounian 2020: 100–102).

Project Polly is far from the only example of sound technology in a military context, and the development of spatial audio technology itself has been fuelled by war efforts. As Ouzounian (2020) explains, until the early twentieth century, research on spatial hearing had been focused on the physics of

sound as well as the physiology and psychology of hearing, but World War I saw vast resources invested into expanding its use as a survival strategy. The conflict saw the development of acoustic defence systems in which sound localisation technology was key, enabling armies to locate and track enemy activities by listening (Ouzounian 2020). Efforts included the establishment of Schools of Listening in France, in which French, British, and American soldiers were trained on the use of these acoustic defence technologies (Ouzounian 2020: 41). One example of the technology developed was the four-horn sound detector for locating enemy aircrafts. This system employed two pairs of horns, each controlled by a different operator, who each listened through a stethoscope-like binaural audio piece. One pair of horns allowed for the determination of aircraft altitude, and the other azimuth. This specific development of listening skills can be connected to what Sterne (2003) has termed *audile technique*, that is, listening practices developed from the nineteenth century in which listening was associated to practical uses and in which a connection between listening and rationality was formed, starting with the use of tools such as the stethoscope for medical diagnosis and then expanding more widely. The aim was to enhance the capacity to listen through the use of different inventions.

In opposition to these specially trained World War I auditors, who received daily training on locating enemy sound sources (Ouzounian 2020: 59), were the average non-specialist soldiers. Bull (2019: 189) mentions that many soldiers lacked the ability to listen to and interpret the sounds on the Front, which in turn resulted in injuries and deaths. Ironically, Bull (2019) points out, the civilians that had been eager to get a taste of sonic realism in the War through films, one that equated to a fantasy, were less eager to contend with the visible consequences of the actual sounds of war traced in the bodies of soldiers, in particular if they translated into facial injuries, which were met with a sense of aversion, which in Britain was not the case with amputees (Biernoff 2011). Those injuries, and hence those soldiers, were a reminder of the inhuman nature of war which not everyone was prepared to accept (Bull 2019: 189). Civilians were more accepting of the non-physical manifestation of sonic harm as a result of shell shock but less understanding of any physical reminders (Bull 2019: 188–189). This was such that when Queen's Hospital, a specialist hospital for facial injuries, opened in Sidcup, Kent in 1917, town and park benches were painted in blue to warn civilians that they might find what they saw, injured soldiers, upsetting (Biernoff 2011: 672; Bull 2019: 190).

In World War II sound was used as a tool for deception. The "Ghost Army" was a division of the US army stationed in Europe, which included artists and sound/radio engineers, with the latter working on using the sounds of war, such as troops and tanks, to misdirect the enemy into believing that troops were located in a certain area compared to their actual location (Goodman

2009: 41). In addition to this, Division 17 of the Ghost Army worked with the Bell Labs and Harold Burris-Meyer to recreate the sonic experience of the battlefield, seeking to deceive the ears and listening devices of enemy soldiers and taking advantage of moments of low visibility (Goodman 2009: 41).

One particularly haunting example of the use of sound in warfare is its use by the US military as part of Psychological Operations (PSYOP) in the Vietnam War under *Operation Wandering Soul*. This consisted of specially created *Ghost Tapes*, broadcast into the countryside by various means, which sought to get enemy soldiers to defect.[31] The tapes drew on Vietnamese beliefs on the afterlife, particularly in relation to unburied bodies, whose souls would be doomed to wander about lost and angry.[32] The tapes, which were in Vietnamese, included sounds such as those of funeral processions, and a child calling for their dad, which in turn prompts the soul of a deceased soldier to realise he is dead.[33] The soul then rants angrily on being unable to rest and beseeches soldiers to leave the war unless they wish to end up like him.[34]

Thompson (2017) reflects on the weaponisation of sound and vibration in more recent conflict scenarios, in particular on the use of sonic booms by the Israel Defense Forces (IDF) in 2005 against civilians in the Gaza Strip, with the aim to generate fear due to them sounding like missiles and bombs. These techniques have been noted to result in negative psychological and physical effects, as well as shockwave damage to the built environment (Thompson 2017: 70–72).[35]

Intensely revealing is the research by Suzanne Cusick (2008) on US-run detention centres during the "global war on terror", including the practices at Bagram Air Force Base (Afghanistan); Camp Nama, Forward Operating Base Tiger, Mosul Air Force Base and Camp Cropper (Iraq); and Guantánamo (Cuba). Cusick (2008), through harrowing accounts of both former detainees and interrogators, as well as through unclassified military documents, explores the use of sound and music as weapons of torture. Cusick's research uncovered that the soundscapes of the prisons were identified both as providing comfort to the detainees and allowing a grounding in time and space, as well as serving as the main means of torturing them. Former detainees mention a variety of sounds, including people crying, soldiers' footsteps, shackles and detainee numbers being called out, as well as the screams of others during interrogations, with soldiers yelling questions into their ears (Cusick 2008). In opposition to this, calls to prayer are mentioned as comforting and familiar, helping to know the time of day and provide some orientation (Cusick 2008: 6). Moreover, sound was also mentioned as a means to keep the mind occupied by listening (Cusick 2008: 21).

Architectural acoustics are crucial to all the accounts, with the aforementioned calls to prayer described as offering "a spiritual communication, reverberating around the camp" (Cusick 2008: 6). One former detainee observed that the use of sound absorbing materials in the interrogation room (thick

carpets all around) induced fear as to what activities they were trying to keep inaudible to the outside, and vice versa (Cusick 2008: 21). The long reverberation time of the sites is also mentioned in relation to the sounds of footsteps and the sound of the music played by soldiers (Cusick 2008: 7). It is this music that constituted a particular means of torture, being played loudly and continuously for long periods of time, preventing sleep and reverberating throughout the buildings.

Cusick poignantly reflects on how the actual energy that was used to power up the detention centres and play such loud torturous music was itself generated from the resources extracted from the home nations of their detainees:

> Our [US] troops' access, in turn, depends on their access to the energy captured in complex hydrocarbon molecules – that is, on the oil used to power our camps' generators. Every amplified sound in these camps, and therefore every bit of music, is the United States' transformation of the energy in Middle Eastern oil into violent, violating sonic energy aimed directly at the people whose land yielded that oil – people who are as powerless to resist our thirst for their lands' resources as they are to resist the use of those transformed resources against them.
>
> *(2008: 18)*

The use of music by the US military in Iraq is also studied by Daughtry (2015), who reflects on the use of the iPod and music playlists before, during and after missions, both through earpieces and loudspeakers. Before a mission they could be used to help soldiers feel pumped up, while during missions they could help maintain focus, while also being utilised to relax after a mission was finished. Furthermore, they were used as a PSYOP (Psychological Operations) tactic during food distribution to attract Iraqi civilian crowds by playing Iraqi pop music (2015: 239). Conversely, Daughtry (2015) reflects on the use of sound to disperse hostile crowds. The Long Range Acoustic Device (LRAD), which could produce an irritating tone that was capable of resulting in physical distress and even hearing loss, was employed, and could also be combined with an iPod to blast music to try to disperse crowds (Daughtry 2015: 240–241). Daughtry analyses these instances as part of a larger reflection on the *belliphonic*, the soundscapes exclusive to conflict scenarios.

Thompson (2017: 102) argues that it is not only sound that can be weaponised, but also silence, referring to the case of solitary confinement practices in prisons and other detention centres. In these contexts, silence is a form of torture and is in stark contrast, Thompson explains, to Schafer's (1994) belief that hi-fi environments (those with lower "noise" ratios) are associated with positive sensations. Corbin (2018: 59) refers to the nineteenth century debate on penal systems in the USA and its connection to silence in relation

to the Pennsylvania System and the Auburn System. In the former, prisoners were kept in solitary confinement leading automatically to silence, in the latter, prisoners lived and worked in groups but were not allowed to speak to each other. Silence was seen as necessary for rehabilitation as it allowed for soul-searching, while also depriving prisoners from both their physical freedom and the freedom of speaking. In Tasmania, at Port Arthur's *Separate Prison*, which was in operation from 1852 to 1877, there was an enforced 24-hour silence policy,[36] with guards wearing felt slippers when patrolling the corridors and using sign language to ensure the removal of sound stimuli (Dyson 2017: 126). Dyson (2017: 126) comments on the irony of this site, now a World Heritage Site and a tourist attraction,[37] having audio recordings re-enacting prisoners' lives, interfering with any possibility of reflecting on what that enforced silence might have been like.

Separated geographically and temporally, accounts from detainees of Argentina's military dictatorship between 1976 and 1983, also reveal the importance of sound and silence. Testimonies were gathered and published in 1984 under the title *Nunca Más* (Never Again), a summarised 500-page version of a 50,000-page report commissioned by democratic president Raúl Alfonsín and led by writer Ernesto Sábato (Cultura Argentina 2006). The testimonies are those from former detainees in clandestine centres in Argentina during a period that saw the systematic kidnapping, torturing, and murdering of thousands of people, resulting in the *desaparecidos*, the *disappeared*, the name given to those whose whereabouts were never found and are presumed dead.

In one of the testimonies (No. 1328) a former detainee retells how she was detained together with her husband, just a few hours after their son had been taken. While detained she could hear her son's screams as he was tortured, which she describes as being audible above "the deafening music" ("música ensordecedora") (Cultura Argentina 2006: 168). A similar sonic experience is retold in another testimony (No. 1639) from a woman who was detained and tortured together with her 14-year-old son, who describes long periods "listening to music and the screams of pain from my son. Then followed again by the frightening silence" ("oyendo la música y los gritos de dolor de mi hijo. Y después de nuevo el silencio aterrador") (Cultura Argentina 2006: 165). The sound of fellow detainees screaming are not exclusive to these accounts and are a feature across other testimonies. The specific use of loud music as a means of torture links directly back to US practices, which were introduced to Latin America from the late 1950s – originally forming part of the SERE methods (Survival, Evasion, Resistance, and Escape) by the CIA and the US military through which they aimed to train soldiers to resist torture (Otterman 2007: 12).[38]

Other sounds mentioned by the detainees include hearing gunshots in the night (No. 2545) (Cultura Argentina 2006: 101) as well as the sound of

detainee numbers being called out and trucks transporting fellow detainees to the "pozo" (the hole). This was a site in which mass shootings took place by placing prisoners at the edge of a hole, before shooting them and using the hole as a place of burial (Cultura Argentina 2006: 108–109). Highlighting the antisemitism experienced by detainees, an account mentions hearing recordings of Hitler's speeches played back during the night (No. 6904) (Cultura Argentina 2006: 69). In addition to this, testimonies have also included mentions of being forced to sing the national anthem and other songs with political content (Polti 2014: 8–9).

Based on the testimonies of these former detainees, Polti (2014) argues, that sound and listening were central to communication and survival within the detention centres, as well as an important way in which prisoners were able to gain understanding of where they were. For example, referring to detainees in "el Atlético" (Buenos Aires), there are references to the sound of oppressors playing ping pong as a recreational activity and conversing while doing so, as well as being able to hear the sounds of football fans outside the detention centre walls (Polti 2014: 11). A former detainee refers to the concurrent sense of proximity and distance to the outside world that these sounds generated: "…we were so close and so far from "civilization" and our families were looking for us" ("…nosotros estábamos ahí tan cerca y tan lejos de la "civilización" y nuestras familias nos estaban buscando" (Polti 2014: 11).

In some cases, those in the outside were also able to hear sounds from the inside. An account linked to a detention centre in Martínez (Buenos Aires) includes a testimony on hearing gunshots as soldiers practised their shot or tried weapons, as well as horrifying screams coming from within the centre (Cultura Argentina 2006: 80). The visual and auditory aspects being noticeable by neighbours was part of a strategy to instil terror throughout the wider populace (Cultura Argentina 2006: 80).

Work on British prison settings in the twentieth century has also found a similar tension between imposed soundscapes and acoustical agency, with prisoners being at the mercy of the soundscapes imposed onto the spaces and the people that inhabit them, but also at the same time using active listening to source information that could be key to survival (Rice 2016). Whereas prison settings can control visual access tightly, sound carries readily through cells and walls, providing clues on what is and might be happening. Furthermore, in Rice's work (2016), the use of music playback devices in prisons has been linked to the establishment of acoustic agency by using them to mask the aspects of the soundscape that they have no control over, as well as a way of imposing their own soundscape on others, both intentionally or otherwise. This said, it is worth noting that Rice's research (2016) does not explore political imprisonment or settings of inflicted torture.

What I here refer to as *soundscapes of trauma* and *acoustics of torture* are central to the experiences of detainees and form part of the traumatic heritage

that is part of Argentina's and other countries' histories – histories that we should not allow ourselves to forget and which should not be silenced. Sonic representations can form a gateway towards the reflection on and transmission of this horrifying past. To be clear, I am not arguing in favour of using sonic experiences in ways that actively generate upset and distress. Instead I am arguing that it is crucial to open up a conversation around the important opportunities that sound might offer in communicating critical aspects of lived experience, recent or otherwise, that we should not allow to be left unheard, given that these are forever imprinted in the acoustics of the buildings they reverberated within.

Before turning my attention to examples of sound experiences that have sought to contend with this heritage of trauma, it is worth noting that outside of the realm of sound, there has been research into the phenomenon of *dark tourism*, that is, travel to sites associated with suffering and death. Here I would like to highlight the work by Gillian O'Brien (2020) on exploring site-specific heritage experiences linked to famine, death, and rebellion in Ireland. O'Brien (2020: 11–12) argues that although dark tourism is often accused of being vulgar and voyeuristic, it is possible to explore how more nuanced approaches that navigate the tensions between education and entertainment can be achieved, avoiding an exploitation of the past and past people.

Let us now turn our attention to an example of sonic experience, the 2021 online piece *Accessing Anna* by Ariana Ellis.[39] The piece is a recreation of the experience of Anna del Monte, a young Jewish woman who in 1749 was forcibly taken from the Roman ghetto in Italy to the Casa dei Catecumeni (House of Converts) as part of a conversion programme that sought to test people's faith by holding them against their will for days and subjecting them to sensory deprivation and emotional torture (Ellis 2021). The audio experience uses Anna's diary as source material and anchors the experience through the 1748 map of Rome by Giambattista Nolli,[40] indicating the different locations of Anna's experience as the listener moves forward. The experience consists of ten separate YouTube videos that are embedded on the website overlaid onto the image of the map, with each representing a different episode of Anna's experience, as well as an introduction and end credits.

The piece is in the second person, placing the listener within the experience. The introduction encourages listeners to wear headphones and in a subsequent section advises them to close or open their eyes depending on what is happening to Anna – placing themselves as closely as possible to her experience. The provision of instructions around how to best experience the piece echoes the guidance surrounding audio only experiences that was discussed earlier in this chapter. In the case of *Accessing Anna*, the introductory clip provides an important opportunity to warn the audience that the type of material presented might be upsetting, dealing with sensitive topics and is

intended to generate tension. The introduction also includes instructions on how to leave the experience if someone wishes to do so.

Sounds featured in *Accessing Anna* include spoken dialogue as well as preaching. Ambient sounds initially try to convey the outside world which Anna is deprived of when she is held in captivity. At the start of the piece, bells, crowds, and river sounds are heard, with only some of the bells remaining audible while she is in captivity. The movement of characters through their footsteps and other sound effects are also included, as well as the water poured over Anna without her consent as they seek to convert her. The proximity of the voices, shouts, grunts, and breaths of her captors, accompanied by the unease generated by the lack of ambience sounds, succeeds in creating a sense of tension, which is relieved when Anna leaves and the ambiences of the outside world become audible once again.

The piece also seeks to be transparent as to its use of source material, with the listener being invited to consult the transcripts, which are provided in full, including annotations on sound effects, and with footnotes on where material was sourced from and what decisions were made. For example, in a footnote it is explained that "As it is impossible to replicate the accent and exact language of the period, I have opted to use voice actors with (generally) non-distinctive accents". Although I would here need to indicate that the concept of non-distinctive accents is relative and these accents are unlikely to be perceived in this way by all listeners.

Accessing Anna is not just a sonic representation of a past event, but it is a reflection on the role of sound in such traumatic heritage and history. It does so in a respectful manner while still avoiding the sanitisation of a traumatic event, conveying the tension of the experience through an audio only format.

Another instance of an audio piece dealing with sonic trauma, in this case a site-specific one, is a sound experience featured in the Museum of the Qasr Prison in Tehran (Iran) as part of the 2015 Old Tehran festival. Nooshin (2016) describes the use of sound recordings in the prison block which once housed political detainees, reconstructing the sounds of inmates and visitors shouting across the corridor that separated them as they tried to communicate. Nooshin (2016: 6) describes the experience as a "disturbing" one, followed by the "unsettling" juxtaposition between the experience and the festive sounds encountered when exiting the building.

A more delimited use of sound, as discussed in Chapter 4, is heard in *ESMA Museum and Site of Memory – Former Clandestine Centre of Detention, Torture and Extermination* in Buenos Aires (Argentina), which includes typewriter and teleprinter sounds to evoke the soundscapes of La Pecera, a space set up as a news agency in which detainees were forced to work.[41]

While technically an audio tour, the sound experience *Doing Time: Alcatraz Cellhouse Tour* includes elements of soundscape and acoustic recreation.[42] With the tagline "As told by the Correctional Officers, inmates, and

residents who lived and worked on Alcatraz during its years as a federal penitentiary", the audio tour incorporates recorded testimonies as well as sound effects to convey the environments in which inmates and officers lived. The audio experience, which is designed to be listened to while visiting Alcatraz, is comprised of 20 episodes which combine testimonies and recreations of violence alongside the quotidian nature of life on "the rock". It does so by taking visitors through the different spaces, each with its own soundscape, as well as referring to different uses of the site throughout its history as a federal prison, which started in 1934 and ended in 1963.

Doing Time includes the voice of a guide, Pat (Patrick) Mahoney, a former Alcatraz correctional officer. In addition to introducing the experience and himself, Pat also provides visitors with instructions on where to go next and what visual elements to focus on as well as different things they can opt to do. For example, Pat gives the option to visitors of entering a solitary confinement cell, one in which inmates experienced the deprivation of sights and sounds. We hear the loud sound of a heavy door being shut and locked behind us and the immediate removal of external sounds. The testimony of a former inmate relates how, when in "the hole", they used to tear a button from their clothes, throw it on the floor, then turn in circles and then go on their hands and knees to find it. Once they found it, they repeated the process. As we hear this testimony we hear the sounds of those actions. As these actions are repeated the sound of drone-like music commences, connecting this testimony to the next one, in which a former inmate explains how they closed their eyes and covered them with their hands to try to generate their own visual images to compensate for the experience of sensory deprivation. As the testimony ends, the guide, with his voice now being processed with the simulated reverberation of the cell, which emphasises the nature of confinement, invites the visitor to open their eyes and exit the cell, upon which the external soundscape resumes and his voice becomes less reverberant. Although in other parts of the audio experience we also hear that long reverberation time to indicate the vastness of the space and the materials used for construction, it is particularly emphasised in this section, reminding us of the emptiness and loneliness the experience was meant to elicit. Non-diegetic music is used very sparingly throughout the tour, and the choice of having it present here reveals the intensity of experience designers wished to convey.

The sounds of violence are portrayed across different sections of *Doing Time*, in particular a depiction of the 1946 Battle of Alcatraz. This was the result of an escape attempt by six inmates that led to the US marines being called in, and who, together with the correctional officers, bombarded the cell houses for two days in a row. The use of sound intensifies as this episode is recounted through officer testimonies and the guide's voice. Starting with the footsteps, movements, and interaction sounds of the escapees, it then includes a few sparse, dialogue-based dramatisations to indicate the building

anxiety of the inmates as they realise their plan is not going to work. The worsening situation is then indicated by ringing phones, which are then followed by sirens, cell doors, and gunshots, as well as shouts. The sound effects are prolonged and processed so that at points they resemble drone music, blurring music composition and sound design.

Another violent episode of *Doing Time* focuses on the dining hall, which is described as being the single most dangerous room of the whole of Alcatraz due to the availability of forks, knives, and spoons. The potential of cutlery being used for violent purposes is explained through testimonies regarding stabbings, which describe the sounds heard and which are accompanied by simulations of them, as well as additional background crowds including shouted lines of "I didn't do it!". This part of the tour focuses in particular on a riot caused by the lowering quality of food, spaghetti specifically. As the former guards recount the sounds heard and their accompanying actions, we hear them as well (tables, cutlery, shouts, bangs), until it all comes dramatically to a pause as an officer shatters three glasses, prepares his gun and blows his whistle "quietly". Calm is restored. The testimonies themselves are already packed with sonic references, the sounds provide a simulation of the tension felt.

Sound references and simulations in *Doing Time* are not centred exclusively around violence and punishment. Sound was central to some of the most positive experiences linked to Alcatraz. This notably includes the installation of radios in the 1950s, with inmates being able to plug in their headphones and have a choice of two stations through which they could listen to different programmes, including music and sports. "The music hour" which took place in the evening from 6.30 to 7.30 pm is also featured, represented by harmonicas, guitars, and trombones – the latter contextualised through a testimony that recalls how this inmate just knew how to play three notes which he repeated continuously for an hour. Visitors also hear the trombone notes, alongside a former inmate imitating them out loud. The playing of music by inmates is also linked to a recollection of New Year celebrations, which includes mentions of saxophones and clarinets, as well as recounting how inmates rattled tin cups across the bars. Testimonies and their sonic recreation are intertwined all throughout. In contrast, there are also episodes that focus on silence. The quiet of night time, which started at 9.30 pm is featured, with statements mentioning that it was "dead quiet" like a "mausoleum" and that guards could hear prisoners grinding their teeth and talking in their sleep.

One of the most poignant sonic references concerns the relationship inmates had to the outside world. Featured are the sounds coming from San Francisco, which were audible depending on the wind and particularly so during New Year celebrations, when sounds coming from the Yacht Club, including laughter and music, reached the ears of prisoners and emphasised their sense of loss. It is this sense of distance, detachment, and loss

that is captured in *Doing Time* through its inclusion of muffled sounds, as a particular sonic memory by an inmate is shared. Conversely, sounds from the prison were also frequently heard by those "outside", such as the families of officers who lived on the island, and these sounds also feature in the audio tour. On this point, throughout the whole experience are various maritime sounds that remind the listener of the island context of Alcatraz, sounds which were also heard by inmates, officers, and families.

Doing Time is grounded on the testimonies and guiding voices of former inmates and officers, and throughout it highlights the importance of sound to both ordinary and extraordinary circumstances within the site. As detailed in the tour, Alcatraz was a site of punishment, not rehabilitation, and the audio experience exposes visitors to the sounds and silences of violence, while also presenting it as a "home" with its own enjoyments to those who lived there, one that through its surroundings and sound experiences reminded them of the free world they were no longer part of – a form of punishment in itself. By basing the recreation on real testimonies and making it the main material of sound creation, the audio tour is able to portray disturbing episodes while remaining respectful of past experiences.

Before concluding, it is important to distinguish these varied examples, which I am listing under the category headings of *soundscapes of trauma* and *acoustics of torture*, from the earlier category *sound as artistic reflection on the past*. Although there has been a reluctance towards engaging in sound recreations connected to traumatic experiences, there have been a much greater number of artistic pieces reflecting on these topics, such as Bill Fontana's 1984 *Entfernte Züge (Distant Trains)* discussed earlier in this chapter. Another example is Susan Philipsz's *War Damaged Musical Instruments* exhibited at Tate Britain in 2015–2016, in which recordings from British and German brass and wind instruments that were damaged in conflicts are used to play the notes of the military call "The Last Post", albeit edited to become an unrecognisable tune and serve as a sonic reflection on conflict and loss.[43] One might consider the differences in engagement between sonic recreations and sound art pieces explicitly as stemming from the artist seeking not to recreate a particular sonic experience but to provide a reflection on it through their own auditory sensibilities. The sound art experience therefore provides a gateway for broader critical reflection rather than an experience that is derived from historical accounts. I argue that both types of creations are necessary to aid reflection on the role of sound in traumatic heritage.

Some Concluding Thoughts

This chapter was never meant to function as a "how to" manual for the use of sound in heritage sites, but to provide instead a starting point for reflection. My aim was to highlight, and sometimes problematise, commonly found features

in sound installations and online experiences. In many cases those experiences reflected on here were about sound themselves, in others sound was a component of a larger experience. Engaging with the sensorial experiences of the past and sharing them with wide audiences requires a sensorial approach to curation which engages with the way those spaces and objects were experienced at the time or times of use. In the case of the various possible sonic pasts, listening to a version of those experiences can aid engagement and can bring back history and heritage from its mostly silent tradition of exhibition. By establishing a framework, I have sought to explore different possible approaches to sound heritage but also different opportunities and challenges arising from curatorial choices, which in many cases are linked to ethical considerations. I have argued throughout that although there are and should be understandable apprehension towards narratives of "bringing history to life", that should not in itself be a barrier for the recreation of the sonic pasts. There are many creative and technological avenues that can be explored in order to share the sounds of the past in a transparent and engaging way, which also acknowledges the cultural specificity of sensory experiences. Furthermore, it is, I believe, time for heritage sites to explore more actively the role of sound in terms of *soundscapes of trauma* and *acoustics of torture* in line with the recognition of the importance of sites of conscience and memory. A study on how these experiences can be communicated ethically and sensitively to visitors is key to a field that does not just engage with the "pretty" but also acknowledges the potential of sound to be simultaneously a source of pain and comfort, and by doing so does not partake in silencing and marginalisation tactics. An approach that engages survivors and bases recreations on accounts and other documentation seems like a good place to start.

Notes

1 *V&A Aims to Get in Touch with Visitors*, 17 June 2005, https://www.theguardian.com/uk/2005/jun/17/arts.lifeandhealth [last accessed on 27th December 2023].
2 *It's 'Play Time' at the Toledo Museum of Art*; Hong Kong ifc mall, *Making of Harmonic Motion by Toshiko Horiuchi MacAdam*, https://www.youtube.com/watch?v=5-cfYu_dj38 [last accessed on 27th December 2023].
3 Balloon Museum, *EmotionAir: Art You Can Feel*, https://balloonmuseum.world/tickets-london/ [last accessed on 28th December 2023].
4 Balloon Museum, *EmotionAir: Art You Can Feel*, https://balloonmuseum.world/lp-london/ [last accessed on 28th December 2023].
5 Balloon Museum, *Hyperfeeling*, https://balloonmuseum.world/hyperfeeling-eng/ [last accessed on 28th December 2023].
6 *'It's very Instagrammable, for sure': Balloon Museum opens in London*, https://www.theguardian.com/artanddesign/2023/dec/28/balloon-museum-opens-in-london-instagrammable [last accessed on 12th January 2024].
7 *Stroll through an Impressionist Garden at In Bloom's Scent Experience*, https://www.denverartmuseum.org/en/blog/stroll-through-impressionist-garden-blooms-scent-experience [last accessed on 27th December 2023].

8 The National Gallery, *Soundscapes*, https://www.nationalgallery.org.uk/ exhibitions/past/soundscapes [last accessed on 27th December 2023].

9 Tate, *IK Prize 2015: Tate Sensorium*, https://www.tate.org.uk/whats-on/tate-britain/ik-prize-2015-tate-sensorium [last accessed on 28th December 2023].

10 *Tate Sensorium and the Project's Findings on Multisensory Experiences*, https://www.youtube.com/watch?v=-_z5p9NSl78 [last accessed on 28th December 2023].

11 *Tate Sensorium and the Project's Findings on Multisensory Experiences*, https://www.youtube.com/watch?v=-_z5p9NSl78 [last accessed on 28th December 2023].

12 *Tate Sensorium and the Project's Findings on Multisensory Experiences*, https://www.youtube.com/watch?v=-_z5p9NSl78 [last accessed on 28th December 2023].

13 *Tate Sensorium and the Project's Findings on Multisensory Experiences*, https://www.youtube.com/watch?v=-_z5p9NSl78 [last accessed on 28th December 2023].

14 *Soundscapes at National Gallery Review – Jamie xx and Friends Make Pointless Soundtracks for Paintings*, https://www.theguardian.com/artanddesign/2015/jul/06/soundscapes-national-gallery-review-pointless-soundtracks-jamie-xx [last accessed on 28th December 2023].

15 *Soundscapes Review – Feeble, Wrong-Headed, and Unambitious*, www.theguardian.com/artanddesign/2015/jul/12/soundscapes-review-feeble-wrong-headed-national-gallery-worst-idea [last accessed on 28th December 2023].

16 *Soundscapes at National Gallery Review – Jamie xx and Friends Make Pointless Soundtracks for Paintings*, https://www.theguardian.com/artanddesign/2015/jul/06/soundscapes-national-gallery-review-pointless-soundtracks-jamie-xx [last accessed on 28th December 2023].

17 Andrew Sachs, *The Revenge*. 1978, radio play, BBC Radio 3. Included in Andrew Sachs, *I Did it My Way*, radio programme, BBC Radio 7, Saturday 24th April 2010, 8.00 pm.

18 Tate, *IK Prize*, https://www.tate.org.uk/about-us/projects/ik-prize [last accessed on 12th January 2024].

19 *Sensorium, Tate Britain, Review: 'Less Than the Sum of Its Parts'*, https://www.telegraph.co.uk/art/what-to-see/sensorium-tate-britain-review/; *Maybe it works: José da Silva on Tate Sensorium*, https://www.theartnewspaper.com/2015/09/17/maybe-it-works-jose-da-silva-on-tate-sensorium; *Touch, smell and eat your art at Tate Britain's 'Sensorium'*, https://www.wired.co.uk/article/tate-sensorium-review-2015; *Tate Sensorium: New Exhibition at Tate Britain invites Art Lovers to Taste, Smell and Hear Art*, https://www.independent.co.uk/arts-entertainment/art/news/tate-sensorium-new-exhibition-at-tate-britain-invites-art-lovers-to-taste-smell-and-hear-art-10438783.html [last accessed on 28th December 2023].

20 https://thomasway.ac.uk/ [last accessed on 12th January 2024].

21 http://soundscapesyorkmysteryplays.com/soundscape/ [last accessed on 14th January 2024].

22 A full analysis of the feedback including how it varied across versions can be found in Mariana López, Marques Hardin and Wenqi Wan (2022) "The Soundscapes of the York Mystery Plays: Playing with Medieval Sonic Histories", in Robert Houghton (ed) *Teaching the Middle Ages through Modern Games: Using, Modding and Creating Games for Education and Impact*. De Gruyter.

23 https://www.sonic-palimpsest.org.uk/map/ [last accessed on 9th February 2024].

24 https://www.acousticatlas.de/echoesalbum [last accessed on 19th January 2024].

25 *Tracking the Past*, www.nzherald.co.nz/entertainment/news/article.cfm?c_id=1501119&objectid=10568432; RNZ Music, *Don McGlashan at the Sonic Museum*, RNZ Music podcast, www.radionz.co.nz/national/programmes/nat-music/audio/2532839/don-mcglashan-at-the-sonic-museum; *Sound and Music in Museums, Everyday Listening: Sonic Inspiration*, http://www.everydaylistening.

com/articles/2010/5/10/sound-and-music-in-museums.html [last accessed on 19th January 2024].

26 https://www.acousticatlas.de/ [last accessed on 9th February 2024].

27 *Virtual Carols by Candlelight 2020 – Chapter House Choir, York Minster*, https://www.youtube.com/watch?v=atvh6RMeses [last accessed on 9th February 2024].

28 I would like to note that this section will reflect on topics that readers might find distressing, including the use of sound for torture and the experiences of detained individuals.

29 *Welcome to Compound Security Systems Ltd*, https://www.youtube.com/watch?v=VpCLYlQRQEM&t=7s; https://mosquitoloiteringsolutions.com/ [last accessed on 21st January 2024]

30 *How Mosquito Helps with Social Distancing*, https://mosquitoloiteringsolutions.com/faq/mosquito-alarm-helps-with-social-distancing/ [last accessed on 21st January 2024].

31 *Witness History, US Psychological Warfare in Vietnam*, 21 July 2017, https://www.bbc.co.uk/sounds/play/p058m0zj [last accessed on 24th January 2024]

32 *Witness History, US Psychological Warfare in Vietnam*, 21 July 2017, https://www.bbc.co.uk/sounds/play/p058m0zj [last accessed on 24th January 2024]

33 *Witness History, US Psychological Warfare in Vietnam*, 21 July 2017, https://www.bbc.co.uk/sounds/play/p058m0zj [last accessed on 24th January 2024]

34 *Witness History, US Psychological Warfare in Vietnam*, 21 July 2017, https://www.bbc.co.uk/sounds/play/p058m0zj [last accessed on 24th January 2024]

35 *Palestinians Hit by Sonic Boom Air Raids*, https://www.theguardian.com/world/2005/nov/03/israel [last accessed on 21st January 2024].

36 *Australian Convict Sites*, https://whc.unesco.org/en/list/1306/ [last accessed on 22nd June 2024).

37 The entry for *Australian Convict Sites* under the WHL was not included in Chapter 4 as it did not come up in my search through the lists with several key-words. The reason for this is that mentions of silence measures are only present in the nomination documents rather than in the summary provided on the UNESCO site.

38 During a visit to the UNESCO heritage site 'ESMA Museum and Site of Memory – Former Clandestine Centre of Detention, Torture and Extermination' in Buenos Aires in August 2024, one of the tour guides mentioned that there were accounts of loud music being used to mask the sounds of detainees being tortured, providing an alternative interpretation for the use of loud music in these accounts.

39 https://storymaps.arcgis.com/stories/ab10e558f8674eccbde3e7924f830c96 [last accessed on 19th January 2024].

40 University of Oregon, Nolli Map of Rome, http://nolli.stanford.edu/ [last accessed on 19th January 2024].

41 *ESMA Museum and Site of Memory – Former Clandestine Centre of Detention, Torture and Extermination*, https://whc.unesco.org/en/list/1681/ [last accessed on 28th January 2024]. Although this information was drawn from the nomination text submitted to UNESCO, I couldn't hear the mentioned sounds when I visited the site in August 2024 – it is possible that it was a temporary use of sound rather than a permanent feature. The display of chairs was there though.

42 I would like to thank the Alcatraz Operations team for very kindly sending me the CD and booklet of the audio tour back in 2018.

43 *Susan Philipsz: War Damaged Musical Instruments*, https://www.tate.org.uk/whats-on/tate-britain/susan-philipsz-war-damaged-musical-instruments [last accessed on 14th February 2024].

References

Aberth, John (2003) *A Knight at the Movies: Medieval History on Film*. London: Routledge.

Bennett, Tony (1998) "Pedagogic Objects, Clean Eyes, and Popular Instruction: On Sensory Regimes and Museum Didactics," *Configurations*, 6, 345–371.

Biernoff, Suzannah (2011), "The Rhetoric of Disfigurement in First World War Britain," *Social History of Medicine*, 24:3, 666–685.

Bijsterveld, Karin, Jacobs, Annelies, Aalbers, Jasper and Fickers, Andreas (2013) "Shifting Sounds: Textualization and Dramatization of Urban Soundscapes," in Karin Bijsterveld (ed) *Soundscapes of the Urban Past: Staged Sound as Mediated Cultural Heritage*. Bielefeld: Transcript. pp. 31–66.

Bogost, Ian (2007) *Persuasive Games: The Expressive Power of Videogames*. Cambridge, MA: MIT Press.

Bull, Michael (2019) "Into the Sounds of War: Imagination, Media, and Experience," in Mark Grimshaw-Aagaard, Mads Walther-Hansen and Martin Knakkergaard (eds), *The Oxford Handbook of Sound and Imagination*, Volume 1. New York: Oxford University Press. pp. 175–202.

Chion, Michel (1999) *The Voice in Cinema*. New York: Columbia University Press.

Clarke, Catherine A.M. (2020) "Introduction: Remaking Medieval Pilgrimage," in Catherine A. M. Clarke (ed) *The St. Thomas Way and the Medieval March of Wales: Exploring Place, Heritage, Pilgrimage*. Leeds: Arc Humanities Press. pp. 1–21.

Classen, Constance (2017), *The Museum of the Senses: Experiencing Art and Collections*. London: Bloomsbury.

Cook, James (2020) "Sonic Medievalism, World Building, and Cultural Identity in Fantasy Video Games," in Karl Fugelso (ed). *Studies in Medievalism XXIX: Politics and Medievalism (Studies)*. Studies in Medievalism. Boydell & Brewer; 2020:217–238.

Corbin, Alain (2018) *A History of Silence*. Cambridge: Polity Press.

Cultura Argentina (2006), *El Nunca más y los crímenes de dictadura*. Ministerio de la Cultura. Argentina: Presidencia de la Nación.

Cusick, Suzanne G. (2008) "You Are in a Place That Is Out of the World…": Music in the Detention Camps of the "Global War on Terror," *Journal of the Society for American Music*, 2:1, 1–26, DOI: 10.1017/S1752196308080012.

Daughtry, J. Martin (2015) *Listening to War: Sound, Music, Trauma, and Survival in Wartime Iraq*. New York: Oxford University Press.

Davidson, Clifford (2013) *Corpus Christi Plays at York: A Context for Religious Drama*. New York: AMS Press.

Denard, Hugh (2009) *The London Charter: For the Computer-based Visualisation of Cultural Heritage. Draft 2.1*, King's College, London, www.londoncharter.org.

Dyson, Frances (2017) "Institutionalized Sound," in Marcel Cobussen, Vincent Meelberg and Barry Truax (eds) *The Routledge Companion to Sounding Art*. Oxon: Routledge. pp. 125–134.

Ellis, Ariana (2021) *Ghetto Streets*, https://www.historyworkshop.org.uk/public-space/ghetto-streets/ [Last accessed 19th January 2024].

Elliott, Andrew B. R. (2017) *Medievalism, Politics and Mass Media: Appropriating the Middle Ages in the Twenty-First Century*. Martlesham: D.S. Brewer.

Elliott, Andrew B. R. and Kapell, Matthew Wilhelm (2013) "Introduction: To Build a Past that Will "Stand the Test of Time": Discovering Historical Facts, Assembling Historical Narratives," in Matthew Wilhelm Kapell and Andrew B. R. Elliott (eds) *Playing with the Past: Digital Games and the Simulation of History*. London: Bloomsbury. pp. 1–29.

Fontana, Bill (n.d.), "The Relocation of Ambient Sound: Urban Sound Sculpture," https://resoundings.org/Pages/Urban%20Sound%20Sculpture.html [Last accessed 19th January 2024].

Foster, Catherine (2013) "Beyond the Display Case: Creating a Multisensory Museum Experience," in Jo Day (ed) *Making Senses of the Past: Towards a Sensory Archaeology*. Carbondale: Southern Illinois University Press. pp. 371–389.

Giles, Kate, Masinton, Anthony and Arnott, Geoff, (2012) "Visualising the Guild Chapel, Stratford-upon-Avon: Digital Models as Research Tools in Buildings Archaeology," *Internet Archaeology*, 32, https://intarch.ac.uk/journal/issue32/1/1.html.

Goodman, Steve (2009) *Sonic Warfare: Sound, Affect, and the Ecology of Fear*. Cambridge, MA: The MIT Press.

Haines, John (2014) *Music in Films on the Middle Ages: Authenticity vs. Fantasy*. Abingdon: Routledge.

Hamilakis, Yannis (2015) *Archaeology of the Senses: Human Experience, Memory, and Affect*. New York: Cambridge University Press.

Holdenried, Joshua and Trépanier, Nicolas (2013) "Dominance and the Aztec Empire: Representations in Age of Empires II and Medieval II: Total War," in Andrew B. R. Elliott and Matthew Wilhelm Kapell (eds) *Playing with the Past: Digital Games and the Simulation of History*. London: Bloomsbury. pp. 107–119.

Holter, Erika, Muth, Susanne and Schwesinger, Sebastian (2019) "Sounding Out Public Space in Late Republican Rome," in Shane Butler and Sarah Nooter (eds) *Sound and the Ancient Senses*. Oxon: Routledge. pp. 44–60.

Houghton, Robert (2018) "World, Structure and Play: A Framework for Games as Historical Research Outputs, Tools, and Processes," *Práticas da História*, 7, 11–43.

Hunter-Crawley, Heather (2020) "Classical Archaeology and the Senses: A Paradigmatic Shift?" in Robin Skeates and Jo Day (eds) *The Routledge Handbook of Sensory Archaeology*. Oxon: Routledge. pp. 434–450.

King, Pamela (2013) "Poetics and Beyond: Noisy Bodies and Aural Variations in Medieval English Outdoor Performance," Presentation at the *14th Triennial Colloquium of the Société Internationale pour l'Étude du Théâtre Médiéval*, Poznan, Poland, July 22–27.

Lacey, Kate (2017) "Auditory Capital, Media Publics and the Sounding Arts," in Marcel Cobussen, Vincent Meelberg and Barry Truax (eds) *The Routledge Companion to Sounding Art*. Oxon: Routledge. pp. 213–221.

Lopez, Mariana (2016) "The York Mystery Plays: Exploring Sound and Hearing in Medieval Vernacular Drama," in Simon Thomson and Michael Bintley (eds) *Sensory Perception in the Medieval West*. Turnhout: Brepols. pp. 53–73.

Lopez, Mariana (2019) "Giving History a Voice," in Nicholas Cook, Monique Ingalls, and David Trippett (eds) *The Cambridge Companion to Music in Digital Culture*. Cambridge: Cambridge University Press. pp. 147–149.

López, Mariana (2020) "Heritage Soundscapes: Contexts and Ethics of Curatorial Expression," in Catherine A. M. Clarke (ed) *The St. Thomas Way and the Medieval*

March of Wales: Exploring Place, Heritage, Pilgrimage. Leeds: Arc Humanities Press. pp. 103–120.

López, Mariana (2023a) "Playing the Sonic Past: Reflections on Sound in Medieval-Themed Video Games," in Robert Houghton (ed) *Playing the Middle Ages: Pitfalls and Potential in Modern Games*. London: Bloomsbury. pp. 51–74.

López, Mariana (2023b) "Sonic Medievalisms in Audio Games: an exploration of design and accessibility strategies," *Leeds International Medieval Congress*, 3-6 July, Leeds, UK.

López, Mariana, Hardin, Marques and Wan, Wenqi (2022) "The Soundscapes of the York Mystery Plays: Playing with Medieval Sonic Histories," in Robert Houghton (ed) *Teaching the Middle Ages through Modern Games: Using, Modding and Creating Games for Education and Impact*. Berlin/Boston: De Gruyter.

Lopez, Mariana, Kearney, Gavin and Hofstädter, Krisztián (2020) "Seeing Films through Sound: Sound Design, Spatial Audio, and Accessibility for Visually Impaired Audiences", *British Journal of Visual Impairment*, 40:2, DOI: 10.1177/0264619620935935.

Lopez, Mariana and Pauletto, Sandra (2010) "The Sound Machine: A Study in Storytelling through Sound Design," *Audio Mostly 2010*, September 15-17, Piteå, Sweeden.

Mills, Steve (2014) *Auditory Archaeology: Understanding Sound and Hearing in the Past*. London: Routledge.

Miller, Paul and Richards, Julian (1995) "The Good, the Bad, and the Downright Misleading: Archaeological Adoption of Computer Visualization," in Jeremy Huggett and Nick Ryan (eds) *Proceedings of the 22nd CAA Conference*. Oxford: Archaeopress. pp. 19–22.

Nooshin, Laudan (2016) "Sounding the City: Tehran's Contemporary Soundscapes," *The Middle East in London*, 12: 2, February-March 2016, https://bpb-eu-w2.wpmucdn.com/blogs.city.ac.uk/dist/a/189/files/2016/02/Nooshin-MEIL-article-Jan-2016-qzafdt.pdf [Last accessed 21st January 2024].

O'Brien, Gillian (2020) *The Darkness Echoing: Ireland's Places of Famine, Death and Rebellion*. London: Penguin Books.

O'Connor, Terry (2013) *Animals in Medieval Urban Lives: York as a Case Study*, (unpublished article provided by the author).

O'Neill, Brendan and O'Sullivan, Aidan (2020) "Experimental Archaeology and (Re)-Experiencing the Senses of the Medieval World," in Robin Skeates and Jo Day (eds), *The Routledge Handbook of Sensory Archaeology*. Oxon: Routledge. pp. 451–466.

Otterman, Michael (2007) *American Torture: From the Cold War to Abu Ghraib and Beyond*. London; Ann Arbor, MI: Pluto Press.

Ouzounian, Gascia (2020) *Stereophonica: Sound and Space in Science, Technology, and the Arts*. Cambridge, MA: MIT Press.

Pearse, D. Linda, Waltner, Ann and Godsoe, C. Nicholas (2017) "Historically Informed Soundscape: Mediating Past and Present," *Journal of Sonic Studies*, https://www.researchcatalogue.net/view/408710/408711.

Polti, Victoria (2014) "Memoria sonora, cuerpo y bio-poder. Un acercamiento a la experiencia concentracionaria en la Argentina durante la última dictadura cívico-militar," *XI Congreso Argentino de Antropología Social*, Rosario, 23 al 26 de Julio, https://www.aacademica.org/000-081/1560.

Presner, Todd (2009) "Remapping German-Jewish Studies: Benjamin, Cartography, Modernity," *German Quarterly, German-Jewish and Jewish-German Studies*, 82, 293–315.

Pugh, Tison and Weisl, Angela (2013) *Medievalisms: Making the Past in the Present*. London: Routledge.

Ramirez, Janina (2022) *Femina. A New History of the Middle Ages, Through the Women Written Out of It*. London: WH Allen.

Rastall, Richard (1996) *The Heaven Singing: Music in Early English Religious Drama: I*. Cambridge: Brewer.

Rastall, Richard (2001) *Minstrels Playing: Music in Early English Religious Drama: II*. Cambridge: Brewer.

Rice, Tom (2016) "Sounds Inside: Prison, Prisoners and Acoustical Agency," *Sound Studies*, 2:1, 6–20, DOI: 10.1080/20551940.2016.1214455.

Redfern, Rebecca and Hefner, Joseph T. (2019) ""Officially Absent but Actually Present": Bioarchaeological Evidence for Population Diversity in London during the Black Death, AD 1348–50", in Madeleine L. Mant (ed) *Bioarchaeology of Marginalized People*. Alyson Jaagumägi Holland, Academic Press, 69–114, DOI: 10.1016/B978-0-12-815224-9.00005-1.

Salen, Katie and Zimmerman, Eric (2003) *Rules of Play: Game Design Fundamentals*. Cambridge, MA: MIT Press.

Schafer, R. Murray (1994) *The Soundscape: Our Sonic Environment and the Tuning of the World*. Rochester: Destiny.

Schulze, Holger (2013) "The Corporeality of Listening: Experiencing Soundscapes on Audio Guides," in Karin Bijsterveld (ed) *Soundscapes of the Urban Past: Staged Sound as Mediated Cultural Heritage*. Bielefeld: Transcript. pp. 195–207.

Shull, Jonathan (2006) "Locating the Past in the Present: Living Traditions and the Performance of Early Music," *Ethnomusicology Forum*, 15:1, 87–111, DOI: 10.1080/17411910600634361.

Smith, Mark (2007) *Sensory History*. Oxford: Bloomsbury.

Soria-Martínez, Verónica (2017) "Resounding Memory: Aural Augmented Reality and the Retelling of History," *Leonardo Music Journal*, 27, 12–16.

Stafford, Barbara Maria (1994) *Artful Science: Enlightenment, Entertainment, and the Eclipse of Visual Education*. Cambridge: MIT Press.

Sterne, Jonathan (2003) *The Audible Past: Cultural Origins of Sound Reproduction*. Durham: Duke University Press.

Stoever, Jennifer Lynn (2010) "The Noise of SB 1070: or Do I Sound Illegal to You?" *Sounding Out*, https://soundstudiesblog.com/2010/08/19/the-noise-of-sb-1070/.

Stoever, Jennifer Lynn (2016) *The Sonic Color Line: Race and the Cultural Politics of Listening*. New York: New York University Press.

Sturtevant, Paul (2018) *The Middle Ages in Popular Imagination*. London: I. B. Tauris.

Taruskin, Richard (1995) *Text and Act: Essays on Music and Performance*. New York: Oxford University Press.

Thompson, Marie (2017) *Beyond Unwanted Sound: Noise, Affect and Aesthetic Moralism*. New York: Bloomsbury Academic.

UNESCO (2023) *ESMA Museum and Site of Memory – Former Clandestine Centre of Detention, Torture and Extermination*, https://whc.unesco.org/en/list/1681/ [Last accessed 28th January 2024].

van Tonder, Cobi (2022a) *Echoes and Reflections – Acoustic Atlas receives IDF Winter 2022 Call funding*, https://www.acousticatlas.de/blog/2022-05-05-Echoes%20and%20Reflections [Last accessed 19th January 2024].

van Tonder, Cobi (2022b) *Echoes of Our Ancestors for Robyn Schulkowsky*, https://www.acousticatlas.de/blog/2022-02-18-Echoes%20of%20Our%20Ancestors [Last accessed 19th January 2024].

Whittington, William (2019) "Sound, Museums, and the Modulation of the Imagination," in Mark Grimshaw-Aagaard, Mads Walther-Hansen and Martin Knakkergaard (eds), *The Oxford Handbook of Sound and Imagination*, Volume 1. New York: Oxford University Press. pp. 549–563.

Workman, Leslie (1997) "Medievalism Today," *Medieval Feminist Newsletter*, 23: 29.

Westerkamp, Hildegard (2001) Soundwalking, https://www.hildegardwesterkamp.ca/writings/?post_id=13&title=soundwalking [Last accessed 22nd April 2024].

Ludology

Age of Empires (Ensemble Studios, 1997)
The Elder Scrolls (Bethesda Game Studios, 2014)

6

REVERBERATIONS

Pasts and Futures

This book started with a memory of a Saturday night, sometime in the 1990s, in Boulogne Sur Mer. No, not the French city, but a town in the Province of Buenos Aires (Argentina), and no, not near the obelisk, nowhere near it. In that memory I sat at a dining table in my paternal grandparents' house, having dinner and listening to a debate surrounding heritage and the destruction versus preservation of *El Cabildo de Buenos Aires*, a national Argentinian monument. This book started with a difference of opinion on what needs preserving and what does not and who makes these decisions. A difference of opinion that goes beyond the dinner table and is key to conversations on heritage, both sonic and beyond.

As I sat doing the final edits to this book, it dawned on me that I had written about a great number of things that I care deeply about, from issues of marginalisation linked to race, ethnicity, gender, disability, and socioeconomics, to the devasting effects of climate change. Throughout the chapters I have argued that researching, valuing, and protecting acoustical heritage and soundscapes cannot be separated from any of these wider considerations. Following this, I have argued that the field of acoustical heritage and historical soundscapes has been dominated by often unspoken biases linked to constructions of a white, male, middle-class, non-disabled European listener. Alongside, I have also argued that there has been a prioritisation of "positive" sound heritage, at the expense of contending with the troubling and sad legacies of sounds in the context of suffering, torture, and imprisonment. Such reflections on this "negative" sound heritage, which I have analysed through the framings of *soundscapes of trauma* and *acoustics of torture*, contribute to what I hope is our collective refusal to silence the experiences of those who have been tortured, marginalised, and oppressed – acknowledging

DOI: 10.4324/b22976-6

sound as having a central role in our reflections concerning sites of memory and conscience.

Throughout this book I have sought to introduce the reader to various approaches to studying sonic pasts, which I have grouped broadly as *humanities and social sciences approaches* on the one side, and *acoustic engineering approaches* on the other. When discussing the former, I have explored research in the fields of Anthropology, Archaeology, and History and how these are connected to Sensory Studies. Through considering these disciplines, I have reflected on hearing and other senses as being *culturally* and *temporally specific* – that is, the way we hear and conceptualise the sense of hearing is not the same today as it was in previous historical periods, with additional significant variations within and across geographical regions and cultures. Furthermore, the senses and their hierarchies have been used throughout history to marginalise those who do not conform to the predominant sensorial regime, with the othering process falling across varied lines of gender, race, ethnicity, social class, and disability – the sensorial regimes themselves used to justify discrimination and colonial rule. In short, *the senses are political* and, in relation to this book, definitions of sound and noise, and the overall construction of sound heritage, are political as well. I have illustrated these aspects through different case studies, such as that of Stonehenge and the debates surrounding road developments near the site, exploring how the arguments in favour of additional construction centre on the damaging impact of noise versus the beauty of quiet as their justifying rationale. In doing so, these arguments invoke universalising notions of quiet and tranquillity that are rooted in imaginaries of a beautiful, quiet, and peaceful countryside. Such framings date back to the eighteenth century and privilege the experiences and aesthetic preferences of a white, middle-class elite, far removed from the more complex historical and contemporary realities of rural living. Another case study I discussed examined the politics of sound attached to Big Ben, particularly in relation to attempts made by Brexit supporters to co-opt its sound to symbolise the UK's departure from the European Union – seeking to gain political support through the use of an iconic sound.

Across the different chapters in this book, I have also reflected on how acoustic engineering approaches have often hidden behind a veil of imaginary objectivity. We can note again how there has been a tendency for the field to investigate historical sites in terms of "optimal" acoustic parameters derived entirely from the study of modern auditoria, despite the fact that the sites in question were built for different purposes and belong to diverse cultures. Analyses of speech intelligibility, clarity, and envelopment, among others, are then used to draw conclusions on the uses and experiences of a broad variety of sites. This variety is questionable in itself, as studies have often focused on a very narrow definition of heritage, emphasising monumental European sites and ultimately sidelining the ephemeral and the immaterial. This lack

of engagement with acoustics outside of Europe is a further reminder that constructions of heritage worth are heavily rooted in geography, a fact that became painfully evident when we considered the case of Notre Dame and the 2019 fire.

Another central aspect of this volume has been a reflection on how UNESCO's Intangible Cultural Heritage (ICH) Convention has been used in acoustical heritage and historical soundscapes studies to evidence and justify the importance sound heritage has gained in the last decades. However, I have discussed how the field itself has often struggled to embrace some of the most central aspects of the ICH Convention, including the fact it originated as a means to tackle the lack of diversity in the World Heritage Lists (i.e. moving away from monumental European heritage) and to centralise the importance of culture bearers. Instead of engaging deeply with what the ICH Convention has tried to stand for, researchers have instead used it as a means to justify their own importance, while still continuing to research monumental European sites and largely sidelining the importance of culture bearers – particularly when approaches are focused on engineering.

An analysis of the ICH Convention lists also presents some worrying trends, with sound being equated to music, and non-musical sound references reduced to just a handful of examples. I have categorised the non-musical sonic references I found into *acoustic communication,* which includes *Manual Bell Ringing, El Silbo Gomero, Alheda'a, oral traditions of calling camel flocks,* and *Culture of Jeju Haenyeo* – in which sound is central to people's environments and has a connection to their engagement with the landscape; *festivities and processions* – including *Holy Week processions in Popayán, Holy Week processions in Mendrisio, Holy Week in Guatemala, Fiesta of the patios in Cordova,* and *Carnival of Binche* – in which sound is part of a wider multisensorial experience; *ceremonies* – which encompasses the entry for *Male-child cleansing ceremony of the Lango,* in which once more sound is part of a wider setting; and finally, *non-musical sound making objects,* including *Oxherding and oxcart traditions in Costa Rica* and *Buklog, thanksgiving ritual system of the Subanen* – the former is an example in which the sounds of the cart wheels are a key consideration in design practices, and the latter in which sound is part of a spiritual experience. I will forward that the scarce mention of sounds beyond music is an indication that State Parties need to engage more rigorously with sonic considerations, taking these into account as a standard part of nomination texts – it is hard to believe that they could be entirely irrelevant to the majority of entries. At the same time, State Parties should redefine what they think of as sound heritage, to expressly include those sounds and acoustics that are key to communities by encouraging thinking beyond music.

My analysis of the UNESCO World Heritage Lists uncovered a similarly limited consideration of acoustics and sounds in relation to heritage, being

present in only a small percentage of entries. In these cases, the vast majority were centred on noise control, with very little reflection on what we are left with once noise is extricated. This focus on noise extraction rather than sound preservation evidences an ocularcentric approach to heritage. There were some exceptions to this, which I categorised in relation to *sounds of nature; sounds linked to quiet and tranquillity* (beyond noise removal); *bells; sound as security systems; sound and spirituality; sound and medicine; acoustics*; and *soundscapes of trauma and acoustics of torture*. When reflecting on the entries linked to acoustics, it was noted that the majority of entries were concerned with theatres and other types of auditoria, and references lacked specificity, with mentions of sites having "excellent acoustics" but with no accompanying explanation of what indeed made them "excellent". The only exceptions to theatre and auditoria acoustics found are the entries for *Great Zimbabwe National Monument* and *Dionysius' Ear* (part of *Syracuse and the Rocky Necropolis of Pantalica*), with the former indicating the crucial role of traditional knowledge in understanding the importance of sound for local communities, moving beyond Western constructions and their focus on materiality and visuality.

As part of this volume, I have also reflected on different strategies utilised in sound installations and online experiences to engage sonically with the past, and with the sonic pasts. I introduced a framework I have developed which classifies sound experiences in terms of *sound as evocation; sound as recreation of the past; sound as dramatisation; sound as artistic reflection of the past; sound as remote access*; and *soundscapes of trauma* and *acoustics of torture*. This framework, I emphasise, does not comprise of closed, immutable categories, but articulates a number of approaches I have encountered and been involved with throughout my years in the field, capturing different types of engagement and connecting them with the ethics of curation practices. My central thread in this regard has been the need to consider the balance between rigour and engagement – about the possible benefit of deploying preconceptions of the past thoughtfully in order to usefully engage modern listeners versus the danger these always pose for reinforcing stereotypes of the past through sound. I have discussed this with reference to the use of accented English in sound recreations, which might reinforce certain beliefs in there being a direct connection between geography and accent, while also erasing the diverse, multi-lingual experiences that are known to have characterised the past. Following this, I have also discussed the risks posed by an overreliance on voice in sound-based heritage experiences, denying space for the other sound elements that were also crucial to the experiences being represented. Although, it is also worth noting that dramatisations can provide playful and informative means to engage audiences with heritage. I have subsequently argued for a need to reflect on ethical ways in which we can create experiences that acknowledge the role of sound in "negative" heritage.

I have highlighted the evidence of the centrality of sound and listening and the soundscapes experienced in connection to traumatic events, while also drawing attention to how the acoustics of sites themselves impacted those sonic experiences, providing further instances of trauma, while also in other cases providing glimmers of hope. Rather than shying away from such work, I believe we should actively tackle the important task of thoughtfully and critically engaging with this darker side of sound and acoustics.

This book has, finally, argued that interdisciplinarity – of the true kind – is key to the future of research on acoustical heritage and historical sound-scapes. We cannot interpret acoustic data without a strong knowledge of context, including an understanding of sensorial frameworks and their rela-tivity. Technology also has a lot to offer, not just in terms of the opportuni-ties it affords to study the acoustics of spaces through measurements and simulations, but also how it allows us to edit and mix sounds together to bet-ter acknowledge and understand their multiplicity of combinations – aspects which can then be shared with others beyond academic circles. To refuse the inspiring frictions and challenges that truly interdisciplinary thinking can grant researchers would be to leave us only focusing on a sonic cabinet of curiosities that is centred around the experiences of a white, male, non-disabled, European middle-class listener, which marginalises and exoticises everything outside of these narrow parameters. By embracing transparency and showing the myriad possible sonic pasts – which are impossible to define precisely, and require our constant rethinking of limitations and biases – we can begin a shift away from materially grounded research and preservation, to fully embrace the richness of ephemerality and diversity in sound.

BIBLIOGRAPHY

Aberth, John (2003) *A Knight at the Movies: Medieval History on Film*. London: Routledge.

Alivizatou, Marilena (2012) *Intangible Heritage and the Museum: New Perspectives on Cultural Preservation*. Oxon: Taylor & Francis Group.

Álvarez-Morales, Lidia, Álvarez-Corbacho, Ángel, Lopez, Mariana and Bustamante, Pedro (2021) "The Acoustics of Ely Cathedral's Lady Chapel: A Study of Its Changes throughout History," *2021 Immersive and 3D Audio: From Architecture to Automotive (I3DA)*, Bologna, Italy, 2021, 1–9, DOI: 10.1109/I3DA48870.2021.9610837.

Álvarez-Morales, Lidia, Lopez, Mariana and Álvarez-Corbacho, Ángel (2019) "Cathedral Acoustics: Bristol Cathedral as a Case Study," *Conference Proceedings of Internoise 2019*, Madrid, Spain.

Álvarez-Morales, Lidia, Lopez, Mariana and Álvarez-Corbacho, Ángel, (2020) "The Acoustic Environment of York Minster's Chapter House," *Acoustics*, 2:1, 13–36. DOI: 10.3390/acoustics2010003.

Álvarez-Morales, Lidia, Lopez, Mariana, Álvarez-Corbacho, Ángel and Bustamante, Pedro (2019) "Mapping the Acoustics of Ripon Cathedral," *Proceedings of the 23rd International Congress on Acoustics, Integrating 4th EAA Euroregio 2019, ICA 2019*, Aachen, Germany, 2335–2342.

Ando, Yoichi (1985) *Concert Hall Acoustics*. Berlin: Springer-Verlag.

Angas, George French (1842) *A Ramble in Malta and Sicily, in the Autumn of 1841*. London: Smith, Elder, and Co., Cornhill.

Angelakis, Konstantinos, Rindel, Jens Holger and Gade, Anders Christian (2011) "Theatre of the Sanctuary of Asklepios at Epidaurus and the Theatre of Ancient Epidaurus: Objective Measurements and Computer Simulations," *The Acoustics of Ancient Theatres Conference*, Patras, Greece.

Arizpe, Lourdes (2000) "Cultural Heritage and Globalization," in Erica Avrami, Randall Mason and Marta de la Torre (eds) *Values and Heritage Conservation*. Research Report. Los Angeles, CA: The Getty Conservation Institute.

Arkette, Sophie (2004) "Sounds Like City," *Theory, Culture & Society*, 21:1, 159–168, DOI: 10.1177/0263276404040486.

Astolfi, Arianna, Bo, Elena, Aletta, Francesco and Shtrepi, Louena (2020) "Measurements of Acoustical Parameters in the Ancient Open-Air Theatre of Tyndaris (Sicily, Italy)," *Applied Sciences*, 10:16, 5680. DOI: 10.3390/app10165680.

Atkinson, Niall (2016) *The Noisy Renaissance: Sound, Architecture, and Florentine Urban Life.* University Park: The Pennsylvania State University Press.

Ballent, Anahi (2016) "El Estado como problema: el Ministerio de Obra Públicas y el centro de Buenos Aires durante la presidencia de Agustín P. Justo, 1932-1938," *Estudios de Hábitat*, 14:2, https://tinyurl.com/nhjs45ju.

Banegal, Hope (1930) "Bach's Music and Church Acoustics," *Music & Letters*, 11:2, 146–155.

Barnes, Colin (2012) "Understanding the Social Model of Disability: Past, Present and Future," in Nick Watson, Alan Roulstone, and Carol Thomas (eds) *Routledge Handbook of Disability Studies.* Oxon: Routledge. pp. 12–29.

Barron, Michael (1983) "Auditorium Acoustic Modelling Now," *Applied Acoustics*, 16, 279–290.

Barron, Michael (1993) *Auditorium Acoustics and Architectural Design.* London: E & FN Spon.

Barron, Michael (1995) "Interpretation of Early Decay Times in Concert Auditoria," *Acustica*, 81:4, 320–331.

Barron, Michael (2000) "Measured Early Lateral Energy Fractions in Concert Halls and Opera Houses," *Journal of Sound and Vibration*, 232:1, 79–100.

Barron, Michael (2005) "Using the Standard on Objective Measures for Concert Auditoria, ISO 3382, to Give Reliable Results," *Acoustical Science and Technology*, 26:2, 162–169.

Barron, Michael (2009) *Auditorium Acoustics and Architectural Design* (2nd ed.). London; New York: Taylor & Francis.

Barron, Michael and Marshall, A. (1981) "Spatial Impression Due to Early Lateral Reflections in Concert Halls: The Derivation of a Physical Measure," *Journal of Sound and Vibration*, 77:2, 211–232.

Bartalucci, Chiara and Luzzi, Sergio (2020) "The Soundscape in Cultural Heritage," *IOP Conference Series: Materials Science and Engineering*, 949. 012050, DOI: 10.1088/1757-899X/949/1/012050.

Baudrillard, Jean (1981) *Simulacra and Simulation*, trans. Sheila Faria Glaser. Ann Arbor: University of Michigan Press.

Beazley, Olwen and Deacon, Harriet (2007) "The Safeguarding of Intangible Heritage Values under the World Heritage Convention: Auschwitz, Hiroshima, and Robben Island," in Janet Blake (ed) *Safeguarding Intangible Cultural Heritage: Challenges and Approaches.* Builth Wells: Institute of Art and Law. pp. 93–107.

Bendrups, Dan (2015) "Sound Recordings and Cultural Heritage: The Fonck Museum, the Felbermayer Collection, and Its Relevance to Contemporary Easter Island Culture," *International Journal of Heritage Studies*, 21:2, 166–176, DOI: 10.1080/13527258.2013.838983.

Bennett, Tony (1995) *The Birth of the Museum: History, Theory, Politics.* London: Routledge.

Bennett, Tony (1998) "Pedagogic Objects, Clean Eyes, and Popular Instruction: On Sensory Regimes and Museum Didactics," *Configurations*, 6, 345–371.

Beranek, Leo (1962) *Music, Acoustics & Architecture*. New York and London: John Wiley & Sons, Inc.

Beranek, Leo (1996) *Concert and Opera Halls: How They Sound*. New York: Acoustical Society of America.

Beranek, Leo (2004) *Concert Halls and Opera Houses: Music, Acoustics, and Architecture* (2nd ed.). New York: Springer.

Berkaak, Odd Are (2019) "Noise and Tranquility at Stonehenge: The Political Acoustics of Cultural Heritage," in Mark Grimshaw-Aagaard, Mads Walther-Hansen, and Martin Knakkergaard (eds) *The Oxford Handbook of Sound and Imagination*, Volume 1. New York: Oxford University Press. pp. 313–331.

Bevilacqua, Antonella, Ciaburro, Giuseppe, Iannace, Gino, Lombardi, Ilaria and Trematerra, Amelia (2022) "Acoustic Design of a New Shell to Be Placed in the Roman Amphitheater Located in Santa Maria Capua Vetere," *Applied Acoustics*, 187, DOI: 10.1016/j.apacoust.2021.108524.

Biddle, Ian and Gibson, Kirsten (2019) "Introduction," in Ian Biddle and Kirsten Gibson (eds) *Cultural Histories of Noise, Sound and Listening in Europe, 1300–1918*. Oxon: Routledge. pp. 1–14.

Bijsterveld, Karin, Jacobs, Annelies, Aalbers, Jasper and Fickers, Andreas (2013) "Shifting Sounds: Textualization and Dramatization of Urban Soundscapes," in Karin Bijsterveld (ed) *Soundscapes of the Urban Past: Staged Sound as Mediated Cultural Heritage*. Bielefeld: Transcript. pp. 31–66.

Blake, Janet (2009) "UNESCO's 2003 Convention on Intangible Cultural Heritage: The Implications of Community Involvement in 'Safeguarding'," in Laurajane Smith and Natsuko Akagawa (eds) *Intangible Heritage*. London: Routledge. pp. 45–73.

Blesser, Barry and Salter, Linda-Ruth (2007) *Spaces Speak, Are You Listening?* Massachusetts: MIT Press.

Bogost, Ian (2007) *Persuasive Games: The Expressive Power of Videogames*. Cambridge, MA: MIT Press.

Bouchenaki, Mounir (2004) "Editorial," *Museum International, Intangible Heritage*, LVI:1–2, May 2004.

Bradley, J.S, Reich, R. and Norcross, S.G. (1999) "A Just Noticeable Difference in C50 for Speech," *Applied Acoustics*, 58, 99–108.

Buckingham, Jane (2018) "Disability and Work in South Asia and the United Kingdom," in Michael Rembis, Catherine Kudlick, and Kim E. Nielsen (eds), *The Oxford Handbook of Disability History*. United States: Oxford Handbooks. pp. 197–212.

Bude, Tekla (2022) *Sonic Bodies: Text, Music, and Silence in Late Medieval England*. Philadelphia: University of Pennsylvania Press.

Bull, Michael, Gilroy, Paul, Howes, David and Kahn, Douglas (2006) "Introducing Sensory Studies," *The Senses and Society*, 1:1, 5–7, DOI: 10.2752/174589206778055655

Cameron, Christina (2010) "World Heritage Sites of Conscience and Memory," in Dieter Offenhäußer, Walther Ch. Zimmerli and Marie-Theres Albert (eds) *World Heritage and Cultural Diversity*. German Commission for UNESCO, Germany, https://www.unesco.de/sites/default/files/2018-07/world_heritage_and_cultural_diversity_2010.pdf [Last accessed 15th April 2024]. pp. 112–119.

Canac, F. (1967) *The Acoustics of Ancient Theatres: Their Teaching* [in French: *L'Acoustique des Theatres Antiques: Ses Enseignements*]. Paris: CNRS.

Catros, Aurélien and Leblanc, Maxime (2021) "When Boston Isn't Boston: Useful Lies of Reconstructive Game Models", *Traditional Dwellings and Settlements Review (TDSR)*, XXXII:II, 23–37.

CATT-Acoustic, https://www.catt.se/ [Last accessed 8th March 2024].

Chion, Michel (1999) *The Voice in Cinema*. New York: Columbia University Press.

Clarke, Catherine A.M. (2020) "Introduction: Remaking Medieval Pilgrimage," in Catherine A. M. Clarke (ed) *The St. Thomas Way and the Medieval March of Wales: Exploring Place, Heritage, Pilgrimage*. Leeds: Arc Humanities Press. pp. 1–21.

Classen, Constance (1997) "Foundations for an Anthropology of the Senses," *International Social Science Journal*, 49:3, 401.

Classen, Constance (2005a) "McLuhan in the Rainforest: The Sensory Worlds of Oral Cultures," in David Howes (ed) *Empire of the Senses: The Sensual Cultural Reader*. Oxford, New York: Berg. pp. 147–163.

Classen, Constance (2005b) "The Witch's Senses: Sensory Ideologies and Transgressive Femininities from the Renaissance to Modernity," in David Howes (ed) *Empire of the Senses: The Sensual Cultural Reader*. Oxford, New York: Berg. pp. 70–84.

Classen, Constance (2017) *The Museum of the Senses: Experiencing Art and Collections*. London: Bloomsbury.

Commins, Daniel (1998) "The Restoration of La Fenice in Venice: The Consultant's Viewpoint," *Journal of the Acoustical Society of America*, 103: 5, DOI: 10.1121/1.421601.

Cook, James (2020) "Sonic Medievalism, World Building, and Cultural Identity in Fantasy Video Games," in Karl Fugelso, (ed) *Studies in Medievalism XXIX. Politics and Medievalism (Studies)*. Studies in Medievalism. Boydell & Brewer; 2020:217–238.

Cooper, Catriona (2019) "The Sound of Debate in Georgian England: Auralising the House of Commons," *Parliamentary History*, 38:1, February 2019, DOI: 10.1111/1750-0206.12413.

Corbin, Alain (1998) *Village Bells: Sound and Meaning in the nineteenth century French Countryside*. New York: Columbia University Press.

Corbin, Alain (2005) "Charting the Cultural History of the Senses," in David Howes (ed) *Empire of the Senses: The Sensual Cultural Reader*. Oxford, New York: Berg. pp. 128–139.

Corbin, Alain (2018) *A History of Silence*. Cambridge: Polity Press.

Cox, Trevor (1993) "The Sensitivity of Listeners to Early Sound Field Changes in Auditoria," *Acustica*, 79, 28–41.

Cox, Trevor (2015) *Sonic Wonderland: A Scientific Odyssey of Sound*. London: Vintage.

Cox, Trevor J. (2021) "Modeling Sound at Stonehenge," *Physics Today*, 74:10, 74–75. DOI: 10.1063/PT.3.4865.

Cox, Trevor J., Fazenda, Bruno M. and Greaney, Susan E. (2020) "Using Scale Modelling to Assess the Prehistoric Acoustics of Stonehenge," *Journal of Archaeological Science*, 122, 105218, DOI: 10.1016/j.jas.2020.105218.

CPRE, The Countryside Charity (2021) *Access to nature in the English countryside: a participant led research project exploring inequalities in access to the countryside for people of colour*, https://www.cpre.org.uk/wp-content/uploads/2021/08/August-2021_Access-to-nature-in-the-English-countryside_research-overview.pdf [Last accessed 9th April 2024].

Crosby, Alfred W. (2004) *Ecological Imperialism: The Biological Expansion of Europe, 900-1900* (2nd ed.). Cambridge, New York: Cambridge University Press.

Cultura Argentina (2006) *El Nunca más y los crímenes de dictadura.* Ministerio de la Cultura. Presidencia de la Nación. Argentina.

Cusick, Suzanne G. (2008) "You Are in a Place That Is Out of the World...": Music in the Detention Camps of the "Global War on Terror," *Journal of the Society for American Music,* 2:1, 1–26, 10.1017/S1752196308080012.

Daughtry, J. Martin (2015) *Listening to War: Sound, Music, Trauma, and Survival in Wartime Iraq.* New York: Oxford University Press.

Davidson, Clifford (2013) *Corpus Christi Plays at York: A Context for Religious Drama.* New York: AMS Press.

De Muynke, Julien, Baltazar, Marie, Monferran, Martin, Voisenat, Claudie and Katz, Brian F.G. (2024) "Ears of the Past, an Inquiry into the Sonic Memory of the Acoustics of Notre-Dame before the Fire of 2019," *Journal of Cultural Heritage,* 65, 169–176, DOI: 10.1016/j.culher.2022.09.006.

de Oliveira Pinto, Tiago (2018) *Music as Living Heritage: An Essay on Intangible Culture.* Berlin: Edition EMVAS.

Denard, Hugh (2009) *The London Charter: For the Computer-based Visualisation of Cultural Heritage. Draft 2.1,* King's College, London, www.londoncharter.org.

Devereux, Paul (2001) *Stone Age Soundtracks: The Acoustic Archaeology of Ancient Sites.* London: Vega.

Dow, Douglas N. (2013) "Historical Veneers: Anachronism, Simulation, and Art History in Assassin's Creed II," in Matthew Wilhelm Kapell and Andrew B. R. Elliott (eds) *Playing with the Past: Digital Games and the Simulation of History.* London: Bloomsbury. pp. 215–231.

Dyson, Frances (2017) "Institutionalized Sound," in Marcel Cobussen, Vincent Meelberg and Barry Truax (eds) *The Routledge Companion to Sounding Art.* Oxon: Routledge. pp. 125–134.

Elliott, Andrew B. R. (2017) *Medievalism, Politics and Mass Media: Appropriating the Middle Ages in the Twenty-First Century.* Martlesham: D.S. Brewer.

Elliott, Andrew B. R. and Kapell, Matthew Wilhelm (2013) "Introduction: To Build a Past that Will "Stand the Test of Time": Discovering Historical Facts, Assembling Historical Narratives," in Matthew Wilhelm Kapell and Andrew B. R. Elliott (eds) *Playing with the Past: Digital Games and the Simulation of History.* London: Bloomsbury. pp. 1–29.

Ellis, Ariana (2021) *Ghetto Streets,* https://www.historyworkshop.org.uk/public-space/ghetto-streets/ [Last accessed 19th January 2024].

Eneix, Linda C. (2014) *Archaeoacoustics: The Archaeology of Sound. Publication of the 2014 Conference in Malta.* Florida: The OTS Foundation.

Eneix, Linda C. (2016) *Archaeoacoustics II: The Archaeology of Sound. Publication of the 2015 Conference in Istambul.* Florida: The OTS Foundation.

Eneix, Linda C. (2018) *Archaeoacoustics III: The Archaeology of Sound. Publication of the 2017 Conference in Portugal.* Florida: The OTS Foundation.

Everest, F. Alton and Pohlmann, Ken C. (2015) *Master Handbook of Acoustics.* (6th ed.). London: McGraw-Hill.

Farina, Angelo (2000) "Simultaneous Measurements of Impulse Response and Distortion with a Swept-Sine Technique," *Audio Engineering Society 108th Convention,* Paris, France, February 18–22.

Farina, Angelo (2007) "Advancements in Impulse Response Measurements by Sine Sweeps," *Audio Engineering Society 122nd Convention*, Vienna, Austria, May 5–8.

Fazenda, Bruno and Drumm, Ian (2013) "Recreating the Sound of Stonehenge," *Acta Acustica United with Acustica*, 99:1, 110–117. DOI: 10.3813/AAA.918594.

Fearn, R.W. (1975) "Reverberation in Spanish, English and French churches," *Journal of Sound and Vibration*, 43:3, 562–567.

Feld, Steven (2005) "Places Sensed, Senses Placed: Toward a Sensuous Epistemology of Environments," in David Howes (ed) *Empire of the Senses: The Sensual Cultural Reader*. Oxford, New York: Berg. pp. 179–191.

Feld, Steven (2015) "Acoustemology," in David Novak and Matt Sakakeeny (eds) *Keywords in Sound*. Durham and London: Duke University Press. pp. 12–21.

Fırat, Hasan Baran (2021) "Acoustics as Tangible Heritage: Re-embodying the Sensory Heritage in the Boundless Reign of Sight," *Preservation, Digital Technology & Culture*, 50:1, 3–14. DOI: 10.1515/pdtc-2020-0028.

Fontana, Bill (n.d.) "The Relocation of Ambient Sound: Urban Sound Sculpture," https://resoundings.org/Pages/Urban%20Sound%20Sculpture.html [Last accessed 19th January 2024].

Forsyth, Michael (1985) *Buildings for Music: The Architect, the Musician, and the Listener from the Seventeenth Century to the Present Day*. Cambridge: MIT Press.

Foster, Catherine (2013) "Beyond the Display Case: Creating a Multisensory Museum Experience," in Jo Day (ed) *Making Senses of the Past: Towards a Sensory Archaeology*. Carbondale: Southern Illinois University Press. pp. 371–389.

Galindo, Miguel, Zamarreño Teófilo, Girón, Sara (2009) "Acoustic Simulations of Mudejar-Gothic Churches," *Journal of Acoustical Society of America*, 126, 1207–1218.

Giles, Kate, Masinton, Anthony and Arnott, Geoff (2012) "Visualising the Guild Chapel, Stratford-upon-Avon: Digital Models as Research Tools in Buildings Archaeology," *Internet Archaeology*, 32, https://intarch.ac.uk/journal/issue32/1/1.html.

Girón, Sara, Álvarez-Corbacho, Ángel and Zamarreño, Teófilo (2020) "Exploring the Acoustics of Ancient Open-Air Theatres," *Archives of Acoustics*, 45:2, 181–208. DOI: 10.24425/aoa.2020.132494.

Girón, Sara, Álvarez-Morales, Lidia and Zamarreño, Teófilo (2017) "Church Acoustics: A State-of-the-Art Review after Several Decades of Research," *Journal of Sound and Vibration*, 411, 378–408, DOI: 10.1016/j.jsv.2017.09.015.

Goh, Annie (2017) "Sounding Situated Knowledges: Echo in Archaeoacoustics," *Parallax*, 23:3, 283–304, DOI: 10.1080/13534645.2017.1339968.

Goodman, Steve (2009) *Sonic Warfare: Sound, Affect, and the Ecology of Fear*. Cambridge, MA: MIT Press.

Griesinger, David (1996) "Beyond MLS – Occupied Hall Measurement with FFT Techniques," *Audio Engineering Society's 101st Convention*, Los Angeles, CA, November 8-11.

Haines, John (2014) *Music in Films on the Middle Ages: Authenticity vs. Fantasy*. Abingdon: Routledge.

Hamilakis, Yannis (2015) *Archaeology of the Senses: Human Experience, Memory, and Affect*. New York: Cambridge University Press.

Hedenstierna-Jonson, Charlotte, Kjellström, Anna, Zachrisson, Torun, Krzewińska, Maja, Sobrado, Veronica, Price, Neil, Günther, Torsten, Jakobsson, Mattias, Götherström, Anders and Storå, Jan (2017) "A Female Viking Warrior Confirmed by Genomics," *American Journal of Physical Anthropology*, 164, 853–860 DOI: 10.1002/ajpa.23308.

Helmreich, Stefan (2010) "Listening against Soundscapes," *Anthropology News*, December 2010.

Hidaka, Takayuki, Beranek, Leo L. and Okano, Toshiyuki (1995) "Interaural Cross-Correlation, Lateral Fraction and Low- and High-Frequency Sound Levels as Measures of Acoustical Quality in Concert halls," *Journal of the Acoustical Society of America*, 98:2, 988–1007.

Holdenried, Joshua and Trépanier, Nicolas (2013) "Dominance and the Aztec Empire: Representations in Age of Empires II and Medieval II: Total War," in Matthew Wilhelm Kapell and Andrew B. R. Elliott (eds) *Playing with the Past: Digital Games and the Simulation of History*. London: Bloomsbury. pp. 107–119.

Holmes, Peter (2006) "The Scandinavian Bronze Lurs: Accident or Intent?," in Chris Scarre and Graeme Lawson (eds) *Archaeoacoustics*. Cambridge: Cambridge University Press. pp. 59–69.

Holter, Erika, Muth, Susanne and Schwesinger, Sebastian (2019) "Sounding Out Public Space in Late Republican Rome," in Shane Butler and Sarah Nooter (eds) *Sound and the Ancient Senses*. Oxon: Routledge. pp. 44–60.

Houghton, Robert (2018) "World, Structure and Play: A Framework for Games as Historical Research Outputs, Tools, and Processes," *Práticas da História*, 7, 11–43.

House of Lords, International Agreements Committee (2024) *5th Report of Session 2023-24 (2024) Scrutiny of international agreements: UNESCO Convention of Intangible Cultural Heritage*, 21 February 2024, https://committees.parliament.uk/publications/43438/documents/216057/default/ [Last accessed 19th March 2024].

Howard, David and Angus, Jamie (2009) *Acoustics and Psychoacoustics*. Oxford: Focal Press.

Howard, David and Murphy, Damian (2008) *Voice Science, Acoustics and Recording*. Oxford: Plural Publishing.

Howard, Deborah and Moretti, Laura (2009) *Sound and Space in Renaissance Venice: Architecture, Music, Acoustics*. New Haven and London: Yale University Press.

Howes, David (2005a) "Introduction: Empires of the Senses," in David Howes (ed) *Empire of the Senses: The Sensual Cultural Reader*. Oxford, New York: Berg. pp. 1–17.

Howes, David (2005b) "Sensation in Cultural Context" in David Howes (ed) *Empire of the Senses: The Sensual Cultural Reader*. Oxford, New York: Berg. pp. 143–146.

Howes, David (2017) "Music to the Eyes. Intersensoriality, Culture, and the Arts," in Marcel Cobussen, Vincent Meelberg and Barry Truax (eds) *The Routledge Companion to Sounding Art*. Oxon: Routledge. pp. 159–168.

Howes, David (2020) "Digging Up the Sensorium: On the Sensory Revolution in Archaeology," in Robin Skeates and Jo Day (eds) *The Routledge Handbook of Sensory Archaeology*. Oxon: Routledge. pp. 21–34.

Howes, David (2021) "Afterword: The Sensory Revolution Comes of Age," *The Cambridge Journal of Anthropology*, 39:2, 128–137.

Hunter-Crawley, Heather (2020) "Classical Archaeology and the Senses: A Paradigmatic Shift?," in Robin Skeates and Jo Day (eds) *The Routledge Handbook of Sensory Archaeology*. Oxon: Routledge. pp. 434–450.

Iannace, G., Marletta, L., Sicurella, F. and Ianniello, E. (2010) "Acoustic Measurements in the Ear of Dionysius at Syracuse (Italy)," *Internoise 2010*, 13–16 June 2010, Lisbon, Portugal, https://tinyurl.com/34bm4etv [Last accessed 10th April 2024].

Ianniello, Carmine (2005) "An Acoustic Catalogue of Historical Italian Theatres for Opera," *Forum Acusticum 2005. Proceedings of Forum Acusticum 2005*, Budapest, Hungary, September 2005.

ICOMOS (2012) *The NARA Document on Authenticity (1994)*, ICOMOS, https://www.icomos.org/en/charters-and-texts/179-articles-en-francais/ressources/charters-and-standards/386-the-nara-document-on-authenticity-1994 [Last accessed 15th April 2023]

ICOMOS (2019) *The Future of Our Pasts: Engaging Cultural Heritage in Climate Action. Outline of Climate Change and Cultural Heritage*, https://indd.adobe.com/view/a9a551e3-3b23-4127-99fd-a7a80d91a29e [Last accessed 14th April 2024].

Ingold, Timothy (2007) "Against Soundscape," in A. Carlyle (ed) *Autumn Leaves: Sound and the Environment in Artistic Practice*. Paris: Double Entendre.

ISO 3382 (1997) *Acoustics Measurement of Reverberation Time of Rooms with Reference to Other Acoustical Parameters*. Geneva: ISO.

ISO 3382-1 (2009) *Acoustics – Measurement of Room Acoustic Parameters. Part 1: Performance Spaces*. Geneva: ISO.

ISO 18233 (2006) *Acoustics – Application of new measurement methods in building and room acoustics*, BS EN ISO 18233.

Järviluoma, Helmi (2017) "The Art and Science of Sensory Memory Walking," in Marcel Cobussen, Vincent Meelberg and Barry Truax (eds) *The Routledge Companion to Sounding Art*. Oxon: Routledge. pp. 191–204.

Jordan, V.L. (1970) "Acoustical Criteria for Auditoriums and Their Relation to Model Techniques," *Journal of the Acoustical Society of America*, 47:2A, 408-412.

Jordan, V.L. (1981) "A Group of Objective Acoustical Criteria for Concert Halls," *Applied Acoustics*, 14:4, 253–266.

Kafer, Alison (2013) *Feminist, Queer, Crip*. Bloomington: Indiana University Press.

Kahn, Douglas (2002) *Digits in the Historical Pulse. Being a Way to Think about How So Much Is Happening and Has Happened in Sound in the Arts*. https://www.mediaarthistory.org/wp-content/uploads/2011/05/Kahn.pdf. pp. 1–9.

Kato, Kumi (2009) "Soundscape, Cultural Landscape and Connectivity," *Sites: A Journal of Social Anthropology and Cultural Studies*, 6:2, 80–91.

Katz, Brian F.G., Murphy, Damian, Farina, Angelo (2020) "The Past Has Ears (PHE): XR Explorations of Acoustic Spaces as Cultural Heritage," in Lucio Tommaso De Paolis and Patrick Bourdot (eds) *Augmented Reality, Virtual Reality, and Computer Graphics. AVR 2020. Lecture Notes in Computer Science*, 12243. Cham: Springer, DOI: 10.1007/978-3-030-58468-9_7.

Katz, Brian F.G. and Weber, Antoine (2020) "An Acoustic Survey of the Cathédrale Notre-Dame de Paris before and after the Fire of 2019," *Acoustics*, 2:4, 791–802. DOI: 10.3390/acoustics2040044.

Kearney, Amanda (2009) "Intangible Cultural Heritage: Global Awareness and Local Interest," in Laurajane Smith and Natsuko Akagawa (eds) *Intangible Heritage*. London: Routledge. pp. 209–225.

Kellert, Stephen R. (1980) "American Attitudes Toward and Knowledge of Animals: An Update," *International Journal for the Study of Animal Problems*, 1, 87–119.

Kelman, Ari Y. (2010) "Rethinking the Soundscape: A Critical Genealogy of a Key Term in Sound Studies," *The Senses and Society*, 5:2, 212–234, DOI: 10.2752/174589210X12668381452845.

Kessler, Ralph (2005) "An Optimised Method for Capturing Multidimensional 'Acoustic Fingerprints'," *Audio Engineering Society 118th Convention*, 28–31 May.

King, Pamela (2013) "Poetics and Beyond: Noisy Bodies and Aural Variations in Medieval English Outdoor Performance," presentation at the *14th Triennial Colloquium of the Société Internationale pour l'Étude du Théâtre Médiéval*, Poznan, Poland, July 22–27.

Kirshenblatt-Gimblett, Barbara (2004) "Intangible Heritage as Metacultural Production," *Museum International*, 56, 1–2.

Kleiner, Mendel, Dalenbäck, Bengt-Inge and Svensson, Peter (1993) "Auralization – An Overview," *Journal of the Audio Engineering Society*, 41:11, 861–875.

Kleiner, Mendel, Orlowski, R. and Kirszenstein, J. (1993) "A Comparison between Results from a Physical Scale Model and a Computer Image Source Model for Architectural Acoustics," *Applied Acoustics*, 38:2–4, 245–265.

Kovacs, Zsuzsi I., LeRoy, Carri J., Fischer, Dylan G., Lubarsky, Sandra, and Burke, William (2006) "How Do Aesthetics Affect Our Ecology?," *Journal of Ecological Anthropology*, 10:1, 61–65.

Krause, Bernie (2013) *The Great Animal Orchestra. Finding the Origins of Music in the World's Wild Places*. London: Profile Books.

Krauss, Sebastian, Völkel, Simeon, Dobner, Christoph, Völkel, Alexandra and Huang, Kai (2019) "Acoustics of Margravial Opera House Bayreuth," *Fortschritte der Akustik - DAGA 2019*, DOI: 10.48550/arXiv.1905.13578.

Kurin, Richard (2004) "Safeguarding Intangible Cultural Heritage in the 2003 UNESCO Convention: A Critical Appraisal," *Museum International*, 56:1–2, 66–77, DOI: 10.1111/j.1350-0775.2004.00459.x.

Kuttruff, Heinrich (1973) *Room Acoustics*. London: Applied Science Publishers.

Lacey, Kate (2017) "Auditory Capital, Media Publics and the Sounding Arts," in Marcel Cobussen, Vincent Meelberg and Barry Truax (eds) *The Routledge Companion to Sounding Art*. Oxon: Routledge. pp. 213–221.

Leech-Wilkinson, Daniel (2002) The *Modern Invention of Medieval Music: Scholarship, Ideology, Performance*. Cambridge: Cambridge University Press.

Lefebvre, Henri (1974) *The Production of Space*, trans. Donald Nicholson-Smith. Oxford: Blackwell Publishing.

Liu-Rosenbaum, Aaron (2015) "Listening to Noise: An Interactive Soundscape Installation that Transforms Place in the Service of Intangible Cultural Heritage," *Material Culture Review*, 82, 113–130.

Lokki, Tapio, Southern, Alex, Siltanen, Samuel and Savioja, Lauri (2013) "Acoustics of Epidaurus – Studies with Room Acoustic Modelling Methods," *Acta Acustica United with Acustica*, 99:1, 40–47, DOI: 10.3813/AAA.918586.

Lopez, Mariana (2015a) "Using Multiple Computer Models to Study the Acoustics of a Sixteenth-Century Performance Space," *Applied Acoustics*, 94, 14–19, DOI: 10.1016/j.apacoust.2015.02.002.

Lopez, Mariana (2015b) "An Acoustical Approach to the Study of the Wagons of the York Mystery Plays: Structure and Orientation," *Early Theatre*, 18:2, DOI: 10.12745/et.18.2.2447.

Lopez, Mariana (2016) "The York Mystery Plays: Exploring Sound and Hearing in Medieval Vernacular Drama," in Simon Thomson and Michael Bintley (eds) *Sensory Perception in the Medieval West*. Turnhout: Brepols. pp. 53–73.

Lopez, Mariana (2019) "Giving History a Voice," in Nicholas Cook, Monique Ingalls, and David Trippett (eds) *The Cambridge Companion to Music in Digital Culture*. Cambridge: Cambridge University Press. pp. 147–149.

Lopez, Mariana (2020) "Heritage Soundscapes: Contexts and Ethics of Curatorial Expression," in Catherine A. M. Clarke (ed) *The St. Thomas Way and the Medieval March of Wales: Exploring Place, Heritage, Pilgrimage*. Leeds: Arc Humanities Press. pp. 103–120.

López, Mariana (2022) "Bude, Sonic Bodies," *The Medieval Review*, 22.11.05, https://scholarworks.iu.edu/journals/index.php/tmr/article/view/35673/38699.

López, Mariana (2023a) "Playing the Sonic Past: Reflections on Sound in Medieval-Themed Video Games," in Robert Houghton (ed) *Playing the Middle Ages: Pitfalls and Potential in Modern Games*. London: Bloomsbury. pp. 51–74.

López, Mariana (2023b) "Sonic Medievalisms in Audio Games: An Exploration of Design and Accessibility Strategies," *Leeds International Medieval Congress*, 3–6 July, Leeds, UK.

López, Mariana, Hardin, Marques and Wan, Wenqi (2022) "The Soundscapes of the York Mystery Plays: Playing with Medieval Sonic Histories," in Robert Houghton (ed) *Teaching the Middle Ages through Modern Games: Using, Modding and Creating Games for Education and Impact*. Berlin/Boston: De Gruyter. pp. 249–278.

Lopez, Mariana, Kearney, Gavin and Hofstädter, Krisztián (2020) "Seeing Films through Sound: Sound Design, Spatial Audio, and Accessibility for Visually Impaired Audiences", *British Journal of Visual Impairment*, 40:2, DOI: 10.1177/0264619620935935.

Lopez, Mariana and Pauletto, Sandra (2010) "The Sound Machine: A Study in Storytelling through Sound Design," *Audio Mostly* 2010, September 15-17, Piteå, Sweeden.

Lopez, Mariana and Pauletto, Sandra (2012) "Acoustic Measurement Methods for Outdoor Sites: A Comparative Study," *Proceedings of the 15th International Conference of Digital Audio Effects (DAFx)*, York, UK, September 17–21.

Lopez, Mariana, Pauletto, Sandra and Kearney, Gavin (2013) "The Application of Impulse Response Measurement Techniques to the Study of the Acoustics of Stonegate, a Performance Space Used in Medieval English Drama," *Acta Acustica united with Acustica*, 99:1, 98–108.

Martellotta, Francesco, Cirillo, Ettore, Carbonari, Antonio and Ricciardi, Paola (2009) "Guidelines for Acoustical Measurements in Churches," *Applied Acoustics*, 70:2, 378–388, DOI: 10.1016/j.apacoust.2008.04.004.

Matos, Sónia (2011) *Here we don't speak, here we whistle. Mobilizing a cultural reading of cognition, sound and ecology in the design of a language support system for the Silbo Gomero*, PhD, Goldsmiths College, University of London.

Matos, Sónia (2014) "Here We Don't Speak, Here We Whistle: Designing a Language Support System for the Silbo Gomero," *8th Conference of the International Committee for Design History & Design Studies*, Blucher Design Proceedings, 1, 209–213, DOI: 10.1016/design-icdhs-046.

Matsura, Koïchiro (2004) "Preface," *Museum International, Intangible Heritage*, LVI:1–2, May 2004.

McEwen, Indra Kagis (2003) *Vitruvius: Writing the Body of Architecture*. Cambridge: MIT Press.

McLuhan, Marshall (1962) *The Gutenberg Galaxy: The Making of Typographic Man*. Toronto: University of Toronto Press.

Metzler, Irina (2011) "Disability in the Middle Ages: Impairment at the Intersection of Historical Inquiry and Disability Studies," *History Compass*, 9, 45–60. DOI: 10.1111/j.1478-0542.2010.00746.x.

Meyer, Julien (2015) *Whistled Languages: A Worldwide Inquiry on Human Whistled Speech*, Springer, Berlin, Heidelberg, DOI: 10.1007/978-3-662-45837-2_3.

Miller, Paul and Richards, Julian (1995) "The Good, the Bad, and the Downright Misleading: Archaeological Adoption of Computer Visualization," in Jeremy Huggett and Nick Ryan (eds) *Proceedings of the 22nd CAA Conference*. Oxford: Archaeopress. pp. 19–22.

Miller Frank, Felicia (1995) *The Mechanical Song: Women, Voice, and the Artificial in Nineteenth-Century French Narrative*. Stanford: Stanford University Press.

Mills, Steve (2014) *Auditory Archaeology: Understanding Sound and Hearing in the Past*. London: Routledge.

Moretti, Laura (2004) "Architectural Spaces for Music: Jacopo Sansovino and Adrian Willaert at St Mark's," *Early Music History*, 23, 153–84. https://www.jstor.org/stable/3874768.

Müller, Swen and Massarani, Paulo (2001) "Transfer-Function Measurement with Sweeps," *Journal of the Audio Engineering Society*, 49:6, 443–471.

Murphy, Damian (2000) *Digital waveguide mesh topologies in room acoustics modelling*. PhD Thesis. University of York.

Murphy, Damian (2008) *Virtual Audio and Past Environments: Audio and Acoustics in Heritage Applications*, https://www-users.york.ac.uk/~dtm3/acoustics_heritage.html [Last accessed 28th February 2024].

Murphy, Damian and Beeson, Mark (2007) *Virtual Acoustics*, https://www-users.york.ac.uk/~dtm3/virtualacoustics.html [Last accessed 28th February 2024].

Murphy, Damian, Shelley, Simon, Foteinou, Aglaia, Brereton, Jude and Daffern, Helena (2017) "Acoustic Heritage and Audio Creativity: The Creative Application of Sound in the Representation, Understanding and Experience of Past Environments," *Internet Archaeology*, 44. DOI: 10.11141/ia.44.12.

Murphy, Damian and Stevens, Frank (n.d.) *Open Acoustic Impulse Response (OpenAIR) Library*, https://www.openair.hosted.york.ac.uk/ [Last accessed 19th March 2024]

Nancy, Jean-Luc (2007) *Listening*. Translated by Charlotte Mandell, New York: Fordham University Press.

Neal, Sarah (2002) "Rural Landscapes, Representations and Racism: Examining Multicultural Citizenship and Policy-Making in the English Countryside," *Ethnic and Racial Studies*, 25:3, 442–461.

Niaounakis, T.I. and Davies, W.J. (2002) "Perception of Reverberation Time in Small Listening Rooms," *Journal of Audio Engineering Society*, 50, 343–350.

Nooshin, Laudan (2016) "Sounding the City: Tehran's Contemporary Soundscapes," *The Middle East in London*, 12:2, February-March 2016, https://bpb-eu-w2.wpmucdn.com/blogs.city.ac.uk/dist/a/189/files/2016/02/Nooshin-MEIL-article-Jan-2016-qzafdt.pdf [Last accessed 21st January 2024].

O'Brien, Gillian (2020) *The Darkness Echoing: Ireland's Places of Famine, Death and Rebellion*. London: Penguin Books.

O'Connor, Terry (2013) *Animals in Medieval Urban Lives: York as a Case Study* (unpublished article provided by the author).

O'Neill, Brendan and O'Sullivan, Aidan (2020) "Experimental Archaeology and (Re)-experiencing the Senses of the Medieval World," in Robin Skeates and Jo

Day (eds) *The Routledge Handbook of Sensory Archaeology*. Oxon: Routledge. pp. 451–466.

Ochoa Gautier, Ana María (2014) *Aurality: Listening & Knowledge in Nineteenth-Century Colombia*. Durham and London: Duke University Press.

Odeon, Room Acoustics Software, https://odeon.dk/ [Last accessed 8th March 2024].

Okano, Toshiyuki, Beranek, Leo L. and Hidaka, Takayuki (1998) "Relations among Interaural Cross-Correlation Coefficient (IACCE), Lateral Fraction (LFE), and Apparent Source Width (ASW) in Concert Halls," *Journal of the Acoustical Society of America*, 104:1, 255–265.

Oliver, Michael (2009) *Understanding Disability: From Theory to Practice* (2nd ed.). London: Palgrave Macmillan.

Ott, Katherine (2018) "Material Culture, Technology, and the Body in Disability History," in Michael Rembis, Catherine Kudlick, and Kim E. Nielsen (eds) *The Oxford Handbook of Disability History*. United States: Oxford Handbooks. pp. 125–140.

Otterman, Michael (2007) *American Torture: From the Cold War to Abu Ghraib and Beyond*. London; Ann Arbor, MI: Pluto Press.

Ouzounian, Gascia (2013) "Sound Installation Art: From Spatial Poetics to Politics, Aesthetics to Ethics," in Georgina Born (ed) *Music, Sound and Space: Transformations of Public and Private Experience*. Cambridge: Cambridge University Press. pp. 73–89.

Ouzounian, Gascia (2020) *Stereophonica: Sound and Space in Science, Technology, and the Arts*. Cambridge, MA: MIT Press.

Papadakis, Nikolaos M., and Stavroulakis, Georgios E. (2019) "Review of Acoustic Sources Alternatives to a Dodecahedron Speaker," *Applied Sciences*, 9:18, 3705, DOI: 10.3390/app9183705.

Papaeti, Anna (2021-2026) *Soundscapes of Trauma: Music, Sound and the Ethics of Witnessing*, DOI: 10.3030/101002720.

Papathanasopoulos, B. (1965) "Acoustical Measurements in the Theatre of Epidauros," [in German] *Acoustiche messungen in theater von Epidauros*, Proceedings of 5th ICA, Liege.

Parkin, P. and Taylor, J.H. (1952) "Speech Reinforcement in St. Paul's Cathedral. Experimental System Using Line-Source Loudspeakers and Time Delays," *Wireless World*, 58:2, 54–57.

Pasoulas, Aki (2022) *A Sonic Palimpsest: Revisiting Chatham Historic Dockyards*, https://research.kent.ac.uk/sonic-palimpsest/ [Last accessed 30th March 2024].

Pasoulas, Aki, Knight-Hill, Andrew and Martin, Brona (2022a) "Sonic Heritage – Listening to the Past," in *(In)tangible Heritage(s), A conference on technology, culture and design*. https://drive.google.com/file/d/1kOgOEeWq0kcCXWC2wGK GSohXnalwHg7A/view [Last accessed 10th November 2023].

Pasoulas, Aki, Knight-Hill, Andrew and Martin, Brona (2022b) "Soundscapes of the Past: Historical Imaginings," in *Proceedings of the ICMC*. https://drive.google.com/file/d/1dQwveGcirbFkSmffTFjyrhANjTOiaI67/view [Last accessed 10th November 2023].

Pearse, D. Linda, Waltner, Ann and Godsoe, C. Nicholas (2017) "Historically Informed Soundscape: Mediating Past and Present," *Journal of Sonic Studies*, https://www.researchcatalogue.net/view/408710/408711.

Pennanen, Risto Pekka (2017) "Cannons, Church Bells and Colonial Policies: The Soundscape in Habsburg Bosnia-Herzegovina," in Ian Biddle and Kirsten Gibson

(eds) *Cultural Histories of Noise, Sound and Listening in Europe, 1300–1918*. Abingdon: Routledge. pp. 152–166.

Pentcheva, Bissera V. and Abel, Jonathan S. (2017) "Icons of Sound: Auralizing the Lost Voice of Hagia Sophia," *Speculum*, 92:S1, S336–S360.

Platts, Hannah (2021) *Multisensory Living in Ancient Rome: Power and Space in Roman Houses*. London: Bloomsbury Academic.

Polti, Victoria (2014) "Memoria sonora, cuerpo y bio-poder. Un acercamiento a la experiencia concentracionaria en la Argentina durante la última dictadura cívico-militar," *XI Congreso Argentino de Antropología Social*, Rosario, 23 al 26 de Julio, https://www.aacademica.org/000-081/1560.

Postma, Bart and Katz, Brian F.G. (2016) "Acoustics of Notre-Dame cathedral de Paris," *22nd International Congress on Acoustics*, Buenos Aires, 5–9 September 2016, http://www.ica2016.org.ar/ica2016proceedings/ica2016/ICA2016-0269.pdf.

Presner, Todd (2009) "Remapping German-Jewish Studies: Benjamin, Cartography, Modernity," *German Quarterly, German-Jewish and Jewish-German Studies*, 82, 293–315.

Prodi, Nicola, Pompoli, Roberto, Martellotta, Francesco and Sato, Shin-ichi (2015) "Acoustics of Italian Historical Opera Houses," *Journal of Acoustical Society of America*, 138:2, 769–781. DOI: 10.1121/1.4926905.

Psarras, Sotirios, Hatziantoniou, Panagiotis, Kountouras, Mercury, Tatlas, Nicolas-Alexander, Mourjopoulos, John N., Skarlatos, Dimitrios (2013) "Measurements and Analysis of the Epidaurus Ancient Theatre Acoustics," *Acta Acustica United with Acustica*, 99:1, 30–39, DOI: 10.3813/AAA.918585.

Pugh, Tison and Weisl, Angela (2013) *Medievalisms: Making the Past in the Present*. London: Routledge.

Raes, Auguste C. and Sacerdote, Gino (1953) "Measurement of the Acoustical Properties of Two Roman Basilicas", *Journal of Acoustical Society of America*, 25, 925–961.

Ramirez, Janina (2022) *Femina. A New History of the Middle Ages, Through the Women Written Out of It*. London: WH Allen.

Rastall, Richard (1996) *The Heaven Singing: Music in Early English Religious Drama: I*. Cambridge: Brewer.

Rastall, Richard (2001) *Minstrels Playing: Music in Early English Religious Drama: II*. Cambridge: Brewer.

Redfern, Rebecca and Hefner, Joseph T. (2019) ""Officially Absent but Actually Present": Bioarchaeological Evidence for Population Diversity in London during the Black Death, AD 1348–50," in Madeleine L. Mant and Alyson Jaagumägi Holland (eds) *Bioarchaeology of Marginalized People*. London: Academic Press, 69–114, DOI: 10.1016/B978-0-12-815224-9.00005-1.

Rembis, Michael, Kudlick, Catherine and Nielsen, Kim E. (2018) "Introduction," in Michael Rembis, Catherine Kudlick, and Kim E. Nielsen (eds), *The Oxford Handbook of Disability History*. United States: Oxford Handbooks. pp. 1–18.

Rice, Tom (2016) "Sounds Inside: Prison, Prisoners and Acoustical Agency," *Sound Studies*, 2:1, 6–20, DOI: 10.1080/20551940.2016.1214455.

Rindel, Jens Holger (1995) "Computer Simulation Techniques for Acoustical Design of Rooms," *Acoustics Australia*, 23:3, 81–86.

Rindel, Jens Holger (2011) "The ERATO Project and Its Contribution to Our Understanding of the Acoustics of Ancient Theatres," *The Acoustics of Ancient Theatres Conference*, Patras, September 18–21, 2011, https://tinyurl.com/yn8hwzys.

Rindel, Jens Holger (2013) "Roman Theatres and Revival of Their Acoustics in the ERATO Project," *Acta Acustica United with Acustica*, 99, 21–29, DOI: 10.3813/AAA.918584.

Rindel, Jens Holger and Nielsen, Martin Lisa (2006) "The ERATO Project and Its Contribution to Our Understanding of the Acoustics of Ancient Greek and Roman theatres," *ERATO Project Symposium, Proceedings*, 1–10, https://backend.orbit.dtu.dk/ws/portalfiles/portal/2457747/oersted-dtu2523.pdf.

Roberts, Brian (n.d.) *Wallace Clement Ware Sabine, Acoustics Pioneer, CIBSE Heritage Group*, https://www.hevac-heritage.org/built_environment/pioneers_revisited/surnames_m-w/sabine.pdf [Last accessed 19th March 2024].

Robertson, Emma (2008) "'I Get a Real Kick Out of Big Ben': BBC Versions of Britishness on the Empire and General Overseas Service, 1932–1948," *Historical Journal of Film, Radio and Television*, 28:4, 459–473, DOI: 10.1080/01439680802310274.

Rodríguez-García, Esperanza (2020–2022), *Experiencing Historical Soundscapes: The Royal Entries of Emperor Charles V in Iberian Cities*, DOI: 10.3030/892680.

Ruggles, D. Fairchild and Silverman, Helaine (2009) "From Tangible to Intangible Heritage," in D. Fairchild Ruggles and Helaine Silverman (eds) *Intangible Heritage Embodied*. New York: Springer. pp. 1–14.

Ruiz Díaz, Matías, "El Cabildo de Buenos Aires," Instituto de Arte Americano e Investigaciones Estéticas "Mario J. Buschiazzo," Facultad de Arquitectura, Diseño y Urbanismo, Universidad de Buenos Ares, https://www.iaa.fadu.uba.ar/?page_id=13180 [Last accessed 28th February 2024].

Ruiz Jiménez, Juan and Lizarán Rus, Ignacio José (2015) *Paisajes sonoros históricos (c.1200-c.1800)*, https://www.historicalsoundscapes.com/ [Last accessed 28th February 2024]

Sabine, Wallace Clement (1922) *Collected Papers on Acoustics*. Cambridge, MA: Harvard University Press.

Said, Edward W. (1979) *Orientalism*. New York: Vintage Books.

Salen, Katie and Zimmerman, Eric (2003) *Rules of Play: Game Design Fundamentals*. Cambridge, MA: MIT Press.

Salter, Linda-Ruth (2019) "What You Hear Is Where You Are," in Mark Grimshaw-Aagaard, Mads Walther-Hansen and Martin Knakkergaard (eds), *The Oxford Handbook of Sound and Imagination*. New York. pp. 765–787.

Savioja, Lauri (1999) *Modelling Techniques for Virtual Acoustics*. Dissertation for the degree of Doctor of Science in Technology, Helsinki University of Technology (Espoo, Finland).

Savioja, Lauri (2015) "Overview of Geometrical Room Acoustic Modeling Techniques," *Journal of the Acoustical Society of America*, 138: 708, DOI: 10.1121/1.4926438.

Scarre, Chris and Lawson, Graeme (2006) "Preface," in Chris Scarre and Graeme Lawson (eds) *Archaeoacoustics*. Cambridge: University of Cambridge. pp. vii–ix.

Schafer, R. Murray (1994) *The Soundscape: Our Sonic Environment and the Tuning of the World*. Rochester: Destiny.

Schávelzon, Daniel (2002) *The Historical Archaeology of Buenos Aires: A City at the End of the World*. New York: Kluwer Academic Publishers.

Schroeder, M.R., Gottlob, D. and Siebrasse, K.F. (1974) "Comparative Study of European Concert Halls: Correlation of Subjective Preference with Geometric and Acoustic Parameters," *Journal of the Acoustical Society of America*, 56:4, 1195–1201.

Schulze, Holger (2013) "The Corporeality of Listening: Experiencing Soundscapes on Audio Guides," in Karin Bijsterveld (ed) *Soundscapes of the Urban Past: Staged Sound as Mediated Cultural Heritage*. Bielefeld: Transcript. pp. 195–207.

Schwartz, Madeleine, Khurana, Malika, Gröndahl, Mika and Parshina-Kottas, Yuliya (2023) "A Cathedral of Sound," Text by Madeleine Schwartz, March 3, 2023. *The New York Times Magazine*, https://www.nytimes.com/interactive/2023/03/03/magazine/notre-dame-cathedral-acoustics-sound.html [Last accessed 13 September 2023].

Shankland, Robert S. (1968) "Acoustical Observations in Greek and Roman Theatres," *Journal of Acoustical Society of America*, 44:1, 367 (meeting abstract), DOI: 10.1121/1.1970428.

Shankland, Robert S. (1973) "Acoustics of Greek Theatres," *Physics Today*, 26, 30–35.

Shankland, Robert S. and Shankland, H.K. (1971) "Acoustics of St. Peter's and Patriarchal Basilicas in Rome," *Journal of Acoustical Society of America*, 50, 389–396.

Shull, Jonathan (2006) "Locating the Past in the Present: Living Traditions and the Performance of Early Music," *Ethnomusicology Forum*, 15:1, 87–111, DOI: 10.1080/17411910600634361.

Silva, João (2017) "Porosity and Modernity. Lisbon's Auditory Landscape from 1864 to 1908," in Ian Biddle and Kirsten Gibson (eds) *Cultural Histories of Noise, Sound and Listening in Europe 1300-1918*. Abingdon: Routledge. pp. 235–251.

Sinamai, Ashton (2018) "Melodies of God: The Significance of the Soundscape in Conserving the Great Zimbabwe Landscape," *Journal of Community Archaeology & Heritage*, 5:1, 17–29, DOI: 10.1080/20518196.2017.1323823.

Sinamai, Ashton (2022) "Ivhu rinotsamwa: Landscape Memory and Cultural Landscapes in Zimbabwe and Tropical Africa," *ETropic: Electronic Journal of Studies in the Tropics*, 21:1, 51–69, DOI: 10.25120/etropic.21.1.2022.3836.

Skeates, Robin and Day, Jo (2020) "Sensory Archaeology: Key Concepts and Debates," in Robin Skeates and Jo Day (eds) *The Routledge Handbook of Sensory Archaeology*. Oxon: Routledge. pp. 1–17.

Small, Ernest (2011) "The New Noah's Ark: Beautiful and Useful Species Only. Part 1. Biodiversity Conservation Issues and Priorities," *Biodiversity*, 12:4, 232–247, DOI: 10.1080/14888386.2011.642663.

Smeets, Rieks (2006) "The Intangible Heritage Convention," *The Intangible Heritage Messenger*, 1, February 2006, https://unesdoc.unesco.org/ark:/48223/pf0000144569/PDF/144569eng.pdf.multi [Last accessed 15th April 2023]

Smith, Bruce R. (1999) *The Acoustic World of Early Modern England: Attending to the O-Factor*. Chicago: The University of Chicago Press.

Smith, Laurajane and Akagawa, Natsuko (2009) "Introduction," in Laurajane Smith and Natsuko Akagawa (eds) *Intangible Heritage*. London: Routledge. pp. 1–9.

Smith, Mark (2007) *Sensory History*. Oxford: Bloomsbury.

Soria-Martínez, Verónica (2017) "Resounding Memory: Aural Augmented Reality and the Retelling of History," *Leonardo Music Journal*, 27, 12–16.

Soulodre, Gilbert and Bradley, John S. (1995) "Subjective Evaluation of New Room Acoustic Measures," *Journal of the Acoustical Society of America*, 98:1, 294–301.

Stafford, Barbara Maria (1994) *Artful Science: Enlightenment, Entertainment, and the Eclipse of Visual Education*. Cambridge: MIT Press.

Sterne, Jonathan (2003) *The Audible Past: Cultural Origins of Sound Reproduction.* Durham: Duke University Press.

Stoever, Jennifer Lynn (2016) *The Sonic Color Line: Race and the Cultural Politics of Listening.* New York: New York University Press.

Stoller, Paul, (1989) *The Taste of Ethnoghraphic Things: The Senses in Anthropology.* Philadelphia: University of Pennsylvania Press.

Sturtevant, Paul (2018) *The Middle Ages in Popular Imagination.* London: I. B. Tauris.

Suárez, Rafael, Alonso, Alicia and Sendra, Juan J. (2015) "Intangible Cultural Heritage: The Sound of the Romanesque Cathedral of Santiago de Compostela," *Journal of Cultural Heritage,* 16:2, 239–243, DOI: 10.1016/j.culher.2014.05.008.

Suárez, Rafael, Alonso, Alicia and Sendra, Juan J. (2016) "Archaeoacoustics of Intangible Cultural Heritage: The Sound of the Maior Ecclesia of Cluny," Journal of Cultural Heritage, 19, 567–572, DOI: 10.1016/j.culher.2015.12.003.

Taruskin, Richard (1995) *Text and Act: Essays on Music and Performance.* New York: Oxford University Press.

The Week of Sound (n.d.) *The Charter of the Week of Sound,* https://www.lasemaineduson.org/the-charter-of-the-week-of-sound?lang=fr [Last accessed 1st May 2023].

Thompson, Emily (2004) *The Soundscape of Modernity: Architectural Acoustics and the Culture of Listening in America, 1900-1933.* Cambridge, MA: MIT Press.

Thompson, Marie (2017) *Beyond Unwanted Sound: Noise, Affect and Aesthetic Moralism.* New York: Bloomsbury Academic.

Till, Rupert (2014) "Sound Archaeology: Terminology, Palaeolithic Cave Art and the Soundscape," *World Archaeology,* 46:3, 292–304, DOI: 10.1080/00438243.2014.909106.

Till, Rupert (2019) "Sound Archaeology: A Study of the Acoustics of Three World Heritage Sites, Spanish Prehistoric Painted Caves, Stonehenge, and Paphos Theatre," *Acoustics,* 1:3, 661–692. DOI: 10.3390/acoustics1030039.

Tilley, Christopher (2020) "How Does It Feel? Phenomenology, Excavation and Sensory Experience: Notes for a New Ethnographic Field Practice," in Robin Skeates and Jo Day (eds) *The Routledge Handbook of Sensory Archaeology.* Oxon: Routledge. pp. 76–93.

Tronchin, Lamberto and Farina, Angelo (1997) "Acoustics of the Former Teatro "La Fenice" in Venice," *Journal of Audio Engineering Society,* 45:12. pp. 1051–1062.

Tronchin, Lamberto, Merli, Francesca and Manfren, Massimiliano (2021) "On the Acoustics of the *Teatro 1763* in Bologna," *Applied Acoustics,* 172, 107598, DOI: 10.1016/j.apacoust.2020.107598.

Truax, Barry (2017) "Acoustic Space, Community, and Virtual Soundscapes," in Marcel Cobussen, Vincent Meelberg and Barry Truax (eds) *The Routledge Companion to Sounding Art.* Oxon: Routledge. pp. 253–263.

UNESCO (1977) *Operational Guidelines for the Implementation of the World Heritage Convention,* https://whc.unesco.org/archive/1977/cc-77-conf001-8reve.pdf [Last accessed 30th April 2023].

UNESCO (1979a) *Convention Concerning the Protection of the World Cultural and Natural Heritage. Third Session of the World Heritage Committee. Item 6 of the Provisional Agenda: Principles and Criteria for Inclusion of Properties on World Heritage List,* https://whc.unesco.org/archive/1979/cc-79-conf003-11e.pdf [Last accessed 7th April 2024].

UNESCO (1979b) *Grand Canyon National Park*, https://whc.unesco.org/en/list/75/ [Last accessed 8th August 2023].

UNESCO (1980) *Operational Guidelines for the Implementation of the World Heritage Convention*, https://whc.unesco.org/archive/opguide80.pdf [Last accessed 30th April 2023].

UNESCO (1985a) *Keoladeo National Park*, https://whc.unesco.org/en/list/340 [Last accessed 13th August 2023].

UNESCO (1985b) *Quseir Amra*, https://whc.unesco.org/en/list/327/ [Last accessed 15th August 2023].

UNESCO (1986a) *Great Zimbabwe National Monument*, https://whc.unesco.org/en/list/364/ [Last accessed 17th August 2023].

UNESCO (1986b) *St Kilda*, https://whc.unesco.org/en/list/387 [Last accessed 8th August 2023].

UNESCO (1986c) *Stonehenge, Avebury and Associated Sites*, https://whc.unesco.org/en/list/373 [Last accessed 16th August 2023].

UNESCO (1987) *Palace of Westminster and Westminster Abbey including Saint Margaret's Church*, https://whc.unesco.org/en/list/426 [Last accessed 8th August 2023].

UNESCO (1988) *Sanctuary of Asklepios at Epidaurus*, https://whc.unesco.org/en/list/491/ [Last accessed 8th August 2023].

UNESCO (1989) *Archaeological Site of Olympia*, https://whc.unesco.org/en/list/517/ [Last accessed 15th August 2023].

UNESCO (1990a) *Historic Centre of San Gimignano*, https://whc.unesco.org/en/list/550/ [Last accessed 15th August 2023].

UNESCO (1990b) "The Recommendation on the Safeguarding of Traditional Culture and Folklore," *Records of the General Conference, Twenty-Fifth Session*, Paris, 17 October to 16 November 1989, Vol. 1, Resolutions, https://unesdoc.unesco.org/ark:/48223/pf0000084696/PDF/084696engb.pdf.multi.page=242 [Last accessed 20th March 2024].

UNESCO (1991) *Royal Domain of Drottningholm*, https://whc.unesco.org/en/list/559/ [Last accessed 16th August 2023].

UNESCO (1992) *Wulingyuan Scenic and Historic Interest Area*, https://whc.unesco.org/en/list/640/ [Last accessed 13th August 2023].

UNESCO (1993) *Complex of Hué Monuments*, https://whc.unesco.org/en/list/678/ [Last accessed 16th August 2023].

UNESCO (1994a) *Convention Concerning the Protection of the World Cultural and Natural Heritage, World Heritage Committee, Eighteenth session*, Phuket, Thailand, 12–17 November 1994, *Expert Meeting on the "Global Strategy" and thematic studies for a representative World Heritage List*, UNESCO Headquarters, 20–22 June 1994, https://whc.unesco.org/archive/global94.htm [Last accessed 20th March 2024].

UNESCO (1994b) *Operational Guidelines for the Implementation of the World Heritage Convention*, https://whc.unesco.org/archive/opguide94.pdf [Last accessed 30th April 2023].

UNESCO (1995a) *Cultural Landscape of Sintra*, https://whc.unesco.org/en/list/723/ [Last accessed 13th August 2023].

UNESCO (1995b) *Historic Quarter of the City of Colonia del Sacramento*, https://whc.unesco.org/en/list/747/ [Last accessed 16th August 2023].

UNESCO (1997) *Morne Trois Pitons National Park*, https://whc.unesco.org/en/list/814/ [Last accessed 8th August 2023].

UNESCO (1998) *Mdina (Citta' Vecchia)*, https://whc.unesco.org/en/tentativelists/983/ [Last accessed 21st August 2023].

UNESCO (1999a) *Historic City of Vigan*, https://whc.unesco.org/en/list/502/ [Last accessed 15th August 2023].

UNESCO (1999b) *Mount Wuyi*, https://whc.unesco.org/en/list/911/ [Last accessed 13th August 2023].

UNESCO (2000a) *Ancient Villages in Southern Anhui – Xidi and Hongcun*, https://whc.unesco.org/en/list/1002/ [Last accessed 13th August 2023].

UNESCO (2000b) *Imperial Tombs of the Ming and Qing Dynasties*, https://whc.unesco.org/en/list/1004/ [Last accessed 13th August 2023].

UNESCO (2001a) Executive Board, Hundred and Sixty-First Session, *Report on the Preliminary Study of the Advisability of Regulating Internationally, through a New Standard-Setting Instrument, the Protection of Traditional Culture and Folklore*, https://unesdoc.unesco.org/ark:/48223/pf0000122585/PDF/122585eng.pdf. multi [Last accessed 15th April 2023].

UNESCO (2001b) *UNESCO Universal Declaration on Cultural Diversity*, https://en.unesco.org/about-us/legal-affairs/unesco-universal-declaration-cultural-diversity [Last accessed 15th April 2023].

UNESCO (2002a) *The Djavolja Varos (Devil's Town) Natural Landmark*, https://whc.unesco.org/en/tentativelists/1700/ [Last accessed 20th August 2023].

UNESCO (2002b) *Upper Middle Rhine Valley*, https://whc.unesco.org/en/list/1066/ [Last accessed 15th August 2023].

UNESCO (2003, 2008) *Carnival of Binche*, https://ich.unesco.org/en/RL/carnival-of-binche-00033 [Last accessed 8th August 2023].

UNESCO (2003) *Quebrada de Humahuaca*, https://whc.unesco.org/en/list/1116 [Last accessed 14th April 2023].

UNESCO (2004a) *Ilulissat Icefjord*, https://whc.unesco.org/en/list/1149/ [Last accessed 8th August 2023].

UNESCO (2004b) *Yalo, Apialo and the sacred geography of Northwest Malakula*, https://whc.unesco.org/en/tentativelists/1971/ [Last accessed 17th August 2023].

UNESCO (2005a) *Historic Centre of Macao*, https://whc.unesco.org/en/list/1110/ [Last accessed 13th August 2023].

UNESCO (2005b) *Operational Guidelines for the Implementation of the World Heritage Convention*, https://whc.unesco.org/archive/opguide05-en.pdf [Last accessed 30th April 2023].

UNESCO (2005) *Syracuse* and *the Rocky Necropolis of Pantalica*, https://whc.unesco.org/en/list/1200/ [Last accessed 15th August 2023].

UNESCO (2005, 2008) *Oxherding and Oxcart Traditions in Costa Rica*, https://ich.unesco.org/en/RL/oxherding-and-oxcart-traditions-in-costa-rica-00103 [Last accessed 8th May 2023].

UNESCO (2007a) *Arochkwu Long Juju Slave Route (Cave Temple Complex)*, https://whc.unesco.org/en/tentativelists/5170/ [Last accessed 17th August 2023].

UNESCO (2007b) *Kaiping Diaolou and Villages*, https://whc.unesco.org/en/list/1112/ [Last accessed 13th August 2023].

UNESCO (2008a) *Melaka and George Town, Historic Cities of the Straits of Malacca*, https://whc.unesco.org/en/list/1223/ [Last accessed 15th August 2023].

UNESCO (2008b) *Monarch* Butterfly *Biosphere Reserve*, https://whc.unesco.org/en/list/1290 [Last accessed 8th August 2023].

UNESCO (2008c) *Operational* Guidelines *for the Implementation of the World Heritage Convention, Annex 3*, https://whc.unesco.org/archive/opguide08-en.pdf#annex3 [Last accessed 20th March 2024].

UNESCO (2009a) *Holy Week* processions *in Popayán*, https://ich.unesco.org/en/RL/holy-week-processions-in-popayn-00259 [Last accessed 8th May 2023].

UNESCO (2009b) *Mount Wutai*, https://whc.unesco.org/en/list/1279/ [Last accessed 13th August 2023].

UNESCO (2009c) *Whistled Language of the Island of La Gomera (Canary Islands), the Silbo Gomero*, https://ich.unesco.org/en/RL/whistled-language-of-the-island-of-la-gomera-canary-islands-the-silbo-gomero-00172 [Last accessed 7th May 2023].

UNESCO (2010a) *Central Sector of the Imperial Citadel of Thang Long – Hanoi*, https://whc.unesco.org/en/list/1328/ [Last accessed 16th August 2023].

UNESCO (2010b) *Historic* Monuments *of Dengfeng in "The Centre of Heaven and Earth,"* https://whc.unesco.org/en/list/1305/ [Last accessed 14th August 2023]

UNESCO (2011a) *Citadel of* the *Ho Dynasty*, https://whc.unesco.org/en/list/1358/ [Last accessed 16th August 2023].

UNESCO (2011b) *The Persian Garden*, https://whc.unesco.org/en/list/1372/ [Last accessed 8th August 2023].

UNESCO (2011c) *West Lake* Cultural *Landscape of Hangzhou*, https://whc.unesco.org/en/list/1334 [Last accessed 14th August 2023].

UNESCO (2012a) *Fiesta of the Patios in Cordova*, https://ich.unesco.org/en/RL/fiesta-of-the-patios-in-cordova-00846 [Last accessed 8th May 2023].

UNESCO (2012b) *Margravial Opera House Bayreuth*, https://whc.unesco.org/en/list/1379 [Last accessed 8th August 2023].

UNESCO (2013) *Cultural Landscape of Honghe Hani Rice Terraces*, https://whc.unesco.org/en/list/1111/ [Last accessed 14th August 2023].

UNESCO (2014a) *Ancient* Greek *Theatres*, https://whc.unesco.org/en/tentativelists/5869/ [Last accessed 20th August 2023].

UNESCO (2014b) *Male-Child Cleansing Ceremony of the Lango of Central Northern Uganda*, https://ich.unesco.org/en/USL/male-child-cleansing-ceremony-of-the-lango-of-central-northern-uganda-00982 [Last accessed 6th August 2023].

UNESCO (2014c) *Namhansanseong*, https://whc.unesco.org/en/list/1439/ [Last accessed 16th August 2023].

UNESCO (2014d) *The Grand Canal*, https://whc.unesco.org/en/list/1443/ [Last accessed 14th August 2023].

UNESCO (2014e) *Trang An Landscape Complex*, https://whc.unesco.org/en/list/1438/ [Last accessed 13th August 2023].

UNESCO (2015a) Christiansfeld, *a Moravian Church Settlement*, https://whc.unesco.org/en/list/1468/ [Last accessed 15th August 2023].

UNESCO (2015b) *The Theatre and Aqueducts of the Ancient City of Aspendos*, https://whc.unesco.org/en/tentativelists/6036/ [Last accessed 20th August 2023].

UNESCO (2015c) *Xinjiang Yardang*, https://whc.unesco.org/en/tentativelists/5989/ [Last accessed 17th August 2023].

UNESCO (2016a) *Culture of Jeju Haenyeo (Women Divers)*, https://ich.unesco.org/en/RL/culture-of-jeju-haenyeo-women-divers-01068 [Last accessed 7th May 2023].

UNESCO (2016b) *Sultan Bayezid II Complex: A Center of Medical Treatment*, https://whc.unesco.org/en/tentativelists/6117/ [Last accessed 17th August 2023].

UNESCO (2017a) *Head Office and Garden of the Calouste Gulbenkian Foundation*, https://whc.unesco.org/en/tentativelists/6228/ [Last accessed 21st August 2023].

UNESCO (2017b) *Kujataa Greenland: Norse and Inuit Farming at the Edge of the Ice Cap*, https://whc.unesco.org/en/list/1536/ [Last accessed 15th August 2023].

UNESCO (2017c) *Kulangsu, a Historic International Settlement*, https://whc.unesco.org/en/list/1541/ [Last accessed 14th August 2023].

UNESCO (2017d) "The Importance of Sound in Today's World: Promoting Best Practices," Item 4.10 of the provisional agenda. *General Conference, 39th Session*, Paris, 2017, https://unesdoc.unesco.org/ark:/48223/pf0000259172/PDF/259172eng.pdf.multi [Last accessed 1st May 2023].

UNESCO (2018a) *Aasivissuit – Nipisat. Inuit Hunting Ground between Ice and Sea*, https://whc.unesco.org/en/list/1557 [Last accessed 7th April 2024].

UNESCO (2018b) *Fanjingshan*, https://whc.unesco.org/en/list/1559/ [Last accessed 14th August 2023].

UNESCO (2018c) *Shwedagon Pagoda on Singuttara Hill*, https://whc.unesco.org/en/tentativelists/6367/ [Last accessed 21st August 2023].

UNESCO (2019a) *French Austral Lands and Seas*, https://whc.unesco.org/en/list/1603/ [Last accessed 9th August 2023].

UNESCO (2019b) *Migratory Bird Sanctuaries along the Coast of Yellow Sea-Bohai Gulf of China*, https://whc.unesco.org/en/list/1606/ [Last accessed 14th August 2023].

UNESCO (2019c) *Buklog, Thanksgiving Ritual System of the Subanen*, https://ich.unesco.org/en/USL/buklog-thanksgiving-ritual-system-of-the-subanen-01495 [Last accessed 21st May 2023].

UNESCO (2019d) *Holy Week Processions in Mendrisio*, https://ich.unesco.org/en/RL/holy-week-processions-in-mendrisio-01460 [Last accessed 8th May 2023].

UNESCO (2020) *Lalish Temple*, https://whc.unesco.org/en/tentativelists/6467/ [Last accessed 20th August 2023].

UNESCO (2021) *Historical Theatres of the Marche Region*, https://whc.unesco.org/en/tentativelists/6556/ [Last accessed 20th August 2023].

UNESCO (2022a) *Alheda'a, Oral Traditions of Calling Camel Flocks*, https://ich.unesco.org/en/RL/alheda-a-oral-traditions-of-calling-camel-flocks-01717 [Last accessed 7th May 2023]

UNESCO (2022b) *Basic Texts of the 2003 Convention for the Safeguarding of the Intangible Cultural Heritage*, 2022 Edition. France, https://ich.unesco.org/doc/src/2003_Convention_Basic_Texts-_2022_version-EN_.pdf [Last accessed 19th March 2024].

UNESCO (2022c) *Manual Bell Ringing*, https://ich.unesco.org/en/RL/manual-bell-ringing-01873 [Last accessed 7th May 2023].

UNESCO (2022d) *Holy Week in Guatemala*, https://ich.unesco.org/en/RL/holy-week-in-guatemala-01854 [Last accessed 21st May 2023].

UNESCO (2023a) *ESMA Museum and Site of Memory – Former Clandestine Centre of Detention, Torture and Extermination*, https://whc.unesco.org/en/list/1681/ [Last accessed 28th January 2024].

UNESCO (2023b) *Mfangano Island Rock Art Sites*, https://whc.unesco.org/en/tentativelists/6682/ [Last accessed 21st August 2023].

UNESCO (2023c) *Purnululu National Park*, https://whc.unesco.org/en/list/1094/ [Last accessed 13th August 2023].

UNESCO, n.d.a., Browse the Lists of Intangible Cultural Heritage and the Register of good safeguarding practices, https://ich.unesco.org/en/lists, [Last accessed 5th October 2024].

UNESCO, n.d.b., *Convention for the Safeguarding of the Intangible Cultural Heritage*, https://www.unesco.org/en/legal-affairs/convention-safeguarding-intangible-cultural-heritage#item-2 [Last accessed 14th April 2023].

UNESCO, n.d.c., *Cultural Landscapes*, https://whc.unesco.org/en/culturallandscape/ [Last accessed 14th April 2023].

UNESCO, n.d.d., *Living Human Treasures: A Former Programme of UNESCO*, https://ich.unesco.org/en/living-human-treasures [Last accessed 14th April 2023].

UNESCO, n.d.e., *List of the 90 Masterpieces of the Oral and Intangible Heritage of Humanity*, https://ich.unesco.org/doc/src/00264-EN.pdf [Last accessed 8th May 2023].

UNESCO, n.d.f., *Proclamation of the Masterpieces of the Oral and Intangible Heritage of Humanity* (2001–2005) https://ich.unesco.org/en/proclamation-of-masterpieces-00103, [Last accessed 14th April 2023].

UNESCO, n.d.g., *World Heritage List*, https://whc.unesco.org/en/list [Last accessed 1st September 2023].

van Tonder, Cobi (2020) *Acoustic Atlas*, https://www.acousticatlas.de/ [Last accessed 19th March 2024].

van Tonder, Cobi (2021) *Measurements at Dowkabottom Cave*, 26th June 2021, https://www.acousticatlas.de/blog/2021-06-28-fieldwork-dowkabottom-cave [Last accessed 5th March 2023].

van Tonder, Cobi (2022a) *Echoes and Reflections – Acoustic Atlas Receives IDF Winter 2022 Call funding*, https://www.acousticatlas.de/blog/2022-05-05-Echoes%20 and%20Reflections [Last accessed 19th January 2024].

van Tonder, Cobi (2022b) *Echoes of Our Ancestors for Robyn Schulkowsky*, https://www.acousticatlas.de/blog/2022-02-18-Echoes%20of%20Our%20Ancestors [Last accessed 19th January 2024].

van Tonder, Cobi and Lopez, Mariana (2021) "Acoustic Atlas - Auralisation in the Browser," 2021 *Immersive and 3D Audio: from* Architecture *to Automotive (I3DA)*, Bologna, Italy. DOI: 10.1109/I3DA48870.2021.9610909.

Vassilantonopoulos, Stamatis, Hatziantoniou, Panagiotis, Tatlas, Nicolas-Alexander, Zakynthinos, Tilemachos, Skarlatos, Dimitrios, Mourjopoulos, John N. (2011) "Measurements and Analysis of the Acoustics of the Ancient Theatre of Epidaurus," *The Acoustics of Ancient Theatres Conference*, Patras, Greece, http://www.ancientacoustics2011.upatras.gr/Files/Vassilantonopoulos%20et%20al._Epidauros%20Measurements.pdf [Last accessed 10th April 2024].

Vierestraete, Pieter and Ylva, Söderfeldt (2018) "Deaf-Blindness and the Institutionalization of Special Education in Nineteenth-Century Europe," in Michael Rembis, Catherine Kudlick, and Kim E. Nielsen (eds) *The Oxford Handbook of Disability History*. United States: Oxford Handbook. pp. 265–280.

Vitruvius, *Ten Books on Architecture*, The Project Gutenberg Ebook, 2006, https://www.gutenberg.org/files/20239/20239-h/20239-h.htm [Last accessed 8th March 2024].

Vorländer, Michael (1995) "International Round Robin on Room Acoustical Computer Simulations," *15th International Congress on Acoustics*, Trodheim, Norway, June 26–30.

Vorländer, Michael (2008) *Auralization: Fundamentals of Acoustics, Modelling, Simulation, Algorithms and Acoustic Virtual Reality*. Berlin, Heidelberg: Springer-Verlag.

Vorländer, Michael (2013) "Computer Simulations in Room Acoustics: Concepts and Uncertainties," *Journal of Acoustical Society of America*, 133, 1203–1213.

Walden, Daniel (2014) "Frozen Music: Music and Architecture in Vitruvius' *De Architectura*," *Greek and Roman Musical Studies* 2, 124–145.

Waldock, Jacqueline (2011) "Soundmapping: Critiques and Reflections on This New Publicly Engaging Medium," *Journal of Sonic Studies*, https://www.researchcatalogue.net/view/214583/214584/0/2094.

Waller, S.J., Lubman, D. and Kiser, B. (1999) "Digital Acoustic Recording Techniques Applied to Rock Art Sites," *American Indian Rock Art*, 25, 179–190.

Westerkamp, Hildegard (2001) *Soundwalking*, https://www.hildegardwesterkamp.ca/writings/?post_id=13&title=soundwalking [Last accessed 22nd April 2024].

Wolman, Susana (2010) *Bicentenario. Pasado y presente de Buenos Aires, en clave de Mayo. Aportes para la enseñanza*. Escuela Primaria. Primer Ciclo. Ministerio de Educación, Buenos Aires, Gobierno de la Ciudad, https://www.bnm.me.gov.ar/giga1/documentos/EL002061.pdf [Last accessed 28th February 2024].

Workman, Leslie (1997) "Medievalism Today," *Medieval Feminist Newsletter*, 23, 29.

Yelmi, Pinar (2016) "Protecting Contemporary Cultural Soundscapes as Intangible Cultural Heritage: Sounds of Istanbul," *International Journal of Heritage Studies*, 22:4, 302–311, DOI: 10.1080/13527258.2016.1138237.

Zubrow, Ezra B.W. and Blake, Elizabeth C. (2006) "The Origin of Music and Rhythm," in Chris Scarre and Graeme Lawson (eds) *Archaeoacoustics*. Cambridge: Cambridge University Press. pp. 117–126.

Ludology

Age of Empires (Ensemble Studios, 1997).
The Elder Scrolls (Bethesda Game Studios, 2014).

INDEX

Note: Page numbers followed by "n" refer to end notes.

Printed in the United States
by Baker & Taylor Publisher Services